Fine Art Printing for Photographers

Exhibition Quality Prints with Inkjet Printers

2nd Edition

Uwe Steinmueller and Juergen Gulbins

rockynook

Uwe Steinmueller, ustein_outback@yahoo.com
Juergen Gulbins, jg@gulbins.de

Editor: Jimi DeRouen
Copy editor: Deborah Cooper, James Johnson
Layout and Type: Juergen Gulbins
Cover Design: Helmut Kraus, www.exclam.de
Cover Photo: Uwe Steinmueller
Printer: Friesens Corporation, Altona, Canada
Printed in Canada

ISBN-13 978-1-933952-31-4
2nd Edition (2nd printing, August 2009)
© 2007, 2008, 2009 by Rocky Nook Inc.
26 West Mission Street Ste 3
Santa Barbara, CA 93101
www.rockynook.com

First published under the title "Fine Art Printing für Fotografen: Hochwertige Fotodrucke mit Inkjet-Druckern"
© dpunkt.verlag GmbH, Heidelberg, Germany

Library of Congress Cataloging-in-Publication Data
Steinmueller, Uwe.
 [Fine art printing für Fotografen. English]
 Fine art printing for photographers : exhibition quality prints with inkjet printers /
 Uwe Steinmueller and Juergen Gulbins. — 2nd ed.
 p. cm.
 Includes index.
 ISBN 978-1-933952-31-4 (alk. paper)
 1. Photography—Digital techniques. 2. Photography, Artistic. 3. Ink-jet printing.
 I. Gulbins, Jürgen. II. Title.
 TR267.S7415 2008
 775—dc22
 2008006983

Distributed by O'Reilly Media
1005 Gravenstein Highway North
Sebastopol, CA 95472

Contents

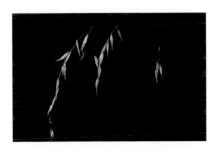

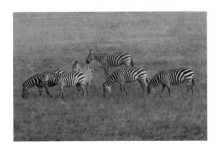

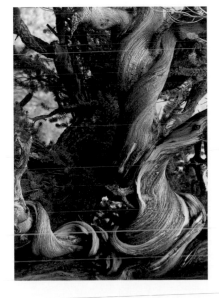

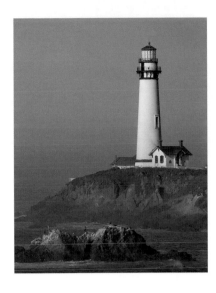

Kamera: Nikon D2X

Preface

A brief history

Inkjet printers have been around for more than 20 years, yet digital inkjet printing technology has only come of age in the past few years. The earliest consumer models lacked the technology and sophistication to print photographs similar in quality to common silver-halogenid prints (stereotypical photos printed on photographic paper), developed from film negatives or slides. Worse, inkjet prints lacked the lightfastness of silver-halogenid prints. For most users, the digital inkjet printers that delivered the desired image quality, e.g. Iris prints, were, unfortunately, rarely affordable. This economic obstacle has changed dramatically in the last few years, with the rise of digital photography. Thus, there is now a sizeable market for a new breed of inkjet printers from seasoned manufacturers like Epson, HP, Canon, Lexmark and Dell, among other newer brands.

Among the first Super B printers, suitable for both fine art printing and the budget of a broad range of buyers, were the Epson P2000 and P2200 (P2100 in Europe). The breakthrough of this line was based on quality, affordable price, and an Ultrachrome ink set.

Size matters

Many photographs impress viewers only when presented at an optimum viewing size; for example, the typical pocket-size 4 x 6 format is clearly unsuitable as a pleasing means of displaying a beautiful print. For most good shots, even the larger Letter, Legal and A4 sizes often leave viewers wanting more. Enter the A3+/Super B prints, which measure an impressive 13 x 19 inches. In 2005, there was an explosion in the use of these medium- and large-format prints, an impressive statistic that further in 2006 and 2007 (and beyond) increased when a number of new fine art printers were introduced by HP, Canon, and Epson.

For some photographs, it is advisable to produce even larger prints. Printer manufacturers like Epson, HP and Canon market printers that promise high-quality prints up to 64 inches wide. There are many other large-format printer manufacturers out there, like Encad, Oce, Mutoh, and Roland, yet they are not designed for true, fine art printing. For this reason, we chose to focus on the moderately sized prints and printers, typically from Letter/A4 to C/A2. Most of the lessons of fine art printing, however, can be applied to both smaller and larger prints and printers.

Fine Art Printing is a Sensuous Endeavor

The highly technical nature of fine art printing should not overshadow its ability to awaken the senses. As the term "fine art printing" expresses, it is the printing of art in a highly artistic fashion. It allows you to project onto paper an image created with a simple digital or film camera, after enhancing the image with image-manipulation software to more accurately represent the original. Today's fine art printing, using a good digital inkjet printer, allows you to produce a quality of equal or higher value than that of traditional silver-halogenid prints, and clearly surpasses the quality of offset or rotogravure printing. When performed optimally, your printing can achieve a richer color gamut and finer tonal gradations than with traditional book- and magazine-printing techniques.

Experiment ... and Discover!

As with other genres of art, without proper knowledge and practical experience, the resulting print may not be as accurate as the image on your computer monitor, so you may have to try several different techniques, papers, paper sizes, borders, and matte styles. With careful practice, you will hopefully be on your way to producing museum-quality work with less effort than you had previously dreamed.

Though most prints are either displayed in frames behind glass or Plexiglas, often to reduce glare, this has the effect of reducing the visual appeal of the print and the fine art paper on which it is printed. Therefore, it is important to experiment with different types of fine art paper to achieve the desired result. Paper with a certain texture and tactile essence can be very sensuous indeed, so take your time to find the paper that best suits your taste and needs and to achieve the result you like.

A printing paper's color, surface, texture, and gloss will determine the kind of print you will produce, and must be carefully chosen to match the feeling you wish to project. An architectural shot may require a different printing paper than a photograph of nature or a landscape. A black-and-white print calls for a certain type of paper that would be unsuitable to a full-color shot. A certain print displayed without glass or Plexiglas will appear entirely different than one framed behind these types of transparent coverings.

Kamera: Nikon D2X

Both authors use digital cameras – Uwe Steinmueller as a professional and Juergen Gulbins as a serious amateur. They were both led to fine art printing by the desire to control their workflow from start to finish, from the shooting of photos to the finished print. Printing with a fine art printer for them, is not a simple, tiresome task, but the final step , and a very important one – toward producing a pleasing image.

Planning for printing and printing itself takes time, but, in most cases, only a perfect, finished print gives full value to a good shot. Normally, only a few of all the photos you take will make it into a perfect, fine art print, but in many cases, this print will be the crowning glory of your photographic shooting. With the techniques shown in this book (together with others books we have published), you should be in complete control from start to finish.

Matting, framing, and hanging of prints is its own subject, and we go into it only briefly. We do, however, give some advice on how to keep and store your prints.

We hope that the control of this process and the creative tasks along the way give you the same satisfaction and relaxation we found while doing it. Producing a satisfying print from your work has similarities to Christmas: the work is finished, and the present is unwrapped. You must still find a place to keep or present it, a place where it can be enjoyed for years to come.

Acknowledgements

Thanks to our many influencers and friends like Bill Attkinson, Jim Collum, Charles Cramer, Brad Hinkel, Mac Holbert and Ben Willmore.

Uwe Steinmueller, San José (California) March 2008
Juergen Gulbins, Keltern (Germany)

Foreword by Mac Holbert (Nash Editions)

Read our brief introduction to Nash Editions in our Printing Insights #22: "Digital Printmaking & Printmakers" at www.outbackphoto.com/printinginsights/pio22/essay.html

In 1989 my partner, Graham Nash, and I embarked on a search for a way to save a large body of his photographic work. The original negatives had been lost while being shipped from Los Angeles to Graham's home in San Francisco. All that was left was a box of "jumbo" contact sheets. Graham had been offered a show at the Parco Galleries in Tokyo and without his negatives he was unable to put together an exhibit. In solving the "problem" we ended up creating a method and a studio that has been recognized by many as the first fine art digital photography studio in the world. With the help of our friends, David Coons and Charles Wehrenberg, Jack Duganne and I experimented with hardware and software and by 1991 had developed a product that we felt was ready for the world. As it turned out we still had much to learn.

The only source of information in those days was from the few individuals that were involved in the technology. When I opened the door to Nash Editions in July of 1991, I had basic working knowledge of word processing and database management but I didn't have a clue what the difference was between a pixel and a raster. I asked a lot of questions, nurtured a lot of friendships and slowly I began to develop an overview of image processing and image output. By the mid 1990's the Internet had become an excellent source of information exchange and I began to frequent the online forums that focused on imaging and printing. I can't remember specifically when I first saw the name Uwe Steinmueller but I believe it was either 2000 or 2001. Suddenly I noticed his name appearing everywhere. Not only was he in quest of information but he was, more importantly, sharing it with anyone and everyone who would listen.

www.nasheditions.com

I finally got to meet Uwe in 2003 when he and his wife Bettina visited my studio. Their enthusiasm for the digital photography revolution was obvious. I have seen many "experts" come and go over the past 16 years. Uwe's expertise and his openness have gained him a high level of respect and admiration in the evolving world of digital photography.

I am very impressed with the book you are about to read. It's information like this that has helped to raise the quality of digital output and reduce the traditional art world's resistance to the use of digital tools in art. It is a book written by someone who KNOWS fine art digital printmaking. Uwe's style is concise and to the point. This comprehensive and complete guide to fine art digital printmaking should be included in the library of anyone who is serious about making fine art digital prints.

I only wish that all this excellent information had been available to me back in 1989 when I embarked on my digital journey. The hours I wasted … The ink and paper I wasted … The late nights …The cold suppers …

Mac Holbert

April 2006

New in Our Second Edition

This is our second edition of this book. Since our first edition in 2006 quite a few new printers suitable for fine art prints were introduced by HP, Epson and Canon, some of them outdating printers that we mentioned in our first edition. We try to cover these new printers in this book. Quite a few new fine art papers came to the market and we will cover them in the current issue too. We also found good ways to determine how much brighteners are used in a specific paper and we will give you some hints on this as well.

New printers and papers will continue to come up. To facilitate the update in these, we slightly changed the scheme of the book. The actual practical printing that is described in chapter 5 now merely serves as an example. We off-loaded details on specific printers to appendix A, where you will find a section for each specific printer or printer line. Additionally, you will find updates on these printers on Uwe's Internet site as soon as we are able to lay hands on new printer models and we have had the opportunity to test new papers. So, for updates, have a glance at that site from time to time at: www.outbackprint.com

New functions have appeared in applications described in our first edition; also new applications and filters have come to the market, which are described in this second edition. Some of the dialogs of Photoshop where updated when Photoshop CS3 was introduced. As the minor changes of the interface were not relevant for our task here, we did not update all screenshots – please accepts our apologies for this.

As we both work on Mac OS X as well as Windows, you will find screenshots from both platforms. As the interface and the handling of Photoshop and most other applications are almost identical on both platforms, this should not confuse you. When using keyboard shortcuts, in most cases we will specify both versions – where not, simply substitute the Windows ⎈Ctrl key by the Mac ⌘ key and the Windows ⎇Alt key by the ⌥ key when working with Mac OS X (and vice versa). ⇧ stands for the Shift key. ⇧-⎈Ctrl-A implies, that you have to press all these keys simultaneously.

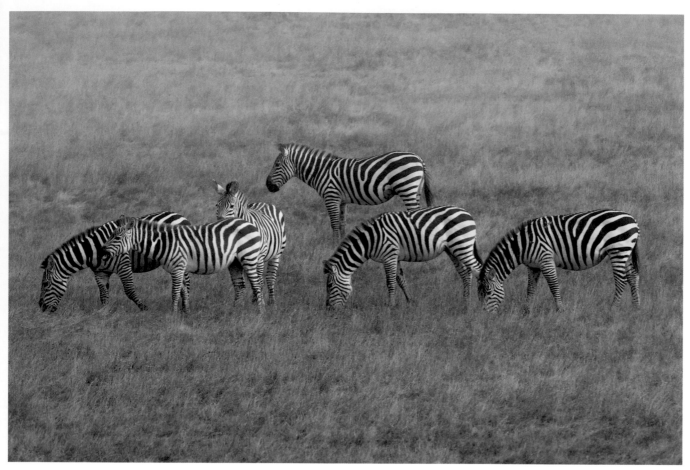

Camera: Nikon D2X

Printing Techniques

1

There are various methods of printing your own photographs. We only address one method in detail – printing using inkjet printers. In this chapter, we take a glance at different printing methods and discuss which are good and why. Most are not recommended for fine art printing.

The special focus of this chapter – and the general focus of the entire book – is fine art printing, and our reader is assumed to be the ambitious amateur, as well as the professional photographer. There are many reasonably good books on prepress work and commercial printing of books, magazines, brochures, or posters using offset printing, silkscreen printing, rotogravure or intaglio printing. We do not cover these methods, as they are either too complicated or too cost-intensive for the reader we target. Nor do they deliver the kind of quality that may be achieved with today's photo inkjet printers.

1.1 Basic Printing Techniques

The Journey from a Pixel to a Printed Point

In image processing, there are several terms used with a similar meaning, often used interchangeably for image and print resolution: **dpi** (*dots per inch*), **ppi** (*pixel (or points) per inch*), and **lpi** (*lines per inch*). Apart from this, the resolution of an image is stated by its dimensions in pixels or in inches (at a certain ppi or dpi resolution). So let's try to clean-up this mess:

When an image is captured by a camera or scanner, the result is a digital image consisting of an array (rows) of separate picture elements (called pixels). This array has a horizontal and vertical dimension. The horizontal size is defined by the number of pixels in a single row (say 1,280) and the number of rows (say 1,024), giving the image a horizontal orientation. That picture would have a "resolution" of "1,024 × 1,280 pixels" (yes, some years ago, there were digital cameras around with such a low resolution).

This is not a physical size yet. You could, for example, display this image on a 17" display (it would comfortably fill most such displays with each pixel of the image representing one pixel of the LCD monitor). It would probably have a display dimension of roughly 13.3 by 10.6 inches.* If you display this same image on a 19" monitor, its displayed size would be approximately 14.8 by 11.9 inches.

A 17" display is diagonally roughly 17 inches

The size of the image displayed is dependent on the number of pixels the monitor displays per inch. The "pixel per inch" resolutions (ppi) of monitors vary, and are usually in the range of 72 ppi to 120 ppi (the latter, larger 21" monitors). In most cases, however, with monitors the resolution is given as the number of pixels horizontally and vertically (e.g., 1,024 × 1,280 or 1,280 × 1,600). So the "size" of an image very much depends on how many pixels are displayed per inch. Thus, we come to a resolution given in 'pixels per inch' or ppi for short.

In Europe, "pixel per centimeter" (ppc) is used often instead of ppi.

With LCD monitors, their ppi resolution is fixed and can't be adjusted (at least not without a loss of display quality). With CRT monitors you have more flexibility (we won't go into this further).

When an image is printed, its physical size depends upon how many image pixels we put down on paper, but also how an individual image pixel is laid down on the paper.

How Image Pixels are Reproduced by Printer Dots

There are only a few printing technologies where a printer can directly produce a continuous color range within an individual image pixel printed. Most other types of printers reproduce the color of a pixel in an image by approximating the color by an $n \times n$ matrix of fine dots using a specific pattern and a certain combination of the basic colors available to the printer.**

Printing techniques that can produce continuous tone values are dye-sublimations, rotogravure and lightjet printing

If we want to reproduce a pixel of an image on paper, we not only have to place a physical printer's 'dot' on paper, but also have to give that 'dot'

*** These "basic colors" (or inks) of the printer are called 'primary colors'.*

the tonal value of the original pixel. With bitonal images, that is easy. If the pixel value is 0, you lay down a black printed dot, and if the pixel value is 1, you omit the dot. However, if the pixel has a gray value (say 128 out of 256), and you print with a black-and-white laser printer (just to make the explanation a bit simpler), we must find a different way. This technique is called *rasterization* or *dithering*.

To simulate different tonal values (let's just stick to black-and-white for the moment), a number of printed dots are placed in a certain pattern on the paper to reproduce a single pixel of the image. In a low-resolution solution, we could use a matrix of 3 printed dots by 3 printed dots per pixel. Using this scheme, we could produce 10 different gray values, as may be seen in figure 1-1:

printer dot pattern
image pixel

white black

"Bi-tonal" means that there are only two colors in your image: pure black and pure white (or any other two colors) but no tonal values in between.

Figure 1-1:

Different tonal values simulated by a pattern of single printed dots

Using more printed dots per image pixel allows for more different tonal values. With a pattern of 6 × 6 dots, you get 37 tonal grades, with a 16 × 16 pattern, 257 tonal grades, (which is sufficient). For a better differentiation let's call the matrix of printer dots representing a pixel of the image a *raster cell*.

Now we see why a printer's "dot per inch" (dpi) resolution has to be much higher than the resolution of a display (where a single dot on a screen may be used to reproduce a single pixel in an image, as the individual screen dot (also called a *pixel*) may have different tonal (or brightness) values.

When you print with a device using relatively low resolution for grayscale or colored images, you must make a trade-off between a high resolution image (having as many "raster cells per inch" as possible) and larger raster cells providing greater tonal value per cell.

The image impression may be improved when the printer is able to vary the size of its dots. This is done on some laser printers,[*] as well as with some of today's photo inkjet printers. If the dot size can be varied (also called *modulated*), fewer numbers of dots (*n* x *n*) are needed to create a certain number of different tonal values, (which results in a finer raster). This technique allows more tonal values from a fixed raster cell size.

Figure 1-2: *Enlarged printing raster of the eagle's eye in a printed image*

* *E.g., HP calls the technique ProRes on laser printers or PhotoREt with inkjet printers.*

There are several different ways (patterns) to place the single printed dots in a raster cell, and the pattern for this dithering is partly a secret of the printer driver. The dithering dot pattern is less visible and more photo-like, when the pattern is not the same for all raster cells having the same tonal values, but is modified from raster cell to raster cell in some random way (this is called *stochastic dithering*).

What are 'Lines Per Inch'?

Using the technique described here to simulate different tonal pixel values, the rows of dots are not laid down exactly one below the other, rather the rows are slightly offset from one another. These macro-dots form a sort of line across an area. Raster cells and lines are not directly placed adjacent to each other, but have a slight gap (in most cases).

In black color, these lines are normally placed at an angle of 45°. The number of raster cells or lines in one inch (see figure 1-3) defines another kind of resolution called "*lines per inch*" or lpi for short (using metric names it becomes "*lines per cm*" or "l/cm" for short). When printing in color, a raster cell not only consists of a single color pattern, but the pattern process is repeated for all the basic (primary) colors found in the print.

Most color printers use cyan, magenta, yellow, and black as their basic colors (also called *primary colors*). Some printers (and almost all inkjet printers that are titled *photo printers*) use some additional basic colors to achieve a richer color gamut and a finer raster, yet, basically, they use the same scheme as printers using only four basic colors. In color printers, the simulation of tonal values is represented using a pattern of primary colors (see figure 1-4).

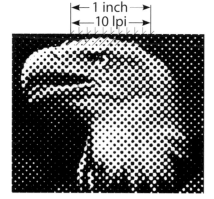

Figure 1-3: Enlarged version of very coarse raster of 10 lines per inch.

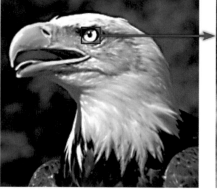

Figure 1-4:
When printing color images, tonal values (in inkjet and offset printing) are produced by a dot pattern of tiny colored ink dots. With inkjet printers, this dot pattern is not totally regular, but uses some randomness. This kind of dot pattern is also called a 'stochastic pattern'.

Different basic/primary colors (in a CMYK print there are four primary colors), raster cell lines are printed by using different line angles. In a normal CMYK print – those encountered in most colored books and magazines –, cyan is printed at 71.6°, magenta at 18.4°, yellow at 0° and black at 45°. Other combinations are used, as well, but this is the common way to place lines of colored raster cells. To avoid moiré patterns stemming from

overlapping rasters, line frequencies of colors vary slightly. Table 1.1 shows an example for a 106 lpi color raster.

Table 1.1: Example of a color raster using 106 lpi basic raster frequency

	Cyan	Magenta	Yellow	Black
lpi	94.86	94.86	100.0	106.0
Angle	71.56°	18.43°	0.0°	45.0°

The number of lines per inch of a print depends upon:

1. the number of tonal values one wants (more tonal values require larger macro-dots as more printed dots are required to provide broader tonal values), and

2. the size of the individual printed dot,* and

 ** The smaller the individual printed dot, the smaller the raster cell can be.*

3. the paper used. If you use newsprint paper, which absorbs a lot of ink, you would use a wider raster cell spacing to avoid the single macro-dots merging into one another. Using coated paper, raster cells may be placed closer together resulting in a finer printing raster and finer image impression.

Table 1.2 provides a guideline at which image resolution in pixels per inch and lines per inch is appropriate for different printing media – if you use a printing technique that works with a fixed raster (for inkjet printers, you don't use a fixed raster but a printer resolution setting in your printer driver or RIP).

RIP = Raster Image Processor, see chapter 6.

Table 1.2: Recommended raster frequency for different printing situations

Raster width		Usage	Image resolution
53 lpi	21 l/cm	Laser printer (600 dpi, 65 grey levels)	70–110 ppi
70 lpi	27 l/cm	Newspaper print, typical rough paper	90–140 ppi
90 lpi	35 l/cm	Good quality newspaper print	140–180 ppi
120 lpi	47 l/cm	Acceptable quality for books and magazines. Raster-cell points can still be seen.	160–240 ppi
133 lpi	52 l/cm	Good quality for books and magazines. Raster-cell points can still be seen.	170–265 ppi
150 lpi	59 l/cm	Good offset or silk printing, individual raster-cell points may hardly be recognized	195–300 ppi
180 lpi	70 l/cm	Good offset and silk printing, very fine raster, individual raster-cell points hardly recognizable; good inkjet printing, individual raster point no longer recognizable at a reading distance of 20–30 cm (8–12 inches)	250–360 ppi
200 lpi	79 l/cm	Very good book prints, you need a very smooth paper for printing. Raster-cell points hardly recognizable.	300–400 ppi

When you use an inkjet printer for fine art printing, you do not have to concern yourself much with raster line width. The dithering pattern of your printer driver is more complex than just described. Don't worry. Learn the native printing resolution of your specific inkjet printer – usually between 240–360 ppi and scale (up- or upsize) your image to that size. The values do not have to be precise – close is good enough. In most cases, the printer driver (or Photoshop) will do the proper scaling when using a value close to the printer's native resolution. Using a modern inkjet printer, you need not bother much with color raster angles. This, too, is taken care of by the printer driver or the RIP.[*] Inkjet drivers do not offer settings for raster width or color raster angles. For offset printing, however, this may (in very few situations) be of interest and may be dealt with in Photoshop when separating colors.

Printing using RIPs is described in more details in chapter 6.

How Many Pixels or Dots Per Inch Do You Really Need?

There is no quick, general answer to that question. It depends on several factors:

▶ **Type of printing technique used:**
Are you using a continuous-tone printing method (such as direct photo or dye-sublimation printing) or a method that produces halftones by dithering (such as inkjet or offset printing)?

The ppi values you need will be roughly the same for both methods. However, the dpi values of the printers will have to change, as in dithering you need several printer points (or ink droplets) to build up a raster cell reproducing a pixel of the image.

▶ **Type of paper used:**
If you use a rough, absorptive paper (e.g., as used in common newspapers), printed dots will bleed a bit and you must reduce the dots per inch frequency (as indicated in table 1.2).[**] If you use a good, smooth-coated paper, you may increase your resolution and get a finer, more detailed image.

The slightly increasing of the dot size caused by this bleeding is called 'dot gain'.

If you use glossy or luster paper, you will be able to reproduce even more details (allowing for higher ppi/dpi) than with matte paper or canvas.

▶ **Viewing distance:**
Viewing distance is an important factor, as the human eye can only differentiate single points up to a certain viewing angle (about 0.01–0.02°). If the viewing angle is less, two separate points can no longer be differentiated and visually merge. For a 'normal reading distance' of about 12 inches (30 cm), this minimal size is about 0.08 mm (0.0032 inch). Bright light may reduce this size a bit, low light increase it a bit. Consequently for an Letter/A4-sized photo, a pixel size or raster cell

size of 0.08 mm is a good value (equivalent to a 300 ppi raster size). If the pixel size is smaller, visual image quality (in terms of visual differentiation of details) will not substantially improve.

If the photo is of Ledger/A3 size, viewing distance is usually increased (in order to see the whole image at a glance). Thus for Ledger/A3, the pixel size (or cell size if we use a dithering method), may increase the (raster) point size to 0.122 mm or about 210 ppi.

If you produce posters, the viewing distance will increase further, and the pixel size may increase accordingly (and the ppi may decrease accordingly). If you move up to large-format printing, your ppi may even go as low as 10–20 ppi. The viewing distance will usually be more than 10 yards (or meters). In a simplified formula, simply divide 300 into your viewing distance in feet and you have the required ppi value or:

$$resolution \text{ (in ppi)} = \frac{300}{viewing\ distance \text{ (in feet)}}$$

For this reason, a photo shot with a 12 megapixel camera may be enlarged to almost any size you want – **if the image is viewed from the appropriate viewing distance.**

▸ **Type of printer driver, driver settings and interpolation used:**
For optimal results, you should use a ppi value close to, or even exactly that of, the printer's native resolution. The printer's native resolution varies from manufacturer to manufacturer. Epson inkjet printers, for example, usually have a 'native resolution' of 720 ppi, while most HP inkjet printer use 600 ppi. Canon inkjets usually use 600 ppi, as well.

Do you really need an image resolution as high as stated? It contradicts a statement given before. Well, yes and no. For optimal results with an Epson inkjet printer, use either 720 ppi or 360 ppi; for an HP printer, either 600 ppi or 300 ppi.[*]

You may leave (automatic) scaling either to Photoshop (as part of the print dialog) or to the printer driver. However, in both cases, you really can't know exactly which algorithms are used for scaling and how well those algorithms will work with your image and your scaling factor (Photoshop will use the scaling algorithm you set in your basic Photoshop Preferences).

If your image is close to the native resolution given above (at the size you intend to print the image), the algorithm will not matter too much. If, however, the image has to be upsized or downsized considerably, the scaling algorithm does matter (it will also influence the effect of sharpening done for printing). In this case, you should either scale an image before calling up the print dialog (and you may have to do this for each individual printing size of the image) or you may use a RIP (see chapter 6).

If you do your scaling in Photoshop, we recommend "Bicubic Smoother" for up-sizing and "Bicubic Sharper" for down-sizing.[**]

** Here, we assume, no further scaling is necessary.*

*** If you leave the sizing to Photoshop (via the Print or Print with Preview dialog), Photoshop will use the resizing (Image Interpolation) method that was selected in your Preferences settings (Edit ▸ General; with Mac OS it is: Preferences ▸ General).*

1.2 Offset Printing

Offset printing is the technique used for most books, brochures, magazines, and newspapers. It is plate-based printing. The image is rasterized – as described under *"Basic Printing Techniques"* – for the print and transferred onto a printing plate by projection. This projection currently is done with lasers or LED arrays. First, a plate is coated with a light-sensitive layer. The laser (or LED array) inscribes the image pattern onto this layer. The printing plate is chemically developed, then wrapped around the printing cylinder ③. Those parts of the plate not printed are smooth and do not pick up water when passing the wetting roller ①. The parts of the plate to be printed are rougher and pick up ink when passing an ink-soaked roller ②. This ink-pattern is transferred (by offset) to a rubber-coated rotating cylinder ④ (this is why the printing technique is called "offset printing"). The paper to be printed passes between this rubber cylinder and the paper roller ⑤ pressing the paper against the rubber cylinder. Thus, ink is transferred onto the paper and the image is transferred. In color printing, this process is repeated in additional printing units – one for each primary color (normally C, M, Y, and K).

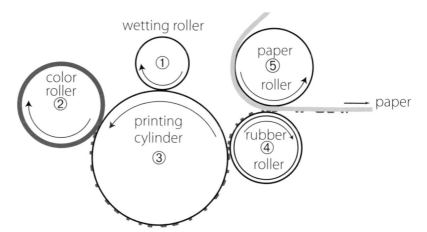

Figure 1-5:
Functional model of offset printing
(traditional analog offset printing)

The image quality achieved with this technology is quite good in terms of resolution and longevity – provided a good, coated, acid-free paper is used and the image is viewed from a correct (reading) distance. The richness of the color gamut is clearly below that of good photo inkjet printing (see figure 1-6).

The gamut of an offset print may be enhanced if six rather than the normal four (CMYK) inks are used. Printing with six inks is also called *hexachrome printing* (in addition to CMYK, green and orange are used). However, this requires special printing presses having additional print units. Hexachrome printing is far more expensive than CMYK (4C or 4-color) printing, and also requires a special color separation process and special plug-ins for Photoshop to prepare images or DTP documents).

Traditional offset printing might be considered if you intend to make a print run of 1,000 or more copies. As few, if any, home-users or small offices can justify printing equipment for offset printing, we will not discuss it any further (additionally, we have a very limited knowledge of the techniques involved).

In recent years, digital offset printing has come onto the market (e.g. HP Indigo press). These systems work with printing techniques similar to that of laser printers. These digital offset printers are mainly used for smaller print runs (typically 50–1,000). With most models, the maximum print size is restricted to A4 or A3. The resolution of digital offset printing is greatly inferior to that of analog offset printing (e.g. HP Indigo press 5000 has a resolution of 812 × 812 dpi, while analog offset printers work with typically 2,400 × 2,400 or even 3,200 × 3,200 dpi). Printing photos, this leads to a visible reduction of image quality. As for color gamut, some digital offset printers exceed the gamut of traditional CYMK offset presses. They, however, are still inadequate for high-quality fine art prints.

Traditional offset printers, as well as digital offset printers are quite fast. For example, HP gives a printing rate of about 4,000 A4 pages per hour for its HP Indigo press 5000. The speed of traditional offset printing presses may exceed 100,000 pages per hour.

The costs of digital offset printers starts at about $50,000 US and up. The price of a traditional offset press may easily exceed one million dollars.

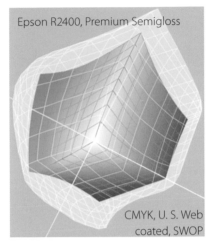

Epson R2400, Premium Semigloss

CMYK, U. S. Web coated, SWOP

Figure 1-6: The gamut of a photo inkjet printer (light-gray area) is larger than the gamut with traditional analog offset printing (colored area).

1.3 Laser Printers

Laser printers are well established, reasonably fast (from four pages per minute up to 100 pages per minute) and reasonably inexpensive for the cost per page (typically about 4–6 cents per Letter/A4 page in black-and-white at an ink coverage of 5% per page and about 16–20 cents at an ink coverage of 90% per page). While color laser printers were quite expensive formerly, in 2004 and 2005 their price dropped dramatically. You can buy a color laser printer for less than $500 US currently. With low-priced color laser printers, manufacturers use a business model similar to low-cost inkjet printers: they sell inexpensive printers and earn their return via rather expensive toner units. A color toner set – lasting for about 3,000–5,000 pages at 5% medium ink page coverage – costs about the same as the basic laser printer unit ($300–$400 US), resulting in a cost per page (Letter/A4) of roughly $0.10 US with a 5% medium ink coverage per page and about $1.60 US when printing full page size colored images. Nevertheless, printing of text and graphic pages with a color laser printer is much faster and somewhat cheaper than using an inkjet printer.

Laser printers use very much the same technique (see figure 1-7) used by modern photocopy systems (some models even combine both functions: scanning and printing).

A photo drum ① is charged positively by a charging unit ②. The image of the print is rasterized by the printer's RIP (*Raster Image Processor*), and this raster is applied onto a drum using a laser beam and rotating mirror ③ (or alternatively by an array of LEDs). Where the light hits the drum, the positive charge is erased. Then, the drum passes the toner unit ④. Those parts that saw light pick up the positively charged toner, while those parts that bear a positive charge reject the toner. Further on, the toner is transfused onto the paper and burned in by a heated roller (fuser) ⑤.

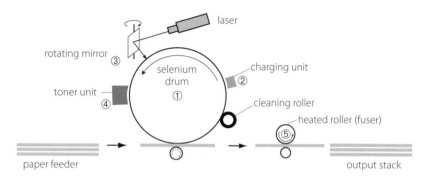

Figure 1-7:
Functional model of a laser printer

Color laser printers use four inks – cyan, magenta, yellow, and black (CMYK). They either use four drums or a transfer belt that picks up toner from four separate drum rotations and four toner units and transfers the complete color image onto the paper with one rotation.

As for image quality, the limiting factor of today's color laser printers is the resolution used (600–2,400 dpi, usually just 600 or 1,200 dpi) and the number of colors they use – which is only four (CMYK). A further limitation stems from the size of the toner particles, much larger than those of dye-based or even pigment-based inks on inkjet printers.

Most laser printers have problems producing homogeneously colored areas or fine tonal gradients (you usually see smaller blotches of unevenly printed colors). With several of the color laser printers, the image shows a gloss, which may impair viewing with some images. You cannot avoid the gloss even when using matte papers. This is especially true for solid inks used by some XEROX color laser printers.

For this reason, image quality with color laser printers is clearly inferior to all other printing methods described here and can't touch that of photo inkjet printers. If, however, you have a color laser printer, we recommend using it for fast index printing. The color and detail quality, in most cases, is good enough for a first, fast inspection.

Image longevity very much depends on the type of paper and inks (toner) used and ranges from about 10 to 20 years. The permanence of black-and-white prints is much better, and may be used for archiving documents (provided you use the appropriate paper).

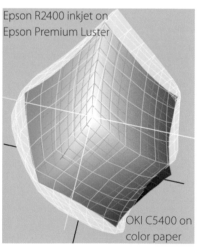

Figure 1-8: Gamut comparison of a color laser
printer (OKI C5400) (inner colored figure) and a
photo inkjet printer
(Epson R2400, using Epson Premium Luster
paper, light-gray area).

1.4 Dye-Sublimation Printers

Thermo-sublimation printers are frequently used for the fast and simple production of photographic prints, often directly from the digital camera via a USB cable using the DPOF (*Digital Print Order Format*) or PictBridge protocol supported by today's digital cameras – even the cheaper consumer models. Alternatively, you may plug your camera's memory card into a card-slot the printer provides.

With thermo-sublimation printing (also called *dye-sublimation* or *dye-sub* for short), color is transferred from a color-coated ribbon (foil) onto the paper. The transfer is done by an array of tiny heating elements (integrated into the print head). Where the ribbon is heated, the color on the foil evaporates (sublimates) and enters the paper where it cools down. CMY as well as CMYK ribbons are used. Three or four passes (or sections) of colored ribbons are needed to produce a complete image on the paper. Usually the ribbon consists of sections with the alternating basic colors (three for CMY or four for CMYK). The used portion of a ribbon becomes unusable, is rolled up and finally discarded. The paper must make three (CMY) or four (CMYK) passes under the print head. Individual color intensity is determined by the amount of heat. When the next primary color is added (to those colors previously composed of several primary colors), their colors merge into a combined color due to the heat. The three or four colors merge in the paper and form an (almost) continuously toned color.

With these systems, production costs are independent of the number and kinds of colors and the amount of color a printed page has, as a ribbon section is used only once and then discarded.

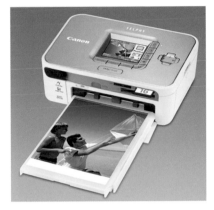

Figure 1-9: Canon SELPHY CP750 dye-sublimation printer, 300 dpi, print-size up to 10 x 20 cm, (Courtesy Canon Germany)

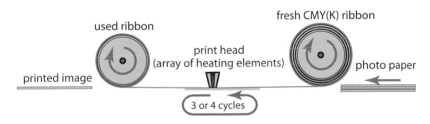

Figure 1-10:
Working scheme of a thermo-sublimation printer

The typical resolution of dye-sublimation printers is 240–300 dpi, which sounds very low. However, keep in mind that dye-sub printers do not render a color via dithering, but do it by merging their basic colors by sublimation, thus achieving an (almost) continuous color tonal range for every dot and a highly photographic image at these resolutions.

Typical dye-sub printers today range from 4 × 6 inch to A4 in print size, the lower-cost models (partly portable) are mainly in the 4 × 6 inches (10 × 15 cm) range. A typical print speed is about 30–100 seconds for a 4 × 6 inch photo. Some printers are much faster (e.g. Kodak Photo Printer 6850, claims 300 dpi, 8 sec. for 4 × 6 inch – but it costs $2,200 US).

The range of printing material used with dye-subs is very limited and highly restricted to papers provided by the manufacturer of the printer – one kind for glossy and another kind for matte paper, in most cases. The same is true for inks (color ribbons).

The lightfastness and longevity of dye-sub prints is about five to fifteen years (considerably more in dark storage).

Prices for small dye-sub printers start at about $ 120 US and go higher with print/printer size; about $ 500–$1,500 US for a Letter/A4 size printer. The cost per print is about $0.20–$0.30 for a 4 × 6 inch print and about $ 1.5–$2.5 for an Letter/A4-sized print.

1.5 LightJet® Printing (Digital Photo Print)

** LightJet is a trade name of Cymbolic Science, nowadays a subsidiary of Océ.*

There are various names for this technique: *digital photo print* or *LightJet® printing** or *direct digital printing* or *direct photo printing*. Here, in essence, the image is imposed onto conventional photographic material by lasers. To produce an RGB print, three lasers are used. The material may be photographic paper used for traditional color photos or may be photographic film for translucent prints. The exposed material is then developed in a traditional wet process. The resolution used by most printers is either 300 dpi (or ppi) or 400 dpi. Lower resolutions may be used, as well, and will be interpolated to the printer's native resolution. This seems very low, compared to the resolution of inkjet printers or offset presses. With direct photo printing, however, no dithering is required to produce halftones, and every exposed dot on the paper combines red, green, and blue, thus resulting in (almost) continuous tone dots. For this reason, 400 dpi or even 300 dpi will produce a very fine image quality.

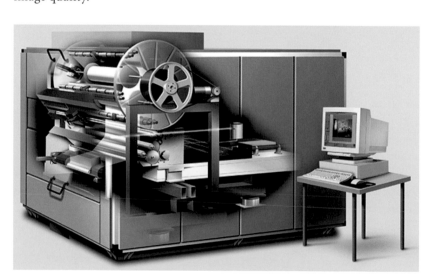

Figure 1-11:
Durst Lambda® large-format photo laser
imager
(Courtesy Durst Phototechnik AG, Brixen, Italy)

There are a number of different makers and models of this type of digital photo printer (e.g. Fuji Frontier minilab, Agfa D-Lab, Lambda, Océ LightJet®, Chromira). Print image size may vary from 4 × 6 inches up to 50 × 50 inches). With some digital photographic printers, you may even go much larger (e.g. the Durst Lambda photo laser imager may produce prints up to a width of 50 inches and a length of 262 feet).

As direct photo printers are quite expensive,* this technique is almost exclusively used by service shops – often the very largest ones.

They start from about $ 100,000 US.

There are two kinds of photographic print shops:

1. **Consumer-oriented photographic print shops**
 They produce a very large quantity of prints per day at very low prices (typically from 15 cents for a 4 × 6 inch print to about $5 US for a Letter-sized print). The processing is done fully automatically and in large quantities. Special requests are usually not handled by these shops. In most cases, an automatic image optimization is performed. This may be disabled at most shops when you place an order, which you should do if you have done your own optimization.

 The quality of their prints is usually quite reasonable and uniform, in most cases.

 Currently, ICC profiles are ignored by these printers; all images are assumed to be in sRGB. If you send an image to them for processing, you should convert it to sRGB (if not already in this format).

 ICC profiles describe the color space of an image or the color behavior of a device. For more on ICC profiles, see section 3.2.

 Most of these shops offer only standard image formats. If your image format differs from those supported, you have the option of using either the full width with some parts of the image being trimmed off or receive an image with white borders – which, for fine art prints, may be what you want, anyway. In most cases, it is preferable to set your image to one of their standard formats and decide where and what kind of white frame (or other colored frame) you wish to use.

2. **Professional photographic service bureaus**
 They specialize in high quality prints (usually in smaller quantities), also accommodating special requests. They may even offer to optimize your image for printing, which may or may not be appropriate. These bureaus should provide you with a printer's ICC profile (often, you may download this from their Web home-page). These profiles may be used for two purposes:

 A) Use as soft-proofing to assess how your image will appear when printed.

 For soft-proofing, see section 3.12.

 B) To convert your image to another profile. When you send your images to a service bureau, the image should be converted to the correct profile as other embedded profiles are ignored by the printing process. This hopefully will change in the future!

Print permanence of digital photographic prints is the same as that of photographic paper (silver-halide color prints), which typically range from 17 years (e.g., Konica Minolta QA Paper Impressa) to 40 years (e.g., Fuji Crystal Archive paper), depending on the kind of paper used. All these data assume that all the chemical residues are removed from the photographic papers. If not, its lifetime will be substantially reduced.

Most shops offer three to four kinds of paper (glossy, semigloss, pearl, and matte). As standard photographic papers may be used for printing, there is sometimes a choice of several papers from different suppliers. For higher quality, often Fuji Crystal Archive paper is used due to its high print permanence.

Some digital photo printers allow printing on transparent and translucent photographic film.

Print speed is quite fast – at least compared to inkjet printers. The Océ LightJet 5000, for example, prints a 50" × 50" print at 405 dpi in about 12 minutes.

The color gamut of modern direct photo printers is about that of Adobe RGB (1998) (slightly larger).

If you want to produce many prints of the same image with the papers offered and their lightfastness (print permanence) is sufficient for your purpose, direct photo prints ordered via the Internet may be an easy and cost-effective way to go.

It is best to start with a test order, and only order more if the results are satisfactory. While you may have your pictures the next day with consumer photographic print shops (at least in Europe, where even snail mail is reasonably fast), prints from a professional service bureau usually take three to five days, plus delivery time.

While most photo services will even print black-and-white prints on C4 paper (photo paper designed for color prints), there are a few pure black-and-white papers available nowadays for direct photo printing. They will probably result in better neutral prints. If your service provider only offers C4 paper, make sure that the system is well (neutral) calibrated – otherwise you may get an undesired color cast in your black-and-white prints. It is best to try the service with a small black-and-white print first.

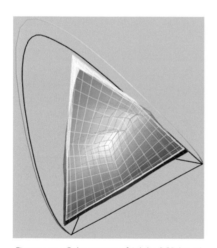

Figure 1-12: Color gamut of Adobe RGB (1998) (white frame) and that of a digital photo laser printer (Océ LightJet 5000) (colored frame)

1.6 Inkjet Printing

Having taken a glance at other printing techniques, we want to dig deeper into inkjet printing. While some techniques mentioned are rather old, inkjet printing is rather young. The first color inkjet printers came to the market in about 1985. Compared to today's inkjet printers, they were very slow and showed extremely poor image quality. They were used largely to render simple color plots and production of transparencies for presentations. Print permanence of that first generation of color inkjet printers was quite poor.

Soon, however, some specialized high-end printers came on the market. The IRIS printer – made by IRIS Graphics of Bedford, Massachusetts (later acquired by Scitex) – was one such machine. The IRIS printer, at an early stage of inkjet history, provided a reasonably high print speed and considerable resolution and image quality, while print permanence and maintenance were problems. Prints produced by IRIS printers are sometimes called *Giclée prints*.

A very nice page by Harald Johnson on Giclée prints may be found on www.dpandi.com/giclee/.

Along with the growth of the PC and Macintosh markets, the need for inkjet printers grew, and today you scarcely find a home PC without an inkjet printer, their cost dropping from several thousands of dollars US to about 150–800 dollars (depending on the maximum print size) for quite acceptable desktop photo inkjet printers. For large-format inkjet printers (those beyond a print size of A3+/Super B), you will have to spend several thousand dollars.

Inkjet Technology

There are a number of different inkjet technologies in use. The basis of all of them is that tiny ink droplets are ejected from a printhead and projected onto a paper. To increase print speed, a printhead now consists of many nozzles – up to about 3,000 per ink channel on contemporary printers.

The technique making the ink droplets eject differs with various printers and printer makers (most printer manufacturers use a single technique in all machines).

The main techniques are:

▶ Continuous flow inkjet printers

The following methods are also called *drop-on-demand*, as they eject a droplet only when needed on the paper:

▶ Thermal inkjet printers (e.g., used by most HP and Canon printers). Canon calls this technique *bubble-jet*.

▶ Piezoelectric inkjet printers (e.g., used by most Epson printers)

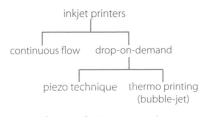

Classification of inkjet printer techniques

Continuous Flow Inkjet

This technique was developed by IBM in the 1970s. With continuous ink flow systems, a continuous stream of charged ink droplets is produced. Those droplets intended to print fly straight onto the paper, while undesired droplets are electronically deflected into a gutter for recirculation. This is the oldest inkjet technology and is used for high-speed production lines. The complex ink-circulation system makes these printers costly in maintenance. They can be very fast compared with the typical drop-on-demand type printers.

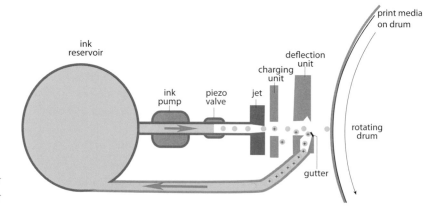

Figure 1-13:
Principal ink flow in a continuous flow inkjet
printer

This technique is used by the famous IRIS inkjet printer, where the paper is mounted on a rotating drum. These systems are quite expensive and not suited for desktop usage or smaller installations. Usually solvent-based inks are used with these printers.

Piezo Inkjet

Certain kinds of crystals expand or contract when subjected to an electrical charge. This piezoelectric effect is used in certain inkjet printers. To eject a droplet, a voltage is applied to the crystal in the print head, the crystal deflects inward, forcing a droplet out of the nozzle. The returning deflection pulls fresh ink from the reservoir, and the cycle repeats. A print head consists of many of these miniature jets (nozzles), and the system allows variations in the size of droplets to produce a finer pattern and smoother color gradients.

Thermal Inkjet

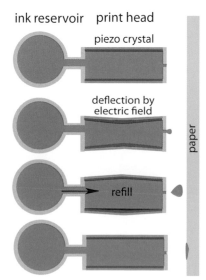

Figure 1-14: Different phases of the ejection of
a droplet with a piezo print head

With thermal inkjet printing – also called bubble-jet printing – there is a resistor in the print head chamber. When it is heated by a short pulse of electrical current, a vapor bubble forms in the chamber increasing pressure. This pressure forces an ink droplet out of the nozzle. Then the bubble collapses and draws in more ink from the reservoir. For the next droplet, the cycle repeats. This technique is used by some HP printers (e.g. HP Design-

jet 30), as well as by most Canon printers (e.g. Canon i9900, W6200). Also some wide-format printers like the HP Designjet 130 and the ENCAD Novajet 1000i use thermal print heads. The technique may be used with dye-based, as well as pigment-based inks, however, it does require an ink suited for thermal inkjet printing (with a low boiling point). The life-cycle of these printers is a bit shorter than that of piezo-based print heads, but the production cost is lower.

Droplet Size

Along with increasing printer resolution, the size of the individual ink droplets has decreased. A smaller droplet allows production of a finer raster of dots on the paper. Today, photo printers use a droplet size down to 1–5 picoliters (1 picoliter is 0.000 000 000 001 liter or 1×10^{-12} liter), thus allowing a single pixel (a raster cell) of the image to be built by many tiny dots, achieving a fine raster (e.g. 360 ppi or even 600 ppi) with a broad range of tonal values.

With some photo inkjet printers (e.g., with piezo-based ones) the droplet size can vary. For dark colors – especially colors of a primary ink color – larger droplet sizes are used. This allows increasing print speed. For light colors, a smaller droplet size and wider droplet spacing is used.

Figure 1-15: Phases of a thermal inkjet printer

Printer Resolution

When inkjet printers first arrived, a resolution of 150 dots per inch was considered good. Today, resolutions of 2,400 dpi, 4,800 dpi, 5,800 dpi, and even 9,600 dpi are normal for photo printers. Please do not be mislead by these advertising claims, as they refer to resolution only in one direction, e.g., horizontal. Canon's i9950 photo printer has a maximum resolution of 4,800 x 2,400 dpi, where the higher resolution is seen in the horizontal direction (achieved by the horizontally moving print head) and the lower resolution in the vertical direction. Here, the increments are determined by the step motor that moves the paper. The same is true for most inkjet printers.

Before you invest your money in one of these high-resolution printers, consider carefully whether you actually need the maximum resolution advertised by these printers. To take advantage of a manufacturer's maximum resolution, you need a paper or other printing medium that can accommodate the fine pattern of ink droplets, so the ink will not bleed noticeably into the open area. The paper (or its coating) must absorb ink very quickly to keep it localized. Ensure your paper can accommodate the resolution you wish to use.

We have found that a horizontal resolution of 1,400 dpi or 2,800 dpi, both of which are typical for Epson printers, is sufficient, even for fine art prints. For higher resolutions, the print speed decreases dramatically and

➡ *Please do not confuse the 'printer resolution' – given in 'dots per inch' (dpi) – and the resolution of the image sent to the printer (the latter given in pixel per inch – ppi). The printing resolution has to be much higher as inkjet printers produce halftones using a pattern of single dots and need several of these dots to simulate the halftone of a single image pixel on paper.*

ink usage increases, neither of which result in noticeably better image quality. Of course, print speed and ink usage can vary among different printers, even from the same manufacturer.

Number of Inks

"light cyan" and "light magenta" are also called "photo cyan" and "photo magenta".

While inkjet printers originally used a single black ink, three more inks (CMY) were added to produce what we now take for granted as the norm: CMYK. All of today's photo inkjet printers use at least six inks: CcMmYK (c = light cyan, m = light magenta).

To enhance the color gamut of these printers, more inks are often used. Epson's Stylus Photo R1900, for instance, uses Red and Orange (and, optionally, a gloss optimizer) but has no Light Cyan nor Light Magenta. Epson's R2400 uses three shades of black inks: a Photo Black (or alternatively Matte Black), a Light Black, as well as a Light Light Black, in addition to the CcMmYK, thus totaling eight inks. This latter collection of inks produces neutral black-and-white prints with very fine tonal gradients.

Figure 1-16: *Though the Epson R2400 may use 9 different inks, only 8 cartridges may be in place at any point of time. You may either have either 'Photo Black' (PK) or 'Matte Black' (MK) in place.*

The color gamut and print permanence of today's professional and semi-professional inkjet prints now surpasses that of traditional silver-halide photographic prints, although there are some weak spots: e.g., saturated blue and red. For this reason, the number of different inks used in a fine art printer will likely increase to 11, with the addition of R, B and a gloss optimizer.

In 2006, Canon announced its "imagePROGRAF iPF5000". This printer accommodates 12 single inks: CcMmYK plus RGB plus Light Black (Canon calls it *Grey*) and Light Light Black (which Canon calls *Photo Gray*). For Black there is a *Photo Black* and a *Matte Black* (all in the printer at the same time). This 17" printer uses pigment inks.

→ *The current line of HP fine art printers, like the Z3100, uses 11 inks – 3 shades of Black/Gray as well as Red, Green and Blue – plus a gloss enhancer. The A3+ line of HP fine art printers (HP B9180 and B8850) use 8 inks (having only 2 shades of Black/Gray).*

Practically, though, the number of inks that may be used is limited by the size and weight of the print heads, and the cost of the numerous ink cartridges.

Type of Inks

For more details on dye-based and pigment-based inks, see section 2.2.

Two different types of inks are mainly used in today's normal inkjet printers:

▸ dye-based
▸ pigment-based

There are, however, several other types of inks on the market, e.g., inks with an oil base that are primarily for large-scale printing and weatherized and/or ruggedized prints for outdoor use. Other inks are formulated for printing on fabric, and are usually solvent based. Some printers use hybrid inks: dye-based for colors, and pigment-based for black to achieve a dark, deep black, a technique used by some Canon printers.

1.7 Other Printing Techniques

Other printing techniques available for fine art printing include: screen printing or silk-screen printing. Solid-ink printing (used by some Xerox Phaser printers), thermoautochrome printing, and various other techniques. Unfortunately, these methods are not practical for home-based printing, because they are expensive, involve large equipment, and are time consuming. Rather they are better suited to a service bureau, especially when producing a large number of prints of the same image or producing very large prints. In these cases, you should ask the service bureau for specific details on how to prepare your images for printing.

1.8 How to Pick Your Fine Art Printer

The inkjet printer market continues to grow. With so many viable choices, how do you pick a suitable printer for your needs? Though it may appear trivial, the first question is: what do you intend to do with your printer? We assume it's for fine art printing or high-quality printing.

First, let's define the requirements for fine art printing:

▸ High to very high image quality
▸ Rich color gamut
▸ Reasonable print permanence (more than 25 years)
▸ Two or more tints of black inks for optimal black-and-white prints
▸ Adequate print size and print performance
▸ Costs

Image Quality

When photos are printed, you should achieve a clearly photographic image, provided you use the proper paper, e.g., glossy. Tonal gradients should be smooth and should show no banding or posterization. The individual pixel (raster cell) should not be visible at a proper viewing distance. Almost all of today's photo inkjet printers with print resolutions greater than 1,200 dpi and having more than the four basic inks (CMYK) achieve this goal.

Rich Color Gamut

A color gamut is the spectrum of colors a particular printer can produce. Dye-based inks tend to provide a larger range than do those which are pigment based. The manufacturers of pigment-based inkjet printers try to compensate for this by employing new ink formulas. Epson, for example, in 2005, with its K3 inks, reached its third generation of UltraChrome ink. Additionally, colors beyond the basic CMYK sets are often used to expand the color palette. Most of them use at least six inks: CMYK, c (light cyan) and m (light magenta). Some add red and blue, others add several shades of

black. As stated earlier, we will probably see printers using both CcMmYKRB and two to four black variations. In fact, the race appears to have started in February 2006, when Canon announced their new printer model image-PROGRAF iPF5000 would come with 12 inks: C c M m Y R G B Photo Black (called *Regular Black*), Matte Black, Gray, and Photo Gray.

With new ink formulas and more colors in use, the gamut difference between dye-based and pigment-based inks virtually vanishes. You may enhance the achievable gamut by using bright white glossy papers, which produces the maximum gamut. These papers are available for both kinds of printers and most, if not all, available inks.

In almost all cases, you can download profiles from each manufacturer's Web site. However, these profiles only cover the manufacturer's own ink and papers.

It's very difficult to interpret gamut size from the technical specification of a printer. If the last bit of gamut size really matters, you will have to compare ICC profiles provided by the printer manufacturer.* There are also hundreds of custom profiles available from fine art printing professionals like Bill Atkinson and Joseph Holmes, both pioneers in the relatively new field of fine art printing using inkjet printers.

Print Permanence

A print should last for a reasonable time without noticeable degradation of color or density. So, what is reasonable? This answer may vary greatly depending on your own expectations and what you hope to do with the print.

You will find more on print permanence in section 2.1.

According to our definition, the print should have, at a minimum, a print permanence of at least 25 years, depending on how it will be used and displayed. If you intend to sell your prints, especially to serious collectors, 20 years may not be long enough. Fifty years or even 100 years is considered the minimum time for museum-quality prints, so perhaps you should consider this metric. You must define your own expectations, however.

Black-and-White Printing

To produce good black-and-white or monochrome images, look for a printer with at least two shades of black ink, or use a good RIP like The QuadToneRIP or ImagePrint, both of which allow you to compensate somewhat for fewer black inks. For some printers, there are also multi-tone black-ink sets. For the Epson 2100/2200, for one example, a number of multi-tone black-ink sets are on the market.** Before switching from color to black inks for mono-chrome printing, you must carefully clean your print heads. Ideally, a printer using multiple black inks in its original set would be preferred. The Epson R2880, using three different black inks (Black, Light Black and Light Light Black) or the HP Z3100 and Z3200 models, which also use three black/gray inks, are examples of printers well suited for black-and-white printing.

You will find more on RIPs in chapter 6 and more on black-and-white printing in chapter 7.

** *Examples of this would be MIS Ultra Tone family of inks (e.g., at www.inksupply.com), and Piezography Neutral K7 inks (www.piezography.com)*

Canon too offers several inkjet printers that use three black inks, including the "imagePROGRAF iPF5100" and the "imagePROGRAF iPF5200"

With the introduction of printers using several shades of black ink, the use of third-party, multi-tone ink sets decreases. If the printer uses two or three toned black inks, its printer driver provided by the OEM usually has special settings for black-and-white printing.

Adequate Print Size and Print Performance

To create the most striking and lasting impression, a print must be displayed at an optimum size. While most desktop printers offer a maximum size of Letter/A4, fine art printing demands a minimum size of Ledger/A3. For some prints, especially for exhibitions, larger formats may be needed. Since larger-format printers tend to be a bit pricey, you might consider something in between, say, a printer that produces prints up to 13" or 17" wide. These are relatively affordable, even for many home-based printing aficionados, and may save you countless trips to the neighborhood print shop. If larger prints are, in fact, your bent, then perhaps the print shop is your best bet. Before choosing, though, analyze your true needs and wishes, then decide whether to purchase your own printer or have someone else do the printing for you.

Types of Papers Supported

Not every printer can adequately accommodate every type of paper. You must carefully match the paper to the printer, considering the following items: size, ink, and paper thickness. While size is obvious, the other two factors may not be. Most printers can only accommodate paper up to a specific thickness and flexibility. You can find this information in the printer's technical specifications. Maximum media thickness is largely influenced by the path through the printer the paper will travel. The Epson R2400, for example, provides three different paper paths: the normal one, from the top; a second one, using rear-feeding; and a third one, where the paper is pulled in from the front and pushed out at the front again. This last method allows a paper thickness of up to 0.06 inch (1.6 mm). Also HP's Photosmart Pro 9180 provides a number of different paper pathes and allows for papers up to 1.5 mm. Canon's fine art printers cover very much the same range.

With printers using dye-based inks, you should only use swellable papers[*] when print longevity is an issue. Lightfastness of HP swellable papers (used with HP dye-based inks, for example) is about 65–130 years for black-and-white prints. Using different papers, print longevity may be much shorter. Some other dye-based inks, especially used with microporous coated papers (more on that in section 2.3), may achieve only a very short print permanence.

You have a wider choice of paper if you have a printer that uses pigment inks, such as the HP B9180 and Z3100 models, the Epson R2400 and R2880, or the Canon PIXMA Pro 9500 and iPF5100, to name just a few. Apart from the manufacturers' own papers, there is a wide range of third-party papers available for use with these printers and inks. Using pigment-based inks definitely gives you more freedom when choosing your paper.

Some printers also accommodate roll paper, which reduces paper cost when printing a lot, and may become more important when you want to print panoramas or long flyers. When using roll paper, an automatic cutter

** For more on swellable paper, see section 2.3, page 41.*

➜ For fine art prints, print longevity should always be an issue.

➜ HP cites a print permanence of 250 years and more (confirmed by Wilhelm Research) for its Vivera pigment inks. This rating is, however, only valid if you use HP Advanced Photo or other fine art papers..

is a necessary advantage, although these are primarily available for larger-scale printers.

A printer's ink set also must be correctly matched to the desired paper. There are inks better suited for glossy and semigloss, while other inks work better for matte paper. To accommodate these differences, some modern photo printers allow switching some inks on the fly, however, it is usually only the black ink cartridges. Perhaps in the future all printers will simply have more cartridges preinstalled, instead of having to switch them physically for different paper types.

So, for example, the Epson R1900 using UltraChrome Hi-Gloss inks and an additional gloss optimizer targets gloss, semigloss and luster papers, and is less suited for matte papers or canvas. You may, however, use either Photo Black (on gloss or semigloss) or Matte Black, depending on the type of paper used. If you print matte, velvet or watercolor papers, the Epson R2400 or R2880 is the better choice, although you may use either Photo Black for gloss or semigloss, or Matte Black on matte papers.*

In general, dye-based inks are better suited for glossy paper, while pigment-based inks print better on matte papers.** Using a pigment-based printer that provides an additional gloss optimizer can reduce this disadvantage.

You will find similar choices with some HP and Canon printers..

*** See section 2.2 for more on this.*

Costs

There are three categories of costs to consider:

▸ The price of the printer
▸ Paper costs
▸ Operational costs, e.g., for inks, print heads, etc.

In printing, the price of the printer is often a minor cost. Paper costs vary greatly depending on the size, type and brand of paper used and the quantity you buy. Generally, the price of an Letter/A4 size page will be $1–$2 and for an Leger/A3 size page will be $2–$4 for good-quality fine art paper.

It's possible to find a cheaper, third-party, in-house paper at Staples or Office Max, but you must consider whether they provide profiles for their papers, or if they offer a lightfastness statement. Probably not. With papers for fine art printing it's best to use inkjet papers from suppliers with a proven track record.

In appendix B we name a few papers we tested and liked. Some papers that give a fine print for black-and-white printing are listed in section B.5.

The most expensive part of fine art printing is the ink set . This is true for most desktop printers, while large-format printers have large ink cartridges that are less expensive per print of a given size. Ink costs per print depend on:

▸ The size of your print

▸ The type of printer used

Some newer printer drivers no longer give the printing resolution in dpi but via quality settings like "Photo", "Best Photo" or "Maximum dpi".

▸ The resolution used for printing. The higher the resolution chosen, the more ink is consumed. Therefore, ensure that the maximum resolution

actually achieves a visible improvement. In our experience, resolution beyond 2,400 dpi (2,880 dpi for Epson printers) uses up more inks without noticeably better image quality. Using some printers and papers, you may even reduce resolution to 1,200 dpi (1,440 dpi for Epson printers).

▸ The kind of paper used. Some papers, to improve image quality, soak up more ink than other papers.

You may slightly reduce ink consumption by avoiding unnecessarily turning the printer on and off. Each time you power up the printer, some ink is used for nozzle cleaning. However, you should activate the printer from time to time, say, once a week, and should clean the nozzles periodically to prevent clogging. If you use your printer infrequently, you may even have to replace a clogged print head or two, clogged by dried ink.

If you print often, it may be cost-effective to buy a larger printer (beyond the Super Super B/A3+ size), since larger printers often use larger ink cartridges, which are less expensive relative to volume; for example, with the Epson R2400 you pay about $1/ml. With the R4800, you only pay about $ 0.50/ml ($54/110 ml), or only $ 0.38/ml when using 220-ml cartridges.

Another way to reduce ink costs is to use third-party inks. For consumer Letter/A4-sized printers, there are many brands. Most of them will result in poorer lightfastness, but this is not true for all of them. Here, you may want to look at tests published by some PC and photo magazines. For A3 and larger professional printers, there are fewer offerings, however, some inks do offer reasonable quality.

A potential problem using third-party inks is that you may void your printer's warranty. You should clean the print heads thoroughly before changing ink brands. For this, there are special cleaning cartridges available. For the printers we discuss, there are OEM-compatible replacement cartridges that come rebranded. Some are original OEM cartridges refilled (ink counters reset). While a few of them are unsuitable for fine art printing, some companies like Phantone ([76]) or Lyson ([102]) claim high quality, good lightfastness, and lower prices.

For more ink suppliers, see appendix appendix D, page 292.

A technique offered for many large-scale printers that also may be used for some Letter/A4-sized printers are *Continuous Flow Ink Systems* (CIS or CFS), also called *bulk-ink systems*. This technique should not be confused with the continuous-flow printing technique described on page 16). Here the OEM ink cartridge is replaced by a different cartridge that gets ink via a tube from a bulk-ink bottle. These systems have two major advantages:

1. The ink per print or per milliliter is much cheaper than using OEM cartridges. For our previous example for the R2400, this is about $0.17/ml with the Mediastreet Niagara II system, 4-ounce (118 ml) or 8-ounce (236 ml) ink bottles. With larger printers and larger bottles, it may be even cheaper.

2. You may print much longer before replacing ink cartridges.

➜ *Epson was successful in court, winning a case against such companies as Mediastreet, and NO companies can sell into this Epson market without posting a bond roughly equal to the full cost of each cartridge they provide. At the moment, all such bulk systems intended for the Epson printers have been pulled from American markets.*

Panta Rhei continuous flow ink system, here
used with an Epson printer.
(But see our note on the previous page.)
(Courtesy Monochrom Germany)

A disadvantage is that you make a pre-investment: for the R2400, it would be about $ 335 for the Mediastreet system (with filled bottles). If you switch inks, e.g., Photo Black to Matte Black, you waste a lot of ink to clean out the tubes. Additionally, you must use auto-reset chips to fool the printer or cartridge.* Also, you can't use the OEM original ICC profiles, and will need profiles for the new ink. If you print a lot, this could be a minor problem. Some ink suppliers offer ICC profiles for their ink and various common fine art papers.

** A microchip inside the ink cartridge*
monitors the ink usage. When the normal
amount of ink is used up the printer will tell
you to change the ink cartridge. When you
refill the cartridge, you have to reset the ink
usage counter of the controlling chip. The
same is true if you use a bulk ink system
(continuous ink system).

Now, how about lightfastness? Here again, you will find some ink manufacturers (e.g. Lyson), that refer to tests done by WIR ([20]).

More Points to Consider

There are a few other points you may want to consider when selecting an inkjet printer:

Printer Interface

Some years ago, the standard interface for PC printers was the parallel port (Centronics or IEEE 1284) or serial format for Macs. This, fortunately, was replaced by USB 1.1 and more recently by USB 2.0 for most desktop printers. Some printers include an additional Firewire (IEEE 1394) interface. This could be an advantage when connecting the printer to two systems. Most large-scale printers also have a local area network (LAN) interface. The LAN is useful if you want to print from several systems in a local network. A small, low-cost print-server with a USB interface to the printer will achieve the same end and may be cheaper than an optional printer LAN interface. Some printers even provide a WLAN interface (more often called WiFi), though we have not yet encountered them with fine art printers.

PostScript RIP

Most desktop inkjet printers use their own proprietary printer language, and most printers additionally support HP's HPCL. In some cases, it is an advantage if the printer also supports PostScript, e.g., to print DTP documents. Most fine art printer manufacturers, however, do not consider this necessary, at least not for printing raster images like photos. With inkjet printers, an integrated PostScript RIP will add about $150 to the basic printer price. If you need PostScript printing only occasionally, you may use a software PostScript RIP in your PC. With Mac OS X, a software-based PostScript RIP comes with GIMP Print, and also with OS 10.4 preinstalled. With Windows, you may use the free public domain version of GhostScript.

A RIP (raster image processor) is a software component in a printing system which produces a raster image (bitmap) from a vector graphic or from text.

Exchangeable Print heads

In some printers, usually consumer inkjet printers (e.g., by HP), the print head is part of the ink cartridge. This makes cartridges somewhat more expensive. When the nozzles of a head are clogged beyond repair, simply replace the cartridge and the problem is solved. With most Epson printers, you can't easily replace the print head, but must send the printer out for repair.* With some HP printers, e.g., the Designjet 130, the ink cartridge and print head are separate, and you may easily replace a print head with a new one. It's definitely an advantage when you can easily pull out the print head and clean it outside the printer, using a hot damp cloth or even some alcohol.

** For Letter/A4-sized printers, it is cheaper to buy a new printer.*

Cutters

On large-scale printers, a paper roll feeder is standard. For these printers, it is an advantage when the printer has an automatic paper cutter. Many of the default cutters on large-format printers, however, are not suited for heavy paper. For heavy paper you may have to replace them with cutters available as optional accessories.

Densitometers and Spectrophotometers

Some printers have an integrated densitometer that allows measurement of the density of color laid down on paper. This allows the firmware of the printer to recognize clogged nozzles, and may also help auto-calibrate the printer. HP uses this technique in some of its inkjet printers, e.g., HP Photosmart Pro B9100 and B8850 and Canon in some if its imagePROGRAF line. Be aware that this is not a substitute for a true profiling device. Better than a densitometer is a spectrophotometer, allowing you to measure the precise color of a color patch. This allows an easy generation of a color profile (ICC profile).** HP, for instance, integrated a spectrophotometer in its 3100 and 6100 line of fine art printers. This is an optimal solution – provided the software for the profiling comes along with the printer.

*** How to profile a printer and use a spectrophotometer is described in section 3.8.*

Inks, Papers, and Print Permanence

2

With photographic prints, paper, ink and the compatibility of these two materials are important keys to a good quality print – assuming you have a good image. You can't actually discuss fine art printing without discussing fine art papers and the right inks for them. For this reason, in this chapter we want to go deeper into inks (for inkjet printers) and papers, and what to watch for, so that these two important components match.

Fine art papers are indeed a hot discussion theme when fine art printers meet – and that discussion is virtually endless. A fine art paper not only should work smoothly with the type of ink used, but also should be appropriate for the photographic subject printed. A print of a landscape may ask for a different paper than a portrait and a product shoot may ask for yet another paper to achieve the optimal visual impression. Additionally, personal preferences have to be taken into account.

Another issue with inks and papers are the longevity of prints that can be achieved using a certain printer-ink-paper combination. This chapter should answer most questions on this.

2.1 Print Permanence

Whether you sell or give away your prints, print permanence (print longevity) is important. It is determined by three major factors:

▸ Stability and permanence of the paper

▸ Permanence of the ink (its colorants). Additionally, ink and paper must match and work smoothly together.

▸ Environmental factors, such as light (especially UV), temperature, humidity, and gases (especially ozone)

The permanence of a digital image is limited only by the permanence of the digital storage media, whether hard disk, CD/DVD or tape. You may extend this range by making a copy of the data on newer media. You must still be cautious to ensure that your media can still be read by your computer hardware and operating system, and that your printing application still supports the data format used to produce your prints. In most cases, this will be years in the future. *Permanence,* in this case, means that you can read the data without unrecoverable errors, and can open the data for displaying, printing or modification.

When you make a print of an image, its permanence may range from four weeks to many years. Here, *permanence* means that the print will maintain its visual impact without noticeable deterioration, and that colors do not fade and the paper does not yellow.

This definition of *print permanence* has two subjective factors:

▸ What is a "noticeable image deterioration"?
▸ What are the conditions under which the print is kept?

Until mid 2006, there was neither an ANSI nor an ISO standard for print permanence – at least not for the kinds of prints we are talking about. Most suppliers of printers, inks and papers state a "permanence" value for their materials, without actually defining how they calculate their "permanence." However, in the community of fine art printers, there is a quasi-standard currently defined by the *Wilhelm Imaging Research, Inc* (WIR, [20]). This organization, founded by Henry Wilhelm and his wife Carol Brower Wilhelm, is one of the most widely recognized and established institutes for the testing of print permanence and lightfastness, and is highly regarded for being independent and unbiased. Most serious manufacturers of components for fine art printing (e. g., HP, Epson, and Canon) use WIR to obtain permanence tests.* You will find a large number of results for various papers and inks (and paper/ink-combinations) at their Web site. xx

They use a well-defined test procedure for their permanence tests of prints, and continually update their tests, considering additional factors that affect fading, e. g., air pollutants.

** Naturally, there are a number of other institutes that do the same and should be considered, e.g., the Rochester Imaging Permanence Institute [18]. However, it is widely accepted that Wilhelm Imaging Research defines the standard in the fine art printing industry.*

"Display Permanence Ratings" are Predictions

When we talk about the *display permanence ratings* (DPR) of digital fine art prints, we look for and talk of a *permanence* of at least 25 years. By using adequate fine art papers and inks, you may achieve a permanence of 60–100 years and perhaps even longer. For black-and-white prints, this figure may be 160 years or more. The difference lies in color-ink colorants being more prone to fading than those used for black inks.

To date, all data on permanence are based on accelerated lab tests and predictions. Prints are exposed to much brighter light (about 20,000 Lux) and at higher temperatures than found in a common exhibition or office environment. The results are then extrapolated, based on years of experience. Nonetheless, the true accuracy of these results will not be known for another hundred or so years.

For exhibition conditions, WIR assumes an average light level of 450 lux for 12 hours a day. They also assume that the print is displayed behind (normal) glass and displayed at 75° F (24° C) and 60% *relative humidity* (RH).

See figure 2-1 on page page 30 for some examples of WiR ratings.

Fine art printers should not necessarily rely on these conditions when looking at a data sheet, as not all suppliers use the test conditions specified by WIR. Read a manufacturer's claims carefully. Kodak, for one, seems to use two different types of tests: one for consumer materials, and another for professional materials, although there is no information about which papers Kodak rates as *consumer* or *professional*. The data resulting from these two tests differ by up to a factor of five, mostly because they use 120 lux/12 hours per day testing consumer material versus 450 lux testing professional material, and assume a UV filter will be used when displaying the print. The reality is that most tests use a standard glass filter, which absorbs much less UV light.

Some of the permanence ratings Canon provides are for *darkroom* or *album storage*. The decrease in print quality in darkroom storage is much slower than that in a lighted office environment. Only the fine print describes a given permanence as *darkroom storage* permanence. What good is long darkroom permanence if you want to hang your prints in an office or studio environment?

We have seen fading in prints made with Canon dye-based inks and papers, specified to have a print permanence of about 100 years, in less than four weeks when presented in a well-lit office environment.

There are several environmental factors influencing the permanence of prints, and not all are yet fully understood or evaluated. Some of the well-known factors are:

▶ Ink
▶ Paper
▶ Paper-to-ink match
▶ Light, especially UV, which causes the most fading
▶ Temperature: the higher, the more damaging
▶ Relative humidity: the higher, the more damaging
▶ Gases: ozone is now considered one of the most degrading factors in an "office environment"; sulphur gases are also known to be destructive.

WIR Display Permanence Ratings for Current Products in the 4x6-inch Photo Printer Category

Type of 4x6-inch Dye-Sub Photo Printer, Inkjet Printer/Inkjet Paper, And Digital Silver-Halide Color Paper/Digital Minilab Photo Printer[1]	WIR v3.0 Endpoints at Both 1.0 and 0.6 Densities With Cool White Fluorescent Illumination and Years of Display Based on 450 lux/12 hrs/day With Prints Framed Under Glass[2]

1. **Epson PictureMate Personal Photo Lab** (and new PictureMate Deluxe Viewer Edition) — **104 years**
 – Printed with Epson PictureMate Inks and Photo Paper (pigment-based inkjet prints)

2. **HP Photosmart 325, 335, 375, 385, 422, and 475 Compact Photo Printers** — **82 years**[3]
 – Printed with HP Vivera Inks (HP 95, 97, 343, or 344 Tri-color cartridges) (dye-based inkjet prints) With HP Premium Plus and HP Premium Photo Papers, High Gloss, Glossy, or Soft Gloss

3. **Canon Selphy DS700 Compact Photo Printer** (dye-based inkjet prints) — **41 years**
 – Printed with Canon BCI-16 tricolor ink cartridge and Canon Photo Paper Pro PR-101

4. **Fujicolor Crystal Archive Type One Paper** (silver-halide color prints) — **40 years**
 – Printed with Fuji Frontier 370 digital minilab and Fuji washless chemicals

5. **Kodak EasyShare Printer Dock, Plus, Series 3, and 6000 Printers** (dye-sub prints) — **26 years**

6. **Dell Photo Printer 540** (dye-sub prints) — **26 years**

7. **Agfacolor Sensatis and Agfacolor Splendix Papers** (silver-halide color prints) — **22 years**[4]
 – Printed with Agfa d-lab.2plus/Select digital minilab and Agfa washless chemicals

8. **Kodak Edge Generations and Royal Generations Papers** (silver-halide color prints) — **19 years**[5]
 – Printed with Noritsu QSS-3011SM digital minilab and Kodak washless chemicals

9. **HP Photosmart 145 and 245 Compact Photo Printers** (dye-based inkjet prints) — **18 years**
 – Printed using HP No. 57 Tri-color cartridge with HP Premium Plus and HP Premium Photo Papers, High Gloss, Glossy, or Soft Gloss
 – Printed with HP No. 57 Tri-color cartridge and — **11 years**[6] Kodak Ultima Picture Paper, High Gloss (Ultima ColorLast "Lasts Over 100 Years" version)

10. **Konica Minolta QA Paper Impresa and Centuria For Digital** (silver-halide color prints) — **17 years**[7]
 – Printed with Konica Minolta R2 Super 1000 digital minilab and Konica washless chemicals

11. **Lexmark SnapShot P315 Photo Jetprinter** (dye-based inkjet prints) — **16 years**
 – Printed with Lexmark 33 or 35 color ink cartridges and Lexmark Premium Photo Paper

12. **Olympus P-10 Digital Photo Printer** (dye-sub prints) — **8 years**

13. **Canon CP-200, CP-220, CP-330, CP400, and CP500 Printers** (dye-sub prints) — **7 years**

14. **Sony DPP-FP30 PictureStation Photo Printer** (dye-sub prints) — **6 years**

15. **Sony DPP-EX5, DPP-EX7, and DPP-EX50 Printers** (dye-sub prints) — **4 years**

. . . . continues next page

This document originated at <www.wilhelm-research.com> File name: <WIR_4x6_Prints_2005_07_03.pdf>

Figure 2-1: Some permanence ratings by WIR (Courtesy of Wilhelm Imaging Research Inc, [20]). See [21] for the complete and original document.

Light as a Factor of Print Permanence

Light is one of the most important factors in determining the permanence of prints.* The more light your prints absorb, the faster their colors (colorants) degenerate. More specifically, the quantity, duration, and wavelength of that light striking the print all determine the level of degradation of a print. Shorter wavelengths in the visible spectrum have a greater effect than longer wavelengths. UV light has a higher energy and higher destructive effect (see figure 2-2). Direct unfiltered sun has a very high degree of UV in its spectrum. For this reason, fine art prints should never be exposed to direct sunlight.

** provided you use well-matched, reliable, stable inks and paper*

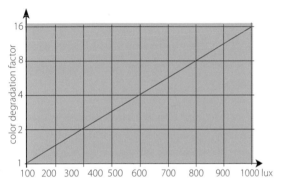
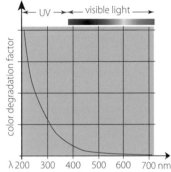

Figure 2-2:
Influence of the light on light fading (Note: the right diagram is a very rough approximation, and the scale is logarithmic).

Not all ink colors fade at the same rate. With most pigmented inks, yellow fades less and slower than other colors. This difference may lead to stronger color shifts and changes in contrast than if all colors faded at the same rate. Usually, there is a shift from red and green to yellow, and from neutral (built with CMYK) to a reddish hue.

Temperature Influencing "Dark Fading"

When storing (archiving) prints for an extended time, temperature is a critical factor. Its influence is termed *thermal degradation* or *dark fade,* as this fading also occurs when prints are stored in the dark. From our chemistry classes, we may recall that higher temperature accelerates chemical processes, and image decay is mainly a chemical process. Figure 2-3 illustrates that temperature is a dominant factor in image degradation when stored in the dark.

Temperature also influences images in the light, but the light factor is dominant. Please note the linear X-axis (temperature), and the logarithmic Y-axis (longevity factor).

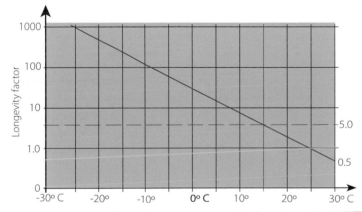

Figure 2-3: Permanence factor relative to temperature. (Diagram derived from data published by Monocrom [106])

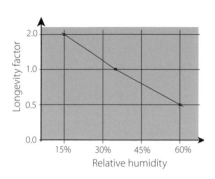

Figure 2-4: Permanence factor in relation to air humidity (diagram derived from data published by Monochrom [106])

Humidity

Relative humidity will influence the longevity of a print as well, though not as strongly as temperature. The higher the relative humidity, the shorter the life of a print (figure 2-4).

Even if relative air humidity is not dominant, humidity above a certain level, around 80%, may lead to fungal decay which in turn may quickly and seriously damage your prints. Note that when the temperature in a room drops, relative humidity rises.

Gases and Their Influence on Print Permanence

Several atmospheric gases strongly affect print permanence. Ozone appears to have the strongest negative effect. Generated by unfiltered sun, as well as by some machines, ozone accelerates oxidation and, as such, the decay of colors. Ozone is also a bleaching agent.

Framing a print with glass, acrylic (e.g., Plexiglas), an UV-absorbing foil or other coating decreases air flow, and hence fresh ozone, over a print. The more UV light in your environment, the more ozone you will probably have, as UV light stimulates the production of ozone. Also, some electric engines like laser printers, photocopying machines, air-conditioners, and refrigerators produce ozone.

As ozone decreases in the upper atmosphere, especially near polar regions, the UV level at the earth's surface increases, generating even more ozone at the surface.

Other atmospheric gases also have a negative effect on the longevity of prints; for example, nitrogen dioxide (NO_2) and sulfur dioxide (SO_2) are suspected of yellowing paper. While their overall effect is not fully understood, it does appear to be less than that of ozone.

Paper Additives

When optical brighteners break down, the paper loses its whiteness and the color of the print shifts a bit due to the more yellowish paper color.

Additives to paper can also influence the light stability of a print; for example, optical brighteners, mainly used to make paper appear whiter, can have a negative effect on photo-fading, as their chemical half-life is rather short (a few years).

These brighteners also may have a negative effect when doing ICC profiling, so we recommend avoiding papers with a high degree of optical brighteners. We will go a bit more into optical brighteners on page 40.

How to Improve the Permanence of Your Prints

All things considered, the optimum recipe for maintaining your prints and their colorants as long as possible is very simple: keep them dark, cool, and dry. For most situations, none of these is practical when prints are to be displayed prominently. There are several ways to improve print permanence:

For more on framing, post-coating and lamination see section 8.5 and 8.6.

▸ **Framing using a glass or acrylic cover**
A covering reduces gas flow and has a filtering effect on UV light. It also helps protect a print from dust and dirt, and may resist large changes in humidity.

 Standard glass or standard acrylic decreases the amount of UV light striking an image by reflecting or absorbing some of the light. Even normal window glass reduces UV light by up to 90 %. Using special glass, as some museums do, you can achieve a reduction of up to 99 % or more. There are also foils on the market, though quite expensive, that absorb about 99% of the UV light.

▸ **Spraying/coating**
Standard glass adds to reflections and is not always suitable for some types of presentations. To protect a print from UV light, ozone and soiling, you may apply protective material over a print, using either a spray or brush. There are many solutions available, but only a few carry a certificate from one of the well known institutes (e.g. WIR).

▸ **Reducing UV light**
Since UV light has the most damaging effect on print permanence, you can reduce it by using appropriate lighting that limits the amount of UV. Interestingly, unfiltered fluorescent light has a higher UV share than tungsten light. You also can cover the light source with special foil or glass, the latter of which can absorb about 99 % of UV light. These foils, properly applied, are hardly visible, but may change the surface appearance of the print slightly. Additionally, these foils are not cheap.

According to some reports, these foils tend to shrink over time (noticeable only after three to four years).

▸ **Laminating**
Lamination is similar to coating: protecting a print from UV light, ozone, dust, and other undesirable materials. An advantage of some lamination techniques is that both sides of the print are protected, providing greater protection.

2.2 Inks

High-quality prints have two important items in common: good inks and good paper, both of which allow the longevity of your artwork. Inkjet printers have been around for almost 25 years. Prints from the earliest printers showed noticeable degradation within a few weeks, or even within a few days when exposed to sunlight. In 2001, Epson became one of the first companies to address this problem, with reasonably priced inkjet printers and an acceptable image lightfastness, using UltraChrome® ink. In 2005, Epson introduced its third generation of this pigment-based type of ink (Ultra-Chrome K3) and updated it in 2007 with some printers by replacing its magenta ink with *Vivid Magenta*.

Desktop and larger fine art inkjet printers use two types of inks:

▸ Dye based
▸ Pigment based

You may even see some hybrid inks, where dye-based ink is used for colors to achieve a large gamut, while pigment-based ink is used to create a dark, dense, saturated black and better longevity; Canon does this with some printers. Some publications use the term *pigmented inks* to refer to hybrid inks. In this book, the term describes true inks with solid pigment.

Each of these two types of inks has specific advantages and drawbacks. HP achieved a very respectable longevity of about 70–200 years even with its dye-based Vivera® inks*(but now also offers printers, which use pigmented inks), while Epson managed to achieve a rich color gamut with its third generation of pigment-based DURABrite® and UltraChrome® inks. Pigment-based inks tend to provide a smaller gamut. In reality, with desktop printers, you normally have no choice between dye-based and pigment-based inks for a particular printer: they are either one or the other. With some higher-end, large-format printers, different types of inks may be used on the same printer.

** Dye-based inks tend to have general problems with lightfastness.*

Dye-Based Inks

With dye-based inks, the colorants are water soluble and are dissolved in the ink liquid. Thus, when hitting the paper, they sink into the paper or its coating, while a small portion remains on the surface. This makes dye-based inks well suited for glossy paper, but they are equally well-suited for matte papers. When the liquid dries, the colorants attach to the fibers of the paper or particles of the coating. To prevent excessive bleeding and mixing with neighboring color points, in general, a coated paper may be used (see section 2.3). To give the print maximum vividness, its coating should be transparent. As the ink penetrates the paper surface or coating, dye-based inks deliver better scratch resistance than pigmented inks.

Compared to the colorants in pigmented ink, the particles in dye ink are much finer, up to a factor of 1,000. As dye-based inks contain a higher percentage of liquid (mostly water), they dry more slowly. Also, such prints are more prone to smudging when coming in contact with moisture or when touched by a moist finger. A microporous coating (or other special sizing) can compensate for both of these effects.

The disadvantage of these tiny dye particles is that they have a larger surface open to attack by light and air contamination, like ozone, NO_2, and SO_2, leading to faster fading. To reduce this effect, HP and other printer-makers recommend using swellable papers for optimum print permanence.[*]

** See section 2.3 for more on this.*

Most desktop inkjet printers and many large-format printers today use dye-based inks. Most HP and Canon printers, for instance, use dye-based inks. Since 2006, however, both manufacturers also offer printer lines that use pigmented inks.

→ For fine art prints we recommend using these.

Dye-based inks are cheaper to produce than pigment ink and are less prone to print-head clogging. Even if the print-head is clogged, it cleans more easily (with a moist Q-tip or a damp tissue) than the heads of pigmented-ink machines. Even if the colorants in the ink should settle down in the ink cartridge after some time, they will be re-suspended when the ink cartridge is shaken.

Dye-based inks tend to provide a richer color gamut, more vivid colors and a darker black than pigmented inks, although newer formulations of pigment inks are gaining some ground.

Pigmented Inks

In pigmented inks, the color stems from pigments, comparatively large colored material that consists of a tightly coupled conglomerate of colored particles. A single particle of pigment is about 1,000 times the size of a particle of dye used in dye-based inks, and thus produces several advantages over dye-based inks: the pigment has a relatively small surface and, thus, is more resistant to light, water/moisture, and air pollutants. Pigment inks better resist damage from light, moisture, gases, and temperature.

The downside of pigments is their somewhat reduced color intensity, compared to dyes, and that they poorly suspend in the ink. Thus, there is a tendency to settle at the bottom of the ink cartridge, similar to sand in a very slow-moving river. You can stir them up but, after some time, they sink down once more.[**]

Also, pigment-based inks tend to show a stronger *bronzing* effect than dye-based inks. Here, dark or black areas show a slight color of bronze under some lighting. Similar pigment-based inks show a stronger tendency toward metamerism, where two colors look identical under one lighting situation, but look different viewed in a different lighting situation.

*** The cartridges of pigmented ink should consequently be thoroughly shaken (while closed and packed) before inserting a new ink cartridge into the printer. What's more, the ink should be used up within about six months. Pigmented-ink cartridges are prone to clogging.*

When used in an inkjet printer, most of the pigmented ink will settle on the surface of the paper and not penetrate the paper (or its coating) to the

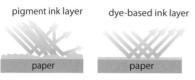

Figure 2-5: The dye particles are much smaller than pigments. Pigments diffuse and scatter light more than dyes.

same degree as dye-based ink. As the pigment sits mainly on the surface of the paper, the print is more prone to abrasion than are dye-based inks. On the other hand, pigment ink dries faster than dye-based ink, since pigment ink uses less solvent. With pigment ink, your choice of paper is somewhat expanded, as you may use coated or uncoated paper (uncoated paper is prone to ink bleeding and a large dot gain), and swellable or porous coatings.

Because pigments mainly reside on a paper's surface, the gloss of a color depends on the quantity of ink/pigment used in the various areas of the print, resulting potentially in an uneven gloss. Additionally, pigments give a more dispersed reflection (see figure 2-5). For this reason, pigment ink is better suited for matte or semi-matte surfaces than to glossy paper. You might compensate for this by post-applying an additional gloss coating if gloss is desired. Epson offers this in its R800/R1800 printers by using a separate gloss optimizer cartridge.

Pigmented inks, when combined with the optimum paper, have a very long lifespan, based on their better light stability, gas resistance, and temperature fastness. Additionally, there is less tendency of prints to smudge when touched with moist fingers or a high moisture content. Taken together, pigmented inks are excellent for stable, long-lasting fine art prints. With its new DURABrite™ and UltraChrome K3™ inks, Epson shows that you now can produce a richer color gamut and achieve a higher maximum density (*Dmax*) in a print.

Since 2006, both HP and Canon added printer lines using pigmented inks to their list of fine art products, thus also competing in the fine art and high-quality photo printing markets.

The overall quality of both types of ink has improved considerably over the past few years. The lightfastness of dye-based inks has improved considerably, and the color gamut of pigment inks also has increased. The tendency toward bronzing and metamerism with pigment-based ink has been considerably reduced, especially by Epson. The total color gamut achievable with inkjets is ultimately improved by better inks and the use of more primary colors.

2.3 Papers

Paper is an ancient, well-studied material. First produced in China, and mass-produced over the past 600 years in the western world, we inherited a long and rich tradition of paper making. There are several paper makers today, whose companies date back several centuries. Since 1584, Hahnemuehle has been one of the best known German paper makers for fine art.

Most of the time, we are unaware of the stability or longevity of paper, but concentrate on its color, surface texture, and the color gamut we can achieve printing on it. For fine art printing, however, we must consider two other items:

▸ Longevity and lightfastness of the paper itself
(it should neither disintegrate nor yellow within a certain time)

▸ Suitability of the paper for the ink used
(the paper must absorb ink without the ink bleeding excessively, drying
too quickly or warping. With dye-based inks, it must protect the ink
from ozone and other atmospheric pollutants)

The longevity of the paper is largely determined by the ingredients in the
paper and how it's stored:

▸ The stability and constitution of the paper. Today, if you use chloride-free,
acid-free papers, this is not an issue. The paper will remain stable for hun-
dreds of years, if stored under appropriate conditions.

▸ The paper should not noticeably change color over the period of time
considered, i.e., it should not yellow. One precondition for this is that it
be lignin-free and not contain an overabundance of optical brighten-
ers.

For fine art printing, in most cases, special fine art papers should be consid-
ered. Fine art paper for inkjet printing is almost always specially coated for
printing (figure 2-6).

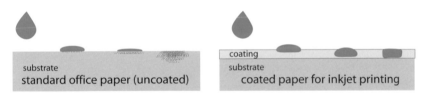

Figure 2-6:
The coating prevents the ink from bleeding
excessively.

Thus, paper consists of a base material (*substrate*) and a coating (and/or
sizing) that ensures that the ink is properly absorbed by the paper and dries
quickly. Additionally, the coating must prevent the ink from bleeding exces-
sively (figure 2-6). This permits higher-resolution printing and finer color
gradients.

Paper Characteristics

There are many characteristics of a good fine art paper:

▸ the raw material used to produce the paper
▸ coating (influencing absorbency): single or double sided
▸ color (whiteness and brightness) and opacity
▸ base weight and paper thickness
▸ surface texture (finish)
▸ size

The technical part of a technical data sheet might look like the following
example, extracted from specifications of Hahnemuehle Photo Rag:

Table 2.1:

Data sheet of a typical fine art paper
(here, Hahnemuehle Photo Rag 188)

Physical Characteristics (Hahnemuehle Photo Rag™, 188 g/m²)

	Unity	Valuation	Test Norm / Notes
Test Conditions		23° C / 50% RH	CSS19
Weight	g/m²	188	ISO536
Thickness	mm	0.30	EN 20534
Whiteness	%	97.5	ISO 11475 (W_{cie}/ D65,2°)
Opacity	%	92.5	DIN 53146
Media Color		white	not bleached
pH		7.9	DIN 53124
Water resistance		very high	
Cobb		70.0	EN 20535
Ink limit	%	245	
Special features	optical brighteners		

Data shown are average values.

Paper Ingredients

The raw-material composition of a paper largely determines its overall quality, plus its behavior for printing, display and storage. With fine papers for inkjet printing, there are at least two layers: the paper base and a coating applied onto this base. The top layer is also called the *ink reception layer* or *inkjet receptive layer*. Both its layers and its raw materials are important in giving a paper its characteristics. Here, we specifically focus on papers excellent for fine art prints. There are two basic kinds of raw materials: cotton (rag) fibers and wood cellulose fibers, and any combination of the two. Thus you may have rag paper, half-rag paper, wood-free, and wood-containing paper. Today, only few real rags are used, mostly raw cotton, even if a paper's name implies otherwise.

There are many other ingredients in the paper to give it the desired color, surface feel, pH, absorbance, and finish, yet cotton/rag or cellulose from wood remain the two basic ingredients.

Rag paper may contain up to 100 % cotton or linen fiber and is the most expensive paper. But one may mix cotton/rag with wood cellulose in almost any combination to reduce cost. For high quality, cotton/linen-based paper is the better paper, but some new formulations of wood cellulose-based paper can achieve about the same longevity as rag/cotton paper.

Cellulose is mainly produced from wood, but there are other plants, like hemp, also used for cellulose production. Wood pulp contains a lot of

➜ *Rag (or cotton) as well as wood is primarily built up of cellulose. These two base materials of paper, however, use different kinds of cellulose. The cellulose from wood and similar plants is called "alpha cellulose".*

lignin, which causes low-quality papers to yellow, and works as a kind of glue in the cellulose cell. For good-quality papers, lignin, or *lignen,* must be removed during the pulping process.

To differentiate between cotton paper and mainly wood cellulose-based paper, sometimes the term *alpha cellulose* paper is used for the latter. Also the term *sulphite* or *sulphite paper* is used for this paper, as the wood pulp is cooked in sodium sulphite or in calcium bisulphate.

Whatever the raw material may be, it is important that the paper is acid-free, meaning it has a pH-value of 7.0 or greater, up to a certain pH. Previously, 7.0–8.5 pH was considered optimal for archival papers. New findings now indicate a range of 7.0–10.0 pH. A pH of 7.5–9.0 seems ideal and provides a buffer for acids absorbed from acidic air pollutants. The latter are also referred to as *buffered* papers. This buffering is often achieved by addition of calcium carbonate.

Whiteness and Brightness

The whiter a paper is, the higher the contrast of colors in your print and the richer the color gamut. For this reason, photographers prefer bright white papers. Since the base material for paper is not bright white, paper manufacturers must use some tricks to achieve proper whiteness. This is especially true when the coating is transparent. If you look at the numerous variations of fine art papers, you will find a very wide range of shades of white, from a bluish bright white to a "natural" white, i.e., a tint of yellow or beige, to ivory or creamy white.

There are several techniques to improve whiteness and brightness of paper, e.g., bleaching. Even white colorants are added to the paper base material. Additionally, optical brighteners may be added, partly to compensate for possible color variations in different paper batches. You will see optical brighteners even in well-known fine art papers like the Photo Rag by Hahnemuehle.

Technically, brightness is a percent of light reflection and ranges from 0 (or 1) to 100 %. Multipurpose bond paper used for copying machines has a brightness value in the 80s, while the brightness of most fine art paper is 90.0–98.5 %. Ideally, the paper would reflect all colors equally well. This, however, is not the case. Another desirable paper property is a good, homogeneous reflectance across the spectrum of visible light (see figure 2-7).

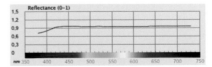

Figure 2-7: Ilford Galerie Gold paper shows a very homogeneous reflectance.

Most papers look very white when viewed alone. The true color becomes visible when compared to other white surfaces, e.g., that of a matte or white frame.

When you choose a paper, you should consider the subject you want reproduced in your print. For most portraits, for example, bright white is not advisable. The same is true for most landscape subjects. So, if high brightness is not important or necessary, you may be able to use a paper free of optical brighteners.

Optical Brighteners

➜ *For some more information on OBAs and how to see if a paper contains OBAs see appendix B (page 267).*

➜ *There are two ways to handle the influence of brighteners in ICC profiling packages. They either use a UV filter attached in front of the spectrophotometer or they recognize the brightener effect in software and deal with it in software (e.g., the latter is done in ProfileMaker by GretagMacbeth).*

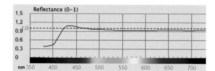

Figure 2-8: A reflectance beyond 1.0 (as shown here) is a clear indicator that the paper contains optical brightening additives. This measurement was done using BabelColor and an i1-Pro spectrophotometer.

Optical brighteners, or *optical brightening agents* (OBA) in paper are used to remove any yellow appearance caused by other raw materials. Additionally, optical brighteners increase the brightness of a paper, thus increasing the maximum contrast in a print, and enlarging the color gamut. They also increase the reflectivity of a (white) paper. Most optical brighteners are fluorescent brighteners. They absorb light in the UV range and re-emit white light in the visible range, tending slightly toward blue.

There are some disadvantages to optical brighteners: a spectrophotometer may give inaccurate results when measuring colors for ICC profiling, leading to incorrect ICC profiles. More importantly, brighteners deteriorate faster than (good) ink colors. This may lead to a gradual color shift in the print. Usually a paper manufacturer will provide a note when an optical brightener is contained in a digital fine art paper. Unfortunately, the amount of optical brightener may vary somewhat among batches of paper. There are different-quality brighteners: better ones deteriorate more slowly. Papers using fluorescent-based optical brighteners can lose some of their brightness and whiteness when the light source has little or no UV light, or when UV filters are used.

For these reasons, if long-term image permanence is an important issue, fluorescent brighteners should be minimized or avoided altogether.

You may test a paper for optical brighteners by viewing the paper in the dark using a UV light source. If brighteners are present, the OBAs will glow under UV.

Paper Weight and Paper Thickness

The weight of a paper is given in either *grams per square meter* (gsm or g/m²) or in pounds (lbs) per 500 sheets (ream) of a specific size. We consider gsm better for comparison as it is independent of the paper size. For fine art printing, a heavier paper usually is preferred, as it gives your print rigidity and a more substantial feel. A standard office copy paper measures about 80–120 gsm, and traditional low-cost photo paper is about 120–150 gsm. We prefer papers of 230 gsm or heavier.

A second measurement to look for is actual paper thickness, or *caliper,* as not all paper has the same weight per square meter. This measurement is either given in millimeters (mm) or in *mils* (a thousandth of an inch). Photo paper is usually 7–10 mils (approximately 0.18–0.25 mm), typical fine art papers 10–35 mils (0.25–0.90 mm).

1 mils = 0.0254 mm

1 mm ≈ 39.4 mils

Using thick papers, you may have to manually assist the printer in feeding the paper, or perhaps use a straight paper path and set special options in the printer driver (e.g., see figure 5-5, page 139). Using lighter papers, on the other hand, you may have to reduce the amount of ink to prevent warping (e.g., see page 139).

Paper Coating

For inkjet printing, paper may be *uncoated*, like bond paper used for laser printers and photocopying machines, or *coated*. Traditionally, many fine art papers used for painting or drawing are uncoated, and thus have a very fine surface. Though you may use these papers also for inkjet printing, as mentioned before, for true fine art prints you should use coated paper. The coating may also affect the surface finish of the paper, e.g., to be more matte, satin or glossy. There are several different types of coatings:

▸ Microporous
▸ Swellable
▸ Resin Coated (RC)

Microporous coating • Here, the coating consists of a fine layer of ceramic (inorganic, inert particles) material ground to fine powder. The ink sinks into the cavities of this layer and is thus absorbed quickly with minimal spread. Ink printed on this kind of paper dries very quickly. This coating provides good water resistance. Unfortunately, the open areas of the coating allow dye-based colorants of the ink to come in contact with air-contaminants and thus these gases accelerate deterioration processes of the ink (figure 2-9). For this reason, microporous papers are not the best choice for dye-based inks when print longevity is essential.

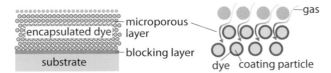

Figure 2-9:
Structure of a microporous paper
(Source: HP, [53])

With pigmented inks, it is best to use microporous papers. They dry very quickly and produce sharp images. Pigmented inks do not sink in like dye-based inks, leaving the pigments on the surface.

Swellable papers • As their name implies, the coating is made of material (polymers) that swells in the presence of moisture, i.e., when the inks hits the paper. The coating absorbs the ink and allows the colorants to penetrate the top layer of the coating. The encapsulating layer below encloses the colorants (dyes), leaving only minor parts of the dye on top of the paper (where it is exposed to light and gases). With swellable papers, you usually have a four-layer paper:

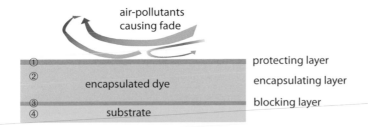

Figure 2-10:
Layers of a swellable inkjet paper
(Source: HP, [53])

These papers, primarily intended for dye-based inks, produce a very fine and crisp print, but are sensitive to high humidity and water contact. You may find swellable papers from Epson, Fujifilm (e.g., Premium Plus), HP (e.g., HP Premium Plus Photo Paper), Ilford, Kodak, and others. Most of these papers are either glossy or luster/satin.

Swellable papers take a bit longer to dry, as the swelling caused by the inks has to release its moisture and return to a smaller size. Keep this in mind when handling prints on swellable paper. Wait even longer if you intend to frame a print, laminate or coat it. Colors also take a bit longer to stabilize and establish their final values. These unique factors are important when you do your own printer profiling.

When printing with the HP printers using dye-based inks, we recommend using only swellable paper if print permanence is an issue. When, however, you use pigmented inks, avoid swellable papers.

Resin coated (RC) papers • This is not actually a real coating but a kind of paper well known in the photographic world for simple consumer prints from the wet darkroom. Classic, good quality, wet prints still use fiber-based paper. This kind of paper is also now used for digital inkjet printing. With RC papers, the base substrate is made of resin (plastic, rather than paper) and usually sandwiched between two thin polyethylene layers. To make it suitable for inkjet printing, either a swellable or a microporous coating is applied on top. This coating determines the printing behavior of the paper.

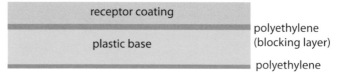

Figure 2-11:
Layers of an RC paper

With some inkjet papers, a distinction is made between "Fine Art Papers" and "Photographic Papers," the latter meaning RC papers. Most RC papers provide a glossy or satin surface and are closer to the feeling of traditional consumer photo material. For many artists, this feeling is too similar to plastic and it lacks the feel and look of real paper.

Do your own coating Finally, you may use uncoated paper and do your own precoating (before you print). Here, you must differentiate between *topcoats*, or *overcoats*, which are intended to protect the finished print against UV light, abrasion and soiling. Basic paper is also coated to make it suitable for inkjet printing. Here we describe the latter. There are several coatings for inkjet printing on the market, but we do not have personal experience with them. These coatings may be applied with a brush or roller. You may also use low-pressure sprayers. inkAID offers several different precoatings, from White Matte to Clear Gloss.

We have had positive reports from photographers using PixelTrust [109]. Another recommended coating is inkAID [96].

Sizing The term *sizing* or *internal sizing* describes the application of substances to reduce overall absorbency and to keep the ink from coming in direct contact with the fibers that make up the support. With different substances, absorbency of coatings is controlled. The term (*surface*) *sizing* is also used for the creation of special paper surfaces.

Paper Surface – Paper Finish

As with silver-halide-based prints, there are papers with different surface structures. For inkjet printing, the choice is even larger, and a paper's surface type is another way to classify papers, from shiny to dull:

- ▸ Glossy
- ▸ Semigloss, Luster, Satin
- ▸ Matte, Watercolor

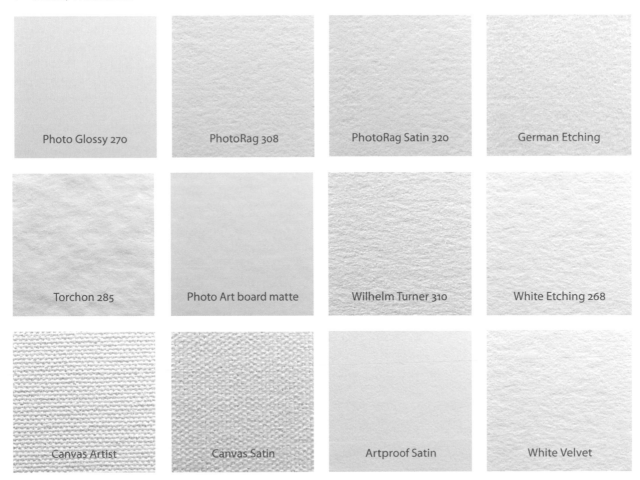

Figure 2-12: *A small collection of paper surfaces and colors. The images show some papers from Hahnemuehle (courtesy of Hahnemuehle Germany).*

While these names or attributes mainly describe surface glossiness, the surface may have an additional structure, most obvious when using canvas. While glossy paper is usually very smooth, all less glossy papers may have different degrees of surface structure.

The smoother the paper surface, the sharper a photo appears, provided you have sufficient contrast in the subject. For optimum brilliance, glossy and semigloss papers are best, while matte and velvet papers provide some more abstraction, especially when used for black-and-white prints.

The surface not only has an influence on the visual appearance of the paper and the print, but may also affect the suitability of the paper for certain inks and, thus, printers. Typically, glossy papers are not optimal for pigmented inks, as pigments mainly reside on the surface and may interfere with the gloss of the surface. To offer a printer for a broad range of suitable applications, the printer manufacturers of pigment-based inkjets must compensate for this effect, e.g., by including a gloss optimizer for glossy prints or by selecting an ink formulation that results in a glossy ink.

If you want to apply your own additional finish to a print, e.g., by doing a post-coating or embellishing, ensure that your coating material is not only compatible with your ink but also with your paper surface. Often, however, at least two versions of a post-coating material are available: one for glossy and one for matte surfaces. This, for example, is the case for the Eco Print Shield product from PremierArt ([111]).

Paper Size

Not all papers are available in all sizes. When we discuss fine art printing, usually we talk about prints at least the size of Letter or A4. Since most images require a larger size for optimum viewing, A3, A3+ and even larger are favorite sizes.[*] Another option is to use roll paper, which you may either cut down to your preferred size (you must flatten the paper afterward) or may use with a roll feeder on your printer if you have one. Some papers may be less expensive when ordered in larger sizes, and cut down to more usable sizes.

See table 2.2 on page 49 for more standard paper sizes.

Matching Inkjet Technology, Subject, Paper, and Ink

In general, it is recommended to use a paper that:

▸ matches the type of printing method used
▸ works smoothly together with the ink and final print resolution
▸ suits the image subject
▸ suits your personal preferences

For a print with many fine details, such as a photo of a fashion model, a glossy bright white paper may give the best result, considering resolution, sharpness, detail, and wide color gamut. A print of a landscape with pictur-

esque scenery may look better on a watercolor paper. Likewise a black-and-white print of a portrait may not want a bright white paper, but may gain from a paper with a slightly off-white tint, or "natural white." Here, Hahnemuehle "German Etching" may be appropriate.

While there are many technical specifications to note when choosing a suitable fine art paper, it is still a subjective decision. There is no single right or wrong choice, and you may even select different papers for different subjects in different print sizes. The larger the print, the thicker the paper, up to a certain size. For very large fine art prints, you may have to return to a thinner paper, as you will likely mount them to a separate backboard. When paper bonding is required, thinner papers are easier to handle.

Some More Characteristics

There are other characteristics to consider when selecting a paper. For example, the pH value of the paper. This value tells how acidic or alkaline a paper is. "Neutral" would be a pH of 7.0. When the paper is more acidic, it will destroy itself after a length of time. As paper may pick up acid components from the environment, other papers, a wooden frame or the air itself, most fine art papers have a native pH of 7.5–10. This provides a buffer when picking up acid. Fine art materials with a prescribed amount of added alkaline are called *buffered*.

Cobb number The *cobb-number*, mentioned in table 2.1 on page 38, gives an indication how much water can be absorbed by a paper over a certain period of time. This number is rarely given by paper manufacturers, and we have found no recommendation for *good* cobb values for fine art papers.

Ink limit The *ink limit* is an important factor in offset printing. Darker colors are built up by overlaying primary colors (in offset printing, usually C, M, Y and K),[*] theoretically, up to 400% to be applied using four inks. This is, in many cases, more than a paper can absorb. When too much ink is applied, the color will break or smear, or the paper may warp. Thus the ink limit specifies how much ink may be overlaid at a particular point. The higher this value, the higher density may be achieved in dark or black areas of the print. Values beyond 230–240 are considered quite good using fine art papers.

Using C, M and Y in addition to Black can achieve a darker, deeper Black.

 With some RIPs, you may explicitly control the maximum amount of ink laid down.

Print maximum density (Dmax) According to Norman Koren [87] Dmax = $-\log_{10}$ (minimum print reflectivity), and is a measure of the deepest black tone a printer/ink/paper combination can reproduce. This is an extremely important print-quality factor. Prints with poor Dmax look pale and weak. A Dmax of 1.7 is a good value for matte prints; 2.0 is good for glossy, semi-gloss and luster prints. With some newer papers using one of the Epson

UltraChrome K3 printers, we even have measured a Dmax as high as 2.3 with Premium Luster paper and even 2.5 with some inkjet Baryt papers.

You only rarely find this value in a paper-manufacturer's data sheet, as it also depends on the type of ink used and on some driver settings. These values become especially important when printing black-and-white. Dmax is measured using a densitometer, but may also be measured using a good flatbed scanner and a spectrophotometer.[*]

* *Imatest, a tool provided by Norman Koren [87], allows calculation of Dmax for printers, inks, and papers.*

Opacity Opacity determines to what degree elements on the back of a sheet (or elements behind the paper surface) are visible. This is important when intending to print on both sides of the paper. This value may range from zero (complete transparency) to 100 (completely opaque). The thicker the paper and the more dense the paper and coating, the higher the opacity value will be. For fine art papers, opacity values of more than 85 are reasonable and greater than 90 is considered good.

Other Materials

For fine art prints, there are several other materials available on which to print, e.g., printable canvas. Hahnemuehle offers a fine "Canvas Artist Matte" (340 gsm, natural white), although you also may use conventional canvas, after preparing it with a coating described earlier.

Traditional film, either clear or white, may be used for backlit prints, or as a digital negative to produce contact prints in a wet darkroom, using papers for Baryt or platinum prints. For backlit film, Kodak offers a "Reverse Print Backlit Film, 6 mil" that may be used with pigmented Epson Ultrachrome inks or dye-based inks. Pictorico [107] offers "Photo Gallery Hi-Gloss White Film" that has received positive comments in several publications. The film is also available in A4. This material may be used to produce large-format negatives for contact proofs. While browsing the Pictorico Web site, check out "OHP Transparency Film," which is excellent for general display transparencies and for making platinum/palladium prints.

A problem with film is that it is difficult to locate ICC profiles for these media. Even though standard profiling software suggests that it's relatively easy to generate your own profiles, it's no simple task when using reflective white film as the print medium.

Fabric has become a popular print medium for the fine art community. Here, however, you will need specialized inks. Also, fabric needs special treatment before printing. Most desktop inkjets are poorly designed for printing on fabric. Moreover, this type of printing is usually done on large-format printers.

The intrepid fine art printer should also look into signmaker and craft supplies, which offer unique papers, e.g., rice paper, and other supplies to enhance the look and feel of fine art prints.

Paper Handling

Handling before printing Printing paper should be kept dry, clean and dark. The manufacturer's box is a suitable, short-term storage solution. Check the expiration date to ensure you use the paper well before it "expires." Also, ensure the humidity is kept at about 50–60 % to prevent excess drying or swelling.

Digital fine art printing paper is quite sensitive to oils and perspiration (which is acidic), so you should wear thin cotton gloves when handling it. This practice is standard when handling photographs, as well.*

Preparing for printing Often there are loose, tiny paper particles attached to paper. These particles may clog your printer's print heads and rollers. If they remain on the paper while printing and fall off later, you could have tiny white (or paper-colored) spots on your print. For that reason, we advise wiping the paper using a very soft brush, or blowing off the particles using low-pressure compressed air immediately before printing.

** The sweat of your hand is acidic.*

Figure 2-13:
Use cotton gloves to handle your fine art papers, and brush or air-spray your paper before inserting it into the printer (Courtesy Monochrom Germany [106])

Handling for printing Make certain you print on the coated side of a paper. Usually, you can see or feel the coating on the paper surface. On glossy and semigloss papers, the coated surface is most obvious: the shiny side. With matte and similar papers, it usually is the side showing the more prominent matte texture. If in doubt, test the paper lightly with a thumbnail. On the coated side, the nail will leave a clearly visible trace as you lightly crease the paper.

If you intend to use thick or heavy paper, first check to learn if your printer is capable of printing that paper thickness (see technical specification of the printer). Even if suitable, it may be necessary to manually guide the paper in the feeder. We recommend feeding any paper a single sheet at a time when printing fine art, and always remember to handle paper only by its edges, or use cotton gloves.

➜ *For further information, please see:*
"A–Z of Paper: Interesting Facts on Paper"
by Hahnemuehle [93].

After printing When retrieving a print after printing, avoid contact with the freshly printed surface until it is completely dry. Place the fresh print on a clean, flat surface, avoiding bright light and direct sunlight, and let it dry sufficiently. Drying time depends on the kind of inks used and on properties of the media. Most dye-based inks take a bit longer to dry, but for most inks and papers, one hour is reasonable. Try to keep the print in a dust-free environment while drying.

If you intend to frame the print or do further protective coating, we recommend waiting at least 24 hours after printing. With RC papers (see page 42), you should wait longer, perhaps a week, to give the paper and ink adequate time to off-gas.

Figure 2-14:
Using a D-Roller to remove paper curl

If you use roll paper, you will have to flatten the paper to remove the curl from the paper roll. When the paper is dry, you may have to run it with a slight pressure over a table edge (the back of the print toward the table) to help remove curl.

D-Roller (figure 2-14, produced by Glastonbury Design ([91]), allows you to take the curl out of fine art papers that come from a roll. Papers may be D-Rolled prior to or after printing with no drying time needed for the inks. (See Uwe's short note on the D-Roller[*]).

* *See Uwe's paper "Printing Insights #27:*
The D-Roller":
www.outbackphoto.com/printinginsights/
pio27/essay.html

Storing your prints Storing digital prints is the same as storing silver-halide-based photos. Keep them clean, dry and, when not on display, in the dark. When stored for archiving, be sure their container is acid free. It is recommended to isolate prints from each other using sheet separators with acid-free paper. There are special buffered tissue papers expressly for this purpose, meaning they have a pH of about 8, so they can absorb/neutralize acidic components from contact chemicals and air pollution.

Suitable digital fine art papers

There are many different types of fine art papers available. In appendix B you will find a number of papers we tested and liked and some more hints on the usage of papers.

Table 2.2: Standard Paper Sizes		
Format/Name	**U.S. Size**	**Metric Equivalent**
U.S. names		
Executive	7.25 × 10.5 inches	18.4 × 26,7 cm
A (US Letter)	8.5 × 11.0 inches	21.6 × 27.9 cm
Legal	8.5 × 14.0 inches	21.6 × 35.6 cm
B (Ledger, Tabloid)	11.0 × 17.0 inches	27.9 × 43.2 cm
Super B/Super A3	13.0 × 19.0 inches	33.0 × 48.3 cm
C (Broadsheet)	17.0 × 22.0 inches	43.2 × 55.9 cm
D	22.0 × 34.0 inches	55.9 × 86.4 cm
E	34.0 × 44.0 inches	86.4 × 111.8 cm
Metric names		
A5	5.83 × 8.27 inches	14.8 × 21.0 cm
A4	8.27 × 11.69 inches	21.0 × 29.7 cm
A4 Plus	8.27 × 13.00 inches	21.0 × 33.0 cm
A3	11.69 × 16.54 inches	29.7 × 42.0 cm
A3+	13.00 × 19.00 inches	33.0 × 48.3 cm
A2	16.54 × 23.39 inches	42.0 × 59.4 cm
A2+	18.00 × 27.02 inches	48.0 × 62.8 cm
A1	23.39 × 33.11 inches	59.4 × 84.1 cm
A1+	24.02 × 35.98 inches	62.5 × 91.4 cm
A0	33.11 × 46.81 inches	84.1 × 118.9 cm
A0++	35.98 × 49.21 inches	91.4 × 125.0 cm

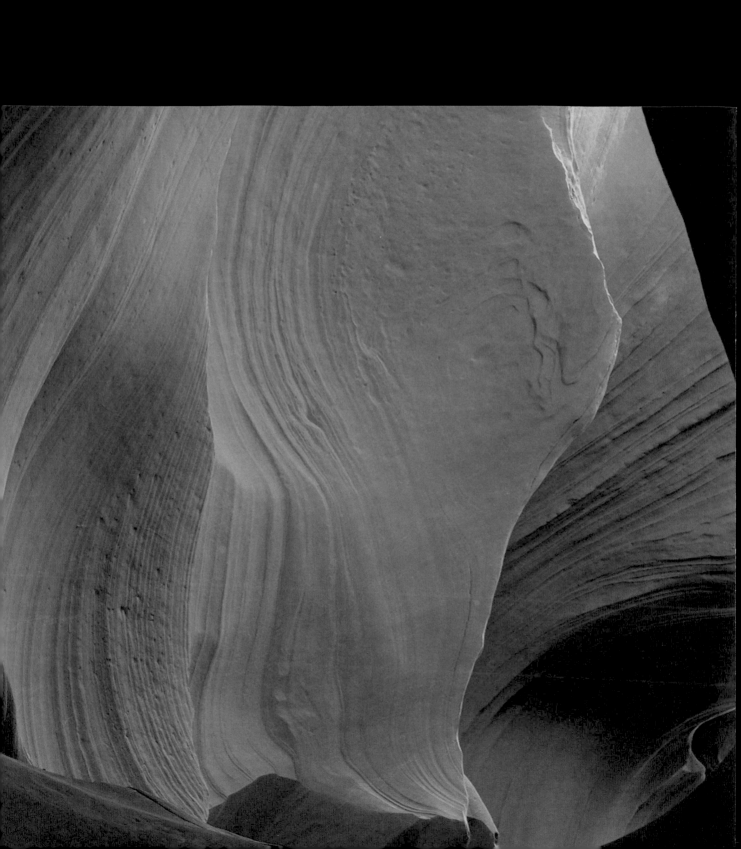

Color Management for Printing

3

With photographic prints, we usually work in color, so it is essential that the color on our monitor is correctly calibrated. It should closely match that seen by the various input devices, e.g., camera and scanner.

After balancing white and black values, adjusting color saturation, or performing other color corrections or contrast enhancements, the color we see on a monitor should accurately represent the color values of our image. Most importantly, when we finally print the image, after optimizing and enhancing, the colors in our print will closely match those we view on our monitor. This is what color management is all about. Of course, to do efficient color work, it is essential to understand the basics of color and color management.

Color management is one of the most demanding subjects in digital photography, and has been the subject of entire books. Because of the extensive information available elsewhere, we provide only a short introduction to color management, with a focus on those parts important to a workflow for fine art printing.

3.1 Understanding Different Color Models

→ *There are several good books on color management: "Color Confidence" by Tim Grey ([3]) and "Real World Color Management" by Bruce Fraser ([5]).*

Let us start with some easy stuff – with the different color models Photoshop supports. We will meet these color modes (or models) again and again – at least some of them. A *color model* defines the way colors are described, in a technical, mathematical way – e.g., from what basic components a color is built up – these components are called *primary colors* or **primaries** – how the numbers of those components are interpreted and are arranged in the color data and – as an extension to this – how much data is used for each component.

Photoshop supports several different color models. A color model defines mathematically how colors in an image are described. The main color models for photographers are:

▸ RGB
▸ Lab
▸ CMYK
▸ Grayscale

Photoshop provides additional color models, but these are rarely used by photographers, so a discussion of them is beyond the scope of this book. These include *Bitmap* for pure black-and-white (bitonality) images, and *Index mode*, used primarily for Web graphics (if you can live with fewer than 256 different color values). *Duotone* is used with grayscale images and allows the addition of a second color, giving a print more depth and feel.

** Some formats even allow for 32 bits per primary color. This, for example, is used with HDR (high dynamic range) images.*

Color depth: In a color model, you may use either 8 bits (one byte) to specify the amount of a single color (e.g., red) or 16 bits (2 bytes).* Thus, you may have your image in 8-bit or 16-bit mode. A different bit depth is possible, but not supported by most applications. Using 16-bit color depth doubles the space needed to store values, but gives you more headroom when it comes to differentiating color values, and allows for more precise calculations with less rounding errors. Using 8-bit, the value of a single component may vary from 0 to 255 (using integers).** Using 16-bit, the range runs from 0 to 65,535 (actually, only 15-bits are used in Photoshop, so the range becomes 0 to 32,767). Though we recommend using 16-bit whenever possible and reasonable, it is common practice to use 8-bit values (0–255).

*** For the technicians among us: integer values are used for 8-bit as well as for 16-bit data (per color channel). With some 32-bit formats, floating point numbers are used.*

For most issues in color management, it doesn't matter which mode you use. When producing final output, e.g., printing, you will be required to reduce your image to 8-bit mode, since nearly all physical devices can not actually produce more than 256 different shades of a color. Considering the various combinations of the three primary colors of RGB, this adds up to 16,777,216 different colors (256 × 256 × 256). Our eyes can only differentiate about 120–200 different hues of a particular color, depending on illumination, contrast, viewing distance, etc. During actual color optimization, however, where color shifting, transformation, and calculation of color values is done, 16-bit is the preferred mode.

Starting with Photoshop CS2, Photoshop also supports 32-bit (per channel) color data. There are different file formats for this (e.g., PSD, PSB, Radiance, PFM, OpenEXR and TIFF).

RGB Color Model

All colors in the RGB color model are created from three primary colors: red, green, and blue. RGB is the color model most commonly used today in digital photography, and we will perform our workflow mainly in this mode. RGB is an *additive color model*, meaning that the sum (addition) of all three basic colors at full strength (100 percent) will add up to pure white.

"0, 0, 0" defines black while "255, 255, 255" is bright white. Pure white should hardly occur in any photo.

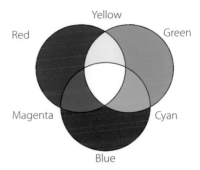

Figure 3-1: The RGB color model

Lab Color Model

The *CIE Lab color model* (often spelled Lab, LAB or L*a*b*) separates colors (chroma, A+B) from the detail and brightness (luminance, L) in images. As in RGB, Lab uses three basic components to build or describe a color: L (for Luminance), ranging from black (0 = no light) to white (100), and two color axes: *a* and *b*. The a-axis is Green to Red (actually more Magenta) and the b-axis, Blue to Yellow.

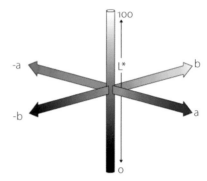

Figure 3-2: Lab color model

CMYK Color Model

The CMYK color model uses four primary colors to define a color: cyan (C), magenta (M), yellow (Y), and black (K). CMYK was designed for printing, where incoming light is reflected by the print.

CMYK is a *subtractive color model*, as each of these colored inks absorbs (subtracts) a certain spectrum of light. Figure 3-3 shows that mixing cyan and magenta gives you blue, and when you add magenta to yellow you get red. In theory, the combination of the colors C, M, and Y alone should be sufficient to produce black, but due to certain impurities in inks, they produce a dark muddy brown instead. To solve this problem, a fourth color, black, is added, and is called the *key color* (K for short).

Although CMYK is an important color model for a printing press, it is not used much in digital photography. Though inkjet printers are technically CMYK printers (most are even CcMmYK with additional light Cyan and Magenta inks), they provide an RGB interface to the user. Transformation from RGB to CMYK is done by the printer driver in the background.

We rarely use the CMYK color model in our workflow. Even when preparing images for printing that requires CMYK, you should stick with RGB-mode images whenever possible and resort to an RGB-to-CMYK conversion as the very last step. After conversion, some additional sharpening and some slight increasing of saturation may be required. Working on photos in CMYK mode has these disadvantages:

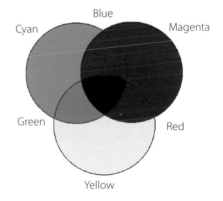

Figure 3-3: CMYK color model

▸ CMYK images are larger than RGB (with four color values per pixel instead of three with RGB).

** A color space is all those colors that a specific device (or device class) can 'see' or can reproduce.*

➜ If you have to convert a photo from RGB to CMYK, you should do the conversion on a copy of your photo.

▸ Some photo filters do not work in CMYK mode.

▸ The CMYK color space* usually contains fewer colors than most RGB color spaces. Thus, when you convert from RGB to CMYK, you may lose some colors, and there is no way to retrieve them should you want to later use your image for something such as Lightjet printing, which is used by photo services to output your image on photographic paper, or a digital presentation using an RGB monitor.

Grayscale Mode

How to convert a color image to a grayscale or monochrome image is described in chapter 7.

Photoshop also works with images in pure black-and-white (B&W) – also called *bitonal* – or in grayscale. However, when working in grayscale, the color of a pixel only describes a single (gray) value. Consequently, even when intending to produce a black-and-white photo (grayscale photo), we use RGB mode to preserve color information. This gives the black-and-white print some tint.

When using Photoshop's bitmap mode, a picture has only two possible color values: black or white; no gray. Bitmap mode is rarely used with photographs, and most imaging techniques and filters do not support bitmap mode.

HSB/HSL Color Model

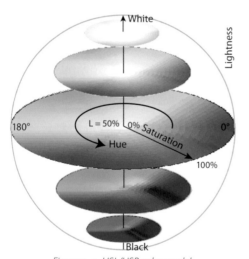

Figure 3-4: HSL/HSB color model

The HSB (*Hue, Saturation and Brightness*) or HSL (*Hue, Saturation and Lightness*) models are not explicitly supported by Photoshop, but are used in quite a few places like the Photoshop color picker (see figure 3-39 on page 86) or the Hue/Saturation tool. Here, the hue is given using an angle from 0° to 360°. 0° (as well as 360°) corresponds to red, 90° to green, 180° to cyan and 210° to blue. Saturation has a range from 0% (white) to 100% while Lightness runs from 0% (black) to 100 % (white).

In some dialog boxes, i.e., those changed from the current saturation like the Hue/Saturation dialog, Saturation may also run from -100 to +100. The same is true for the Lightness slider.

Color Spaces

** e.g., represented by the sRGB color space*

A *color space* is the total range of colors that real devices like monitors or printers, or virtual devices like *theoretical average monitor** can record or reproduce. This range defines the *gamut* of the device.

Every real device has a unique color space, and even identical devices (same make and model) have slightly different color spaces, e.g., due to different age and production tolerances. These differences increase with variations in user-selected hardware or software settings: different monitor

resolution, different printer inks or paper, or even a different brightness setting on a monitor.

To improve the ability to work with color, the International Color Consortium (ICC) and some other companies (e.g., Adobe, Kodak, Apple) have defined *virtual color spaces* representing the gamut of a virtual, rather than a real, device. Later, we discuss the advantages of these virtual, standardized color spaces.

For ICC, see www.color.org. There, you will find a lot of information on color management.

3.2 Understanding Color Management

Color correction and *color management (CM)* are two of the most important yet difficult areas to master in digital photography. As stated earlier, the goal of color management is to ensure that the photo you view on your monitor accurately matches the print produced by your printer or Lightjet print from a photo service. Color management helps reproduce colors as faithfully as possible across a broad range of different devices. While an identical reproduction is often impossible, because of the different ways various devices produce color, you should at least be able to predict the printed color from the color you view on your monitor.

For an in-depth introduction to color management, we recommend [3], [5] and [6].

The ability of a color-managed application to display on your monitor the colors and the impression that an image will have when printed on a specific printer or other output device is called *soft proofing*. *Hard proofing* is when you actually print using the same inks and the same paper used for final output. Some printing houses now use less-expensive paper and printing techniques for their proofs, unless the client specifies otherwise.

For more on "soft-proofing", see section 3.12 at page 84.

Why You Need to Understand Color Management

If you post a photo on the Web and ask different people to discuss its color quality, without color management the resulting image will display colors at least slightly differently on all those monitors. In fact, some monitors may not even render some RGB values at all. It is the domain of color management to significantly reduce the problem described here.

The challenge Your challenge is to have a monitor display the correct impression of how a certain photo would print on a color printer. The latest inkjet printers produce amazing results, but without proper color management, color printing largely remains trial and error. You end up changing the printer's color settings for every print; hardly a satisfactory solution.

The solution The solution to this color problem is to determine the color characteristics of a device, and to incorporate them when reading colors from an input device, or when sending color to an output device. Essentially, you put a "tag" on color images that defines how the color values of the image are to be interpreted most accurately.

ICC Profiles

The ICC color profile describes a device's color characteristics, e.g., the colors the device can record or reproduce, the values recorded for a perceived color (input device), or the values you must send to an output device to produce a certain color. These profiles are available from the device manufacturer (usually called *canned profiles*), or you produce your own using special profiling hardware and software. A profile produced for your specific device is called a *custom profile*. Almost all color management systems today use ICC profiles. With the help of such profiles, the color values required to produce a specific color on device A, e.g., a monitor, can be translated to values that will reproduce that specific color on device B, e.g., a printer, as accurately as possible. A device's color profile also describes the gamut of the device.

> **Note:** Because most people use their monitor as their soft-proofing device, the first step toward complete color management is to profile your monitor.

> **Note:** A raw RGB value does not define color in an absolute way, as the color produced by a certain RGB value is very much dependent on the device used or on the device that recorded that value. An RGB value in the context of a color space, defined by the ICC profile of the color space, however, does define an absolute color.

What do you do when you get an image that, without color management, displays different colors on different monitors? With the help of the input profile, a color management system may correctly interpret the RGB values of the (input) image and, with the aid of an ICC profile for your monitor, will accurately transfer them to color values that produce a similar color on your output device. The next section describes this in detail.

What is a Color Management System?

A color management system (CMS) is a set of program modules that mediate color translation among different devices. These modules are often part of a computer's operating system, and also are usually provided by software companies (e.g., Adobe). If an application is used to display, edit or print a color image, it initiates the proper function(s), e.g., displaying a particular image, generates the correct ICC profile information, and then tells the CMS what function should be performed. The central part of the CMS is a *color management module,** which performs the calculations needed to translate (transform) a color from color space A to color space B. Here's how it works:

CMM = "color management module". This is also called "color matching module".

1. First, the CMM translates the device- dependent color values of the image to a device-independent color space, using the description of the source ICC profile. Now the color values of the image are in Lab color

space, which is device-independent. This intermediate space is called *transfer color space* or *profile connection space* (PCS).

2. Next, these Lab values are translated to color values that will produce a color on the output device that is as close to the original color impression as possible. If the output device cannot produce the very same color, the CMM will try to find the closest match. Finding the best match is determined by the translation intent (explained in section 3.4 at page 62), also called *rendering intent*.

The ICC profiles used in this scheme are actually simple translation tables. They support translation from device-dependent color values to device-independent color values, and vice-versa.

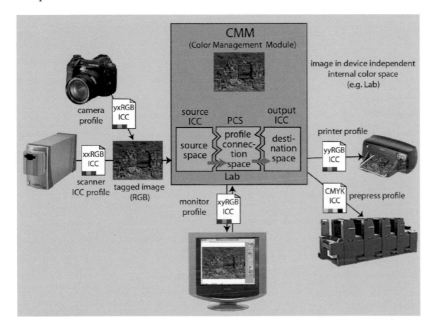

Figure 3-5:
How color profiles function within a color management system

Photoshop and other applications that support color management embed the ICC profile data within the image file; this new file is called a *tagged file* or *tagged image*. When you pass the tagged image along, the profile information is passed along, as well. You should be aware that not all image file formats can include ICC profiles. While TIFFs and JPEGs can, GIFs cannot. As you have probably noticed, a GIF image has an unacceptable color depth anyway.

Color Working Spaces

It is often a challenge to work with a large number of different device-dependent color spaces, which is how virtual, standardized color spaces were defined. Rather than describe the gamut of a real device, they define the gamut for an abstract or virtual device. There are several different spaces for each of the color models (RGB, Lab, CMYK), and range from a narrow

Note: Avoid applications that do not use or create these embedded profiles, or that do not support use of monitor profiles. The color of the image they display on the monitor or print may or may not be correct or even close to the true colors. Some applications may even remove the profiles from your image when editing, without alerting you.

to a broad gamut: for the RGB color model, we have sRGB, Apple RGB, Adobe RGB (1998), ECI-RGB and ProPhoto RGB (and several others).

To eliminate a specific working space (including its ICC profile) of your input device, you usually convert an image from the original input color space to a standardized color space and continue to work on this image using this working space. With digital photos, you may accomplish this conversion using a RAW[*] converter.

➜ *Avoid color space conversions (explicit ones) whenever possible, as every conversion will result in some rounding errors and – more seriously – some color compression or color clipping in many cases.*

** This "RAW" data is the data coming from your digital camera when you shoot RAW instead of JPEG or TIFF. It mainly consists of the raw data the camera reads from its sensor.*

Why define several working spaces for a color model? These spaces differ mainly in the color range (their gamut) they cover. In some work-flows, it is advantageous to use a narrow color space, while in others, a wide space is better. If your input device, say, a digital camera, has a wide gamut, you should use a work space with a wide gamut if you are intending to produce output for several different methods.[**] If you convert your image to a working space with a narrow gamut, you may lose some colors that could be reproduced by some output devices. If, however, you use a working space with a very wide gamut, the numbers (bits) representing color values may not be sufficient to differentiate the many different colors your gamut allows. Many of these discrete values may be lost because your image may never have colors that extend to the outer edge of the theoretical gamut of the space. This may become worse if you must do a lot of correcting, round-ing, and if you perform transformations. For this reason, we recommend using 16-bit mode when you intend to use a color space with a wide gamut.

*** e.g., inkjet printer, LightJet printer, monitor, etc.*

➜ *In 8-bit mode, there are only 256 discrete values available for each of the three basic colors.*

The following list shows some of the most important color spaces for pho-tographers:

▶ **sRGB**: This color space was designed to be used with monitors, and is probably a good one for photos to be presented on the Web. It defines a gamut that can be displayed by the average monitor, a relatively narrow color space. Though many DSLRs allow you to produce images using this color space, sRGB color space is much narrower than the color space cameras can see and record.

▶ **Adobe RGB (1998)**: A very popular color space among Photoshop users. It has a larger gamut than sRGB and covers most printable colors. This is the color space we prefer for digital photos.

▶ **ProPhoto RGB**: This color space was defined and is supported by Kodak. It provides a very large gamut and should only be used when working with a color depth of 16-bit. Of the RGB working spaces men-tioned here, it is the only one that can hold the full camera gamut. It is also the internal working space for Adobe Camera Raw.

Another color space often mentioned is "Apple RGB". But Apple RGB is outdated and should no longer be used today! It was defined by the gamut of a certain line of Apple monitors.

▶ **ECI-RGB**: This color space was defined by ECI, the European Color Initiative, a group of companies attempting to define color-production standards in Europe. The ECI-RGB color space was designed to include all colors that may be reproduced by printers. Its gamut is somewhat wider than that of Adobe RGB (1998) and includes some green colors

that can be reproduced by many printers (inkjet and offset, as well as gravure), but that are not part of either sRGB or Adobe RGB (1998). ECI-RGB is the standard RGB color space within the European prepress industry and serves as the European alternative to Adobe RGB (1998) for prepress work.

Since the ECI-RGB profile is not part of Adobe's Photoshop distribution, you have to download this profile from ECI's Web site (www.eci.org).

3.3 Visualization of Color Spaces

Color spaces are actually three-dimensional (e.g., L-, a*-, b*-axis). The profile shown in figure 3-6 is that of sRGB, using the ColorSync utility of Mac OS X. For Windows XP, there is a similar utility, *MS Color Control Panel*, that you may download [73]. In figure 3-6, the gray shape shows the gamut of Adobe RGB (1998) and allows comparison of these two color spaces.

The industry also uses some form of 2D charts to display color spaces. The color space plot shown in figure 3-7 was generated with the X-Rite ProfileMaker Pro 4.1 Profile Editor.

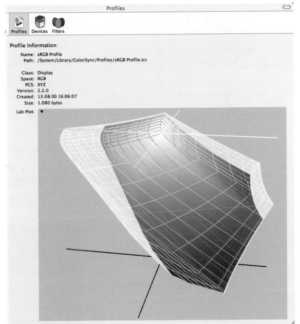

Figure 3-6: 3D diagram of sRGB (color) and Adobe RGB (1998) (gray shape) using a Yxy diagram.

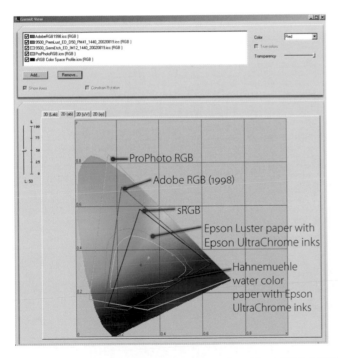

Figure 3-7:
Gamut Display (plotted by ProfileMaker Pro) using a 2D Yxy diagram.

In figure 3-7 , ProPhoto RGB is extremely wide, while Adobe RGB (1998) is much smaller and sRGB is very narrow.

We often use "Hahnemuehle German Etching watercolor paper" when printing with our inkjet printers. This paper's gamut, using Epson's Ultra-Chrome inks, exceeds sRGB's but fits well into Adobe RGB's gamut. The

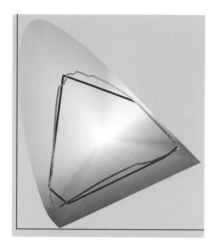

Figure 3-8: The red line shows the simplified gamut while the muliti-colored line shows the gamut in more detail. Both plots show the gamut of Epson Premium Semigloss on an Epson R2400 using K3 inks.

color space of the "Epson Lustre" paper has a much wider range than that of "Hahnemuehle Watercolor" paper, and exceeds both sRGB and Adobe RGB (1998) (in some blues and greens). If you have ICC profiles describing different printing sets, i.e., combinations of printer + ink + paper, a display like the ones shown in figure 3-6 and figure 3-7 allows you to compare the gamut and thus the color richness you may achieve using different papers.

Both figures (figure 3-6 and figure 3-7) were plotted using a Yxy plot where the Y axis represents luminance. In figure 3-7 the Y axis is perpendicular to the plotted plane showing the gamut at a lightness value of 50% of maximum brightness – white. Also, the gamut outlines in figure 3-7 are rough, simplified outlines. Figure 3-8 shows the gamut of the Epson Premium Semigloss in a simplified (red line) and in a more detailed outline (colored frame).

Though the Yxy diagram is a very common way to plot the gamut on a color space, there are a number of other plots that are used – both in a 2D and a 3D form. With 2D plots a brightness value of 50% is the standard. Another very popular form is using the L*a*b* axis (actually, only the a* and b* axis are shown in the plot, while the L* axis is perpendicular to the plotted plane).

Figure 3-9 shows such a plot, comparing the gamut of Adobe RGB (1998) (orange outline) to that of a profile for the Epson Premium Semigloss paper for a Epson R2400 printer using Epson's K3 inks and specific driver settings.

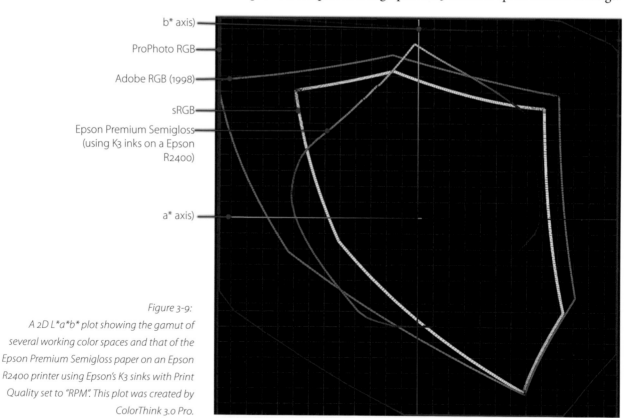

Figure 3-9:
*A 2D L*a*b* plot showing the gamut of several working color spaces and that of the Epson Premium Semigloss paper on an Epson R2400 printer using Epson's K3 sinks with Print Quality set to "RPM". This plot was created by ColorThink 3.0 Pro.*

This L*a*b* type of plot is quite good for comparing different gamuts and ColorThink Pro (that we used to create this plot), is a very nice tool for producing such plots (and it does much more – e.g., ICC profile inspection and corrections).

Figure 3-10 demonstrates a 2D plot in LUV coordinates. While this type is often used for color spaces for TVs (the TV signal uses LUV coding), you will rarely find this kind of plot used for color spaces for digital photos.

The plot in figure 3-9 also shows that there are a few colors (e.g., saturated yellows and some saturated cyans) that this printer + paper combination could print that lie outside of the Adobe RGB (1998) color space. If you shoot your digital picture in RAW and convert it to Adobe RGB (1998), these colors will be clipped (mapped to colors that are available in the gamut of Adobe RGB – section 3.4 will explain how this is done). If you did your digital shooting in JPEG, the conversion and color mapping from the camera's gamut to the color space of the JPEG image will automatically be done by the camera, either using Adobe RGB (1998) (which we consider to be the better solution) or sRGB as the target space.* If you want to retain as much gamut as possible for the editing of your image, you should use RAW for your digital shooting (provided your digital camera supports RAW) and convert to ProPhoto RGB when converting the image in your RAW converter to an external RGB color space.

However, as the gamut your monitor can reproduce most likely is even smaller than Adobe RGB (1998), you can't see these colors on your monitor. Photoshop (or whatever color managed application you are using) will map those colors to colors the monitor can reproduce using the relative colorimetric mapping algorithm described in the next section. This sounds bad, but in fact turns out to be practical, though not an ideal solution.

At some point on the path of your digital image from the camera or scanner to the print, the colors of your image have to be mapped to the color that the printer, the inks used, and the paper can reproduce. The same is true when the colors of an image have to be reproduced on screen for showing or for editing the image. There are several ways to do this. A good application (e.g., like Photoshop, Adobe Photoshop Lightroom, and many other color-managed viewers and image editors) allows you to define – at least for printing – how this will be done (see section 3.4).

If you can't reproduce the full gamut of a the rich color set which a good digital camera or a good scanner can capture on your monitor or your printer, why then should you keep the full gamut using a large color space like ProPhoto RGB or Adobe RGB (1998)? There are several reasons for this:

1. Devices are going to improve. While, for example, in the past most monitors could only reproduce (roughly) the gamut of sRGB (that's why sRGB was defined), monitors are becoming better. Today, you can buy monitors that cover (almost) the complete Adobe RGB (1998) color space, and this path will continue. Also printers are improving, and new ink sets (e.g., using 10 inks or even more) extend the reproducable color space.

This depends on your in-camera settings. For JPEG and TIFF images, advanced digital cameras allow you to select either sRGB or Adobe RGB (1998) as your target color space. If you have this choice, we recommend using Adobe RGB (1998).

ProPhoto RGB
Adobe RGB (1998)
sRGB
Epson Premium Semigloss

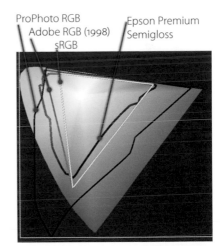

Figure 3-10: A plot using LUV coordinates (the L axis is perpendicular to the plotted plain). The CIE Luv color space is a perceptually uniform derivation of the standard CIE Yxy space. "Perceptually uniform" means that two colors that are equally distant in the color space – specified by the standard cartesian distance function of the square root of color offsets – are equally distant perceptually.

2. While editing, you can loose colors – e.g., selectively reducing or shifting color –, or you may gain new colors through various editing operations. Therefore it is reasonable to start with a rich set of colors and a large color space and use 16-bit color depth as long as possible.

3.4 Color Space Mapping

When images need to be converted from one color space to another, e.g., when displaying an image on a monitor, the image is transformed from its source color space (device color space or working color space) to that of the output device, in this case, your monitor. In most cases, the gamut of the source and the destination are different, so some color mapping has to take place. This transformation is performed by the color-management module (also called the color-management engine).

The main challenge is what to do with those colors of the source space that are not present in the destination space. Because there are several ways to handle this problem, ICC has defined four different ways of mapping, called *intents*:

Perceptual (also called *Photographic*): If the gamut of the source space is wider than that of the destination space, all colors are compressed to fit into the destination space (figure 3-11). If the gamut of the source space is smaller than the destination space, i.e., all colors of the source are present at the destination space, a one-to-one mapping takes place: all colors keep their original appearance.

When mapping from a wider space to a smaller space, perceptual mapping usually shifts colors to a bit less saturated and somewhat lighter colors, but the overall impression of the image is preserved, i.e., different colors keep their relative color distance. When the white point of the color spaces are different, a white point mapping takes place. Perceptual and *Relative colorimetric* mapping are the two intents used when converting photographs.

Relative colorimetric: When mapping from a wider color space to a smaller color space, a color in the source space that is not present at the destination space is mapped to the closest color at the destination space, usually at the border of the destination space (figure 3-12).

With this type of mapping, two colors, both different in the source space and not present in the destination space, may be mapped to the same color in the destination space, but usually at the edge of the envelope. This could result in some color clipping or banding. The white point of the source space is mapped to the white point of the destination (if they differ), and all colors are adapted relative to the destination white point.

This intent is useful for photographs and should be used when the source and destination spaces have a similar gamut with lots of overlap. It

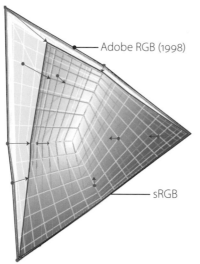

Adobe RGB (1998)

sRGB

Figure 3-11: Perceptual gamut mapping from Adobe RGB (1998) to sRGB

Here, the "white point" is the color temperature (or color spectrum) of the color "white" of the corresponding color space. Adobe RGB (1998), for example, has a white point at 6,500 K while ECI-RGB has its white point at 5,000 K.

is also useful if most of the colors in your image, which may not use the full gamut of the source space, have an identical color in the destination space. In this case, most colors remain unmodified when transformed. This intent also is used when colors in an image are translated to colors on your monitor.

Absolute colorimetric: This intent is like a relative colorimetric, where colors present in both color spaces are mapped 1:1, and colors that are *out of the gamut*, i.e., when a color of the source space is not present in the destination space, are mapped to the border of the destination space. This mapping is particularly useful when using your output device (e.g., monitor) to simulate the behavior of another device, e.g., for soft proofing. In this case, the monitor simulates the white color of the paper. Note that there is no mapping for the white point.

Saturation: This intent tries to map an out-of-gamut color to a color of the destination space with the same level of saturation, even if the color has to be shifted significantly. Use this intent when converting logos and colored diagrams from a larger color space to smaller one. It is not useful for photographs, as it discards information for hue and lightness, and does not preserve color realism. Some third-party profiles adapt this intent for a special color mapping that retains the saturation as best as possible, without a noticeable color shift; it may be used for some photos.

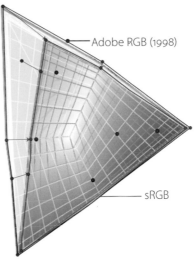

Figure 3-12: Relative colorimetric mapping (Adobe RGB (1998) to sRGB)

➡ *Some profiling packages – and accordingly some profiles – misuse the "Saturation" rendering, which then allows them to create a modified version of "Perceptual", which will result in less color shifting than regular "Perceptual".*

3.5 Creating Device Profiles

Since most of our digital work is done using a monitor, when setting up a color managed workflow, we need to consider monitor profiling as our most important task. In this section, we turn our attention to building a device profile. Normally, there are two steps:

1. **Calibration**
 The aim of calibration is to define a highly accurate, *standardized state* for the device; for example, when calibrating a monitor, you manually set the controls of your monitor to achieve a certain *luminance* (brightness of your monitor's white) that is known to be good for color work. Also, you set a *white point* that conforms to an industry standard, such as D50 or D65 (color temperatures of 5,000 or 6,500 Kelvin, respectively). The *white point* of your monitor is a mix of R, G, and B that will represent *white*.

2. **Characterization**
 When characterizing a device, a *target* is recorded by the input device, or sent to an output device. A target (test chart) is a pattern of color patches with known color values. By comparing the color values recorded by the device (such as a scanner) to the known color values of

the target, the profiling program calculates a device's *color profile*. The profile is essentially a translation table of device-dependent color values to device-independent color values (with input devices), or vice-versa (with output devices); for example, if the profile is for an input device, it translates device-dependent colors seen by the device into the device-independent profile connection space (PCS, which is CIE Lab space). If, on the other hand, it is for a profile of an output device, the table provides translation from the profile connection space to the device-dependent colors of the output device.

To perform either step, especially when calibrating a monitor, it is advisable to use a hardware device like a colorimeter or a spectrophotometer to measure color.

We discuss profiling only briefly in this book, focusing mainly on profiling your monitor and your printer(s).

Camera Profiles

There are two types of camera profiles: *generic camera profiles* and *custom camera profiles*; the latter are for specific cameras. All RAW converters come with quite good generic profiles. Some of them also support custom profiles. * For some RAW converters, you may also buy good third-party camera profiles.

** e. g., Raw Shooter and Capture One*

Creating your own camera profiles can be very tricky since targets must be shot under highly controlled lighting conditions. Additionally, individual cameras of the same model can vary significantly: certain cameras vary more than others within type and brand. For more details on camera profiling, see one of our RAW conversion books ([13]).

Printer Profiles

There is no single profile for a printer. A printer profile is always specific to that printer using a specific paper, ink set, and a specific driver and its settings.** Profiles for different types of printing paper also vary significantly.

*** Such as the dpi or quality settings*

When profiling a printer, a target is printed using precisely the printer settings, ink, and paper specified by the profile. Once the print has dried (from one to 24 hours), the color values of the print are measured using either a spectrophotometer or a profiled scanner (less accurate). By comparing known values of the color patches of the target to those of the measured patches of the print, the profiling software produces the printer profile.

Fortunately, you don't need to invest in a costly spectrophotometer and profiling software; you can use several profiling services that do this job for you. Look up "printer profiling service" in your favorite search engine. For more details on printer profiling, see section 3.8.

3.6 Profiling Your Monitor

As stated earlier, an accurate monitor profile is the basis for highly accurate color-managed workflow. When calibrating your monitor, you have a choice of doing so by eye or with specialized hardware.

When profiling your monitor, begin by turning it on and leaving it on at least 30 minutes before beginning any calibration. To perform the calibration, follow the instructions provided by your choice of tool, whether calibrating by eye or using hardware-based tools as those discussed below.

Be aware that room lightning, the color of your walls and desktop, and even your clothing, can influence precise calibration.

➜ *Before starting to calibrate and profile your monitor, make sure you have set a display color depth of at least 24 bits.*

Calibration by Eye

Photoshop for Windows comes with a utility called *Adobe Gamma* that lets you calibrate your monitor. With Mac OS X there is a similar utility called *ColorSync Calibrator*. Both utilities use your eyes as their measuring instrument, which is better than nothing at all but not as good as a hardware-based calibration.

➜ *With hardware-based calibration packages such as huey™ [76] or Spyder2express ([67]) for about USD $90, there is hardly an excuse for not using one of these hardware-based monitor profiling packages devices if you care for color confidence in your work!*

Hardware-Based Calibration

Although calibrating your monitor by eye is better than doing no calibration at all, if accuracy and precision are important to you, you should use a hardware-based, color-measuring device, e.g., a spectrophotometer or colorimeter, to achieve much more precise results. There are several reasonably priced packages currently available: $90–$270 for a complete kit.*

We use and recommend GretagMacbeth (now X-Rite) Eye-One Display 2.

The entire calibration and profiling process will take you about ten minutes. Once a good initial calibration is achieved, the next calibration will be much faster.

* *Your choices include: X-Rite Eye-One Display 2 [78], Datacolor's Spyder2express, Spyder2Pro and Spyder3Elite products [67], and the entry level device huey, that is sold by Pantone [76] as well as by X-Rite[78].*

Calibration Settings

We recommend using the following values when calibrating and profiling a monitor:

White point	6,500 K (D65)
Gamma	2.2
Luminance	100–120 cd/m²

We recommend these values even for prepress work (where a white point of 5,000 K is the standard) and even if you work on a Mac where a gamma of 1.8 is traditional (see also side note).

➜ *A luminance of 100–120 cd/m² may imply that you have to turn down your monitor brightness to about 15% of its maximum. Do so! This will also help prevent eye tiredness. If your primary work is for press printing, and your profile kit allows for this setting, go for a white point between 5.600 and 6.000 Kelvin as recommended by the Swiss UGRA: http://www.ugra.ch*

Calibrating and Profiling Using Eye-One Display 2

→ *A description of monitor calibration using the quite inexpensive huey kit may be found in FotoEspresso 2/2006 at www.fotoespresso.com..*

The Eye-One Display2 package from X-Rite ([78]) includes software (Eye-One Match) for calibrating and profiling monitors, as well as a sensor (colorimeter). It supports both Mac and Windows, and allows the calibration of CRTs as well as LCDs and laptop displays. To use it to calibrate your monitor:

1. Launch Eye-One Match (EOM) and select the monitor from the list of devices you can profile. We recommend using Advanced mode.

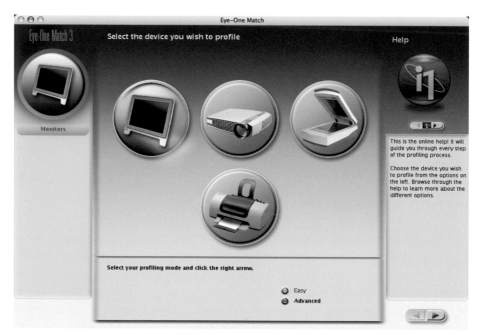

Figure 3-13:
Startup screen of Eye-One Match:
Select the monitor to profile

2. Select the type of monitor you intend to calibrate (CRT, LCD or Laptop), then Click ▶ to continue.

3. The first task is to calibrate the sensor (not your monitor). Follow the instructions given on the screen. (Help will provide you with additional information.)

4. Select your target calibration settings. We recommend the values shown in figure 3-14. ▶ will take you to the next step.

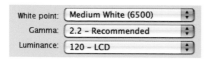

Figure 3-14: Recommended settings for your monitor calibration

5. Attach the sensor to your monitor, using either the suction-cup (if calibrating a CRT), or by attaching the lead weights to your sensor cable and letting them dangle on the backside of the monitor. If calibrating an LCD, you may have to tilt the monitor backward a bit, so that the sensor lies flat on the screen.

Figure 3-15:

Eye-One Display2 colorimeter

6. Begin the calibration phase using the controls on your monitor, if it has them. (Skip this step if you are calibrating a laptop or LCD without controls, and continue with step 9).

 You will set the contrast control to maximum, and then slowly reduce it until the indicator is inside the green area and close to o. Don't worry: Eye-One Match will guide you through this calibration.

 If possible, place your on-screen display (OSD) menu somewhat off the middle of your display. It should not interfere with your Eye-One Match screen.

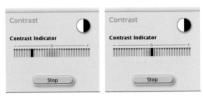

Figure 3-16: Use your monitor control to bring the contrast marker near the zero value.

7. Press Start to have EOM begin measuring the contrast values, then Stop and ▶ to begin calibration of the RGB controls. This step will set the control dials so that the monitor's white point is set close to the intended color temperature (6,500 K or 5,000 K).

 This may be achieved either by adjusting an OSD setting on the monitor choosing a color temperature of 6,500° K, or by setting the monitor's R-, G- and B-controls, if any. In this step, all three colored bars should be in the green area for optimum calibration. The Eye-One Match screen will provide useful feedback.

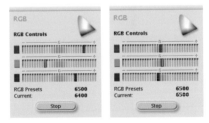

Figure 3-17: If your monitor has RGB controls, set your target white point.

8. Next, set luminance using your monitor's brightness controls. A luminance of 100–140 cd/m² is recommended for LCD monitors. If your calibrate a laptop display, you may have to reduce the value to 100–120 cd/m². For CRT monitors, providing less brightness, you will probably also have to chose 100 cd/m².

9. This finishes the calibration phase. Eye-One Match now will start the actual characterization: it will display a number of color patches and measure their values. You won't need to do anything during this approximately five-minute process.

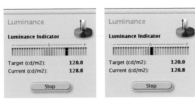

Figure 3-18: Set the luminance using your brightness control of the monitor to a target value of 120–150 cd/m².

10. Once the characterization is finished, Eye-One Match will display the values used and then display a diagram of the resulting color space (figure 3-19).

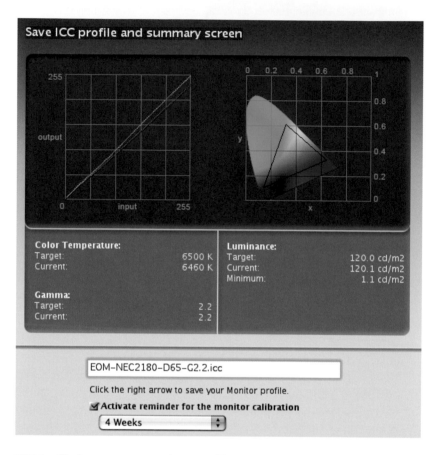

Figure 3-19:
EOM shows the profiling values and the
monitor color space. Enter a descriptive
profile name.

EOM will also prompt you for a profile name. Choose a descriptive name reflecting the tool used, the make of the monitor, as well as the values used; for example, if your are using EOM to calibrate an NEC 2180 monitor with X values, a suggested name might be "EOM-NEC2180-D65-G2.2." You may also want to include the date.

Eye-One Match will save the ICC profile to the appropriate folder, depending on your operating system, and will immediately make it the active and default monitor profile. In Windows and with Adobe Gamma installed, you should move Adobe Gamma out of your start folder to prevent it interfering with the correct loading of the new monitor profile when Windows starts up.

Once you have completed these profiling steps, do not change any monitor settings without re-calibrating.

For LCD monitors, we recommend that you re-calibrate and re-profile about every four weeks. With CRTs, every second week would be preferable.

3.7 **Photoshop Color-Management Settings**

Before beginning to work with Photoshop, set up the program with your personal color-management preferences. The way color settings are made is similar among all Adobe applications since Adobe Creative Suite 1 (CS1). When using CS2 or CS3, you may use centralized color settings. These settings will be used (by default) by all other CS2/CS3 applications, as well. With CS2 (or later), the settings may be done in Bridge.

Photoshop probably offers the most advanced color-management support of any application. For that reason, its color settings offer many different options and parameters.

To begin setting your color-management preferences, select Edit ▸ Color Settings to open the color-setting dialog. Figure 3-20 shows how we set the Color Settings in Photoshop.

With Mac OS and CS1 (or previous versions), you will find this 'Color Settings' dialog in your Photoshop Preferences.

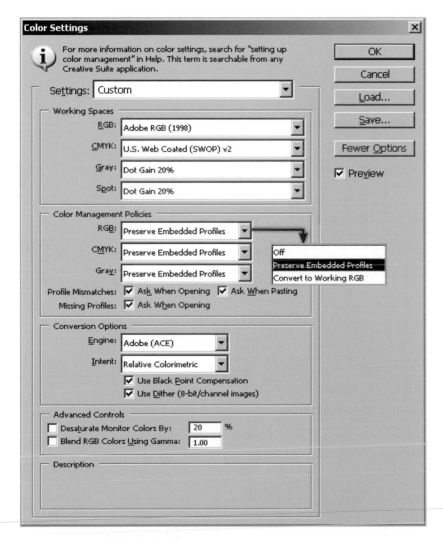

Figure 3-20:
Photoshop color settings

Working Spaces

Here, you define your default working spaces for the various color modes (RGB, CMYK, Grayscale and Spot Color). The RGB working space is the most important for photographers.* The CMYK working space is important only when converting RGB images to CMYK. The profile selected here is used as the destination color space. In the United States, U.S. Web-Coated (SWOP) v2 is the best choice for CYMK, if your print shop does not provide you with different instructions.

* *We use either Adobe RGB (1998) or ProPhoto RGB.*

Figure 3-21: Recommended working spaces for prepress work in Europe

> **Note:** We ignore settings for CMYK and Gray here, as we only cover RGB color setup in our workflow. If you live in Europe, your CMYK setting should either be *Euroscale Coated* or *ISO Coated*. If you are mainly preparing your images for prepress, use ECI-RGB as your default RGB color space, in which case your settings might look like that in figure 3-21.

Dot Gain 20, Photoshop's default value, is usually appropriate when you work with grayscale images. If your print shop gives you different values, use them. The same is true for spot color.

Color Management Policies

With Color Management Policies, you define the default action that Photoshop takes when you open an image or paste pixels into your opened image, and when no profile is embedded or the color space of the image is not the same as your current working space. Again, you can set this for RGB, CMYK, and grayscale images.

In most cases, Preserve Embedded Profiles is the best choice. The only reasonable alternative is to choose Convert to Working. Selecting Off rarely makes sense in a color-managed workflow. If you choose Off, color management will still take place. With off, the colors of the image will be treated as if the image is the current working space. When the image is saved, no profile will be embedded. The check boxes allow you to define Photoshop default actions when a mismatch is found. If a box is not checked, Photoshop will execute the action selected for the particular color mode. When a box is checked, Photoshop will prompt you about what action it should take.

Figure 3-22: We recommended these settings for your Color Management Policies.

Conversion Options

Using the Engine drop-down menu, you can select the color engine (color-management module) you want to use. We prefer Adobe (ACE) because it is probably better than ICM (Microsoft Windows) or ColorSync (Mac OS) and it will be the same on Mac and Windows.

As for Intent, you should choose *Relative Colorimetric* or *Perceptual* for photos (see section 3.4 " Color Space Mapping").

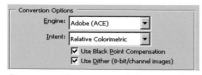

Figure 3-23: We recommended these settings for your Conversion Options.

The Use Black Point Compensation option should be checked. It helps when you are converting images from one profile to another by adapting the black point of the image to that of the destination space, thereby ensuring that the full tonal range of your destination is used (e.g., a printer).

The Use Dither (8-bit/channel images) setting is effective only when converting 8-bit images from one color space to another. If the source color is not present in the destination space, Photoshop will try to simulate the source color using dithering. This may improve the color visual accuracy, but at the same time it will introduce some random noise (due to dithering) into your image.

➔ *If, however, the supplier of a profile (e.g., in the profiles supplied with some ink jet papers) states otherwise, follow his advice! There are also some recommendations stating that* Use Black Point Compensation *should also be unchecked when using a Perceptual rendering intent.*

You should experiment on your own to find the optimum setting for "Use Dithering".

Advanced Controls

Leave these settings unchecked as shown in figure 3-20 at page 69.

Photoshop is not particularly intuitive when it comes to finding the monitor profile in use. So use this method to find out which monitor profile is currently active:

Windows: Right-click on some free space of your desktop. Select Properties. A Display Properties dialog box will pop up. Select the Settings tag and click the Advanced button. Select the Color Management tab. This will show a dialog box with all monitor profiles installed. The profile currently active is highlighted (see figure 3-24 for Windows XP).

Here, you may add further monitor profiles, delete installed ones, and make another of the existing profiles your default monitor profile. You may have to restart RawShooter or Photoshop to activate or apply this change.

If you are running Windows XP and have MS Color Control Panel installed ([73]), you may also use *WinColor*. Go to tab Devices and select *Displays* to see the profile associated with your display.

Mac OS X: Call up System Preferences (you may find in your dock). Select Displays and activate tab Color. The dialog will list all monitor profiles installed and highlight the one currently active (figure 3-25).

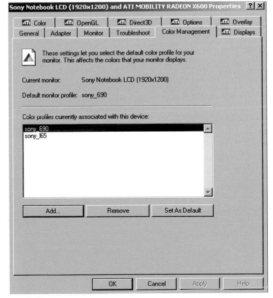

Figure 3-24: Finding the System Monitor profile in Windows XP

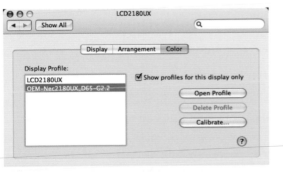

Figure 3-25: Current monitor profile in Mac OS X

➔ *Photoshop and most modern color-managed applications get their monitor profiles from the Mac OS X system settings.*

3.8 Profiles for Your Printer

Having set up your CMS settings in Photoshop and calibrated and profiled your monitor, it's time to think about profiling your printers. You must perform a profile for each combination of printer + printer-quality settings + paper + ink. Let us assume we deal with just one printer, e.g., an Epson R2400, and only use standard Epson inks for that printer. In this case, we still have a separate ICC profile for each type of paper and for each quality or resolution-setting of the printer. If you want to use glossy, semigloss and matte, we will need three different profiles, as each paper has a different gamut. Even if you want to use only two different types of matte paper, e.g., "Epson Archival Matte" or "Hahnemuehle PhotoRag", you will need two different profiles.

There are several ways to get a profile for your printer+ink+paper set:

1. **The profile may be part of your printer kit or may be downloaded from the Web site of the printer maker.**
 These profiles will only cover the original maker's inks and some papers the printer's manufacturer sells. These are "canned profiles" that do not consider individual derivations for your specific printer. They are a good start, depending on the manufacturer, the printer and the variations of the printer line. For the Epson R2400 or the HP B8190 paper these manufacturers' profiles will give up to 95% of the maximum quality a custom profile could provide.

2. When using a third-party paper, the paper manufacturer may provide profiles for their papers and some well-known fine art printers: Epson P2100/2200 with Epson UltraChrome inks and other manufacturer's papers.[*] If a new printer hits the market, it usually takes a few months until the profiles are uploaded to the paper manufacturer's Web site.

3. Some suppliers of third-party inks provide generic profiles for their own inks that are profiled with often-used papers for some well-established printers: Lyson [102] offers profiles for several Epson and HP printers for their inks and their papers. You should also have a look at the Web site of Bill Atkinson [80] and his high-quality profile effort.

4. There are several companies out there that sell profiles for different printers and inks, e.g., Digital Domain, Inc. ([83]).

5. There are several services that produce a custom profile for you:

 A) You download a print target from the service's Web site.

 B) You print the target using your specific printer, ink and paper (and other printer settings), and send the print to the service by regular mail.

*For example see Hahnemuehle [92], Moab [105] or Tetenal [115]. You will find more manufacturers of fine art papers on page 292. Most of them provide ICC profiles for some or all of their papers on their Internet site, covering several of the fine art printers from HP, Epson and Canon.

C) The service will measure your target print, generate the profile and
e-mail it to you.

D) You then install the profile.

The cost of this service varies from $30–$80 per RGB profile,* and is
often lower if you order several profiles at once.

 This is definitely not a bad choice for custom profiles. It avoids the
cost of expensive printer-profiling software and hardware, plus the pro-
filing is done by experienced personnel. Some companies restrict their
services to specific printers or makers. You will find a list of profile ser-
vices in appendix D.

6. **Build your own custom profile**.
The next section describes this in detail.

Ordering CMYK profiles, needed for press work, is somewhat more expensive. However, photographers only rarely need CMYK profiles – at least when printing with inkjet or LightJet or direct photo printers.

Profiling Your Printer

Profiling a printer follows a basic scheme:

1. You select an appropriate target with well-known color patches, and
print that target on the printer to be profiled. When printing, use the
paper and ink set you intend to use.

 You should use the same printer driver settings for print resolution,
paper-type and other settings that you will use later on. It is strongly
recommended that you save these settings using a descriptive name;
most printer drivers allow this. Avoid any color-correction settings at
this point.

 Also, avoid any further color correction in the application you print
from, e.g., Photoshop.

2. Let the print dry for at least one hour; 24 hours is better.

3. Now the colors of the print must be measured (there are several ways to
do it) and profiling software will calculate the resulting ICC printer pro-
file. Usually, it installs the profile immediately. Otherwise, you have to
install it, using a method that is appropriate for your operating system
(see section 3.9).

Most printer profiling packages offer several different print targets. The more color patches a target provides, the more precise your profile can be. But with more patches, the effort to measure them increases. There are profiling devices, that will read these printed targets with their patches automatically (e.g., DTP-41, DTP-70, or i1iO by X-Rite [78]), but for most photographers, their price is prohibitive. For such photographers, a standard spectrophotometer using a ruler to lead the device across a patch row will be sufficient. Such a ruler is, for example, part of the i1Photo kit or the i1Proof kit by X-Rite.

There are several methods for measuring the colors of your target print:

A) Spectrophotometer.
This is the most accurate way to do this job, although a good photo-
spectrometer is about $800–$1000. We recommend Eye-One Photo (or
Eye-One Proof) by X-Rite. We also saw some favorable reports on
PrintFIX PRO by Datacolor ([67]), priced at about $ 550 US, but we have
no experiences of our own with this newer package.

B) Dedicated patch-reader.

The patch-reader is a small, dedicated scanner that reads the patches of the target print (e. g., as part of the *PrintFIX* kit by Datacolor [67]).* It is much cheaper than a spectrophotometer, but not as accurate. We have found it to be the least-accurate method.

* Instead of buying PrintFIX, we recommend that you spend some more money and buy PrintFIX PRO, which comes with a spectrocolorimeter and will give much better results (profiles).

C) Standard flatbed scanner for acquiring the patch values.

This is probably the cheapest way to do the scanning. The accuracy of the method depends very much on the (color) quality of the scanner. The scanner itself should first be profiled. Some profiling packages, e.g., MonacoEZcolor, scan a scanner target together with the printed target and (internally) do the profiling of the scanner first. Based on this "profile-enabled scanner," it interprets the color values of the patches of the printed target.

This is a rather inexpensive and easy way for measuring the printed target, but for several reasons is less accurate than method A. Its accuracy should be about the same as standard canned printer profiles and may be a cheap source of profiles, if using a third-party ink set or paper, where no generic profile is available.

D) You may send your printed target image to a profiling service. In this case, you should use the target the service provides on their Web site, and should accurately follow the instructions provided.

The accuracy of theses profiles should be as good as method A, and may even be better, as the service personnel probably have more experience than you do. The processing usually takes two to three days plus the time it takes to send the print via regular mail. The cost per profile is $35–$80.

You may improve and optimize your profile using a profile editor, which is part of some of the printer profiling packages (e.g., *Eye-One Proof** or *Profile-Maker Pro* by X-Rite or *DoctorPro* by Datacolor). This, however, should only be done when having gained some experience with profiling.

* Since version 3.3, you may also edit profiles using Eye-One Match which is part of all Eye-One packages (e.g., Eye-One Photo).

Printer Profiling Using Eye-One Photo

Eye-One Photo is a profiling kit by X-Rite that consists of the software Eye-One Match (EOM), a spectrophotometer Eye-One Pro, a scanner target (reflective) and a Mini-ColorChecker. It may be used to profile displays, scanners, printers, and cameras, costs about $1,500, and runs on Mac OS X and Windows. For profiling a printer, use the follow steps:

1. Launch Eye-One Match (EOM) and select the printer for profiling (see figure 3-26).

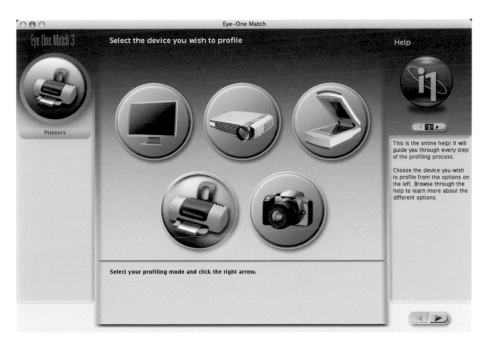

Figure 3-26:
Eye-One match with "Printer"
selected for profiling

2. Select the type of target you want to print (figure 3-27). EOM offers 3 types: a very simple one (i1 Easy RGB 1.x.txt), the standard target with 288 patches[*] and a TC9.18 target for best quality (i1 RGB 1.5.txt). The TC9.18 target should only be used if you use a device that scans the printed patches automacially. If you profile a PostScript printer, your choices may be reduced to just 1 or 2 targets. For inkjets, we recommend using "i1 RGB 1.x.txt". Now click Print to print the target.

* i1 RGB 1.x.txt, which we recommend for
 inkjet printers

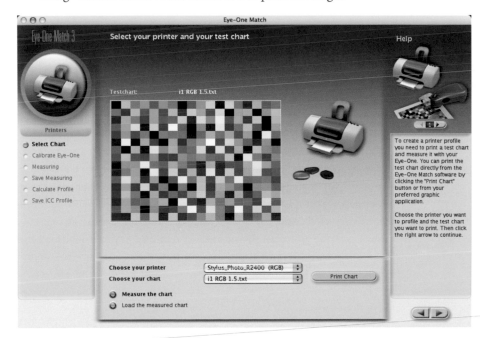

Figure 3-27:
Select the printer to profile and
the target type

➜ *We strongly recommend that you make notes about your printer driver settings and additionally save these settings in the printer driver using a descriptive name.*

3. The print dialog of the operating system will display and should already be configured correctly. However, check that all driver color management is disabled, and that all other driver settings are appropriately set for your target:

 A) correct paper type is selected

 B) print resolution or quality settings are those you intend to use later on with that paper

 C) all other settings, e.g., ink-set, ink-density, etc., are correctly set to those values you intend to use in your profile.

 This setup is dependent on your operating system, your printer (and printer driver), and may even depend on optional installed components, or paper and ink-set used.

 It may well be worth writing down and saving these settings for later use. When everything is set correctly, click on Print.

4. Let the print dry for at least 1 hour. We prefer to wait for about a day before we proceed.

5. Restart Eye-One-Match; again select the printer for profiling and the target type used before. Activate the option Measure the chart and click ⏩.

6. EOM will ask you to calibrate your spectrometer by placing it on its profiling base. Press the calibration button at the site of the spectrometer. When EOM informs you that the calibration was successful, continue with ⏩.

7. Select strip-mode for measuring. Put your target print on your desktop and put a white paper underneath (if your paper is not reasonably opaque) to prevent the color of your desktop from distorting the colors of the patches. Use the transparent plastic ruler to guide the spectrometer along the patches, as shown in figure 3-28.

 To make sure that your measurements are not falsified by the color of your desktop shining through the paper of your target, you should put one or two sheets of the same paper below the target you scan.

 Now scan, line by line, and release the button of the spectrometer at the end of your sweep. EOM will indicate if the measurement sequence for the row was not OK. In that case, repeat the last sweep. Repeat this step for each row of patches. Click ⏩ when all rows are scanned.

 The first time you scan the patches, it will take some time to get the right feeling and the right speed for scanning. Scanning several targets will, however, provide experience, and scanning will become smooth.

➜ *If you scan a lot using Eye-One Pro, it may well be worth it to buy Eye-One iO, which will do the scanning in an automated way. This will allow you to use targets with more patches, resulting in better (more precise) profiles.*

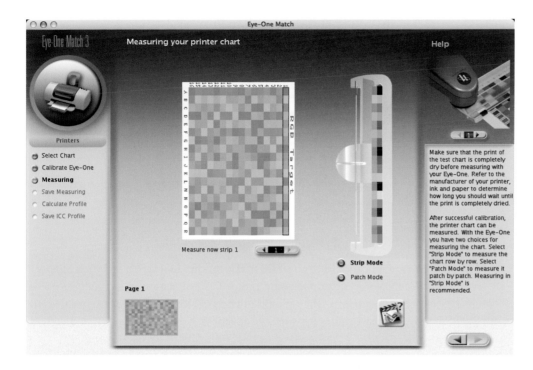

Figure 3-28:
Select "Strip Mode" and
start reading the patches
of your printed target.

8. You may save the measurements. Continue with 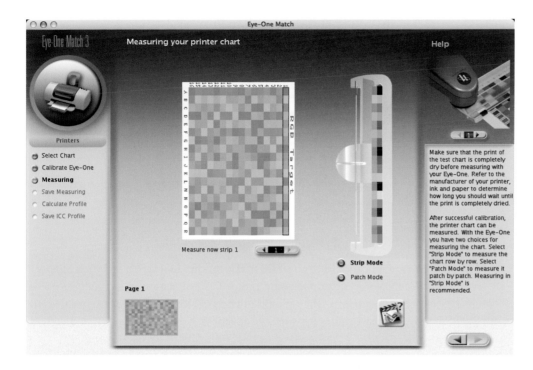.

9. Now EOM will automatically calculate the printer profile and ask for a
 profile name when finished. Use a descriptive name that includes the
 printer name, the paper used and, optionally, special settings used.
 Clicking Save As will save the new profile and install it.

Please keep in mind that this profile is only valid for the specific printer, the
paper used for profiling, the ink set, and the specific driver settings used. If
any of these parameters change, you should create a new profile. This may
happen when an ink supplier changes its ink recipe, without informing the
customer; this happens from time to time. If your prints do not look as
expected after replacing ink or using another batch of paper, profile again.

 You may use the same printer profile for Mac OS and Windows, pro-
vided the drivers work the same and offer the same settings. This should be
true if you use the original manufacturer drivers of companies like HP,
Canon or Epson. With third-party drivers, e.g., with Linux or Unix, or
RIPs, you will have to profile again.

> **Note:** When doing profiling, you should take your time and work very
> carefully and thoroughly. Take notes on what you are doing step by step.
> This will be of help when reconstructing what went wrong (or right).

3.9 Installing and Uninstalling Profiles

Profiling software, in most cases, automatically installs freshly generated profiles. If you download profiles, you may be lucky getting executable files that also install the profiles. In some cases, though, you will have to install them manually:

** However, you may use Windows ".icm" profiles as well.*

Mac OS X Profiles use the file name extension "icc".* Simply move or copy the profile to one (or several) locations given below:

[1] These profiles are accessible to all users of the system, however, you need to have administrator-level permission to set, add or delete them.

[2] These profiles are accessible only to the specific user and may be added or delete by the user.

[3] These profiles are those managed by Mac OS X and should be left alone.

Mac OS X System/Library/ColorSync/Profiles/[1]
 ~*user*/Library/ColorSync/Profiles/ [2]
 Library/ColorSync/Profiles/ [3]

Mac OS 9 System Folder/ColorSnyc Profile/

Adobe applications use an additional location: *Library/Application Support/ Adobe/Color/Profiles/* for some profiles. This location is for general use of Adobe applications. They should not be used for device-specific profiles, but only for new profiles for working spaces (e.g. to add ECI-RGB as a general work space).

To uninstall a profile, simply delete it or move it to another location.

Windows With Windows, profiles use either the file name extension ".icm" or ".icc" (both types may be used). Right-click on the profile file. A popup menu will appear. Select Install Profile and Windows will install the profile for you. The profiles are stored in the following locations:

Windows Vista c:\windows\system32\spool\drivers\color\
Windows XP c:\windows\system32\spool\drivers\color\
Window 2K c:\winnt\system32\spool\drivers\color\
Window NT c:\windows\system32\color\

(In all cases we assume, that your operating system is installed in drive "c:").

You should use the same method to uninstall the profile (this time selecting Uninstall Profile).

Avoid keeping too many installed profiles, especially with older Windows versions. For this reason, uninstall those profiles not needed, yet do keep a copy of them somewhere.

In Windows XP, the Microsoft utility *Color Control Panel* or *WinColor* may be downloaded from [73]. It facilitates color management administration for Windows XP by installing and uninstalling ICC profiles. The utility also allows displaying the color gamut of a color space or profile, and compares the gamuts of two color spaces.

Figure 3-29: Color Control Panel for Windows XP

3.10 Finding a Printer's Black Point and White Point

You will need to print a white and black ramp to find out where your printer starts, to differentiate tonal values, especially when optimizing an image for printing to a specific printer.

Using your printer profile selected in Photoshop, print the B&W-Ramp using your standard printing method. (A free version is here: [37]; a more compact version is part of our test image of figure 3-32 at page 81). Let the print dry thoroughly. Inspect the print to find out at what black and what white values you can differentiate in the black/gray patch field from the enclosed black area and from the previous patch field. Use a bright white light source for inspection (preferably, a D50 light source or diffuse daylight). Write down this value. Do the same for the white or almost-white patches.

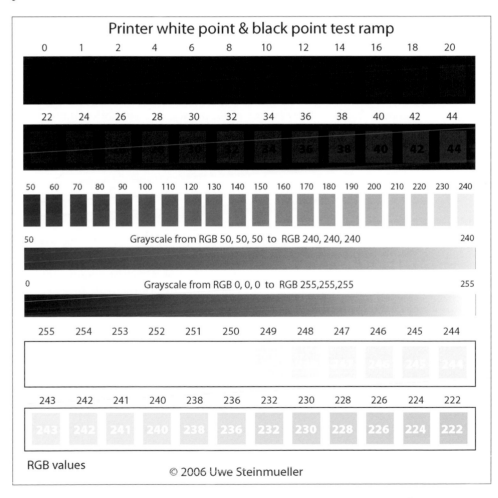

Figure 3-30:
Image to find your printer's
black-point and white-point

Don't become frustrated if your printer shows a long black ramp, especially when printing to a laser printer. This is usually not adequate for fine art printing. The undistinguished black ramp will probably go up to about

40–44, and the white ramp down to 251. With a good fine art printer, however, those values should be much tighter (about 10–20 for black; 252–253 for white). Remember, you have to repeat this test for each type of paper used.

These are the values to which you should restrict your tonal values, using Levels in Photoshop when preparing your image for printing (figure 3-31).

Don't use original images, but rather a copy made for printing, or use adjustment layers. This might look like reducing the tonality of an image, but as you see in the print of the B&W-Ramp, all pixel values beyond the black-point will be printed with the darkest black the printer can produce, and will not be distinguishable from black.

All pixel values lighter than this white point will not be distinguishable from the white of the paper.

With some pictures, however, you may not want differentiated structures in your shadows, which may even show some noise. Have them quite dark or black. In this case, use a lower value for your black point.

If you intend to use your image for a publication as part of a DTP project, and your image shows much white (or almost white) at the borders, it is often better to increase the white point a bit more into a light gray so that the white of an image will be set slightly apart from the white of the paper or the display.

Figure 3-31: Restrict your tonal values to the white point and black point of your printer.

3.11 Sanity-Check

After profiling, whether it's your monitor or printer, some sanity check should be done. There are some good images available on the Web that include different colors, grayscale ramps and so-called *natural colors* or *memory colors* like skin and face colors that are critical in an image.

You may find the image of figure 3-32 at Uwe's Web site [79] and additional useful images and test targets at Hutcheson Consulting [72]. Another good test image can be found with at the web site of Bill Atkinson [80].* (Our own test image was built using some of the parts taken from Bill Atkinson's image – with his permission.) Use one of those images to verify your profile and settings.

If the displayed image on your monitor is off, or the print on your printer using your profile is off, search for the source of the problem. With the monitor, you have to redo calibration and profiling. With a print, ensure you did not perform the color-management steps twice, e.g., in Photoshop **and** again in your printer driver.

If, for example, your print is too dark,** often, the reason for this is a monitor that is too bright. With many LCD monitors you have to start your calibration process by turning your brightness way down!

* Bill Atkinson's image is stored in CIELab mode. While this is no problem with Photoshop, some applications can't properly handle this image mode. For those, convert the image to a standard RGB mode (e.g., for printing using Qimage or Apple Aperture).

** compared to your image on screen

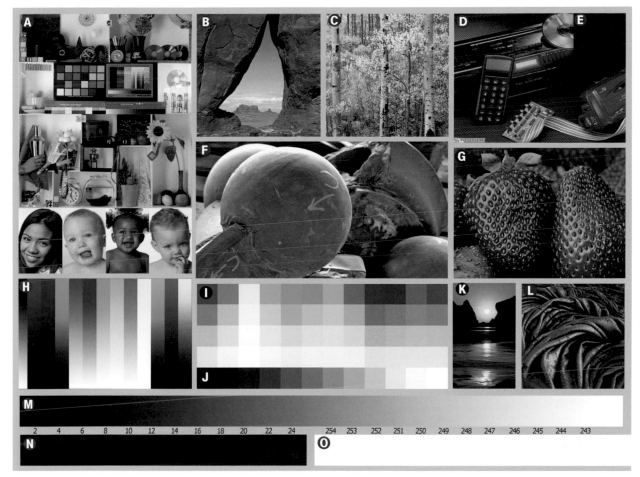

Figure 3-32: Our image for the sanity check of your monitor profile or your printer profile and printer settings

(www.jirvana.com/printer_tests/PrinterEvaluationImage_V002.zip)

When inspecting the image of figure 3-32 on screen, you should for example be able to clearly differentiate all 12 gray levels of the gray stepchart (see figure 3-32 Ⓙ). If not, your monitor probably has a poor setup – it might be too old or your brightness may be too high. In a print, all 12 steps should be clearly differentiable.

But let's do our inspection systematically. We will now describe how to inspect a print. However, much that pertains to prints is just as valid for images on monitors. When inspecting a print, use good bright light – either real daylight near a window or a daylight-like light source.[*]

Let's start with the gray ramp Ⓜ and the colored ramps at Ⓗ. There should be no banding in any of the gradients Ⓗ and Ⓜ, and all gradients should run smoothly. There should also be no color cast at all in the Ⓜ ramp. Neither should there be any color cast in the patches at Ⓞ. The RGB patches at Ⓙ should also all be a neutral gray. A color cast may be recognized here more easily.

** For daylight-like light sources, see the description in section 8.1.*

The patches at Ⓝ and Ⓞ allow you to identify the tonal values (in the range from 0–255) that are distinguishable from pure black and pure white (plain paper). We have described this process in section 3.10 on page 79. The white point at the right of Ⓞ lies outside the edge of the test image. This allows you to evaluate printers that make use of a gloss optimizer.

If you are using the image for a test print, it might be interesting to get at least a rough value for the Dmax of your paper and printing technique. For this, you need a spectrophotometer. To measure Dmax we use BabelColor [62]* by first measuring the reflexion of the paper white and then measuring the reflection of the darkest black patch we can produce. You can find our pure black patch Ⓔ at the upper right corner of the test image. Dmax is the difference between this black patch and the L-value of the pure paper.

** Another good application for measuring Dmax is Imatest [87].*

Let's look more closely at black-and-white and inspect the photography at Ⓕ. This photograph contains a rich set of grays, from full black to pure white (plain paper). Further, it has a number of gradients. The image allows us to see how the printer is able to handle gray transitions. Naturally, there should be no color cast visible in this black-and-white image. Also some bronzing may show up here if the printer + ink + paper combinations tends to bronze. For this, view the test print under different lighting conditions and also look at the print from a flat angle. (For more on bronzing, see section 3.13 at page 87.)

Figure 3-33: This part shows pure white up to pure black and should have smooth gradations.

Now look at the gamut ramps at Ⓗ again. The first three ramps represent the RGB primaries. Though not a primary ink of most inkjet printers, they should appear clear and clean. For most printers, the reproduction of blue is a critical. It should not look too purple. As mentioned before, the transitions of the ramps should be smooth and uniform. Banding in these ramps, if not minor, is an indication of a profile problem. Still worse if you see an inversion here, with the brightness first increasing, then decreasing and finally increasing again.

Figure 3-34: Check that these RGB ramps show not strong banding and no inversion.

When inspecting the RGB patch at Ⓘ, you should be able to clearly differentiate between adjacent hues. Most monitors and many printers as well as specific printer-profile combinations have difficulties clearly differentiating some greens and cyan.

Skin colors can be inspected by using the faces Ⓔ that stem from the Kodak test patch Ⓐ. In poor profiles these skin colors will easily be off. This may result in the skin of the Asian girl appearing a bit too yellow or too pink, a baby face that is unnaturally pink, or (and) some green may show up in the skin of the black baby.

The rest of Ⓐ shows a variety of objects and images, including a shot of the Gretag Macbeth/X-Rite Mini ColorChecker. In a print, using a spectrophotometer, you might even measure how close your print comes to original Lab values of the ColorChecker patches.*

Figure 3-35: Skin colors are "memory colors" and all faces should look natural.

* *If you have your own ColorChecker, compare these values to your own patches; otherwise Danny Pascale (Babelcolor) published the values of his version of the ColorChecker at [64].*

Now, let's see what the other photos of our test prints can tell us. The sky in image Ⓑ is slightly cyan, but should not be too cyan, otherwise your profile has a problem. And, well, the red rocks in the background are a bit pink – but that's OK.

Image Ⓒ shows aspen trees with leaves from bright yellow to darker yellow with a touch of orange. The trunks should show a pleasant contrast with a gradation of grays to black.

The image Ⓓ showing a CD player illustrates how the printer (or monitor) can handle shadow details while the reflections on the CD display a number of metallic shades.

The strawberry image Ⓖ allows you to evaluate the reds. The berries should look really appealing, the greens of the leaves should look natural.

The photography of the lava rock Ⓛ shows some highlights as well as deep shadows. Close inspection of the lava folds, with the help of a magnifying glass, allows you to judge the shadow differentiation of

your printer/paper combination and that of your profile. These areas can also be used to see if you should use "Black Point Compensation" with your profile and to compare the shadow performance of different profiles. Depending on the software used to create the profile, you might get better results when Black Point Compensation is turned off for printing. With other profiles it should be turned on. Try both versions.

The highlights of the image Ⓛ should look neither yellow nor green, but instead bronze-metallic. Don't mind any black shadows here too much – they do contain real black or are very close to pure black, as you can see in Photoshop when you open the Info palette and move the mouse across these shadows.

When you have attained a good print of this test image, you should keep it as a visual reference for comparing new prints – e.g., using a new paper or a new profile.

3.12 Soft-Proofing and Gamut Warning

As stated previously, a printer may not be able to reproduce all the colors of an image accurately: the printer may have a smaller gamut than the gamut of the image. All color management can do is to prepare the printer to be as close as possible to the impression of the digital image. Before printing, it is often useful to view what a printed image will look like on your monitor. For this type of soft-proofing, the image is implicitly converted to a printer's color space,* and the result is displayed on the monitor. This is useful with inkjets to avoid costly and perhaps disappointing prints. It is still more important with commercial print runs, like offset prints, as those runs are much more expensive. Imagine a print run of 2,000 books with poor-quality photos. To achieve an optimum or accurate proofing, your proofing device, e.g., your monitor, should be able to reproduce all colors that the other proofing device (the printer) may reproduce. As we saw in chapter 1, this may not be completely true if you soft-proof modern photo inkjet printers on your monitor, since modern photo inkjet printers have a gamut exceeding that of most current monitors, at least in some color areas.

To set up soft-proofing in Photoshop, call up View ▸ Proof Setup ▸ Custom. The dialog box of figure 3-36 will appear.

Select the profile of the printer you want to simulate with your proof Ⓐ. As with standard printing, ensure you use the printer profile that reflects the printer,** the type of paper used, the type of inks used and the proper printer settings. Leave Preserve RGB Numbers Ⓑ **unchecked**! Select your

_ You need the printer's ICC profile for this._

*_** Or printing technique, in the case of offset or rotogravure printing_

rendering intent Ⓒ. As stated in section 3.4, page 62, select the rendering intent you will use later for printing or profile conversion. For photos, this should either be *Perceptual* or *Relative Colorimetric*.

You should activate Black Point Compensation Ⓓ and Simulate Paper Color Ⓔ (see figure 3-36). The latter will also activate Simulate Black Ink Ⓕ.

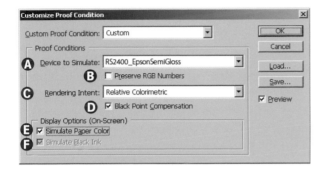

Figure 3-36:
Proof setup in Photoshop

If you want to do soft-proofing regularly, you should save these proofing settings and give them a descriptive name, including the printer simulated, as well as the paper and printer settings.

To activate soft-proofing, select View ▸ Proof Colors (or just enter Ctrl - Y (Mac: ⌘ - Y)). Using Ctrl - Y you may toggle proofing on and off (in most cases, for image optimization, it should be off).

Gamut Warning

After setting up soft-proofing, you may also activate *Gamut Warning* (View ▸ Gamut Warning or ⇧ - Ctrl - Y, Mac: ⇧ - ⌘ - Y).

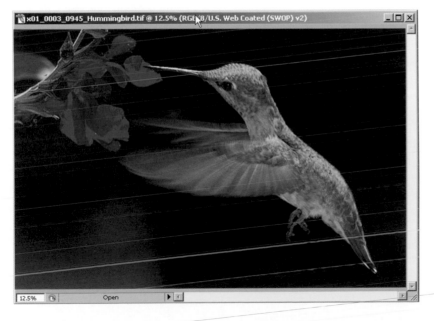

Figure 3-37:
Image displayed with Gamut warning active.
■ is used as warning color and "U.S. Web Coated (SWOP) V2" as destination profile.

When Gamut Warning is active, Photoshop will mark all areas of your image that use colors that are out of gamut of your target color space. Default marking color is gray. Since gray is a color easily overlooked, we recommend selecting a different warning color, e.g., a loud and saturated magenta, which rarely occurs in photographic images.

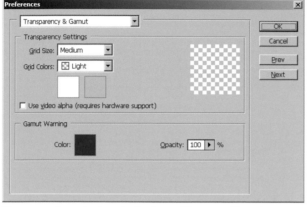

Figure 3-38: Setup for the color for Gamut Warning in Photoshop

To set a new gamut warning color, e.g., gray should be a good one – select Edit ▸ Preferences ▸ Transparency & Gamut. Click on the Color field to display the color picker (see figure 3-38).

If you did not do a custom proof setup in Photoshop and activate Gamut Warning or Proof Colors, the CMYK setting of your Working Spaces setting is used as a default (see figure 3-20, page 69).

Again, you may toggle Gamut Warning on and off using either ⇧-Ctrl-Y (Mac: ⇧-⌘-Y) or going via the View menu.

What is Gamut Warning really good for? First, you will get an impression of which colors in your image may not be reproduced accurately, but will have to be remapped to different colors. This usually involves mapping highly saturated colors to less-saturated ones. It may also help to modify these colors (colored areas of the image), so that they fit well into the destination color space (usually the printer's gamut). Decreasing their saturation, or otherwise tuning these colors, may be done in a more controlled way than is done by automatic gamut mapping, which may only be controlled by the selection of the rendering intent (see section 3.4, page 62).

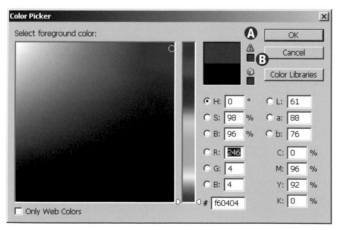

Figure 3-39: Gamut Warning in Color Picker

Even if Gamut Warning is not active, you will get a warning in the Color Picker dialog when you pick a color that is out of gamut of your target device (either selected explicitly by a proof setup or by default by your Photoshop Color Settings for CMYK). If you pick a color that is out of gamut, a triangle ⚠ will show up beside the selected color (figure 3-39, Ⓐ). If you click into the field Ⓑ, the selected color will be replaced by a color as close as possible and fit into the destination color space.

3.13 **Metamerism and Bronzing**

Metamerism usually refers to a problem that may occur using some inks in prints, i.e., it occurs when colors look different under different lighting. It is very natural and well known to us. When there is almost no light, all cats look gray. When there is very bright light, colors may look bleached out because too much light is reflected. Similarly, printed colors are absorbing part of the light spectrum hitting the paper and reflecting other parts. When the lighting changes, the color spectrum and the intensity of the different wavelengths of the incoming light changes. This will lead to a different pattern of absorbed and reflected light waves.

Under normal light, the metamerism effect may become a problem when two colors built up of different primary colors create the same (or similar) color perception under one light (say, a halogen-based lamp) but create a different color perception under another lighting (say, tungsten lamps). The metamerism phenomenon may create a problem when two colors change their visual color distance with changed lighting. To achieve a sound basis for color judgment in practically any color management system, D50 (daylight at 5,000 K) is defined as the standard lighting for inspection of printed colors. Some printer-profiling packages and some RIPs allow compensation for a different lighting target.[*]

The intensity of the metamerism with two colors may depend on the kind of inks used, the combination of primary inks with which the colors are built up, and the dithering method used by the printer driver or RIP. Some pigment inks are more prone to produce problematic metamerism. This was a problem with the second-generation Epson UltraChrome inks, but was reduced by its third-generation K3 inks. The effect may be reduced somewhat by different mixing of primary inks to achieve certain colors, and it may be reduced further by using different dithering patterns. This is why some RIPs reduced metamerism using second-generation Epson UltraChrome inks, e.g., using the Epson P2100/P2200 printer line.

Bronzing is a phenomenon occurring with some inks, mostly black, due to their reflective properties. Under certain lighting conditions, correct inks or build-up color samples take on a slightly bronze appearance. On prints, this is usually disturbing and undesirable. Bronzing is an effect attributed to some pigment inks of the first-generation printers, e.g., the Epson P2000, and to a lesser extent of the second-generation printers like the Epson P2100/2200 (but also shows with some first generation pigmented inks from HP and Canon). The ink formulation of the third-generation of Ultra-Chrome inks eliminated this problem almost completely. (The same is true for the second generation of pigmented HP and Canon inks.)

When a print shows disturbing bronzing, this effect may often be reduced or eliminated by framing the print under glass.

* *e.g., ImagePrint by ColorByte Software, as described in section 6.3 at page 173. Some of the profiling software – e.g., X-Rite's ProfileMaker – also allow you to adapt a color profile to a certain lighting conditions.*

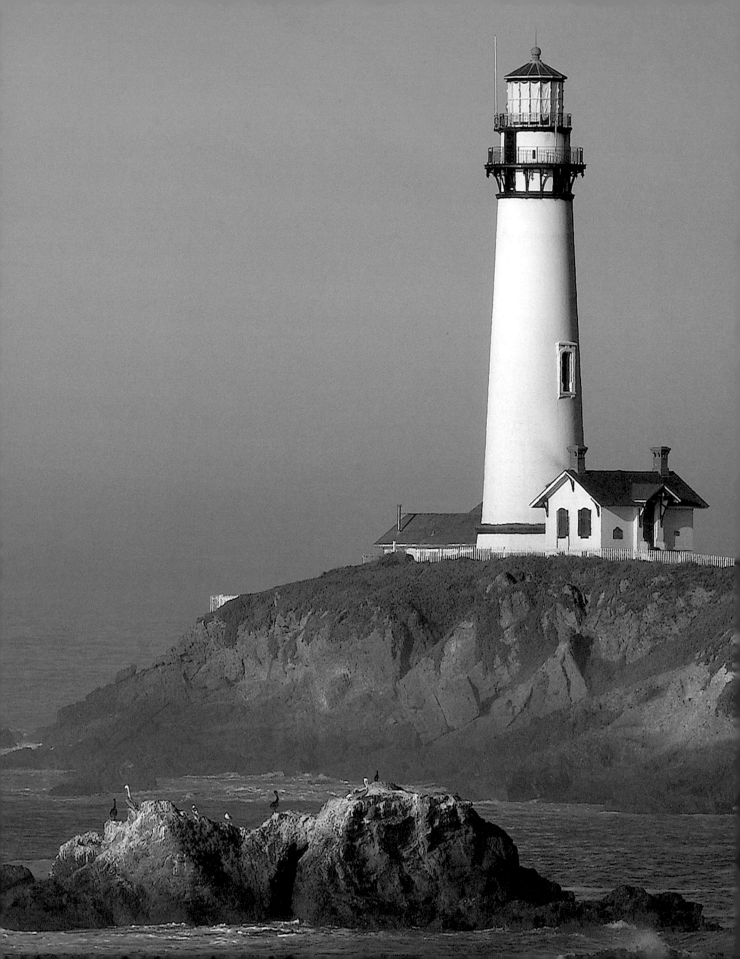

Fine Art Printing Workflow

4

So far, we have discussed some printing techniques, papers, inks, and basic color management. We now introduce how to prepare an image for printing. Of course, you may simply open a master image in Photoshop, call up the print dialog and leave the process to Photoshop and the printer driver. This, however, may not lead to the most desirable results. With almost all images, some tuning of tonality and color will improve your image and result in better prints.

When an image is optimized and almost ready for printing, the final steps are scaling and sharpening. Both steps depend on your image size and your output method. So, they may have to be done for every print with a different size and for every different output method – whether that is inkjet or direct photo printing.

At this time, we want to describe our own workflow for printing, which you may adapt to your own preferences and requirements.

4.1 Basic Printing Workflow

Printing workflow begins when you have converted a file from RAW to TIFF or JPEG, or imported your camera JPEG or scanned image.* Next, you edit your file: correct tilt, correct any problems with perspective, and crop your image (if necessary). Corrections of lens deficiencies may also be necessary: e.g., correcting lens distortions, vignetting, and chromatic aberrations. If there are dust patches, other blemishes, or unwanted objects in your image, remove them now or as early as possible in your workflow. If you need to remove blemishes later, before you print, use the same techniques described in our e-books DOP2000 [12] and DOP3002 [13]).

If you are working with one of the new all-in-one applications like Apple Aperture or Adobe Photoshop Lightroom, not all of the points shown here can be done. The principles described, however, also applies to them.

You have already done some initial sharpening, but final sharpening should be left until the end of optimization. In fact, you might leave this step to your RIP, if it offers good output-specific sharpening.

For this, your "first master" draft, you have made basic color corrections, and the image is now "correct," but still may not be satisfactory.

→ *Keep contrast on the softer side, as you can add contrast during fine tuning, but it is very hard to get soft gradations from harsh, contrasty images.*

The next step is to optimize the image, until it appears similar to what you had in mind when the picture was taken or the scan was made. This often requires tonal optimizations, including contrast enhancements and selective color correction. We address this in sections 4.2 and 4.3.

Most of these corrections can be applied, first globally, and then both selectively and locally. The result is an image (an image file), we refer to as our *master image*.

The real printing workflow actually begins here (section 4.4). This implies that your image is pretty close to producing a good print, but you still need to fine-tune the result. It is also assumed that you are using a good printer profile. But a printing workflow is also about correcting imperfections in your profiles and/or printers.

4.2 Tuning Tonality

Obtaining correct tonality is key in every good print. There are no hard-and-fast rules about what range or level of tonality is good and not so good. It very much depends on your image and on what you want to express.

Take for example the zebras at page xvi (at the first pages of the book).

Take, for example, a photo of a foggy scene.* On one hand, you can make the image so soft that it looks like a hazy mess; on the other you can turn up the contrast so much that you lose all soft characteristics of fog.

It is important to remember that we are discussing the tonality you create on a print. It is not possible to produce the same high contrast on paper as can be viewed on screen. Keep in mind that matte papers produce consistently lower contrast prints than the same image on semi-gloss or gloss papers.

Tonality includes:*

▸ Brightness
▸ Contrast in:
 – Midtones
 – Shadows
 – Highlights
▸ Smoothness

As always, begin by adjusting the global tonality as best as possible, and then continue working on local areas to improve tonality there. The core tools used to adjust tonality are Photoshop Levels and Curves.

Brightness

Brightness seems to be a basic property. But again, it always depends upon what you want to show in your print. Both very dark and very bright images can be beautiful. Equally important is where you display your images. This is the reason you should try to judge images under controlled light, carefully considering both brightness and light spectrum.*

First, let's take a look at the different tonality ranges of an image.

** Unfortunately, all these elements are related and must be tuned in careful steps.*

** See chapter 8 "Image Evaluation and Presenting Fine Art Prints".*

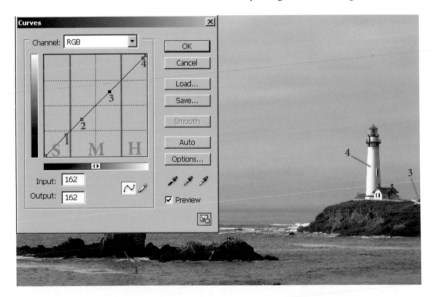

Figure 4-1:
Tonality regions

We use the Curves tool (black on the left, white on the right). The standard grid setting displays four horizontal segments. Roughly, the first quarter makes up *shadows*; the next two, *midtones*; and the last, *highlights*. Three regions must be treated carefully but play a different role for the viewer.

If you [Alt]-click the diagram, Photoshop will switch the resolution of the raster lines from four horizontal segments to ten horizontal segments and back.
In all our Curves examples, we will have black to the left and white to the right!

▸ S = Shadow area
▸ M = Midtones
▸ H = Highlights

Midtones

The primary content of any image is in its midtones. You must be very careful to achieve good midtone contrast. Otherwise, you end up with a flat image. We show the following test (figure 4-2) to demonstrate that you do not lose content in an image by making the shadow range only black and the highlights white.

In figure 4-2, we cut-off all data in shadows and highlights and stretched the midtones over the full range, from 0–255. As you can see, the entire content remains, but the image looks ugly and quite unrefined.

One might conclude that highlights and shadows are "the icing on the cake."

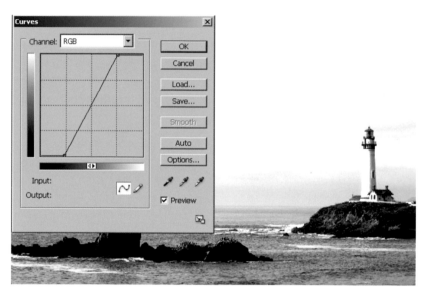

Figure 4-2:
Showing only the midtones data

Without solid highlights and shadows, you cannot create a quality print. Both shadows and highlights are, in general, the more important parts.

Shadows

Shadows can be open or close to black. There are cases where complete black is not only acceptable but beautiful, as may be seen in the photo in figure 4-3.

A solid black background works here, because the photo has a strong graphic character, and background details would be distracting. The rocks in our lighthouse photo cannot be only black. You must balance open shadows with overall contrast. You will realize that opening up shadows lowers the overall impression of contrast.

There is an additional challenge in the shadow portion of digital images: most noise is hidden in the shadows. This implies that you may find it necessary to remove noise when you open up shadows substantially (see later in this chapter).

Figure 4-3:
Grass – giving a very graphic image. This image consists almost completely of dark shadows and some highlights.

Highlights

Highlights are largely a challenge during image capture. If you overexpose highlights, data are lost forever.* If you underexpose too much, you lose dynamic range and pictures tend to be noisy.

** Traditional film is somewhat more forgiving due to its different sensitivity curve for light.*

Correct highlights bring a proper sparkle to your images. If they are too strong, like in figure 4-4, all the smoothness and beauty of the photo disappears.

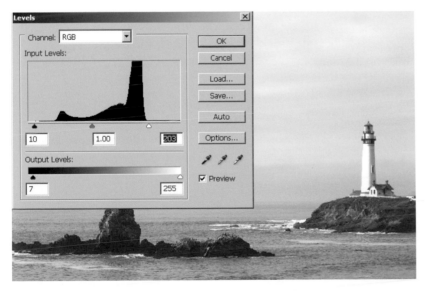

Figure 4-4:
Overly strong and blown-out highlights

The other extreme is muddy highlights, like in figure 4-5. The image looks dull and dark. We must find a balance between these two extremes. If your original photo resembles the first sample (figure 4-4: blown-out highlights), there is little you can do to get a good, or even acceptable, print. The second

example still permits getting a good print, if we correct tonality and live with some level of noise.

Contrast

The correct contrast is vital for any good print. With too little contrast, you end up with muddy, flat-looking prints, but with too much contrast, you get harsh tonality. There is no general rule here, as it depends on your images and what qualities you want them to depict. Be aware that paper cannot reproduce the contrast you see on screen. The same goes for brilliantly projected slides versus the same images on a print. Begin with slightly soft contrast, and tune the image for the balance you want.

Slides or film negatives may cover a contrast range of about 8–9 stops, digital still cameras about 7–8 stops, and a print (using an inkjet printer) about 5–6 stops.

> **Note:** Comparing the same image with different contrast is quite tricky, as the more contrasty image nearly always grabs your attention. This does not suggest that a higher-contrast image is the better choice. Generally, it is good practice to view a photo at higher contrast, to discover whether you are missing an opportunity to improve your image. If the higher contrast is created at the expense of too highly compressed highlights and/or dark blocked shadows, then it is probably time to decrease it a bit.

Global Tonality Tuning

The first step in tonality tuning is to set global tonality as closely as possible to the final desired result. *Global* means that all pixels in an image are treated with the same transformation. What's more, this operation does not depend

on other pixels (we cover this later in this chapter in the section "Local Tonality Tuning").

Tonality Tuning Using Photoshop "Levels"

Levels is a major tool for tuning tonality. It is easiest to understand its function by looking at a sample image:

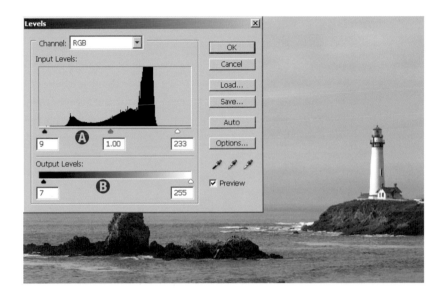

Figure 4-6:
Levels in action (preview on)

We display the same image with preview "On" (figure 4-6) and "Off" (figure 4-7). Levels in Photoshop has five sliders that are important to understand:

▸ Three for the Input Levels (figure 4-6, Ⓐ) and
▸ Two for the Output Levels (figure 4-6, Ⓑ)

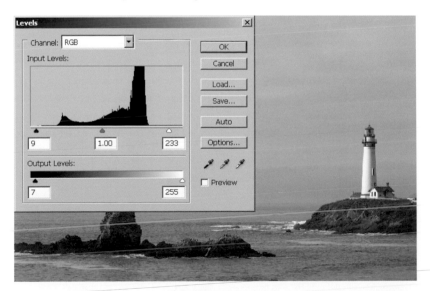

Figure 4-7:
Levels in action (preview off)

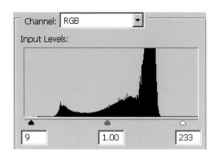

Figure 4-8: 3 basic sliders for Input Levels

Input Levels

Let's take a look at the **Input Levels**: We use Levels only in RGB mode. The histogram is some help in visualizing the distribution of different tones. It is not a good idea to correct by looking only at the histogram. We prefer to adjust Levels while viewing the full image. There are three triangles, each of which is a slider used to correct, from left to right:

▸ Black Point ◆
▸ Gamma (brightness) ◆
▸ White Point △

With this lighthouse photo, we use the Black Point slider (◆)to achieve a bit more black in the shadows. We have to be very careful not to block the shadows too severely in the rocks. If, for example, we set the value to 9, all pixels having a value of 9 or less will have a value of zero after this operation. All other values are linearly transformed, and receive some lower (darker) values. If we do not correct the white point, as well, the entire image becomes just a bit darker, with additional contrast.

The Gamma (Brightness) slider ◆ remains at a default value 1.00, even though the slider will have moved a bit to the right.

As said earlier, setting the White Point slider △ can be a balancing act. You want a slight sparkle, while maintaining a smoothness, in the highlights. If, for instance, we set the value to 233, for example, all pixels at 233 will be now become 255. All the other values are linearly transformed, and will be set to some higher (brighter) values.

Output Levels

Figure 4-9: Output Levels

Output Levels becomes useful in a case where the printer (with its profile in use) cannot show a difference between lower black levels (0–x). Let's assume that the printer cannot show different black levels below 7. In such a case, we may push ◆ of *Output Levels* up to 7. This means that the black values of zero are now transformed to 7, and all other values above that are linearly transformed. See section 3.10 on page 79 for more on this topic.

Note that some images look perfectly fine with all black below a certain value, e.g., 7. For some of these images, we may need to make only very small corrections for the output white point △, as most well-made profiles compensate quite well.

Always correct by visually inspecting an image, and not trusting the histogram alone. On the other hand, try to avoid removing too much shadow detail, and always think twice before clipping off highlights.

We only perform Levels corrections using a new adjustment layer. By doing so, we "layer" corrections and still are able to fine-tune values later.

> **Note:** When correcting tonality in black-and-white images, sometimes you can correct a bit more aggressively, gaining a higher contrast. Doing so can often help a black-and-white image.

Tonality Tuning Using Curves

Curves are more complex and also more powerful than Levels. In principle, you can do everything in Curves you can do in Levels, while the reverse is far from true. Our first example shows how you may simulate Levels using Curves:

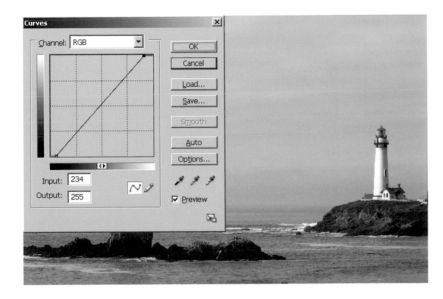

Figure 4-10:
Linear transformation with Curves.

Of course, in some of these cases, it would be advisable to use Levels. But a linear curve can provide a good starting point for more advanced curve corrections.

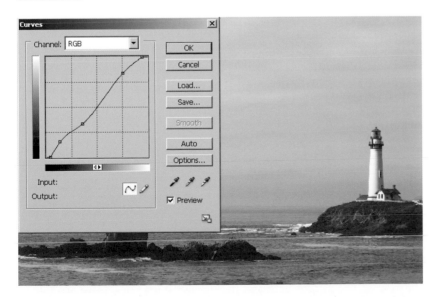

Figure 4-11:
Some more advanced curves

Here (figure 4-11), we start with the linear curve of figure 4-10 and try to achieve the following:

→ *A flat curve part will lead to low contrast in those tonal areas and steep curve parts will result in high contrast and may result in some banding.*

▶ Slightly brighten the shadows (foreground rocks)
▶ Increase contrast in the midtones and highlights (S-curve)

Be careful that no section of your curve becomes too flat or steep, as the latter may result in posterization.

Some Useful Standard Curves Shapes

For minor global **brightening/darkening**, we use these curves:

→ *Photoshop CS1 and CS2 support two sizes for the Curves and Levels dialogs. You may switch by clicking at the symbol (▧ or ▧) at the lower right side of the dialog box. In Photoshop CS3 click on the Curve Display Options triangle see or hide more options.*

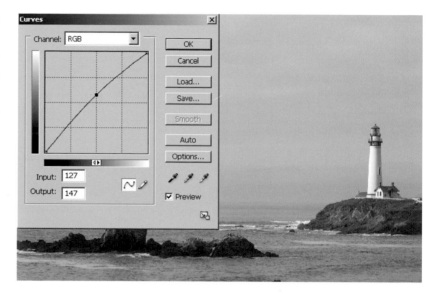

Figure 4-12:
Brightening curve

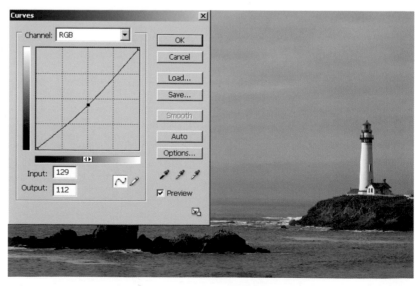

Figure 4-13:
Darkening curve

Why do we use Curves here and not Levels? With Curves, we are able to tweak behavior more easily than with Levels, where we are unable to change the gamma curve used by Levels.

We use **S-curves** to enhance contrast (figure 4-14). This curve looks like a shallow S-curve, but it has a strong effect on an image. In our view, a major down side of curves is that minor changes often have dramatic (and even negative) results.

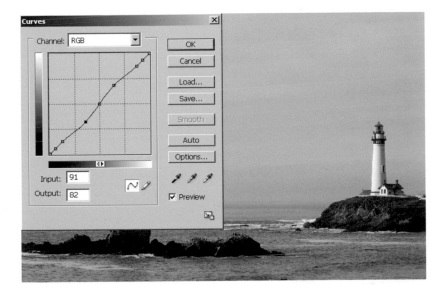

Figure 4-14:
S-curve to improve contrast

What also happens, in this case, is that midtone contrast is nicely improved without compressing shadows and highlights too much. Especially in this image, shadows are very delicate, and we want to avoid this type of compression. We use adjustment layers for Curves adjustments, and fix some problems by changing the Advanced Blending Options:

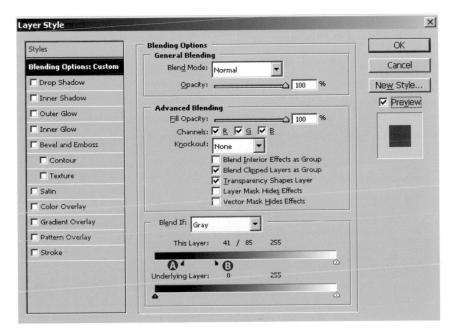

Figure 4-15:
Advanced Blending settings to preserve the original shadows.
Here, blending is controlled by sliders Ⓐ and Ⓑ. At first the sliders will look like this: ⬆. By pressing the Alt key while dragging the left or right part, you may split the slider into two separate parts. In the tonal values in-between, the effect will gradually diminish.

Alternatively, we use a different curve that restricts the effect of the S-curve entirely to midtones:

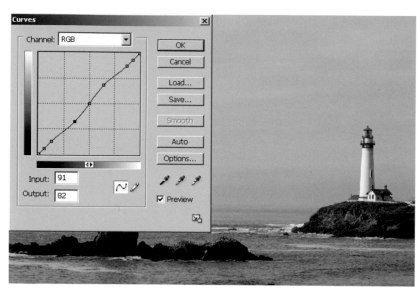

Figure 4-16:
Midtones S-curve

In this case, we prefer the latter solution. Overall, the S-curve can be very useful in many situations.

Local Tonality Tuning

We assume that, in most instances, you have done essential global tonality tuning before beginning your printing workflow. In fine-tuning your prints, it is vital to understand how to perform local tonality corrections that only apply to certain parts of the image. Here are some major ways to improve local tonality:

* Shadows/Highlight *was introduced in*
Photoshop CS1 (Photoshop 8).

▸ Adaptive shadow and/or highlight correction[*]
▸ Corrections to selected areas using masks
▸ Corrections related to certain tonality ranges (shadows, midtones and highlights)
▸ Painting techniques (mainly dodge and burn)

Adaptive Shadow and/or Highlight Correction

We have described some information about shadows in the section on local tonality tuning. In fact, Levels and Curves understand shadows differently than we normally do. They consider a shadow as pixels with reduced brightness. Let's demonstrate what we mean with the following example:

This picture contains dark letters, but also real shadows that have detail within them. From their pixel brightness, the black letters, although in the sun, may be as dark or even darker than the real shadows. Both

Curves and Levels would treat both the same way. That is not really what we intend when we plan to open up shadows a bit.

In situations like this, there exist more useful tools that work *adaptively*; they take into account the context in which the pixels reside and not merely a single pixel value alone. Currently, the best known tool is Photoshop's Shadow/Highlight tool. Below is a demonstration target to show the principles of Shadow/Highlight:

There are five incrementally darker dots that are identical in each column. It is well known that we perceive the same brightness differently, depending upon its context or contrast:

Figure 4-17: Shadows and dark areas

▸ Bright spots look brighter in a dark context
▸ Dark spots look darker in a bright context

The above example should illustrate that treating all pixels equally, as with Curves and Levels, is not always helpful. Why don't we see more of these adaptive tools today? Because they:

▸ Are computing intensive
▸ May have color-shift side effects
▸ Sometimes create issues at their edges (e.g., show halos, so watch out for them)

Shadow Recovery

When Shadow/Highlight is used to open up shadows, we see the following result:

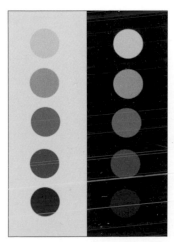

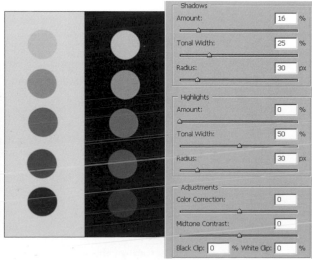

Figure 4-18: Shadow/Highlight test chart

Figure 4-19: Shadow/Highlight used to open up the shadows

Based on the result in figure 4-19, we observe the following:

▸ All spots in the bright area remain unchanged
▸ The dark background brightens up
▸ The three darker spots on the darker background increases brightness

Highlight Recovery

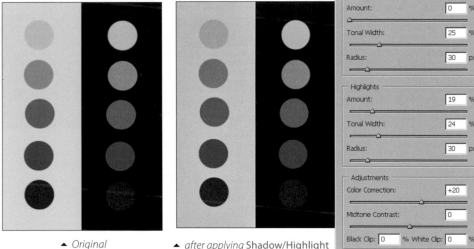

Figure 4-20:
Shadow/Highlight *used to*
tone down highlights

▲ *Original* ▲ *after applying* Shadow/Highlight

We observe the following in figure 4-20:

▸ All spots in the dark area remain unchanged
▸ The bright background darkens
▸ The four brighter spots on the brighter background tone down their brightness

True, you could accomplish the same task with complex masking, but the main drawbacks would be:

▸ More complicated, involving much more work
▸ With real-world images and fine details, masking can become quite challenging

Corrections to Selected Areas Using Masks

This book does not cover all possible techniques in using complex masks. The fact is, we rarely use them anyway. But here is a technique that often works well.

We wish to make the shadows on the dune photo (figure 4-21) a bit brighter. It looks satisfactory on the screen, but when printed, we found it a bit too dark.

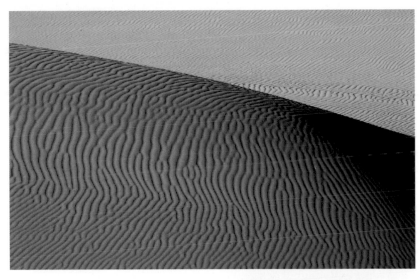

Figure 4-21:
Start photo

So, we selected the shadow using the tool lasso ⋎ . (Figure 4-22 shows just the relevant part of the image.)

Then we switched over to the Quick Mask mode (use the key ⎡Q⎤) and could see that mask edges are too difficult to make a clean selection (figure 4-23).

We therefore feathered the selection (with values between 25–150 depending on the image and the selected area, see figure 4-24).

Figure 4-22:
Select the shadow area with the lasso tool.

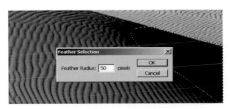

Figure 4-24: Selection feathered at 50

Figure 4-23:
Same selection shown in Quick Mask mode

The result is shown in figure 4-25.

Now, we needed to tune the selection a bit at the upper dune shadow edge. Finally, we used a Curves adjustment layer with this selection as a layer mask to brighten up the shadow:

Figure 4-25:
Selection after applying feathering

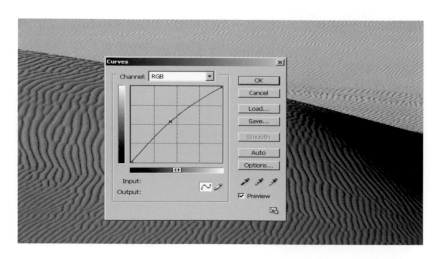

Figure 4-26:
Using a Curves adjustment
layer to brighten the
shadow

This technique is useful when the area you work with does not have complicated edges as its boundaries.

Corrections Related to Certain Tonality Ranges (Shadows, Midtones, and Highlights)

Often, we use a technique to restrict the effect of Curves and other tuning tools to only certain tonal areas:

▸ Shadows (e.g., opening up shadows)
▸ Midtones (e.g., adding contrast, brightening and darkening)
▸ Highlights (e.g., toning down aggressive highlights)

All our masks are based on a Luminosity mask similar to the black-and-white image of the original photo. We may invert this mask and also restrict it to certain tonal regions. Because this process can be quite tedious, we created our DOP Tonality Tuning Toolkit [29]. Here is an example:

Figure 4-27:
Original dune photo

As before, we want to open up the shadows. First we create a shadow tonality mask (using our DOP Tonality Toolkit):

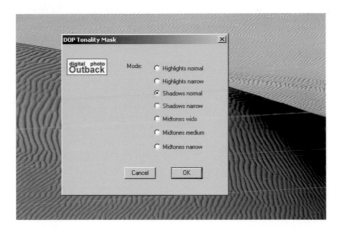

Figure 4-28:
Use the Tonality Mask automation plug-in to create a shadow mask

We get the following selection:

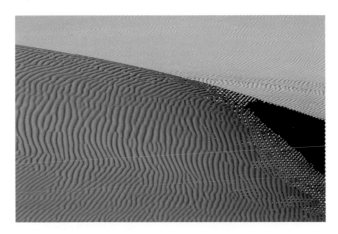

Figure 4-29:
Shadow selection

Again, we use Curves with the selection applied to a layer mask:

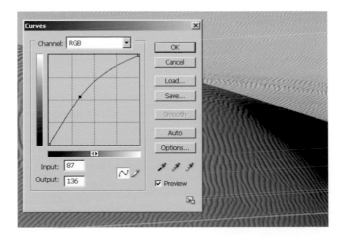

Figure 4-30:
Curves applied to selected shadows only

Here is the Layer Mask that we created:

Figure 4-31:
Tonality Mask (shadows normal)

Just for demonstration, we show the mask that would be created if we had chosen the "shadows narrow" option.

Figure 4-32:
Tonality Mask (shadows narrow)

Different from the mask in the last section, we created these tonality masks that include all the shadow parts (even the dune ripples). Whether this effect is intended by you is based on how you want to present the print. This last method exaggerates the soft character of the shapes (reduced contrast), while the previous method shows more highlights in graphic patterns of the shapes. It is always helpful to have multiple ways to explore the potential of your photos for printing.

It is fairly easy to modify these masks using the following painting techniques.

Painting Techniques (Mainly Dodge and Burn)

In principle, you can paint all your masks (layer masks) with soft brushes (we usually use *Hardness* set to zero).

Painting Using Layer Masks

Figure 4-33:
Original image

In this example, in figure 4-33, the eye and part of the head of the Avocet chick are in the shadow. We would like to brighten them up.

1. We create a Curves adjustment layer to brighten the whole image (see figure 4-34). The resulting image of figure 4-35 is clearly too bright, but don't worry.

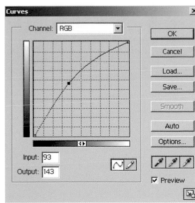

Figure 4-34: Curve to brighten up the image

Figure 4-35:
The image in figure 4-33, brightened up by Curves, is too bright.

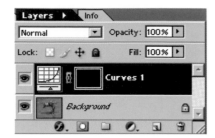

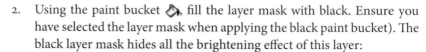

Figure 4-36: When the layer mask is completely black, the adjustment layer has no effect.

2. Using the paint bucket 🪣, fill the layer mask with black. Ensure you have selected the layer mask when applying the black paint bucket). The black layer mask hides all the brightening effect of this layer:

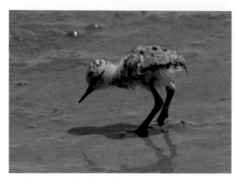

Figure 4-37:
The effect of the Curves adjustment layer is completely masked by the black layer mask.

3. Using a soft, big brush
 ▸ Color White
 ▸ Opacity 15%

 paint a few strokes over the face. By using 15 % opacity, you have a lot of control in brightening the face (try even higher opacity to experience the difference).

 A look at the Layer Mask by clicking on the layer-mask thumbnail) reveals the secret (see figure 4-38):

This is a universal technique for selective image enhancement and can be used with many different types of layers:

▸ Layer with a sharpened version of an image
▸ Layer with a noise-removed version of an image
▸ Hue/Saturation adjustment layers
▸ Curves adjustment layer using S-curves

Figure 4-38: Layer mask after painting with the soft white brush.

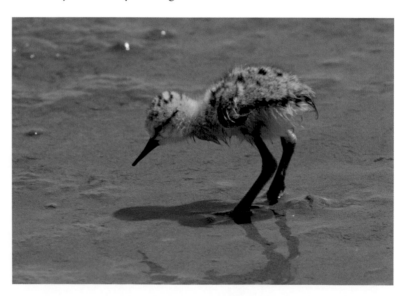

Figure 4-39:
Optimized image. Here, the head is somewhat brightened up.

Dodge and Burn Using Layers

With the same sample image we show a different technique we learned from Mac Holbert. Again, the image would be good if those parts of our Avocet chick could be lightened up a bit.

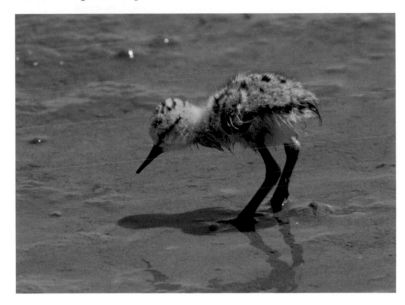

Figure 4-40:
We want to brighten up the bird's body

1. Create a new layer in the layer palette

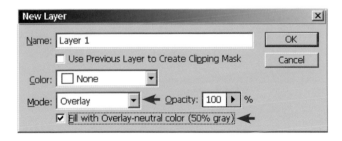

Figure 4-41:
Create a new layer with Overlay
Blending mode

2. Set *Mode* to *Overlay* and select Fill with Overlay-neutral color (50% gray).

 Overlay is a very special blending mode with the following properties (for more details, consult Photoshop Help):

 ▸ 50 % gray leaves the image unchanged (our starting point)
 ▸ values > 50 % gray will darken the image (black being strongest)
 ▸ values < 50 % gray will lighten the image (white being strongest)

 For painting in your grey level, you may use any of the painting tools – e.g., a white or black brush (you should usually use a soft brush and a low opacity of about 10–15%). We, however, will use the Dodge tool 🔍 for lightening and the Burn tool ✊ for darkening.

3. Select the Dodge Tool ().

4. Set exposure to 5–15 %. Enable the Airbrush option and use a reasonably large, soft brush.

Now, when you paint on areas that are too dark for your taste, they will brighten the more you paint in that area. The lower the exposure, the more you need to paint, giving much greater control.

Figure 4-43: Shows only the Dodge & Burn layer

5. Dodge the bird's head and body with a few careful brush strokes.

 If you make all other layers invisible, you can see what your "dodge & burn" layer looks like.

 Dark areas would show portions used to burn (no burning here) and the bright ones are those used for dodging. The following picture (blending of the original picture and the "Dodge & Burn" layer) illustrates our point.

Here is the original image (figure 4-44) and the optimized image (figure 4-45).

 As you have seen, most of the time there are several ways in Photoshop to achieve a certain optimization.

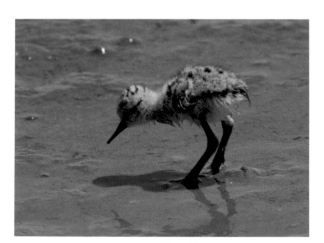

Figure 4-44: Original image

Figure 4-45: Avocet now has a brighter body while the rest of the image has kept its tonal values

4.3 Tuning Colors

We assume you have the white balance of your image as you like it. Color tuning involves fine tuning of colors and not major color corrections.

A key issue is to achieve correct saturation. Ensure the contrast is correct before even thinking of tuning saturation. Often simply tweaking the contrast automatically alleviates any problems with saturation.

Selective Saturation Improvements

Sometimes we perceive an impression that a digital photo may need more saturation. Actions and filters to do this are quite popular. Let me open with some general comments:

Films like Velvia often produce high saturation of colors in photographs, i.e., they appear "larger than life," and thus the image seems to lose other subtle, more natural colors. When you place two photos side-by-side, differing only in saturation, the one with greater saturation draws your attention more. Does that imply it is better? Not necessarily. Again, before you even consider enhancing saturation, adjust the contrast. Some S-curves might do the trick.

What about those times when you absolutely must enhance the saturation of an image? What's the best way to go about it, given the hundreds of possibilities?

An excellent tutorial on this subject can be found in an article by Ben Willmore in the Photoshop User magazine: "Saturate Your World." It certainly has changed our view on saturation.

As a side remark: whenever you come across an article by Ben Willmore, read it. Also his excellent book on Photoshop CS3 [15] is now part of our library.

Figure 4-46:
Grand Canyon: Mather Point

At first, his message sounds pretty obvious: "Use selective saturation in Photoshop." Why hadn't we considered this before? It seemed complicated,

and it actually is when you try it on your own without Ben's guidance. But he gives a wonderful practical tutorial on how to master the art of selective saturation.

Global saturation enhancement seems an inappropriate method in most cases. In the following example, we apply selective saturation enhancement only to selected areas of our photos:

We want to enhance saturation in the top part of this photo, yet keep the bottom as is. Create an adjustment layer using Hue/Saturation. Change the layer mask in this layer to something resembling figure 4-47.

The black portion prevents saturation changes at the bottom but allows a soft transition to white in the upper areas.

Then, open the Hue/Saturation dialog, but do not change the "Master" settings. We altered the reds using the "Red" settings.

Figure 4-47: Black to white gradient used as a layer mask

Figure 4-48: (Left)
No changes done in "Master"

Figure 4-49: (Right)
For our image of figure 4-46 we do our settings in "Reds".

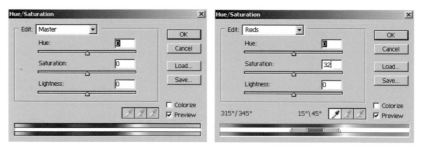

We encourage you to learn for yourself what the different sliders mean, and thus do not include all the details from Ben's article.

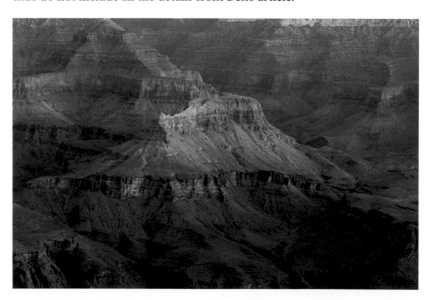

Figure 4-50:
Image after selective Hue/Saturation corrections in "Reds".

Here is the result of this operation. We concluded that the change might be a bit too strong and considered changing the saturation settings. Instead, we modified the opacity of the adjustment layer.

Figure 4-52 shows our final version. The differences can be subtle, but this is precisely what selective saturation is all about: **think selectively!**

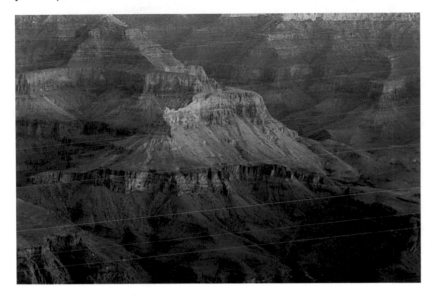

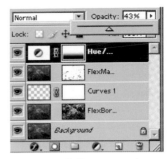

Figure 4-51: *Different tuning layers (adjustment layers) of the final image*

Figure 4-52: *Final version of our image*

More Saturation and Contrast Tricks

As all photographers learn, there is rarely anything better than the "right light", In our book, *California Earthframes**, we made the following choices:

▸ Midday sunlight creating harsh shadows and burned-out highlights
▸ Evening sun with better light but longer shadows
▸ Overcast skies providing flat light

* *See www.outbackphoto.com/booklets/dop9001/DOP9001.html.*

From these three alternatives, we favored "overcast," the lighting from which is like a good light box.

We probably get some flat images directly from the raw converter. Of course, we could tweak the raw converter (and sometimes we do that), but usually we prefer to do this work with layers in Photoshop. Then we are able to revisit all changes and improve on them at a later time. The first step is most often an adjustment layer using Levels:

Figure 4-53: *We start with a flat image*

Figure 4-54: *Levels adjustment layer*

Figure 4-55: After Levels

As you see, we moved the white point only slightly, so the photo would not get too bright and retain only truly white details.

Now, increase the contrast using some S-curve in a Curves adjustment layer.

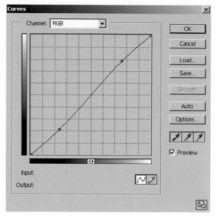

Figure 4-56:
Slight S-curve for a bit more contrast, resulting in image in figure 4-57

S-curves tend to create color shifts that can be removed by changing the blending mode of the layer to *Luminosity*. This change is subtle, so experiment with it.

Figure 4-57: After Curves

Figure 4-58:
Our layer palette up to now

Figure 4-59:
Changing blending mode to Luminosity

Figure 4-60: After change to 'Luminosity'

Some still may want to increase saturation and tweak contrast just a bit, so there are several ways to go, in particular a technique explained to us by Katrin Eismann, author of "Photoshop Masking and Composition" [2].

Using an Adjustment Layer with "Hard Light" Blending Mode

Create a new Curves adjustment layer and change the blending mode to *Hard Light* (figure 4-61).

This effect – as seen in figure 4-62) is probably not what you want, but don't worry.

The right selection of layer opacity allows us to tone down the effect to a more pleasing level.

Figure 4-61: Image with 100 % "Hard Light"

Figure 4-62: Additional Curves adjustment layer using "Hard Light" blending mode

Figure 4-63: Changing the Opacity

A problem can occur in using this technique: shadows might become too dense. Since we use a Curves adjustment layer, we could use curves to control the impact on the shadows, but there is a more elegant solution. Open the layer's blending options and move the left slider for the *Underlying Layer* to the right. Below 46, values are no longer affected.

Figure 4-64: Opacity of "Hard Light" layer reduced to 27 %

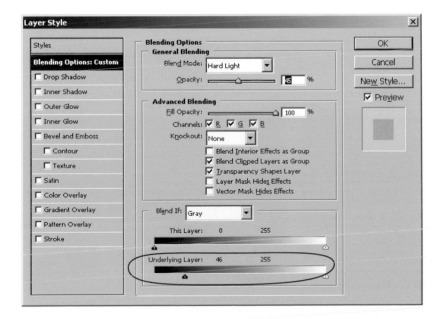

Figure 4-65: Setting the "Blending Options"

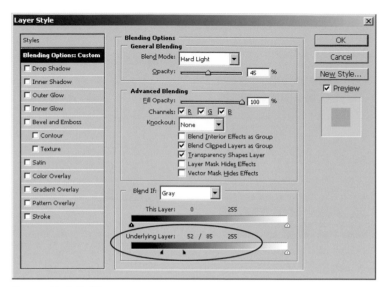

Figure 4-66: Split sliders

This is still not what we want, as the transition would become visible. If you look carefully, notice that the tiny triangle sliders are split. You can separate them by using the [Alt] key and moving the right portion of the triangle to the right (figure 4-66). Voilà:

Now, all shadows below 52 are protected from our "Hard Light" layer, and there is a smooth transition zone up to 85. Finally, the layer effect is fully visible above 85.

Figure 4-67: Here, shadows below 52 are protected from the 'Hard Light' correction

Variation with "Soft Light"

You can do the same thing using the *Soft Light* blending mode. This time, the effect is less dramatic.

Be careful or your photos will become too dramatic and punchy. Also, photos directly contrasted using strong saturation appear even flatter than they really are. This is one reason naturally saturated photos are perceived as flat. We are bombarded with too many overly saturated photos today, and sometimes call it the "heavy metal of photography."

Figure 4-68: Soft Light at 100% opacity

Figure 4-69: Soft Light at 27% opacity

Removing Blue Shadow Casts

We revisit our dune photo again.

Figure 4-70:
Initial dune image

This time we look for a blue cast in the shadows. Be aware that this scene was actually illuminated by two light sources:

▸ Sun or sun-in-overcast
▸ Sky in the shades

The light actually has two different color temperatures. In this situation, the global white balance should be selected to correct for the main light source, in this case, the sun.

In shadows, we detect quite a bit of blue shadow cast, which is often not too easy to see on a monitor. We don't like an extreme blue cast in our prints and usually try to tone it down. The techniques here are shown at a 100% magnification crop (all screen shots).

We added a Hue/Saturation adjustment layer to pump up the blue, and to intensify the cast (see figure 4-73 at page 118).

Pushing up saturation temporarily is a very general technique when doing color corrections. This will show up the colors in your image and where they are. First do this in Hue/Saturation dialog selecting *Master* in the Edit pull-down menu. You may be surprised what colors your image will show. Having seen them, set saturation back to normal and go to the color tint you want to correct and there fine tune – using your sliders – the colors you want to correct. In our example this is Blue.

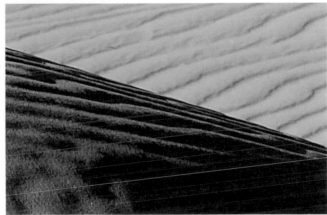

Figure 4-71: Crop of the original photo

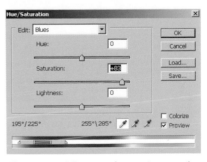

Figure 4-72: Adjustment layer to increase the saturation

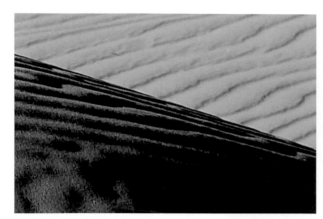

Figure 4-73: Visualize the blue cast

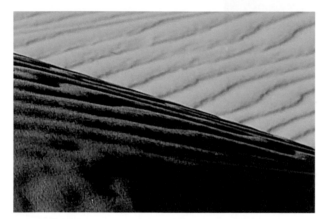

Figure 4-75: Blue, toned down

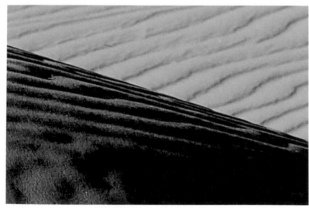

Figure 4-76: Reduced blue with mask

As stated, the blue cast looks much too strong, but it gives an idea where blue cast resides. As shown in our workflow book [12], we use selective Hue/Saturation to tone down this cast. We keep the test Hue/Saturation layer on top, just to show the effect:

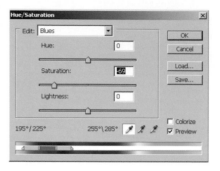

Figure 4-74:
Selective reduction
of the blue cast

A nice side effect is that shadows get a bit brighter when we tone down the blue. It is possible that this strong removal might be too much, and we may want to limit the blue reduction to shadows. This is why we used our Tonality Tuning Toolkit [15] and created a mask to limit the Hue/Saturation layer only on the shadow portion of the image:

Note: We often use the same shadow mask to limit the effect of a noise-removal layer to the shadow part of the image. These shadows sometimes contain a lot of noise.

Remember, our Hue/Saturation test layer still strongly amplifies the blue. Figure 4-78 at page 119 shows the final version, after disabling the Hue/Saturation test layer.

Keep in mind that sometimes the difference is not as impressive on screen as it can be in a print, so you also must test these effects by actually printing some test prints and studying them under optimum lighting.

Of course, you must be careful if other blue areas reside in your image (e.g., sky). In that case, you should use masking techniques to protect those areas.

If you want to create a luminosity mask using the standard selection mechanism (instead of using our Tonality Tuning Toolkit), choose Select ▸ Color Range and *Sampled Colors* in the *Select* drop-down menu. Control the width of your Luminosity using the *Fuzziness* slider. You can then invert the mask it necessary (⇧-Ctrl-I, Mac: ⇧-⌘-I).

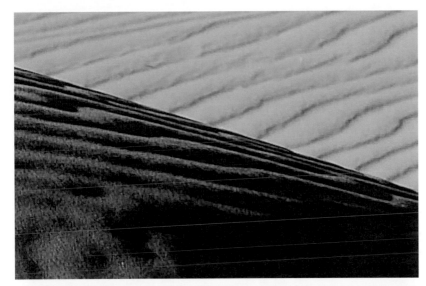

Figure 4-77:
Initial version of the image.

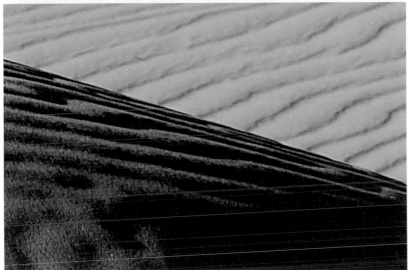

Figure 4-78:
Final version of the image

4.4 "Ring Around" and Variations

This chapter covers material strongly influenced by our friend Brad Hinkel.

Finally, only an actual print can show how a print will look in its final form. Soft-proofing is just one way to get as close in quality to the final print as possible. Here, we want to cover two important techniques in fine-tuning your prints:

▶ Ring Around
▶ Variations (on screen and in print)

Both techniques are based on seeing the same image (or partial image) in variations of the original to verify you get the interpretation of the image you prefer.

Ring Around

This text is from Brad Hinkel (see www.easycolormanagement.com).

Printing a "ring around" is a traditional technique for evaluating images in the wet color darkroom. We all did it for a basic color printing class. I found the process useful, but far too tedious to repeat for any image other than that particular assignment.

Figure 4-79:
"Ring Around" scheme

In the digital darkroom, this procedure is still effective, but much easier. The "ring around" is designed to help evaluate if an image has the appropriate color balance and/or density. It can potentially be used for a wide range of options, i.e., anything that can be placed on an adjustment layer. We will be

investigating more options in the future. The basic "ring around" shows some variations of an image for +R, +G, +B, -R, -G, -B, darker and lighter.

Use a "ring around" when you have an image:

▸ that you feel looks great – but just to test the final evaluation
▸ that you just can't seem to color-balance well

It is important to remember that our eyes/brains will sometimes compensate for color balance issues in an image, to make it appear better than it really is. So, take time away from an image, say, a couple of minutes, and return to it to evaluate its color. A "ring around" forces a better evaluation of color.

We automated the whole process. The action provided helps to create a "ring around" quite easily. (You may download it from Uwe's Web site [31].)*

1. We create a folder (PC: "C:\tmp\ring_around").
2. Empty the folder.
3. Run the action.
4. Browse to the folder in Bridge or the Photoshop file browser.
5. Run the Contact Sheet II tool from Bridge or Photoshop (figure 4-80 and 4-81).

** Sorry, this action is for Windows only, as we need to write to disk, but the action is a blueprint for your own actions on a Mac.*

Figure 4-80: Calling Contact Sheet II from Bridge

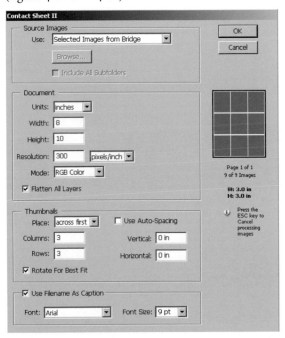

Figure 4-81:
Contact Sheet II dialog

6. Select a 3 × 3 matrix.
7. Enable a filename as a caption.
8. Click OK.
9. Photoshop will create a one-page proof sheet.
10. Print the contact sheet using the appropriate profile (suiting printer, inks, paper, and printer driver settings).

You can find and download our free Photoshop action for "Ring Around" at [31].

Using Variations

Fine-tuning an image takes at least as much effort as getting the image in the first place. Here is a technique to help you visually optimize pictures. These routines look simple, yet they really help for that which they are designed: fine tuning.

We have implemented this technique in a "DOP Variations" plug-in, and you can do the same steps by hand.

Comparison is a powerful tool in optimizing color, brightness, contrast, saturation, and more. There is a nice tool in Photoshop called *Variations* (Image ▸ Adjustments ▸ Variations) that guides you through a sequence of image variations (figure 4-82).

Figure 4-82:
Photoshop Variations

It is a nice tool, but has some shortcomings when seriously fine tuning:

- ▸ Images are much too small
- ▸ It works only on 8 bit color (even with CS3)
- ▸ Once confirmed, a change is "cast in stone" and cannot be edited; it would be nice to make it an adjustment layer.
- ▸ Not easy to customize

When our friend Brad Hinkel introduced us to "Ring Around," it stimulated us to design a better way to use variations. Our goals were:

▸ Use the full Photoshop image to compare
▸ Have different comparison patterns
▸ Correct in iterations
▸ Leave all corrections in adjustment layers (let nothing be "cast in stone"!)
▸ Preview before and after at any time
▸ Easy to customize
▸ Not waste too much disk space

DOP Variations

Though this is our own tool, feel free to create your own variations workflow using Photoshop actions. You will find our tool here: [30].

As with many good ideas, it is really very simple. The plug-in creates adjustment layers with layer masks that are used to compare before/after scenarios. Here are the masks you can select:

Figure 4-83: Starting image

Figure 4-84: Masks that you may use with our Variations plug-in

The two masks to the right will be used for the "left/right quarter" option, and provide an alternative method of comparing. We use this same image also in our full variations workflow.

Let us assume that you use mask #1 ("Diagonal Split"). Then, the action *"DOP Variations Layers"* will create a layer group (or layer set) with layer masks that use mask #1. It would look like figure 4-86 and result in an image displayed like that in figure 4-87.

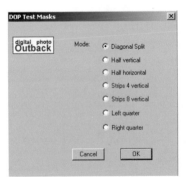

Figure 4-85: Different comparison masks (only available in the Windows version of the plug-in)

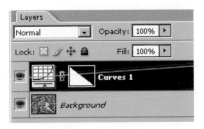

Figure 4-86: Layers palette showing the Curves adjustment layer with its layer mask

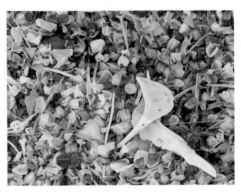

Figure 4-87: Image with split layer mask #1

The goal of the mask is to provide an aid to see the difference between "before" and "after." The adjustment layer is easily tuned using opacity to reduce the brightening effect. Its full benefit is seen in our next example. Here, we provide information on how these variations work, at least in principle.

The full optimization workflow:

Again, we start with an original file. This time we use the supplied action called "*DOP Variations Layers*" and use option 1. This creates the layer structure of figure 4-88.

The plug-in, together with the actions, creates a layer group (before CS2, called *layer set*) with all layers disabled. We get 14 adjustment layers:

▸ Blue plus/minus color balance (+30/-30 at 50 % opacity)

▸ Red plus/minus color balance (+30/-30 at 50 % opacity)

▸ Green plus/minus color balance (+30/-30 at 50 % opacity)

▸ Darker/brighter levels (0.8/1.2 midpoint at 72 % opacity)

▸ More/less midtone contrast S-curves (at 80 % opacity)

▸ More/less saturation (+20/-20 at 75 % opacity)

▸ Warmer/cooler (Photo Filters at 50 % opacity)

The task is now to inspect each pair of corrections and decide whether a picture benefits from one of the corrections.

Sample #1 Darker

We enable the "darker" layer and see the image of figure 4-89. We can now tune the opacity of this layer to darken it as much as we like (here, less is probably more). When we are happy with the result, we disable the layer mask:

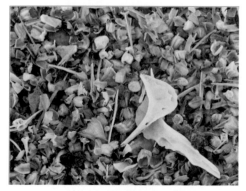

Figure 4-89: Image when layer "darker" is enabled.

Figure 4-90:
Use "Disable Layer Mask" to remove the partial disabling of the layer effect.

You will get the layer structure of figure 4-91. Now "darken" with opacity 25% is applied to the full image. Also we can check the global effect at any time by enabling/disabling the complete layer group.

Figure 4-88: Layers

As we perform these tests for each of the layers, in many cases we see right away that this sort of correction may not make sense.

Don't these many adjustment layers blow up a file size? We tested it on a full Canon 1Ds Mk. II file (14.7 Megapixel RAW image):

Name	Size ▲	Type	Date Modified
1ds2_0000_2861_no_layers.tif	35,314 KB	TIF File	11/2/2005 7:06 PM
1ds2_0000_2861_one_adjustment_layer.tif	81,230 KB	TIF File	11/2/2005 7:13 PM
1ds2_0000_2861_with_layers2.tif	83,384 KB	TIF File	11/2/2005 7:11 PM
1ds2_0000_2861_with_layers.tif	85,708 KB	TIF File	11/2/2005 7:08 PM
1ds2_0000_2861_one_layers.tif	127,414 KB	TIF File	11/2/2005 7:12 PM

- ▸ Image without any layers: 36 MB
- ▸ Image with a single adjustment layer: 81 MB
- ▸ Image with the full layer group: 85 MB

This means the overhead is significant compared to not using layers at all. But because layers are the way to go for fine-tuning anyway, our base size is at 81 MB. In this case, we have about 4–5 MB overhead and this means no more than 5% more than the minimal size for just one adjustment layer.

All this fine-tuning will take some time and is only worth it for prints you really care for – but that's all this book is about.

4.5 Local Contrast Enhancement

Local contrast enhancement is one of the newer functions of image editing. What we are talking about here is the enhancing of the local contrast in your whole image – though it may also be restricted to certain areas by using layer masks or similar methods. This technique allows you to enhance the contrast between neighboring pixels that have slightly different colors or tonal values. A very old technique for this is to use sharpening (e.g., the Photoshop USM filter), applying a large Radius but a low Amount. If you have fine structures in your image – e.g., small leaves or fine color variations in a stone surface –, this will bring some pep to your image.

There are also a number of optional Photoshop filters (plug-ins) that can do this even better. One of them is Akvis Enhancer [35] which does a very fine job. We used this quite a bit in the past. It allows you to separately set the preferred level of local contrast enhancement for highlights and shadows, and it allows you to brighten up your shadows – in much the same way as Photoshop Shadow/Highlight filter does it.

Before we use this filter, we first duplicate the previous layer or create a new composite layer using ⇧-Ctrl-Alt-E (Mac: ⇧-⌘-⌥-E). Like almost all filters, Akvis Enhancer can only work on a pixel layer. (Although earlier versions of Akvis Enhancer did not work as a Smart Filter in Photoshop CS3 or CS4, newer versions of Enhancer do – at least since version 9.5).

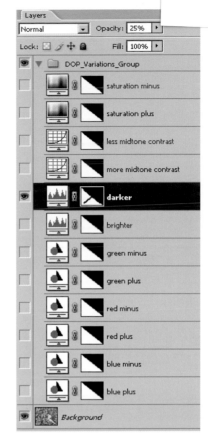

Figure 4-91: Final layer structure after our optimization using the "Variation plug-in". If you keep all disabled layers, you may activate them later for further tuning.

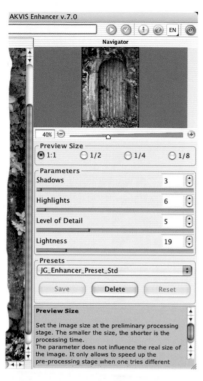

We recommend starting with low (standard) values for *Shadows*, *Highlights*, and *Level of Detail* (see figure 4-92). We also found that you should reduce *Lightness* a bit (as compared to the default setting).

This filter is very resource-consuming concerning computing power as well as memory. To generate a preview, set your controls and click the ⊙ icon. The progress bar will show how far down the line the calculation currently is. With the standard settings, Akvis Enhancer will lighten up your shadows a bit. Watch for any noise that might appear with this.

If you like the result, click ⊙. This produces the actual enhancement. If it's too much, you have to restart the whole process, or you can simply reduce the opacity of this filter layer (one reason we always use a separate layer).

As with most modern plug-ins, you can save your current settings as a new preset with this filter. This is quite convenient as you will probably find your own style for certain types of images and in this way you can recall your presets without much fiddling with the sliders.

Another filter we regularly used (until Uwe created his own filter), is Photomatrix ToneMapping [56]. Sometimes we even combined these two filters (apply first ToneMapping and then Enhancer).

◀ *Figure 4-92: Dialog of the Akvis* Enhancer *filter with the navigator at the top.*

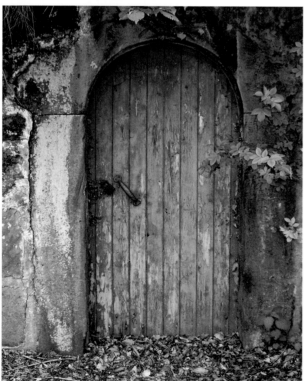

Figure 4-93: Original Image

Figure 4-94: Door after applying the Akvis Enhancer *Filter*

Uwe also created his own plug-in script for local contrast enhancement. It's called *DOP Detail Extractor* and is available at [33]. It offers three different methods for contrast enhancements. For the image demonstrated in figure 4-95, we used method *Extract 1* (see figure 4-97).

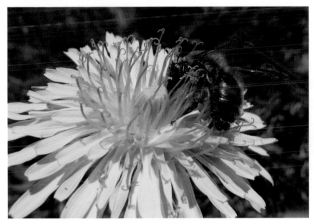

Figure 4-95: Original image – a bit of bang is missing.

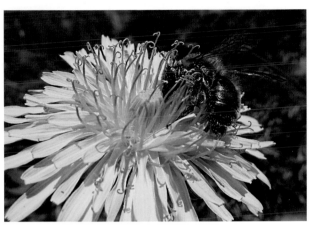

Figure 4-96: Image after applying the Detail Extractor script.

Here, you don't have to create a layer, as this script will do it for you. To preserve the fuzziness of the background, I used a roughly painted layer mask, shown in figure 4-98.

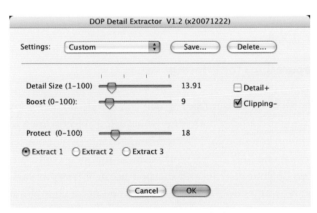

Figure 4-97: Detail Extractor settings for figure 4-96

Figure 4-98: Layer mask to preserve the fuzziness of the background

I also like that the DOP Detail Extractor script will include the slider settings in the layer name (see figure 4-99).

Whether you use the USM method, the Akvis Enhancer, or Uwe's plug-in, in all cases the image will need less final sharpening for printing, as all these methods do a bit of sharpening. With all three methods, the effect can be restricted to certain image areas by using a layer mask. We usually use layer mask to preserve smooth gradients, e.g., in the sky, for skin in portraits or for burry areas where we don't want to enhance details.

Figure 4-99: The layer created by Detail Extractor is named with the values used in the tool.

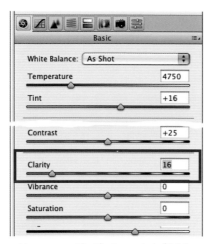

*Figure 4-100: The **Clarity** control of Adobe Camera Raw 4.x allows you to enhance the local contrast in your image.*

When you are shooting in RAW and you are doing your RAW conversion in Photoshop CS3 using Adobe Camera Raw 4.x (or if you are doing your RAW editing using Adobe Lightroom), there is already a basic function for local contrast enhancement. Use the Clarity control for this. With *Lightroom*, Clarity is part of the *Basic* tuning block; with Camera Raw, you will find this slider in the *Basic* tab (see figure 4-100). Most images will benefit from a moderate non-zero value in this slider. If, however, you intend to use an enhancement filter as described above, use only very little or no Clarity in order to avoid halos.

As local contrast enhancement, like sharpening, will also enhance noise in your image, you have to reduce noise before doing this enhancement. This is why we placed this step at the end of our image optimization. You might also have to restrict your local contrast enhancement to certain areas by using a layer mask (or a similar technique) in order to avoid amplifying noise or producing halos.

When we do a black-and-white conversion, as described in section 7.2, we usually do some minor local contrast enhancement before we perform our black-and-white conversion and, optionally, some additional detail extraction after the conversion.

All the methods described above – though focussed on local contrast enhancement – will result in some sharpening. Therefore, you should use no or very little sharpening before this step. However, these methods don't completely replace sharpening; therefore, you will have to apply some additional sharpening afterwards, but to a much lesser extent than without such an enhancement step.

4.6 Further Preparations for Printing

Before you resize and sharpen your image, (which you should do on a copy of your image), you might consider flattening your various layers down to one layer. We recommend you save your layered image first (as a new master image) make a copy of it and only flatten your layers in that new copy. This is the copy you should do your resizing and sharpening on. Give your various copies consistent file names linking the different versions of your photo together by their file names. According to our experience, you will often want to go back to a previous version (e.g., the version with the correction layers still intact) and do some more fine-tuning there or use it as the base for a print on another output device or for another print size.

→ *Your image may lose some visual contrast on screen when you reduce your tonal values. But don't worry, it won't reduce the quality of your print but will result in more details in shadow and highlight areas!*

The final step in print preparation should be restricting the tonal values of your image to those the printer can reproduce. How this is done is described in section 3.10, page 79. You may perform this operation either before or after scaling (sizing) your image copy.

If you do some print or printer-specific tuning, do not apply this to your general image. Instead stay in the same image file, create a new layer

group in Photoshop,* and put all your printer-specific tuning into this group. This allows you to switch these modification on and off by enabling or disabling the layer group, and even permits you to have several separate layer groups for different printing situations. Once you have achieved a specific optimization for a specific print situation using this layer technique, you may even copy the optimization adjustment layers to another similar image.

When working in Lightroom and doing some printer-specific optimization, we first create a virtual copy and do the specific optimization in this virtual copy.

* *Use* Layer ▸ New ▸ Group:

4.7 Resizing

As in Sharpening, *Resizing* is a complex topic. For printing, we mainly deal with increasing the size of an image only after the print sizes becomes larger. There are two main reasons to increase the size:

▸ Bring the ppi (pixel per inch) up to a value that is optimal for your printer. Most printers work fine with the original ppi between 240 to 360 ppi. Some even use 180 ppi and leave the further "up-sizing" to the printer driver.

▸ Make significantly larger prints than the original image size and ppi would normally allow. We rarely try this, as it always means extrapolation of many new pixels. Admittedly, good up-sizing algorithms can create wonderful illusions.

When you perform major up-sizing, you normally need to add final sharpening.

In chapter 6, " Printing Packages and RIPs", we feature Qimage, (see section 6.2) because it does all these things:

▸ Use first-class up-sizing algorithms

▸ Up-sizes to a printer's native resolution (Epson 360 ppi or 720 ppi, and HP 600 ppi and Canon 300 ppi)

▸ Applies some mild amount of final sharpening that often results in some nice local contrast enhancement.

If you really must up-size your image first, which you should do if you want to print a larger image using Photoshop and the standard printer driver, we recommend the following up-sizing tools:

▸ Photoshop *Bicubic Smoother*: does a nice job for moderate up-sizing

▸ DOP Up-sizing [44]: Our free automation plug-in that implements a strategy by our friend Jack Flesher.

▸ Genuine Fractals [58]: the classic up-sizing tool, but slightly expensive.

* *When using "Bicubic Sharper" for
downsizing an image, you may use less
sharpening as the image already underwent
some sharpening by the scaling process.*

> **Note:** If you have to resize an
> image, never do it to your
> master image but only to a new
> copy of the image file!

For down-sizing, Photoshop's *Bicubic Sharper* will do the job in most cases.*

If you have to up-size more than 50–80%, you may consider using one of those numerous up-sizing Photoshop plug-ins like Genuine Fractals [58] (as mentioned), plx SmartScale [58] or Sizefixer [49]. But most of these plug-ins are costly and are only worth their money if you do a lot of up-sizing and scale up considerably.

When you are shooting RAW and intend to print large, you may prefer to do your up-sizing in the RAW converter. In most cases, the results are slightly better than scaling in Photoshop.

4.8 Sharpening

All images produced by a digital camera need some sharpening, as some softness is introduced internally by the anti-aliasing filter of the digital camera (in front of the sensor). Some additional softness is introduced by the demosaicing filter. With digital scans, some softness is produced in the digitizing process.

Sharpening usually should be performed as the last optimization step. After removing noise, sharpening may make noise more visible. There actually are three types of sharpening you should apply to an image:

A. **Compensate for the slight fuzziness that is caused by the color interpolation** (demosaicing process). If you are shooting RAW, you should do some sharpening in your RAW converter. If, however, we do explicit sharpening in Photoshop or some other image editor like LightZone, we omit this step or do it only very slightly.

B. **Some general sharpening** to improve an image, independent of the output method. This is also called *creative sharpening*. Usually, you will restrict this sharpening to certain areas of the image – e.g., the eye in a portrait– and preserve other areas.

C. **Output-specific sharpening.** If the output method produces additional softness, e.g., due to dithering as used for offset or inkjet printing, you would apply more sharpening to compensate for this. If your output method does no dithering, e.g., say for presentation on monitors, or when using dithering-free printing such as LightJet printing (direct photo printing) or output on a dye-sublimation printer, no additional or only slight sharpening after step B is required.

Sharpening of kind C should be done after final scaling for output, as sharpness is influenced by increasing or decreasing the size of an image. Ideally, scaling and sharpening may be left to the printing process (e.g., RIP), if this process offers such a feature.

With some printing packages or RIPs, you may leave sizing and sharpening to those packages (e.g., Qimage, ImagePrint, and Adobe Lightroom).

Uwe's personal note on sharpening:

I try to sharpen an image at the camera's resolution so that I can see as few artifacts as possible (**at 100% magnification**), but still keep the image in focus. Later on, I try to avoid too much up-sizing (see next section) and do hardly any extra print sharpening. This ensures a natural sharpness for the print. Too much sharpening always makes prints look so *digital* or *less smooth*. Even though I use my own sharpening tool, EasyS Plus Sharpening Toolkit,* there are many other valid sharpening strategies that will suit your needs.

** For EasyS Plus Sharpening Toolkit, see [32].*

We do our sharpening using a separate pixel layer. For this we reduce all visible layers down to a new layer (⇧-Ctrl-Alt-E, Mac: ⇧-⌥-⌘-E).*

For sharpening, when not using our own EasyS Plus [32], we use the Photoshop Unsharp Mask filter (USM, Filter ▸ Sharpen ▸ Unsharp Mask), setting the *Radius* to 0.8–1.0 and the *Amount* to 120–180 (see figure 4-101).

Since Photoshop CS2, we use Filter ▸ Sharpen ▸ Smart Sharpen (see figure 4-102). With this filter, in most cases, we use less sharpening in the shadow as there is more noise there and we don't want to increase it by the sharpening. Additionally, we use a layer mask with the Unsharpen Mask and Smart Sharpen filter to preserve critical areas like clouds in the sky, skin in portraits, or smooth transitions (increasing *Threshold* in the Unsharpen Mask filter will also help here.) With both of these filters, you may use a somewhat stronger sharpening and control the effect by reducing the opacity of the layer.

** With Photoshop 7 and Photoshop CS1 you have to use two steps: first create a new empty layer (⇧-Ctrl-N) and then do the flattening (⇧-Ctrl-Alt-E).*

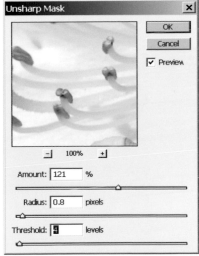

Figure 4-101: Unsharp Mask *filter in Photoshop.*

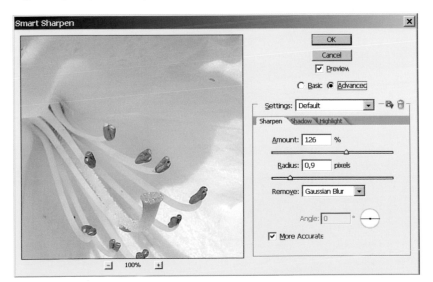

Figure 4-102:
Smart Sharpen, *available since Photoshop CS2.*

With the techniques demonstrated in this chapter, your image should be fine-tuned. Now, you are actually ready to print, and we will show you how in the next chapter.

Fine Art Printers in Practical Use

5

When everything works correctly, printing with today's fine art printers can be a pleasure. Unfortunately, many things can go wrong and spoil the fun, which implies that you need to know when to use or not use certain features of your printer and the various set-ups for proper color management. Knowing the basics gives you the freedom to experiment.

In this chapter we will give a general overview on how to do your printer setup, your print settings in your application (Photoshop and Lightroom), and in the printer driver. We will show this with an Epson printer with Mac OS X and with Windows. While the basic scheme is the same for most fine art printers, some details will change from manufacturer to manufacturer, from printer model to model, and it may even change from driver version to driver version.

We off-loaded details on the various fine art printers from Epson, Hewlett Packard, and Canon to appendix A. Updates on new printers and new experience that we encountered using existing printers and drivers will be published at Uwe's Internet site at www.outbackprint.com. Therefore, you should pay a visit to Uwe's site from time to time.

5.1 Printer Installation

The physical installation of a printer is similar, whether connecting to a Mac or PC. Unfortunately, the software is usually quite different. Typically, we install a new printer in about 15–30 minutes. With some large-format printers, the ink charging time may take longer. In most cases, printer installation is a very smooth process (HP, Canon, and Epson).

Connection Types

USB/USB 2.0: Currently, USB is the most common type of connection offered by all new printers, although there is usually no cable supplied in the box. A connecting cable can extend from about six to 20 feet. Avoid cables that are too long. Additionally, you can connect most USB printers via a USB hub that has its own power supply. Often, passive* USB hubs do not allow adequate power to reach the various devices connected to it. USB hubs may, in some cases, cause problems with certain printers e.g., HP Designjet printers, as we will discuss later. USB 2.0 ensures a better throughput, and is also the current standard for the newest printers. Sadly, the speed of most printers is not high enough to even challenge the USB 1.0 connection.

Firewire (IEEE-1394): Firewire is less common and Firewire IEEE-1394a not significantly faster than USB 2.0. Firewire, however, allows slightly longer cables than does USB.

Ethernet (LAN): Ethernet allows the longest cables, 50 feet or longer. Most large format printers like the HP Z3100, the Epson Pro 7880 or the Canon iPF6100 come with USB and Ethernet, or you may add an Ethernet network card, as is true with some Epson large-format printers. This throughput is adequate most of the time, and using Ethernet allows you to easily share printers among multiple computers. On the other hand, networking can be challenging. If you don't like dealing with a network, we suggest using one of the other kinds of connections. With large format printers and prints, it is desirable to use high-speed LAN. For this reason the 64-inch Epson Pro 11880 offers LAN speed up to 1000Base-TX.

Parallel: This classical type of PC computer-to-printer connection has been largely replaced by USB. We would not recommend using parallel with today's printers because their short/thick cables potentially cause more problems. This port is also quite slow compared to USB 2.0, Firewire, or 100Base LAN.

Unpacking

During physical set-up, follow the manufacturer's set-up instructions word-for-word. Place the printer at a location where you can handle all paper input/output easily, provide adequate space for cooling (most inkjet printers don't generate excessive heat), and allow for proper ventilation of various ink, paper and other printer chemicals that discharge during printing.

➜ *With some HP printers we encountered problems when connecting them to the PC via a USB hub.*

* *These are hubs without their own power supply.*

➜ *Do not connect a printer to your computer until you are prompted to do so by the printer's manual.*

Installing the Print Heads

Some printers (HP and Canon) have removable heads, while others (Epson) have fixed ones. Both are related to the inkjet technology used; there are pros and cons for both technologies. Overall, this aspect should not affect your choice of a printer, other than that you must take into account the cost of new heads in your cost analysis. If you need to install heads (HP and Canon), follow the manufacturer's instructions carefully.

Installing the Ink Cartridges

Follow the manufacturer's instructions carefully. Never touch the electronic contacts. If you do, clean them with a lint-free cloth and isopropyl alcohol, as the perspiration on your fingers can cause the contacts to corrode.

➜ *If you install cartridges with pigment inks, carefully shake them before installing to stir up the pigments.*

Calibration and Printer Tests

Some recent printers ask you to insert plain paper to perform an automatic head alignment or color calibration (usually, it is not really a color calibration, but a density calibration for the individual inks). Both steps may be repeated later, but it is best to do the printer set-up as early as possible. Normally, the final test sheet indicates that the printer passed all its tests.

Installing the Drivers and other Software

> **Note:** Do not connect the printer to your computer before the manufacturer's manual or the installation software prompts you to do so (usually, after a printer driver is installed).

All the printers we cover in this book are shipped with software installation programs to safely guide you through the entire driver-installation process, step-by-step. Follow the instructions carefully and take your time. Some printers come with software other than that of the driver itself. We rarely install this extra software, as we are familiar with our printing software (Photoshop, Qimage, ImagePrint, or Lightroom), and none of the software packages we recommend needs more than the printer manufacturer's drivers.

Once you have installed the drivers, it is time for a test print. This is merely a print confirming that the connection and the drivers work correctly. This does not test the print quality and colors you want. We will check that later.

Installing Printer Profiles

Many modern printers come with generic profiles for the printer. Sometimes these may require an additional installation step. In most cases, these profiles are installed with the printer drivers. Without them, you will have a difficult time getting good prints.

➜ *It may be well worth it to look for updated, improved or additional ICC profiles on the Internet site of the printer's manufacturer.*

5.2 Printer Adjustments

Though most printers are ready to go after the installation process, some require a fine-tuning for their behavior.

Head Alignment

Head alignment is crucial for optimum print results without banding. Fortunately, many new printers now use sensors inside the printer to perform this alignment automatically. Check the user manual to perform head alignment, if necessary.

Nozzle Check

→ You should use your inkjet printer regularly – once a week should be a good time frame. This will prevent the nozzles of the print heads from clogging. It may be sufficient just to switch it on and off after a few minutes.

Especially when not using your printer every day, some nozzles may become clogged. The Nozzle Check prints a test pattern to show you whether any nozzles are clogged or not. If possible, you should use your printer at least once a week.

Clean nozzles are an important issue for high quality prints. For this reason we run a nozzle check every time before we start printing when the printer was not used for some time. Professional services do this every morning!

*Figure 5-1:
Nozzle check pattern showing some clogged nozzles with the black and blue ink*

Head Cleaning

If some nozzles are clogged, you must perform one or more head-cleaning cycles. Unfortunately, this procedure uses up some ink that adds to overall ink cost.

Color Calibration

** Actually, this is a density calibration and not real color calibration but will improve color accuracy.*

Some printers perform a color calibration on the printer, e.g., HP Designjet 30/90/130. This has the advantage that a printer can more easily be used with generic profiles, as the printer is set to a defined state. Color calibration is best performed after changing heads or inks.*

With its new, large-format printers, Epson (4800, 7800, 9800) has tried to avoid this step by using the following measures:

▸ Very low production variations between printers of the same model
▸ Fixed heads
▸ Factory printer linearization

5.3 General Driver Tasks and Settings

Printer drivers seem to be simple tools, yet there are many aspects that influence image quality, not to mention comfort of the user. Here, image quality should clearly be a high priority.

Settings that Influence Print Quality

> Note: All these parameters may influence your choice of profiles. Remember that any given printer profile is only valid for a specific printer plus paper plus ink set and driver setting combination.

Paper/Media Type

Paper or media type is one of the most important settings in your driver. Be aware that most drivers only allow a choice between papers of a specific printer manufacturer. Third-party papers may be a close match or completely wrong. Expect the least problems by staying with the family of papers a manufacturer provides or suggests.

With paper type selected, you implicitly select many other parameters of the printer driver, and often there is no other way to select them directly. Only the manufacturer knows exactly how these settings work. Often, there is a lack of a reasonable description of the settings in the printer manual.

➜ *When using third-party papers, you should look for instructions for the proper printer settings (including the appropriate paper type) when using their paper. You will probably find this information on the Internet site of the paper manufacturer (see appendix D, page 292, for some of the URLs).*

- ▸ Paper thickness (distance from heads to paper)[*]
- ▸ How much ink to lay down
- ▸ Drying time
- ▸ Paper transport speed
- ▸ Possible print quality selections (dpi)

* *With some thick (heavy) third-party papers, you may have to manually adjust the head distance for the paper (be it at the printer or in the driver).*

Print Quality Settings

DPI (dots per inch): Each paper is assigned a certain dpi setting. Generally, higher values give better results, but print slower, and often use more ink. Also, in many cases, you may distinguish the difference only upon close inspection with a magnifying glass. With newer printers and drivers, quality settings do not name dpi values but use names like *Draft*, *Standard*, *Photo* and *Best Photo*. We are usually quite pleased with the settings referred to as *Best*.

> Note: Do **not** confuse these dpi settings with the ppi (pixel per inch) resolution your image should have when sent to the printer. These dpi settings are the printer's internal resolution used to set individual printer dots on the paper. This resolution has to be much higher than the ppi resolution of the image.

Color and Color Management Settings

These settings make or break good prints. We provided a full chapter on Color Management to ensure you get the best possible prints.

There are three different strategies in working with printers to create the colors you want.

1. Let the client (application) handle color management
2. Let the printer handle color management
3. Use manual or automatic color settings for a printer

** If you do not use color management, then you should, at least, leave your original image in the sRGB color space, as in most cases the driver will assume the picture is in this space.*

We never use option 3, as this eliminates proper color management and makes printing of correct colors more of an undesirable gamble.* Now, let's see, how the first two options are handled.

1. Let the Client Handle Color Management

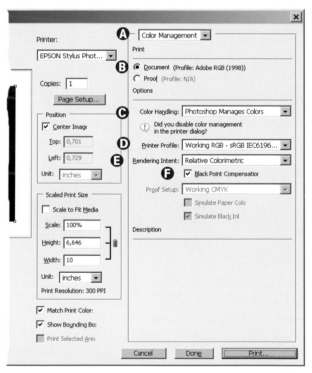

Figure 5-2: Select your Color Management strategy in Photoshop CS3

Here are the settings to be used, when you let a client application, e.g., Photoshop, handle color management: (File ▸ Print, with Photoshop CS3; for CS1 or CS2 use File ▸ Print with Preview). This means the printer should not do color changes at all. The dialog of figure 5-2 will come up. (On page 145, we will explain in some more detail how you will come to this view demonstrated in figure 5-2 if you are working with Photoshop CS1 or CS2.)

To see the relevant color management settings in the Photoshop dialog, you may have to select Color Management from menu Ⓐ. Important settings are marked in red in figure 5-2. Also make sure that *Document* Ⓑ is activated. At Ⓒ, set Color Handling to *Photoshop Manages Colors* or *Let Photoshop Determine Colors* (depending on the Photoshop version you are using). Now select the appropriate profile at Ⓓ. Use either *Perspective* or *Relative Colorimetric* from the *Rendering Intent* menu Ⓔ. For most printing profiles, *Black Point Compensation* Ⓕ should be activated.

When color management is done by an application, you must disable color management in the driver (figure 5-3). In other words, **do not** enable CMS in the application and in the driver!

This is our preferred option used most of the time. It is much easier to understand what a client application does than what the printer is doing in the background. As

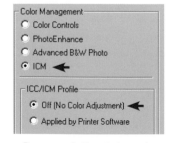

Figure 5-3: Settings to turn color handling off in the printer driver

mentioned earlier, to get the results you want, work on your profiles, and improve them.*

Good profiles are your ticket to accurate prints!

2. Let the Printer Handle Color Management

In this case, the client application does not handle profile conversions, and leaves it to the printer driver (see figure 5-4). In almost all cases, this is not a good idea, as you rarely understand what the driver is doing. Only on some printers, especially when printing in black-and-white, do we use this option, which is covered later in chapter 7 "Black-and-White Prints".

Printing Speed

Some printers are faster when printing bidirectional.* In some cases, this somewhat decreases image quality. We recommend using this setting only if you can see no difference in quality or when you need sample proofs quickly.

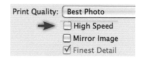

Advanced Settings (Ink Volume, Color Density, Drying Time, etc.)

Most of the time, you won't need to change any of these settings.

Yet, we have had situations where, for example, the prints on Epson Enhanced Matte paper came out too wet, which caused warping. To solve the problem, we reduced color density to -5 or -10. If you do this regularly with a paper, you might be wise to create a special profile with these settings.

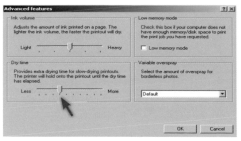

Figure 5-5: HP Photosmart 8750 advanced settings

Figure 5-6: Epson R2400 advanced settings

We will go into more details on these settings on page 145.

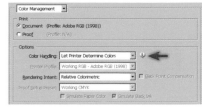

Figure 5-4: With these settings, Photoshop lets the printer driver handle color management.

With some printer drivers, this feature is named "High Speed":

More Settings

The settings listed here are not related to image quality, but more to controlling the layout, paper feed and more.

Paper Size • Quite obviously, an important setting. The drivers also allow the creation of your own custom paper sizes.

Paper Sources • Most printers have different paths to feed paper:

▸ Different trays
▸ Single-sheet feed

▸ Roll feeder, which also involves automatic or manual cutting. Check whether a built-in cutter can handle your paper's weight.

Paper orientation • Select landscape or portrait mode.

Borderless printing • We have little experience using this mode, as fine art prints nearly always have a border, (at least an inch), to allow proper space for matting.

Number of copies • Normally, you can select the number of copies in the client application's printing dialog.

Scaling • We recommend performing any scaling in the client application, e.g., Photoshop.

Print preview option • We rarely use this option. Sometimes it makes sense to check whether your prints have the expected orientation and size.

> **Warning:** We have heard users say that their prints look "wrong." Eventually, we learned that these users had never actually printed their images, but were merely viewing the Epson print preview screen. Do NOT judge the ultimate colors of prints using the Epson print-preview window. They display without color management and can be completely inaccurate, generally tending towards magenta.

Ink-Level Monitor

Checking ink levels is important, but can also be confusing. When the printer indicates some inks being low, have replacement cartridges available. Manufacturers want you to change ink as early as possible (for obvious reasons). The following has been our experience with two different printers:

Epson Stylus R2400, Pro 3800, Pro 4880 We wait until the printer stops printing before changing an ink cartridge. So far, we find that we have not lost a single print in doing this.

HP Printers We do not switch the cartridge immediately when we get a warning. It may be a good idea, however, not to wait until the cartridge is completely empty as with some HP printers these cartridges contain three different colors of ink, and you may be low on only one. Waiting too long may cause pages to print with decreasing quality.

Canon Printers With Canon printers, you should change your ink cartridge as soon as you get an ink low-level warning (according to our experience).

Figure 5-7: R2400 ink level monitor

5.4 Summarizing the Relevant Steps for the Actual Printing

As there are quite a few steps in the final print set-up, let's summarize these steps before going into more details. Here we assume that you have set up your printer correctly,[*] and your image is tuned, scaled, sharpened, and ready for printing. We also assume that you have checked that you have enough ink for the print and your nozzles are not clogged. Then, there are three main areas you have to deal with:

** This includes installing all hardware components, including inks, your basic software and profiles, and that you have inserted you paper correctly.*

A. Page Setup
 You may have to do this twice: in your application as well as in your printer driver.

B. Print Setup in the application dialog

C. Setup in the printer driver dialog

Here are the individual steps for this:

A. Call up your Print dialog and do your Page Setup:

 A.1 Select the printer you intend to use (if it's not your default printer).

 A.2 Select the Paper Source, Orientation, and Paper Size.

B. Back in Photoshop (or whatever application you are using), set the way the image should be scaled and positioned on the paper/media.

 B.1 Set the correct color handling (usually letting the application manage colors).

 B.2 Select the appropriate ICC profile (if the application is managing the color mapping), Rendering Intent (usually either *Relative Colorimetric* or *Perceptive*), and Black Point Compensation (in most cases this should be activated).

➜ In Photoshop, to see all the settings described here, you have to select "Color Management" in the top drop-down menu (see figure 5-12 Ⓐ on page 145).

 B.3 Click Print to enter the actual printer driver dialog.

C. In the printer driver dialog, check that the Page Setup, orientation and similar settings match those done in the Page Setup part of the application Print dialog! Further settings you should do, or at least verify, are:[**]

*** Check these parameters even when you recall a previously saved preset!*

 C.1 Select the correct paper/media type – and, if available, the proper paper source (Sheet or Roll) and/or paper feed.

 C.2 Select the proper Print Quality or DPI Settings. This may include the Ink Configuration.

 C.3 Where necessary, select the *Advanced* dialog mode.

 C.4 Check your Print Options (e.g., disable High Speed or Bidirectional Printing).

C.5 Set the appropriate Color Management. If the application does the color management (as recommended), disable color management in the print driver.

D. Finally, click *Print* to start the actual printing.

Saving settings as presets is extremely useful, both in the application (if provided) as well as in the printer driver or Print/Export plug-in. Nevertheless, you should check all the settings even when recalling presets for your print. We found that when you use a preset and change a single parameter, this may change other settings as well!

These steps might look a bit different, depending on your operating system and the application you print from. It may also differ a bit depending on whether you print going via the standard application print dialog followed by the printer driver dialog or whether you use one of the new Photoshop plug-ins.* But in all cases the basic parameters you will have to set are very much the same.

* We will describe an example in section 5.9.

There is some overlapping of the parameters to be set in these steps, e.g., you may have to set your paper size twice – once in the application dialog and again in the printer driver. If you are lucky, the setting done in the application will be passed on (and thus be synchronized) to the driver. But don't count on that. Make sure that both settings match. With some printers, the printer will refuse to print if these parameters don't match! There might even be a third setting done at the front panel of the printer.

There are also some printing applications, like Tecco:Print by Tecco or some provided by Epson or Canon, which try to facilitate printing. For fine art printing, however, we recommend that you refrain from their usage. They oversimplify printing and hide some of those settings, that might be important for an optimal quality print. For a beginner they might be helpful, but for an advanced user, they are not.

Instead, do your setup carefully, and save them as presets. The next time you print under the same printing conditions, recall the appropriate preset. Delete those presets that are flawed in order to have a short and clear list. Use descriptive names, though they have to be brief, as with long names important parts may be hidden in the menu lists.

Refrain from manually renaming ICC profiles, as these profiles have an internal as well as an external file name. Photoshop and similar applications will show the internal name. Renaming the file using Explorer or the Mac Finder will not update the internal name but only produce inconsistencies. With Windows XP, you can use *Color Control Panel* instead (described on page 78 and downloadable from [73]) for renaming.* *ColorThink Pro* by Cromix [66] is another useful utility for this purpose and does a fine job here. It is able to inspect ICC profiles, plot their gamut in 2D or 3D, and Color Think Pro can correct a number of profile inconsistencies like a mismatch of the internal and external profile name.

* This Color Control Panel will not run with Windows Vista!

5.5 Printing from Client Software (Windows)

Quality printing requires applications that are color managed such as Photoshop, ImagePrint, Adobe Photoshop Lightroom, Qimage, and many others. We describe printing only from those applications that are mature products and come with good documentation. If you do not own any of these programs, we recommend keeping all your documents in an sRGB working space. With some trial and error and a little luck, you are likely to get some decent prints.

Having discussed the basics of the actual printing in a more general form, we now show the workflow for this. After calling up the Print dialog, this workflow consists of three phases:

1. Select your target printer and set up the media source and media size and the placement of your image (or images) on the media.

2. Set the appropriate parameters for the handling of color in your printing application.

3. Set the relevant parameters in the printer driver.

Here we will show the first two steps when printing from Photoshop under Windows. As the printing dialog slightly changed from Photoshop CS2 to CS3, we will show both versions.

Page and Printer Setup

With most applications, and this also applies to Photoshop and Lightroom, your first step should be the Page and Printer Setup. Use File ▸ Page Setup for this. The dialog demonstrated in figure 5-8 will appear.

If your target printer is not your system's default printer, your first step is to select your target fine art printer. For this click on *Printer* and select the appropriate printer from the *Name* menu (figure 5-9).

Figure 5-9: In Page Setup, click Properties to display more printer driver settings.

Now click *OK* to go back to your Page Setup dialog, where you select your media Source, your media Size and whether you want to use Portrait or Landscape printing. Photoshop will associate these settings with your image and recall them the next time you call up the Print dialog for this image (which might or might not be appropriate).

Figure 5-8: Page Setup. The Printer button may not be available in Windows Vista or with newer printer drivers or with Photoshop CS3.

Printing from Photoshop CS1 or CS2

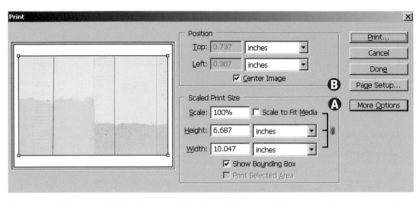

*Figure 5-10: Photoshop CS2 basic print dialog. You will have to click on **More Options** to see the full dialog, demonstrated in figure 5-11.*

To initiate the Print dialog use Print with preview. Initially, Photoshop shows the dialog of figure 5-10. This dialog does not offer color management settings. Therefore, you should activate the advanced dialog by clicking *More Options* at Ⓐ to see the full option list displayed in figure 5-11. Additionally, you may have to select *Color Management* from menu Ⓐ to see those options that are relevant for a good print. Finally, you should see the dialog demonstrated in figure 5-11.

Before changing any other settings, make sure you have the correct Page and Printer setup (see figure 5-8). (You can verify it by clicking on the *Page Setup* button Ⓑ, in figure 5-10.) Now place your print on your page by setting appropriate values for the Scale (or Height and Width) and the Top and Left margins. You can change the size of the image. Normally, we do this in Photoshop before entering the printing dialog, because all this option does here is to change the ppi of the document to match the new print size. This is fine for minor resizing, but in other situations you are better advised to use the more advanced scaling techniques in Photoshop, or perhaps a dedicated Photoshop plug-in.

The next step concerns color management, located in the Color Management (or Options) block of the dialog box (figure 5-11). As these items are the same for Photoshop CS3, we will explain them on page 145

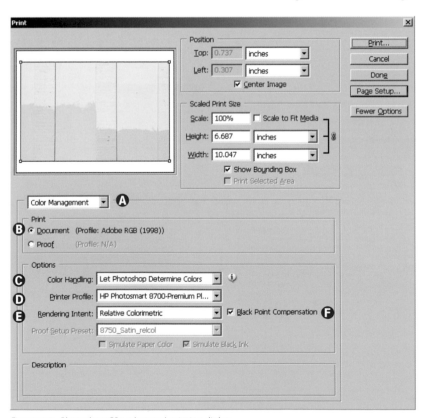

Figure 5-11: Photoshop CS2 advanced-printing dialog

Print Dialog with Photoshop CS3

Since Photoshop CS3 there is no longer a Print with Preview option. Instead, you use File ▸ Print (or just ⌈Ctrl⌉-⌈P⌉). The dialog of figure 5-12 will appear. Again, it's reasonable to check the appropriate settings for the Printer and Page Setup. The dialog here offers additional items, allowing you to directly select your printer from menu Ⓖ and also to switch between Landscape and Portrait mode Ⓗ. Place your print on the page as described with Photoshop CS2 (previous page).

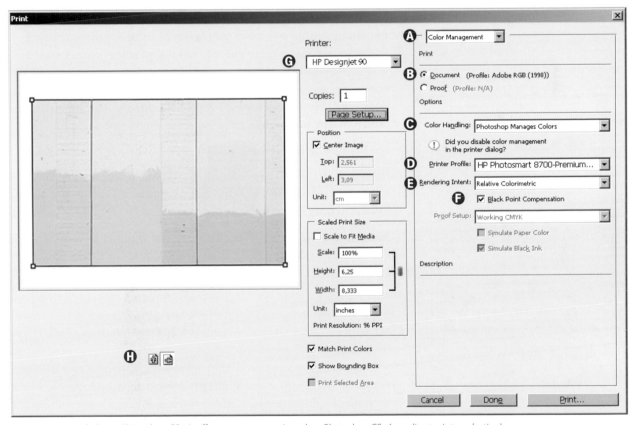

Figure 5-12: Print dialog in Photoshop CS3. It offers some more options than Photoshop CS2 (e.g., direct printer selection).

Now let's go into a bit more detail on the Color Management settings:

Ⓐ Make sure *Color Management* is selected in menu Ⓐ.

Ⓑ We select the **Document Option,** which shows our document's work-ing space; here it is Adobe RGB (1998). *Proof* should only be used when you intend to do a Proof for another device or print method (e.g., CMYK press printing) on your inkjet printer.

Ⓒ Color Handling allows a selection from four options (see figure 5-13): Normally, we would use *Photoshop Manages Colors.* (With CS2 this reads: *Let Photoshop Determine Colors*). This way, Photoshop controls

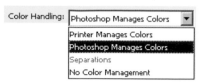

*Figure 5-13: Color Handling options in
Photoshop's Print dialog*

** In section 7.5 we describe how you may
produce a black-and-white ICC profile.*

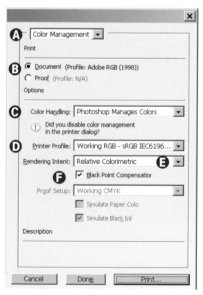

*Figure 5-14: Color Management settings in
CS3 (repetition)*

the mapping of color values from those images to those of the printer.
There are situations where we may use different settings:

– Black-and-white printing. If we have no special black-and-white
profile, we let the driver do the color mapping.

 If, however, we have a black-and-white profile, we again use this
profile and use *Photoshop Manages Colors.**

– Printing of color targets to create printer profiles. Here we need to
set Color Handling to *No Color Management*.

For fine art prints we never use *Separations* or *No Color Management*.

Ⓓ In **Printer Profile** you select the correct or most appropriate profile. It
has to match the printer, plus the media, plus the ink set used and,
finally, also the driver settings used (this refers to your *Quality* or *DPI*
settings in the printer driver). As stated previously, good profiles pro-
duce good prints. Currently, many printers come with adequate generic
profiles to get you started.

Ⓔ For **Rendering Intent** there are two choices when printing photos:

Perceptual: This is appropriate when your image has a lot of colors "out
of gamut" (see section 3.4, page 62). This may be the case when printing
a colorful image on matte paper.

Relative Colorimetric: Use this intent when colors in your image fit
into the gamut of the printer color space. Check for this in Photoshop
by activating gamut warning (⇧ - Ctrl - Y , Mac: ⇧ - ⌘ - Y).

No best rendering intent is suitable for all images. You need to experi-
ment to learn which one fits your personal style or even a specific image.
We prefer to print with the relative colorimetric rendering intent most
of the time.

 There are also some profiling packages (e.g., *basICColor* by Color
Solutions [65]), which use **Saturation** for a modified version of the
Perceptual rendering intent, which will result in less color shifting and
more saturated colors than regular Perceptual.

Ⓕ Check the box **Black Point Compensation**. This feature by Adobe com-
pensates for a different level of black between the working color space
and the printer color space.

 Activating *Black Point Compensation* may not yield the best result
with all RGB profiles. There seem to be a few profiles (actually profil-
ing packages), where leaving this option deactivated will result in bet-
ter prints. If the provider of your profile (e.g., a paper manufacturer)
says you should deactivate the option, follow that advice.

Finally, click on *Print* to open the driver settings, which we will describe in
the following sections.

5.6 Print Driver Dialog in Windows

In section 5.7 we will describe the printer driver dialog in Mac OS X. Though the basics are very much the same, the dialogs and tabs look different in Windows. We use the Epson R2400 printer as an example in both cases. This example is also valid for the whole line using the K3 ink set: Epson Stylus Photo R2400, Epson Stylus Pro 3800 / 4800 / 7800 and Pro 9800. Also the newer generation of the Pro lines (4880 / 7880 / 9880) will show almost identical dialogs.

The Inks

This series of Epson printers feature the same ink type (Ultra-Chrome™ K3, 9 inks).

> Photo Black, Matte Black, Light Black, Light Light Black
> Cyan, Light Cyan, Magenta, Light Magenta, Yellow

These printers actually simultaneously use (and have online) only eight inks out of the nine.* Photo Black and Matte Black are used for glossy and matte papers, respectively. Unfortunately, it is required to switch the Matte Black ink for Photo Black ink when switching from matte to glossy media and vice versa. This procedure costs time and ink, and on the Pro printer line, it is a substantial amount of ink – about $75 worth is used up for every change of black inks. These printers do not use a Gloss Optimizer, because the new ink formulas do not require it.

All nine printers have three different dilutions of black, Photo or Matte Black, Light Black and Light Light Black, allowing them to produce very good black-and-white prints with a highly neutral look and smooth gradients. We cover this in more detail in chapter 7 on black-and-white printing.

Figure 5-15: Epson Stylus Photo R2400 (Courtesy of Epson America Inc.)

* *An exception is the Pro 3800, which allows all nine inks to be installed simultaneously but which still has to switch the Photo Black and Matte Black ink when changing media and rinse out the corresponding ink channel (nozzles).*

Driver settings recommendations

As stated earlier, what is covered here is not a replacement for the printer manual. And as before, we assume you do all color management in your printing application, e.g., Photoshop. We show only the settings of the R2400, as the same principles apply to the other more professional printers (Pro 4880 through the Pro 9880).

Paper source selection Most users will print single sheets with this printer directly from the paper tray, but the R2400 also comes with a roll-feeder option out of the box.

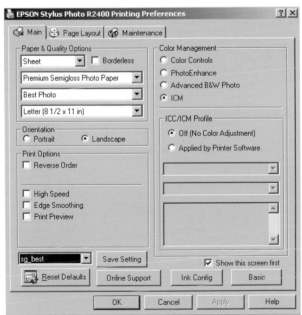

Figure 5-16: Driver settings recommended for fine art printing using the Epson R2400. (Your current version might look a bit different.)

Figure 5-17: Selecting the right media is essential, as it determines a lot of printing parameters like ink density, drying time, and even head distance to the paper.

Figure 5-18: Menu for media size selection

Figure 5-19: Save your settings in a preset.

Paper Type The list offered here is dependent on which black ink is used in the printer (Photo Black or Matte Black). You should try to find an exact match here. Using a third-party paper, you'll have to estimate which Epson paper is closest to the characteristics of your specific paper. You may have to do some experimenting, using different paper type settings. With some luck, you may find advice on paper type settings at the Internet site of the paper manufacturer of your paper (See appendix D, page 292, for the URLs of some of the well-known paper manufacturers.) This setting will influence quite a number of internal parameter for printing, e.g., the amount of ink laid down, drying time (and thus print speed) and also determine what kind of quality or print resolution settings the driver dialog will offer (see next point).

While up to now most printers do not allow the addition of a new media type – actually, it is a kind of *media profile* –, HP offers this possibility with its B9180 and Z3100 printer line. We describe that in section A.4 on page 251. HP also provides a technical paper on how to do it.

Print Quality The available quality settings depend on the media type selected. The highest-quality setting usually produces the best results at the expense of speed and ink usage. A lower-quality setting may produce a result close to maximum quality, e. g., *Best Photo* instead of *Photo RPM*.

Paper/Media Size Most of the time you will find an appropriate paper size listed here. In rare cases, you may need to create a custom size by selecting *User Defined*. Simply select and follow the instructions.

Orientation Choose either Landscape or Portrait mode.

Print Options

▸ High Speed: Off, for best quality

▸ Edge Smoothing: Off, for fine art photos

▸ Print Preview: We usually turn it off. Be aware that colors may appear untrue. This preview is not color managed.

Save your settings

You will probably use only a few different papers with few variations. Therefore, having found the right settings for a certain type of print job and paper, save the settings and recall them later. It is much faster, and there is no danger you will forget to set all parameters correctly for this particular type of job. To save your current settings, click *Save Setting* (see figure 5-16, lower left side), but with Windows, you have to use terse names (31 characters, maximum).

Color Management in the Printer Driver

For the R2400, we turn printer *Color Management* off (unless printing black-and-white images) and do profile selection and color control inside Photoshop. The dialog for the printer driver setting shows exactly how.

For black-and-white printing we would use the *Advanced B&W Photo* mode, which we describe in our "Black-and-White Prints" chapter 7. If we have a black-and-white ICC profile, we use this profile and will select *Photoshop Manages Colors* in the Photoshop dialog Print with Preview and nevertheless deactivate color adjustment in the printer driver and activate *Advanced B&W Photo* mode in the driver's Color Management settings.

Figure 5-20: Disable CMS in the driver if it is activated in the application.

Ink monitor and maintenance tools

When using Epson printers, continue printing until the printer prompts you to replace an ink cartridge. When you get the Ink Low message, ensure you have a replacement ink cartridge available, as the printer will soon be out of ink and stop printing.

The dialogs for the ink level monitor and the maintenance tools are almost identical to those of the Epson R1800. See page 230 for the description of those dialogs.

Status Monitor: Shows the ink-level dialog

Nozzle Check and Cleaning: Select this when you have not used the printer for some days. Check for banding or missing colors. Be aware that this procedure consumes ink.

Nozzle Check (manual) / Head Cleaning (manual): Use these only when you feel there is a major problem. Again, this will consume quite a bit of ink.

Print Head Alignment: Check this if you see banding.

Printer and Option Information: This is the dialog (see figure 5-22) used to indicate which black is currently loaded. Be sure it shows the black that actually is loaded into the printer, because the driver depends on this information to work properly.

Figure 5-21: Always check your ink levels before starting a new print job.

Profiles provided by Epson for the R2400

Epson provides good generic profiles, but only for their own papers. You may further improve color fidelity by using custom-made profiles. Most profiles come specifically targeted to certain print quality settings. (When you create your own custom-made profiles, you should do the same and include an indication of the settings in your printer profile name.) Check that your choice of profile (in the client

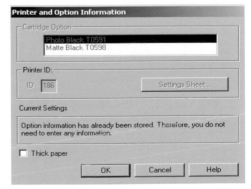

Figure 5-22: This dialog indicates what version of the black ink currently is installed.

SPR2400 Archival Matte.icm
SPR2400 D-S Matte Paper.icm
SPR2400 D-S Matte Paper_PK.icm
SPR2400 Enhanced Matte.icm
SPR2400 Enhanced Matte_PK.icm
SPR2400 Matte Paper - HW.icm
SPR2400 Matte Paper - HW_PK.icm
SPR2400 Photo Qlty IJP.icm
SPR2400 Photo Qlty IJP_PK.icm
SPR2400 PremGlsy BstPhoto.icc
SPR2400 PremGlsy Photo.icc
SPR2400 PremGlsy PhotoRPM.icc
SPR2400 PremiumGlossy.icm
SPR2400 PremiumLuster.icm
SPR2400 PremiumSemigloss.icm
SPR2400 PremLuster BstPhoto.icc
SPR2400 PremLuster Photo.icc
SPR2400 PremLuster PhotoRPM.icc
SPR2400 PremSmgls BstPhoto.icc
SPR2400 PremSmgls Photo.icc
SPR2400 PremSmgls PhotoRPM.icc
SPR2400 ProofingSemimatte.icm
SPR2400 UsmoothFineArt.icm
SPR2400 UsmoothFineArt_PK.icm
SPR2400 Velvet Fine Art.icm
SPR2400 Velvet Fine Art_PK.icm
SPR2400 WC Paper - RW.icm
SPR2400 WC Paper - RW_PK.icm

Figure 5-23: Profiles provided by Epson for the R2400. Some of these you may have to download from Epson's Web page.

application, e.g., Photoshop) matches the print quality settings done in the print driver dialog (*Photo, Best Photo, Photo RPM*).

Some help for paper feeding

With the R2400, we have encountered some problems when feeding sheet paper. If this happens, it may be helpful to apply slight pressure with a finger at the top of the sheet.

Handling with Other Fine Art Printers

The scheme we showed here is a typical one. The driver dialogs will slightly change from one printer manufacturer to another, from one printer model to another and may even change with new releases of the operating system or new updated versions of the printer driver. A setting you find with tab *A* for one printer might be located in tab *B* with a different printer. So, take your time to find your way around to determine where the settings for media type selection, print quality selection, and color management settings for the driver are located. The basics, however, as summarized in section 5.4, will remain the same for all printers.

You will find the description of more fine art printers from Canon, Epson and Hewlett Packard in appendix A.

When intending to print in black-and-white, there are actually three options (as mentioned before):

A. Print it the same way you do a color print as described in this chapter. This will require a good, gray-neutral color profile. It allows you to tone or tint your image in Photoshop, Lightroom, or whatever image editor you are using. It even allows you to do a split toning.

B. Use the special black-and-white mode that your printer driver offers. This method will be explained in chapter 7. It will allow for a very neutral black-and-white print. With this method, toning can be done in the dialog for the black-and-white mode of the driver.

C. Print using a RIP (*Raster Image Processor*) that offers special features for high-quality black-and-white prints. We will describe this method in section 6.3.

5.7 Printer Driver Settings in Mac OS X

There are many variations of a Windows-version printer driver interface; the look of the interface depends on the printer manufacturer. Even the driver dialog boxes of the same manufacturer show many variations when handling different printers from the same manufacturer – or even different from one version of the driver to the next. While we will use Windows-based examples later in this chapter, we would also like to show the driver setting scheme for Mac OS X. Apple has designed a very clean and consistent framework for various driver dialogs. The basic Mac OS X driver dialog hierarchy looks like this:

A disadvantage of the Mac OS X solution is that important settings are often spread across different dialogs.

Printer Choose the printer you wish to print on.

Presets If you have saved some printer settings previously, you will find those names in the drop-down menu. Load a set by selecting its menu item. Otherwise, use *Standard,* and make individual settings in the various dialog boxes selected from the drop-down-menu:

This is a menu where you find most of the various settings' dialog boxes for the printer. There is a standard scheme, and menu items are there for nearly all printers (e.g., *Copies & Pages, Layout, Scheduler, ColorSync,* and *Summary*). Some menu items are printer and manufacturer specific: e.g., *Print Settings, Extension Settings* and *Paper Configuration*. With some printers you will find even more entries in this menu, while with other printers some of the entries might be missing (e.g., *Extension Settings*). So, the first time you enter this domain for a new printer, take your time to find your way around. This may be a bit confusing when you do this with a new fine art printer.

Here is a short explanation of the various menus and settings:

Layout • Lets you specify the number of images you wish to place on one sheet (see figure 5-25). For fine art printing this is not useful, as placement is arbitrary. If you want to do an index print or place several images on one sheet, you can use Photoshop or other applications to do this. This dialog box changes slightly when a different printer is used.

Schedule • You may specify (see figure 5-26) when the print job should begin. With fine art printing, you usually want it to start right away, which may be the default in the print queue.

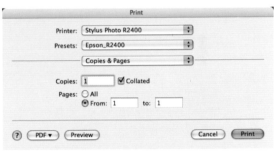

Figure 5-24: Basic print dialog in Mac OS X.

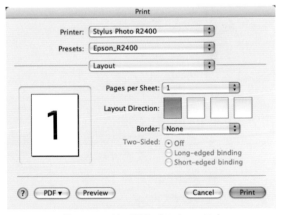

Figure 5-25: Mac OS X printer Layout tab

Figure 5-26: Mac OS X printer Scheduler tab.

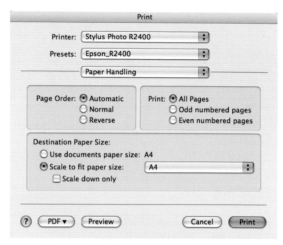

Figure 5-27: Mac OS X printer Paper Handling tab

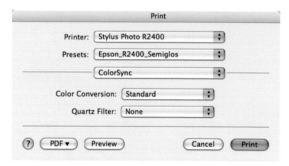

Figure 5-28: Mac OS X ColorSync tab

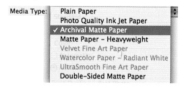

Figure 5-29: With 'Print Settings,' you do most of the settings for your print.

Paper Handling • You may scale your print here, which is fine when slight scaling is required. For fine art printing, scaling should be done either when preparing the image for print (see chapter 4) in Photoshop, or should be left to the RIP when using one. If you print a portfolio with a multi-page document, and want to print duplex without having a printer equipped with duplex capability, you may use the strategy of first printing all *Odd numbered pages*, re-inserting the paper stack and then printing *Even numbered pages,* while activating *Reverse.*

ColorSync • Here, you select how the Mac OS X color-management system is involved. You may do some image preprocessing using Quartz filters, which we do not recommend, when printing directly from Photoshop.

ColorSync settings are useful when printing from an application that is not color managed. In this case, ColorSync may take over and provide color management, e.g., mapping image color from the image color space to the printer color space. However, you can't select the printer profile from this printer driver dialog, but must do that set-up using the ColorSync Utility (found in Applications ▸ Utilities ▸ ColorSync Utility). See Mac OS X help for more information.

Cover Page • This option allows you to print a cover page. In fine art printing, this may be undesirable, considering the cost of fine art paper and expensive ink.

Printer Settings

These are the most important settings in fine art printing. This dialog box is printer- and manufacturer-specific, resembling Windows printer driver dialogs. Figure 5-29 shows an example of the dialog for the Epson R2400 printer:

▸ **Page Setup** With the R2400, you are given a choice between *Standard* (Sheet Feeder) and *Paper Roll.*

▸ **Media Type** Select your media (paper) here. The R2400 printer driver only offers those media working together with the type of black ink cartridge in place, either *Photo Black* or *Matte Black* (the latter was inserted as the screen shot was taken). All unsuitable media are greyed out and therefore not accessible.

As with most printer drivers, the driver interface only offers Epson media. If you use a third-party paper, you must estimate which Epson paper is the closest equivalent.

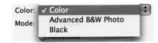

▸ **Color** For the R2400 (and this line of Epson printers), you may either print in *Color*, *Advanced B&W Photo*, which we select for black-and-white printing (see chapter 7) or *Black* only, which is useless for our purposes.

▸ **Mode** For fine art printing, select *Advanced*, so that the dialog will show the advanced settings for the printer as shown in figure 5-29.

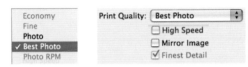

▸ **Print Quality** The drop-down list will offer different printing qualities, depending on the media type selected (e. g., for plain paper, only *Economy* and *Fine* are possibly enabled). For fine art prints using the Epson R2400, we recommend *Best Photo*. Below that, we disable *High Speed* and activate *Finest Detail*.

Color Management You may define how color management is done and by which application. If printing directly from Photoshop, turn color management off as shown in figure 5-30. If you print from a non-color-managed application, you should activate *ColorSync* and do your printer-specific set-up in ColorSync (Applications/Utilities/ColorSync Utility).

Extension Settings This is printer specific and only available for some printers. For example, with the Epson R2400, you may specify that you are using *Thick paper*.

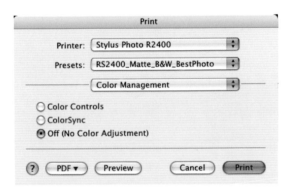

Figure 5-30: Color management tab

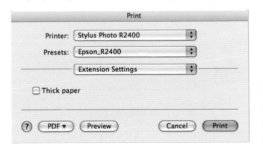

Figure 5-31: Extensions Settings with the Epson R2400 driver

We only activate Thick paper if the paper is rated at more than 200 g/m².

Paper configuration This item is only available with some printers (such as the Epson R2400). You may reduce Color Density – actually ink density – (see figure 5-32), which may prevent paper warping when printing on thinner paper.

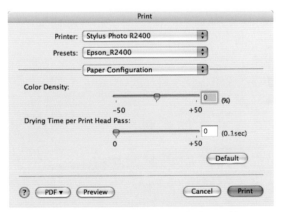

Figure 5-32: Paper Configuration tab with the R2400 driver

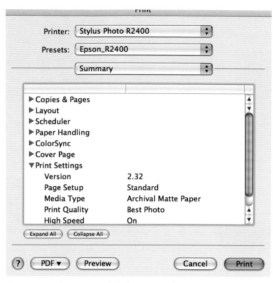

Figure 5-33: *Summary of all the printer driver settings*

Summary This can be very convenient, as all settings are summarized here and the individual details may be shown or hidden by clicking on the small ▶ icon (see figure 5-33).

Save Settings

After having tested various settings and discovered the proper settings for a printer and a specific type of print job, you should save those settings so you may recall them at a later time. To save your settings, go to the menu item *Save As* under the drop-down menu for Presets. Give a descriptive setting name that states the type of paper and other important parameters. This name will then show up in the drop-down menu for Presets.

Figure 5-34:
*Save your driver settings
using a descriptive name.*

Printer-Maintenance Utilities

You will find printer maintenance utilities for inkjet printers in the dock: *Printer Setup Utility* 🖨 (see figure 5-35).

Figure 5-35: *You should be able to find the Mac OS X "Printer Setup Utility"
inside your dock. It shows a list of all printers installed.*

Select your printer there (we did it for our Epson Stylus Photo R2400), and click on *Utility* (🛠). This utility, used with the Epson inkjet printers, will bring up the Epson maintenance utilities as shown in figure 5-36:

Figure 5-36:
*From the "Printer Setup Utility" you may
call up the "Epson Printer Utility", which
offers major maintenance functions.*

Here, you find those maintenance functions already described in section 5.2.

Starting from the "Printer List" (actually, it is the *Printer Setup Utility*; see figure 5-35), you may also call up the Mac *ColorSync Utility*. (Click ✖.) When Color Sync Utility appears, select tab 🔲 *Devices* (figure 5-37). There, you may assign profiles to a device (here, a specific printer). This is useful if you print from a non-color-managed application, and ColorSync must do the color mapping. However, we do not use this feature, as we control color management in our application print dialog or (when printing black-and-white) in the printer driver, and do not use this feature of ColorSync for fine art prints.

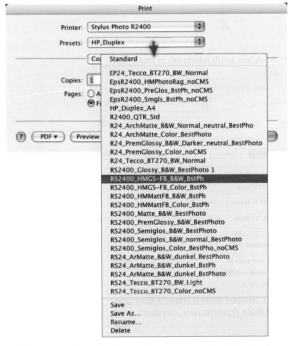

Figure 5-37:
You should assign the appropriate profiles to your devices using the "ColorSync Utility". This helps when printing from a non-color-managed application.

As said before, some of the printer driver dialogs described here are very printer-specific, while others – e.g., *Copies & Pages*, *Scheduler*, *ColorSync*, *Cover Page,* and *Summary* are the same for all printers. Also the dialogs for *Paper Handling* and *Paper Configuration* are of a general nature, and only differ in some paper options.

The problem with this potentially large number of tabs and dialogs is that you easily forget to set an important parameter, and some settings in one dialog box can influence settings in another one, without you noticing this. Therefore, saving driver settings (as described on page 154) for a specific combination of a printer plus the type of media and some more settings (e.g., *Print Quality*) is really essential. Later on, when printing under the same conditions, you can simply recall the major settings from the *Preset* list (see figure 5-38).

Figure 5-38: From the Presets list you can recall settings that you saved previously.

5.8 Printing from Adobe Photoshop Lightroom

Let's have a look at a different application – this time it's Lightroom. We will see that most of the settings we did in Photoshop we will meet again in this application.

In Lightroom, printing is done using the Print module. It allows you to do an even finer page layout, adding more information like a caption and similar metadata to the print. For most fine art prints you will probably refrain from this. Here, we will not go into all the page layout details of Lightroom but only have an eye on the points concerning color management. A really nice feature of Lightroom is the possibility to save the setup for a print to a Lightroom preset and to select a preset – either previously saved by you or provided by the Lightroom installation – when printing. This preset can only cover page size, page orientation and page layout, but also settings like sharpening, print resolution, ICC profile and Rendering Intent. Nevertheless, the basic scheme is very much the same as with Photoshop:

1. Select a suitable preset and adapt its settings to your current image (concerning cell size, boarders and information that should be included in the print). Here, the presets are called Templates and can be found in the Template Browser pane (see figure 5-40 Ⓐ).

2. Do your Page Setup (figure 5-40 Ⓑ), which covers the paper size, print orientation (Landscape or Portrait) and, optionally, the scaling. All these settings may already be included in your Lightroom print preset (here called *Template*).

3. The color management oriented settings are found in the *Print Job* pane of Lightroom (see figure 5-40 Ⓒ and figure 5-39). So let's have a closer look at this pane, herewith ignoring *Draft Mode Printing*.

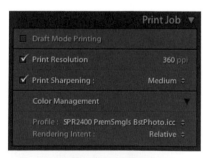

Figure 5-39: Here you set some important parameters for your print.

* *Print resolution (ppi = pixels per inch) here is the number of image pixels set per printed inch, while the dpi of the printer (set via the print quality setting in the printer driver) is the number of ink droplets laid down on paper to reproduce image pixels – several droplets per pixel.*

Print Resolution • For most inkjet printers, the optimal *print resolution* will be from 300 to 360 ppi (also called *printer's native resolution*). Don't confuse this with the printer's printing resolution which is usually much higher – 1200 to 5600 dpi for modern inkjet printers.* For Canon and HP printers, the best native resolution setting here should be 300 dpi, while for Epson Printers you should use 360 dpi.

With high-quality fine art inkjet printers, you might get an even better print if you use a *Print Resolution* setting of 600 ppi for HP and Canon printers and 720 ppi for Epson fine art printers. Lightroom, however, does not support this. Lightroom's maximum setting for *Print Resolution* is 480 ppi, which, to our experience, is good enough. Lightroom will automatically up- or down-sample your image to this resolution when sending the image data to the printer.

Use *Draft Mode Printing* only if you produce contact sheet prints or just want to do a fast draft. Lightroom will use the preview image (if

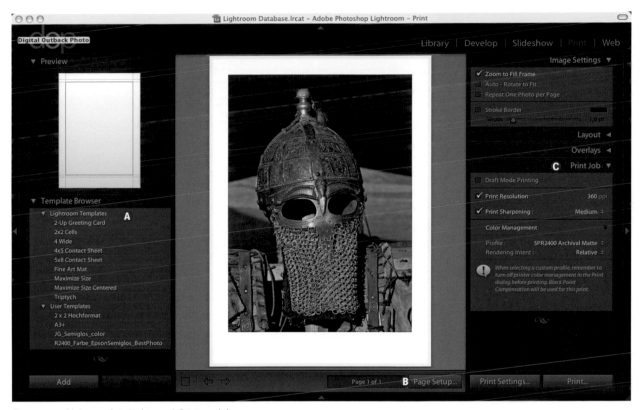

Figure 5-40: Main panels in Lightroom's Print module.

available) instead of down-sampling the actual image. This may speed up the printing, but it does not produce optimal image quality. If you use draft mode, color management settings are not available.

If you plan to produce a fine art print, your settings for color management are relevant: select an ICC color profile and a rendering intent. They depend on whether you intend to print color or black and white.* We elaborate on black-and-white prints in chapter 7. There, we also cover more settings for specific printer drivers.

* *Provided the printer has a special mode for black-and-white printing.*

Print Sharpening • If you did not yet perform an output-specific sharpening, you can let Lightroom do some print-sharpening. Lightroom offers only three settings: *Low, Medium,* and *High* (see figure 5-41). The right degree of sharpening depends on the extent to which you have already sharpened in Lightroom's Develop mode. It also depends on your image. In most cases, using *Low* is just fine. With sharpening, photographers have a saying: *Sharp, sharper, busted.* So don't overdo it. But without extensive experience, it is quite hard to properly judge the right sharpening for printing from your on-screen preview (and Lightroom does not simulate its additional print sharpening in its preview). So, some iterations may be necessary until you find your best settings. Having found them, save them in print template.

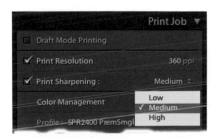

Figure 5-41: Here, you can set your print-specific sharpening.

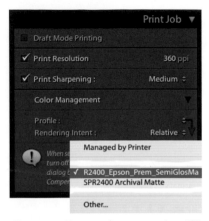

Figure 5-42: Here, you choose your printer ICC profile.

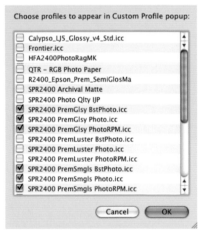

Figure 5-43: Place a checkmark next to all profiles that you want to be listed in the profile menu of Lightroom.

Color Management • When doing color prints, we let the application (here, it's Lightroom) do the color management (as we did with Photoshop). We have two parameters for this: *Profile* and *Rendering Intent*. The Photoshop option *Black Point Compensation* is missing here. We assume, that black point compensation is done in any case.

When you try to select an ICC profile for the first time in Lightroom, the application will offer only a few, though you might have quite a few more installed on your system. So, you first have to select which profiles show up in the *Profile menu*. To do so, select *Other* (see figure 5-42). Lightroom will bring up a dialog containing a list of printer profiles (figure 5-43). Check profiles that you want to be listed in the Lightroom profile menu and click OK. Now select the profile from the menu that you intend to use for the print. The profile name should (hopefully) include the printer type it was designed for, the paper it is intended for, and the quality settings used in the printer driver. (Naming is up to the one who did the profiling. Though you can rename the profile file, we do not recommend it because it may cause inconsistencies.)

Out of the four rendering intents named in section 3.4, Lightroom offers only *Relative Colorimetric* and *Perceptual* – just the two suited for digital photos. In most cases, we use *Relative*, which stands for *Relative Colorimetric*. With this setting, all image colors that can be reproduced 1:1 are reproduced 1:1, while all colors that lie outside the printer's color space are mapped to the closest color in the printer's space. This will result in less color shifts than by using *Perceptual* for Rendering Intent. If, however, your image has a lot of highly saturated reds and blues, using *Perceptual* may provide better results. With *Perceptual*, if the color space of your photograph is wider than the color space of the printer (which quite often is the case), all colors are compressed to fit into the destination space. This will result in less color clipping of out-of-gamut colors. Thus, images with highly saturated colors will retain more of the original image impression. With *Perceptual*, the result is more dependent on the quality of the ICC profile than it is with Rendering Intent set to *Relative*.

Note: Some profiles are designed for a specific rendering intent. When you use them, you should use that specific intent. So, for instance, the profiles provided by Bill Atkinson and some of HP's printer profiles are designed to be used with a *Perceptual* intent. Some others (e.g., produced by basICColor) will offer the best mapping of saturated colors using a *Saturation* intent; Lightroom, however, does not offer this. With those profiles, you may have to use Photoshop or some other print application or use *Perceptual* and achieve a somewhat less saturated print.

Finally, you click the Print button. This will bring up the Print dialog of your operating system, the same way it will be with Photoshop.

5.9 Printing Using a Printer Plug-in

As can be seen from our previous descriptions, you actually have (at least) three instances to deal with when printing: the Print dialog of your application, the general print dialog of your operating system and the printer specific parts of the printer driver. There is also some overlapping of the tasks performed by the operating system and those performed by the printer driver. Some of the parameters – e.g., print size – can be set in either the application or operating system interface, or in the printer driver dialog.* Examples of this are Photoshop's Print dialog, the print Size dialog, and the driver dialog. For the user it's not always clear whether a parameter set here will be passed on consistently to the other side.

Additionally, in the past, only 8-bit data (per color channel) were passed from the application to the operating system and driver. This might not be too bad, as the dynamic range most printing techniques can reproduce is less than 8 bit. (8 bit allows for 256 shades of a color/channel, while prints on paper typically lie in the range of about 60–128 shades.) Nevertheless, every new generation of fine art printers, and even newer papers are going to extend this range, and it would be desirable, that if you work with 16-bit images (per color channel), you could pass this full 16-bit data on to the driver and leave the task of 16-bit to 8-bit mapping to the driver, especially, as the driver doesn't map RGB to RGB, but RGB to the number of ink colors available with the printer: 8–12 color with the printers we discuss here.

Therefore, in 2006, for some fine art printers, manufacturers started to provide 16-bit enabled drivers for their printers. They did this in the form of a special (Export) plug-in, but up-to-now, only available for Photoshop. Canon did this when introducing the iFP 5000 printer line, and HP started to do it with its B9180 printer.

* With the Canon iPF5000, for instance, the printer will not start, if there is a mismatch between these two settings.

Canon imagePROGRAF Print Plug-In for Photoshop

When the plug-in is installed, an additional entry will be encountered in your Export list in Photoshop (File ▸ Export ▸ iPFxxx). So, with the Canon solution, instead of using Print you use this Export module. This plug-in controls your complete print job with all parameters. They are grouped into four tabs (see figure 5-44): *Main, Page Setup, Color Settings,* and *Print History.*

Figure 5-44: With the Canon Export plug-in, the settings are grouped under four tabs.

Main Tab

The Main tab controls:

▸ *Printer* (if you have more than one)

▸ *Media Type* (select the Canon media or a paper type that comes close)

▸ *Input Resolution to Plug-in* (we use 600 ppi)

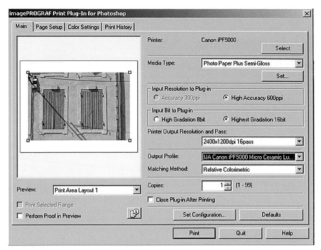

Figure 5-45: The Main tab of the Export plug-in for the Canon iPF500

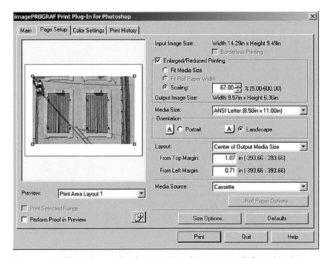

Figure 5-46: This tab provides those settings that are usually found in the Page Setup dialog when printing with Photoshop.

▸ *Input Bit Depth to Plug-in* (we use 16-bit which of course makes more sense with 16-bit images)

▸ *Printer Output Resolution* (we mainly use the maximum 2400 × 1200 dpi 16 pass)

▸ *Output Profile.* You can also use *Auto (Monochrome Photo)* for black-and-white prints).

▸ *Matching Method* is the so-called rendering intent (we mostly use *Relative Colorimetric*).

▸ *Set Configuration* allows the setting of the up-scaling algorithm and extra sharpening (we left it at zero, so far).

For the other entries you should consult the manual or play with the dialogs.

Page Setup tab

This tab (see figure 5-46) provides those settings that are usually found in the *Page Setup* dialog when printing with Photoshop. You can scale your print size here, but we prefer to do this in Photoshop because we don't find scaling by percentage that appealing (this is actually our only minor issue so far). The essential parameters here are:

▸ Media size (needs to match with the printer setting)

▸ Orientation (Portrait or Landscape)

▸ Layout

▸ Media source (also needs to match printer settings)

The *Size Options* allows you to create new custom paper sizes.

Color Settings tab

In normal color mode, you get the dialog demonstrated in figure 5-47. We never tweak colors in the driver (the proper ICC profile should do this); therefore, we leave all at the default.

If, however, you print a black-and-white image* and you select *Monochrome Photo* from the *Output Profile* menu (see figure 5-45), the dialog changes to that shown in figure 5-48. This dialog is used to tweak the black-and-white output. Most important to us is the control of the black-and-white white tone. We generally use X = -2 and Y = -10.

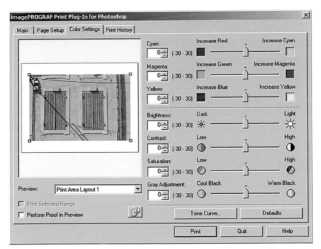

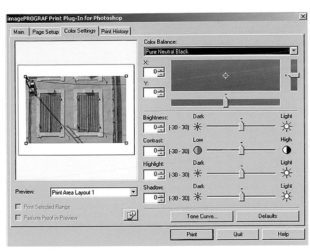

Figure 5-47: *The Color Settings tab provides those settings that are usually found in the Page Setup dialog when printing with Photoshop.*

Figure 5-48: *Color Settings when using the Auto (Monochrome Photo) mode*

You may also tweak the Tone Curve to match the preview and the print better (see figure 5-49). However, you may prefer to do this either in a profile (see section 7.5) or in Photoshop using an adjustment layer.

Print History tab

This tab (see figure 5-50 and figure 5-51 on page 161) is very helpful for your print workflow. It serves two purposes. It will allow you to:

▸ Revisit and recall recently printed jobs (last 100 are recorded)

▸ Save print job settings as favorites that can be later applied to new prints jobs.

This is a very useful tool.

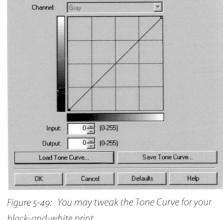

Figure 5-49: *You may tweak the Tone Curve for your black-and-white print.*

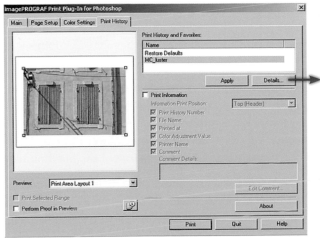

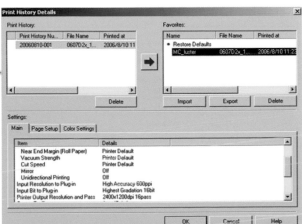

Figure 5-50: *Print History tab of the iPF5000*

Figure 5-51: *Print History details*

Conclusion on the Plug-in

Overall, we love this plug-in and don't want to be without it. Up to now, the main advantage of using this plug-in has been the point that all major settings for a print are gathered in one dialog (even if you have to deal with several tabs). Again, use the possibility to save settings and recall them when printing under the same conditions. We could not really see a big difference quality-wise between printing in 16-bit instead of 8-bit, but that may change in the future (or our eyes may not be critical enough or the effect may not be visible with the images we printed).

5.10 Test Prints

Having installed your printer, your printer driver and, optionally, a Photoshop plug-in for 16-bit printing, and finally looked at your printer manufacturer's Web page for updates for your printer driver and for ICC profiles for various papers and installed them,* it's a good time to perform a test print. For this you can use one of your own images – preferably one with a rich set of colors, and one where you know what the colors should look like. For a verification of your printer installation, new kind of inks, or a new paper, however, it's best to use special test images that show a variety of printer properties and limitations.

You may have also downloaded additional profiles from the web site of your paper supplier (or even created your own profiles),

In section 3.11 we named a few sources for these kinds of images and you will find our own test image at [79], that you can download for free. Resize the test image, if necessary, to fit your paper size and print it. Let it dry for about an hour before you do your close-up inspection. Then check for the following points:**

*** For more details on the inspection, see our description on page 81.*

▸ Possible casts in the gray ramps
▸ Handling of strongly saturated colors
▸ Skin tones
▸ Shadow details

If the print doesn't meet your expectations, check the following points:

➔ Never expect your prints to match your on-screen display if your monitor is not properly calibrated and profiled).

A. Is your monitor well calibrated and profiled? If, for example, your print is "only" too dark, your monitor is probably too bright. Does your monitor profiling include a proper calibration? If not – some entry-level packages do not provide this feature –, turn down the monitor's brightness, re-profile, and try again. With some newer LCD monitors we had to turn down brightness to about 15–20% of the maximum!

B. Did you use the proper media setting in the print dialog? If your driver (or plug-in) doesn't offer the exact media type, try to find a close match – e.g., another paper having the same surface (gloss, semigloss, matte, canvas, …

C. Did you really use the right profile for your setting – matching the printer plus media plus quality setting?

D. Did you soft-proof your image before printing? (See section 3.12 on soft-proofing.)

If all points are checked, and your result is still off, run a head alignment and a nozzle check. If even this doesn't help, try another profile or perhaps another paper (using the proper profile for it).

However, we **do not** advise you to tweak your image considerably in order to match the print and the on-screen preview – you'll have to do it for every image you print this way (again, assuming your monitor is correctly profiled).

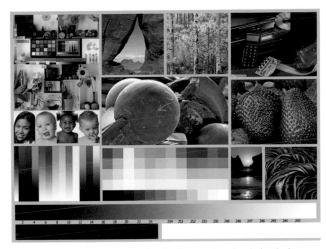

Figure 5-52: Our own printer evaluation image, downloaded at [79].

Finally, keep in mind, that the print will never match your preview 100 percent – your monitor and your printer use quite different ways of reproducing colors. All a preview can achieve is a close match.

5.11 Print Quality Related Issues

Here is an additional short list of issues to be aware of:

Drying time • Refrain from judging a print critically without giving it sufficient time to dry. A safe bet is 24 hours, but for most prints, three to four hours is enough. Likewise, never use prints in profiling without allowing enough drying time.

Prints from some printers (e.g., HP) are especially delicate immediately after printing. Make certain you don't touch the surface of a print, and let it dry in a dust-free space.

Inspecting your prints • Inspect your prints using standardized daylight, D50 (Daylight at 5,000 Kelvin), as all color management is based on this. For information on how to obtain such light, and for more details on image inspection and judgment, see section 8.1 *Critical Image Inspection.*

Roller marks / pizza wheels • Sometimes you may encounter roller marks on a printed paper surface. There are many possible reasons. Check that the paper settings match the paper. Sometimes it is a good idea to consult printer-specific news groups to pick up ideas from experienced fellow users, maybe even things such as removing some printer wheels.

Roller and transport • With our Epson R2400, we sometimes had problems when printing on a heavy paper like the Hahnemuehle PhotoRag 308. The printer just refused to feed in the paper. After cleaning up the rollers using Epson Cleaning Sheets, everything worked fine again.

Epson does not recommend this method with the R2400! However, it helped and didn't cause any problems in our case. Another way might be to clear your rollers from dust using Q-tips or a soft white eraser, but with some printers it's quite hard to get there. Make sure you remove all rubber and dust from the printer after this cleaning!

Banding • If you see banding, run a nozzle check and perform print head cleaning, if necessary. The next step is to check head alignment and realign the heads, if needed. If this doesn't help, check your paper settings and turn off high speed. When not using standard paper, setting your printer to custom thickness may avoid banding.

Dust spots • Using some cotton papers, you occasionally see small spots after a print dries. This can be caused by cotton dust and/or scuffing. The paper has dust or other loose cotton particles on its surface. The printer places ink on these areas. After printing, the particles fall off and you get white spots. Always gently brush cotton-based paper before feeding it into the printer.

Water spots • Be careful not to get water on a picture. It is best to let it dry naturally. Trying to wipe the water off can smudge the print and/or leave a mark.

5.12 Some More Recommendations for Printing

Though we have already mentioned some of the following recommendations, we want to repeat some of them here:

Print regularly • Inkjet inks tend to dry up fast and may clog up the nozzles of your print heads. For this reason, you should use your inkjet printers regularly, e.g., once a week, or at least every two weeks. Nozzle clogging seems to be somewhat worse with the Epson printers, obviously due to the pigmented inks. If you really have no inkjet print to do, simply run a nozzle check with your printer.

Check your inks and run a nozzle check before you start a large print. It is annoying if you spoil an expensive sheet of paper due to clogged nozzles, or because there is not enough ink to complete your print. Therefore, it is well worth checking your inks.* If you have plenty of ink for your print and have not printed for some days, run a nozzle check, usually offered as part of the printer's maintenance utility (see page 136) to make sure that your nozzles are not clogged. Nozzle clogging may show as banding, or as color shifts or stripes in the print.

Clean your paper before you print • Often, inkjet papers come with some paper dust on it. Therefore, you should clean the paper before inserting it into the printer. You may use a large cosmetic brush** or a small, soft broom.

All of the printers we discuss here will show the status of all the inks.

** *One that is not used for anything else!*

This prevents the dust from clogging your print heads or your printer's rollers. It is also very annoying if tiny paper fragments stick to the paper when the print is done and fall off afterwards, exposing plain paper spots with no ink. Some papers are more susceptible to this problem than others. We had some experience with this phenomenon with Hahnemuehle papers (e.g., Photo Rag).

Give your prints ample time to dry before touching and framing. Actually, you should never touch the printed area of your prints, at least not with your bare hands. Wear cotton gloves when handling your prints or printing papers.

Cover up your printer when not in use with a dust cover • This avoids dust settling on and in your printer.

Keep your spare inks cool.

Keep your spare paper dark, dry, and cool, and store it horizontally. The best way is still to keep them in the original box the paper came in. Keep old paper boxes and use them for those papers that didn't come in a box (this might be the case if you buy in small quantities). These boxes are also good to store your final prints.

Make sure your printer is correctly set up for your paper • With some printers, you have to set up your printer if you use thick paper. You may have to set this either within your printer driver, a lever on the printer, or you may have to use a special paper feed.

Make sure you use the proper profile for your paper and your printer settings • As stated when describing how to produce a printer profile, the profile is specific not only to the printer, the inks used and the paper used, but also to the printer settings. Printer settings, e.g., print quality settings, should be reflected in the profile name. Make sure that you select a printer profile that closely corresponds to your settings in the printer driver.

Make notes • Juergen uses a small booklet where he keeps notes on printers and papers. If you only have one fine art printer and always use the same two or three types of media, this may be exaggerated. If, however, you use different printers and try a number of different media, like we do, this is really useful. In this booklet he has a page or two for every paper type he experimented with. He makes notes on the proper media settings in the printer driver – e.g., which Epson media has to be set in the driver to get the best result for Hahnemuehle Photo Rag[*] –, or which Tone setting suited his on-screen preview best when using the "Advanced B&W Photo" mode with the Epson R2400 when using this mode for producing black-and-white prints (see section 7.3). He also adds notes on what to watch for when handling this media. With Photo Rag and German Etching by Hahnemuehle, for example, we always brush the paper with a soft broom before use. This prevents paper dust from clogging our print heads and transport wheels.

** You can find this information on the Website of Hahnemuehle [92], it's tedious to look this up every time you use their paper.*

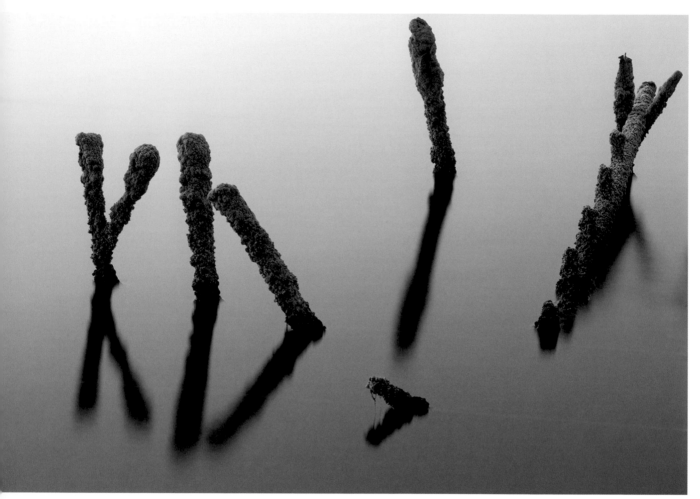

Camera: Canon 1DsX

Printing Packages and RIPs

6

You may achieve excellent prints when printing from Photoshop or another color-management application using the standard printer driver of your operating system. In most cases, this printer driver is supplied by the printer manufacturer. The process for doing this is described in sections 5.5 to 5.12.

In some cases, however, you may need additional options, e.g., when you not only want to print a single image, but also a DTP-built page with text, raster images, and line-art graphics. In other situations, you may look for greater control over printing settings than the standard printer driver provides, or you may want to use fine art papers that the driver does not support. In this case, a Raster Image Processor (RIP) may help.

6.1 What is a RIP?

A RIP takes the input and, from it, produces a raster image that can be sent directly to a printer. It does all the color conversion, such as from RGB to the printer's primary colors,[*] the dithering, the required resolution adaptation, and more. It's what a standard printer driver does, and usually more, e.g., supports standard ICC profiles. There are two basic types of RIPs:

* In photo inkjet printers, this are usually 6–12 different colored inks.

▶ RIPs that only do rasterization of the input
▶ RIPs that do additional print-language translation, e.g., from PostScript or PDF to the internal printer language

For fine art printing, the first type of RIP is acceptable in most cases, and is often considerably cheaper. PostScript- and PDF-enabled RIPs make sense when you use the RIP for contract press-proofing. Using a PostScript printer, the second type of RIP is already integrated into your printer's hardware. This integrated RIP, however, may not provide all the features and controls offered with separate RIPs.

HP has discontinued its software-based RIP and replaced it with an "EFI Designer Edition RIP" described in section 6.3.

Most RIPs are *optional equipment*; you must pay extra for them. Both HP and Epson offer separate software RIPs for some of their inkjet printers. There are many other RIPs offered by third-party companies which are frequently less expensive, more universal, and offer better quality or flexibility for a particular task like black-and-white printing.

Why Use a RIP?

Above, we have listed the main reasons for using a separate RIP:

▶ More control over printing parameters
▶ Support of high-level printer languages (often PostScript or PDF)

A RIP also provides the following useful features:

** For instance providing network-printing, hot-folders, and different job queues for different job types.

▶ Smoother workflow than printer drivers[**]
▶ Better dithering and/or up-sizing algorithms
▶ More control of ink lay-down
▶ Additional ICC profiles for some fine art printers, third-party inks, or press printing
▶ Support for profiling
▶ Support for special third-party inks (often for black-and-white printing)
▶ Optimized placement of several images on the same page
▶ Special features for black-and-white printing[***]
▶ Special features for CMYK proofs (contract press-proofs)

*** Such as special black-and-white profiles for printing, as well as soft-proofing.

Not all of these features are provided by all RIPs, and not all features may be needed. For this reason, there is no single solution for all users. We will describe some of the RIPs we have used, and the particular features useful for our kind of work.

6.2 Printing Using a Printing Package

When direct-printing with the printer manufacturer's printer driver is not quite good enough, but a RIP is too expensive,* a printing package may be the answer. These printing packages are stand-alone applications that help to prepare an image for printing by calling up a printer driver and passing the image along for printing. They do no actual dithering (also called *screening*), which a RIP or a printer driver can do.

** Though there are some moderately priced RIPs around.*

Nevertheless, printing packages may be helpful when doing printer-specific up-sizing or down-sizing of an image, and can even do some sharpening.** They also may replace Photoshop as the printing application, and do color management, rather than leaving it to the printer driver. These packages sometimes come with additional profiles, or aid in creating printer profiles. This software also features image placement, i.e., several images on a single output page. While we rarely use them for fine art prints, printing packages may be useful for test prints or for contact sheets.

*** Additionally, they usually can save important print settings in a set of preset lists. For this purpose, they usually work better than most printer drivers or print dialogs of the operating system.*

Often, these utilities offer additional image-enhancement operations. Qimage is one such a utility. As a rule, we don't use these features. According to our experience, good RAW converters plus Photoshop are usually superior. There are other printing packages, but we have little or no experience with them.

Qimage

Qimage by ddisoftware, Inc [83] is a low-priced image-printing package for Windows. It includes free lifetime updates and upgrades. For the budget-conscious artist, Qimage also offers a Lite version. According to our experience, Qimage Lite is sufficient in most cases, although the price of the Pro version is reasonable enough for us to recommend purchasing the full version.

Qimage Pro is priced about $50 and may be downloaded from the Internet. Qimage Lite costs about $ 39.

While no native Mac version is currently available, Qimage may now be run using Boot Camp that, paradoxically, runs Windows even faster than a Windows-based PC. Below is a list of features in Qimage we consider useful:

▸ Supports a broad range of inkjet printers from HP, Epson, and Canon
▸ Fully color managed; works with ICC profiles
▸ Provides batch-processing of images (printing, scaling, format conversion, etc.)***
▸ Allows placing several images on one output page
▸ Automatic image scaling for optimum prints. Offers several different scaling algorithms
▸ Offers optional sharpening
▸ Offers selective color correction and fine-tuning
▸ Has an image-oriented browser for selecting files for printing

**** You may, for example, do batch printing as well as image scaling and format conversion in batch mode. Qimage also supports a number of RAW formats (but we don't print RAW files).*

➜ *There are a number of features in Qimage that we do not use, for example image editing, RAW conversion, Flash Card import, RAW conversion, or import via TWAIN (scanner).*

The user interface is somewhat outdated (but was updated in recent versions) and requires a bit of learning, partly due to the large number of settings involved. This, however, provides a lot of flexibility.

You may download a fully functional version of Qimage from the Web and test it for 30 days. If you purchase a license (via the Web), a license-key is sent by e-mail. Installation is simple: click on the installation file. Although there is little to set up, you should check if the monitor profile is correctly selected (Qimage accesses the Windows system default profile).

Qimage is not actually a true RIP. Instead of doing its own dithering and color translation, it uses the manufacturer's printer driver for actual output to the printer. While this suggests limitations to the program, it supports a large number of printers.

Qimage performs several important printing tasks:

** Qimage knows the optimal image resolutions for the printers supported by the program and will up- or down-scale the image accordingly before passing them on to the actual printer driver.*

▸ It does up-sizing or down-sizing of the image to an optimal printer's native resolution.* It offers several different sizing algorithms, and is quite good at it

▸ It does some sharpening (may be activated or deactivated)

▸ It offers some helpful administration tasks such as saving and loading printer driver settings

▸ It allows placing several images on one output page, which may be useful for producing contact sheets

*Figure 6-1:
Qimage Pro window with
folder browser open*

After starting Qimage, browse to your image folder. Qimage will build up thumbnails and display all images in the folder in thumbnail view (see figure 6-1). This may take a few minutes when accessing a folder with many images. Once in the proper folder, you may hide the Folder Browser.*

** Click on the separation line between the folder and the thumbnail window.*

Before starting the print, you should make three settings:

1. Printer setup (click 🖨 or File ▸ Printer/Page Setup). This brings up the standard print dialog box of your printer, in which you can make all settings. Qimage stores these settings and they can be saved under a special name.

2. Page setup (page size, orientation, borders, and so on) using the various options under Page Formatting)

3. Settings for interpolation and sharpening. For this click the *Job Properties* button – or even more detailed – use Edit ▸ Preferences ▸ Printing Options (see figure 6-2).

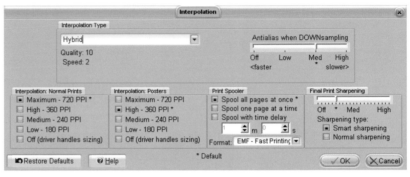

Figure 6-2: Here you can adjust the interpolation and sharpening settings in Qimage Pro.

Now select the interpolation method for up- and downsizing your image (figure 6-2). Qimage offers various methods and indicates their respective quality and speed (Qimage Lite shows a simplified dialog box).

Additionally, check the color management settings accessed by choosing Edit ▸ Preferences ▸ Color Management (see figure 6-3) By default, Qimage uses the monitor profile set by the operating system. You can also define the working color space for the print. As mentioned before, it is important to select the right printer profile. You also set the rendering intent here. For most profiles, *Black point compensation* should be activated. The settings you define here are just default settings. You may change them for a specific job – e.g., when printing on different paper, you have to select another printer profile.

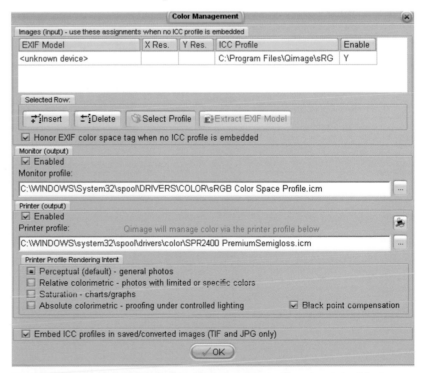

Figure 6-3: The Qimage CMS dialogs allows to set your printer profile and rendering intent.

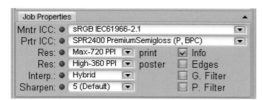

Figure 6-4: The Job Properties are shown and can be modified here.

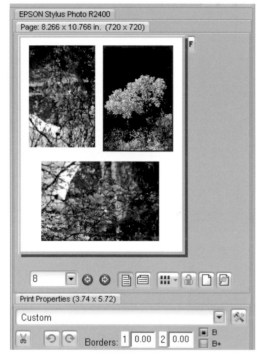

Figure 6-5: Drag your images onto the page preview icon.

This can be done in *Job Properties*. If the job properties are not visible, click the *Job Properties* button (see figure 6-4). You can also change your Print resolution, Interpolation and Sharpening settings. There are also options to add information about the file name or EXIF data of the print, add crop marks, guide lines, or even borders.

To print an image, merely drag your image icon onto the empty page icon (figure 6-5). Alternatively, you may select the image thumbnail and click ✚ (🅟 calls up an image preview).

When you select several images and click ✚, the images are automatically placed on the page at the image size currently selected in the page window. As many images as possible are placed on a page, and additional pages/print jobs are created automatically as needed. You may delete individual images from a page or modify their placement. You can also still scale any image in this preview using your mouse, change the placement, and delete images from the page, or an entire page from the job. You can also change the page orientation using the 🗐 and 🗐 icons.

If you want to fine-tune the layout of an image on the page, click on the 🖻 icon. Qimage will bring up its Full Page editor (see figure 6-6). In this editor you can crop and rotate the image and tune the layout and placement of the image.

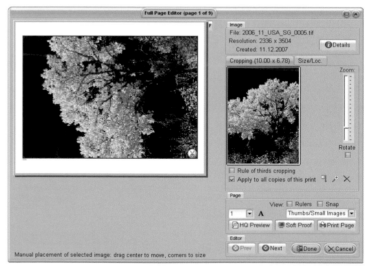

Figure 6-6:
The Full Page Editor of Qimage allows to fine-tune the image on your page, including cropping, rotating and changing the placement on the page.

Images printed with Qimage look more concise, which means they appear sharper than prints made from Photoshop. This may be attributed to the optimized scaling done by Qimage before the page is passed on to the print driver, as well as to the sharpening applied to the image (deactivate the sharpening feature if the image appears too sharp). The up-scaling algorithm that Qimage uses is good even for significant enlargements and can save you the cost of special scaling software.

6.3 Printing Using a RIP

As mentioned, there are a number of good RIPs for fine art printing on the market. We begin with a good, reasonably priced RIP, and later move on to RIPs focused on more professional-level press work (CMYK) proofing.

QuadToneRIP

Some personal history: We've known Roy Harrington for some years, meeting as members of the *Gallery House*. Roy is a passionate 4×5 black-and-white landscape photographer who has produced inkjet black-and-white prints for some time now. In Spring 2003, Roy bought our Epson 7500.** He began experimenting with different black-and-white quad-tone ink sets. Here, he was not alone. But, because Roy also knows programming inside and out, he began to write his own quad-tone driver for his inks and the 7500. From this project evolved the new tool called *QuadToneRIP*. When Roy told us that he gets as good a result from standard Epson UltraChrome inks (Epson 2200/7600/9600) as from his own ink mix, we became curious, as we believe Roy understands digital black-and-white printing at a highly expert level.

*** We have now upgraded our printing equipment to the Epson 7600.*

QuadToneRIP (QTR for short) is available for Mac OS X and Windows. On the Mac, QTR works like a printer driver. On Windows, it is actually a set of batch programs outputting through the standard Windows printer driver. Handling on Windows originally was not as smooth as with Mac OS X, but with version 2.3, it got a new front-end graphic user interface that makes handling (printing) with QTR easy and convenient. QTR is a shareware program and, for $50, offers a lot for little money. You may download QTR from the Web and test it before you buy.

You have to download the QuadToneRIP from the Internet at:
http://harrington.com/QuadToneRIP.html

QTR focuses on black-and-white printing. It does not offer PostScript support, but only TIFF (uncompressed or LZW), making it small and simple. You may also output color images, however, they are automatically converted to black-and-white.

QTR supports a number of Epson printers, desktop and large-format, with several different ink-sets, e.g., UltraChrome, UltraChrome K3, Neutral K7, QuadBlack, and Ultratone. The package includes additional tools for ICC black-and-white profiling, as it is not easy using standard ICC tools. For black-and-white profiling, however, you need a spectrophotometer. There are also tools that allow you to produce your own tone curves for black-and-white printing.

➜ *A quite useful feature of the QTR package is a supporting application that allows you to produce black-and-white profiles that may be used for black-and-white soft-proofing and printing using "Let Photoshop Determine Colors." For more on this, see section 7.5 at page 196.*

At about $50, the QTR package is very reasonably priced and, in our opinion, well worth the money.

Installation on Mac OS X

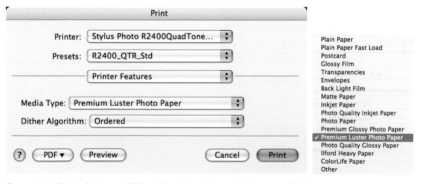

Figure 6-7: Select 'QuadToneRIP' from the 'Print Using' list and choose your printer model

QTR comes with an installation script making installation quick and easy. On Mac OS X, you must be sure that *GIMP Print* is installed before installing QTR. If it is not, you may simply install it from your Mac OS installation disk, using *Optional Installs.mpkg.* (With current versions of Mac OS X, e.g., 10.4 or 10.5, GIMP Print will be installed by default.) When you reach *Custom Install,* select Printer Drivers, and check *Gimp Printer Drivers.*

The QTR install script will install the RIP. Next, you must install the ICC profiles for your printer. These profiles come with the package.

The driver will **not** show up immediately in your printer list. First you must add 🖨 a new printer using your Mac *Printer Setup Utility* (🖨). Within the utility, select the printer (already installed and online) you want to use for your black-and-white printing using QTR, and use *QuadToneRIP* from the Print Using list. Additionally, select your printer model from the drop-down list (see figure 6-7).

That does it. From now on, you may use QTR like a regular printer when printing from an application, e.g., Photoshop.

Printing with QTR under Mac OS X

We use Photoshop as our printing application (selecting Print with Preview) and leave color management to the printer (see section 5.3 at page 137). If however, we have a black-and-white profile for our printer (+ paper + inkset + driver settings combination), we will use *Let Photoshop Determine Colors.*

Figure 6-8: First select your Dither Algorithm, then select your media type.

In the setup of the printer driver, first select Printer features and then select your media type and Dither Algorithm (which we leave at *Ordered,* see figure 6-8). For our Epson R2400, QTR not only offers Epson papers, but several others: Ilford Heavy, Transparencies, and Glossy Film.

While in driver settings, go to tab QuadToneRIP (see figure 6-9). Here, you do your setup for black-and-white prints. *Curve 1* and *Curve 2* boxes determine your ink+paper profile (including your color hue). There are curves for a cool color, as well as curves for a warm color. You may mix this color hue via the *Tone Blend* drop-down list. A 50-50 blend, as in figure 6-9, will result in a neutral tone. *Ink Limit Adj* and *Gamma Adj* give still more control of the print. A higher

or lower *Gamma* value will darken or lighten an image in the print, without requiring editing of your original image.

Printing with QTR under Windows

With Windows, QTR does not run as a driver. Since QTR 2.3, however, there is a convenient front-end application called *QuadToneRIP Graphical Interface* (QTR GUI). It will be installed in your Windows Quick Start list. If you want to generate your own curves, e.g., for new inks or papers, you would also install the *Curve Creator*.

QTR offers a *Monitor folder* (a Hot folder). When you drop an image into this folder, it will be printed by QTR automatically.

To print an image the simplest way, call up QTR GUI and do your initial setup (see figure 6-10). Then select the image you want to print (Image ▸ Select Image) and set the scaling (if necessary). QTR can only print TIFFs that are Grayscale or RGB, uncompressed or LZW. Sixteen-bit TIFFs will be internally converted to 8-bit. In most cases, this is no real restriction in fine art printing. The program takes most versions of TIFFs produced in Photoshop.

QTR has good black-and-white profiling and linearization, although its manual is a bit weak. For more details on profiling, linearization, and curves adaptation, see the various QTR tutorials and help files.

Additionally, the QTR package includes a utility to generate a black-and-white ICC profile that can be used for black-and-white conversion (e.g., in Photoshop or Lightroom). This profile works well for soft-proofing grayscale and black-and-white RGB images. Finally, it can be used to print an RGB image directly from Photoshop (or any other good printing application), where you leave the color conversion to Photoshop (see section 7.5 for more detail).

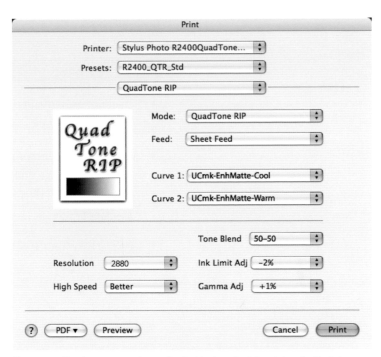

Figure 6-9: You do your actual setup for the black-and-white print under the tab "QuadToneRIP".

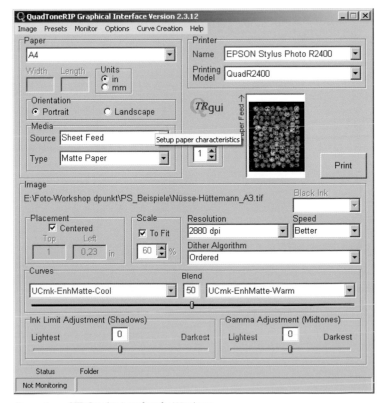

Figure 6-10: QTR Graphic Interface for Windows

ImagePrint by Colorbyte Software

ImagePrint by ColorByte ([82] ⊞,) is a very popular RIP for fine art photographers. The main benefits of ImagePrint are:

* *ImagePrint does not use any part of the printer manufacturer's drivers.*

▶ Excellent print quality*

▶ 16-bit capability

▶ Very good profiles for many papers are included, as well as profiles for different lighting conditions. This is important, as creating good profiles can be quite time consuming

▶ Very good black-and-white printing, with very low levels of metamerism

▶ Easy to use, compared to other RIPs

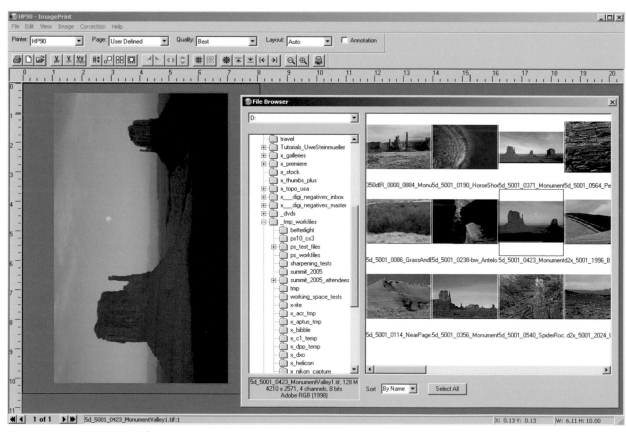

Figure 6-11: ImagePrint user interface

We have used ImagePrint for the Epson 7600/2200 and also for the HP Designjet 90, and have been very pleased with the results. Like most RIPs, ImagePrint allows you to select one or more images (for fine art you will usually print one image at a time), position it on the paper template, resize, and finally print.

Color Management with ImagePrint

ImagePrint is fully color-managed, yet it also provides extra control over printing. Here we will cover the basics, as far as we use them ourselves. You may also make image corrections in ImagePrint, but we prefer performing these operations in Photoshop.

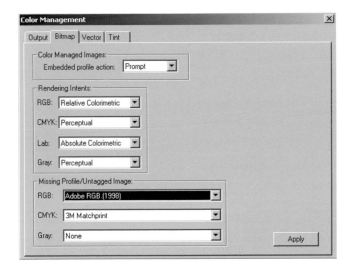

Figure 6-12:
Color Management strategy

We want ImagePrint to notify us about the embedded profile, and use mainly *Relative Colorimetric* rendering intent for color images. For gray-scale images, we use the *Perceptual* rendering intent.

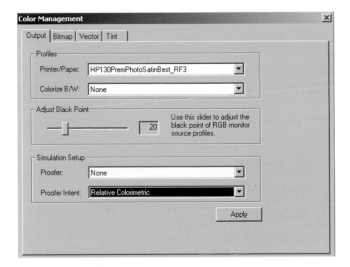

Figure 6-13:
Output options

The key property is the profile for the paper. ImagePrint has two different kinds of profiles:

▶ Color profiles for different papers and viewing light conditions (often five variations). The user can also create new profiles.

▸ Grayscale profiles for black-and-white printing on various papers. These profiles can only be created by ColorByte.

In special cases, you can have a black-and-white profile plus a color profile to use the colorizing feature, although we have no hands-on experience with this.

The Adjust Black Point slider is important, as you can define the level of black definition for your prints. We did tests, found a good setting, and left it at that level for subsequent prints. The simulation tab is set to "None" because we are not simulating any other target printers.

For black-and-white prints, ImagePrint features a powerful tint control:

Figure 6-14:
You may select different tints for Shadows and
Highlights

We use the same tint for the entire image, but ImagePrint allows so-called *split toning,* where the shadow part of an image receives a different tone than the highlight part. Using the slider *Tint Blend*, you can also control where the split should be for a particular print.

For the HP Designjet 30/90/130 printers, ImagePrint also supports in-printer color calibration (these printers have their own density sensors):

Figure 6-15:
The Calibrate dialog

EFI Designer Edition

EFI [84] is well known for its PostScript RIPs (called *Fiery print controllers*) for color laser printers. *EFI Designer Edition* is a software RIP.* Running under Windows (2000, XP, and Vista), as well as Mac OS X, it is suited not only for fine art printing, but also produces highly reliable proofs of images for press printing. It provides an *Ugra/Fogra Media Strip* (a color-controlling tool well established in Europe's press industry). It includes several profiles for this kind of proofing and for a multitude of different papers mainly for professional inkjet printers from Epson, HP, Canon, Encad, and Roland (and others. It offers Adobe PostScript 3 compatibility, as well as PDF and tagged TIFF (RGB, CMYK, and Lab).

EFI may be installed as a virtual printer driver and thus used by any application on your system. It also supports "hot folders." When you drop an image (PostScript or PDF file) onto its hot folder, the image is added to the print queue and processed according to the rules defined for that folder. Thus, the virtual printer may also be used in a network if the folder can be shared. It is fully color managed and provides extended profile options. You may add linearization files to profiles. Additional tools help build linearization files and build connection profiles (these are combined profiles allowing simulation of the printing behavior of device B on device A).

With a price tag of about $650, EFI Designer Edition definitely is not a throwaway application but still reasonably priced.

EFI Designer Edition (EFI-DE for short) offers three different printing modes:

▸ **Proof** (simulating a press print on your inkjet printer)

▸ **Photo print** (very much like printing from Photoshop, but with the additional advantage of batch/spool processing)

▸ **Black-and-white print** (converting an image to black-and-white on the fly)

You may also export a job (rendered as TIFF).

EFI-DE comes with a good installation script, so installation may be completed in a few minutes. We had to update this version online (just another click) to get support for our Epson R2400.

To setup the RIP, select Preferences (▦) and set the parameters for:

▸ **Printer** settings
▸ **Paper profiles** settings
▸ **Color** (including color output mode. *Photo* for fine art printing)
▸ **Output**. Here, you define the RIP's resolution and what kind of additional control information should be included for the print.

EFI offers several versions of the EFI Designer Edition described here. Their main difference is the maximum print size (related to printers) you may use: version M (printers up to A2), version XL (printers up to 24"), version XXL (printers up to 60"). If you only want to print photos (images), you may go for "EFI Photo Edition", which is a bit less expensive.

→ *HP offers the EFI Designer Edition as an optional RIP for its lines of professional printers.*

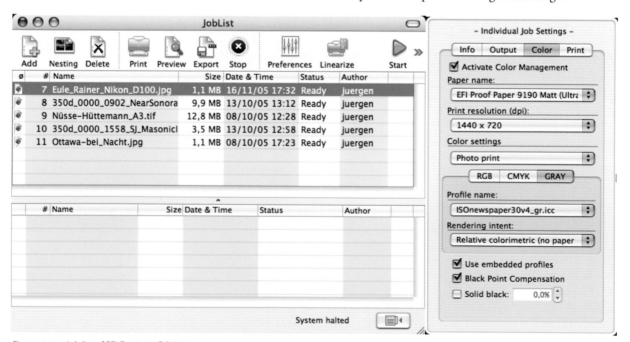

Figure 6-16:
Color setup for your printer

Additionally, using the tab General, set up the location where your hot folder will be and where exported and preview images should go.

Figure 6-17: Job list of EFI Designer Edition.

For fine art printing, we prefer using drag-and-drop, dragging the image file onto the open job list. Selecting a job and clicking [icon] will show the details (right palette of figure 6-17). Here, you may still change some of the job parameters (as long as printing has not started).

EFI-DE does an acceptable job in fine art printing; you may even improve profiles by building a linearization file for a printer and paper using the *Ink Assistant* [icon]. Here, you adapt gamma and individual ink curves, but only for CMYK inks. You may also build custom ICC profiles. EFI-DE offers a pass-through option for printing a target and allows importing the new profile (you still need a separate profiling package). However, apart from color management (which is important), there is no special support for fine art printing, though for test prints the nesting feature comes in handy.

The program's real strength lies in doing a proof before sending your files to a printer for press printing. If your image is part of a DTP document, PostScript and PDF support are quite important. The Ugra/Fogra media-wedge is another plus for these types of jobs. If bought separately, it makes up about half the price of the EFI-DE package.

Figure 6-18:
Ugra/Fogra Media-Wedge may be used as a control strip for printed colors.

In Europe, this may be used to verify the color/print quality of a press print. You may also proof using spot colors, and there is a *Color Editor* to define additional spot colors. For press proofs, the virtual printer driver is convenient, as you may print from any DTP application to a (supported) non-PostScript inkjet printer.

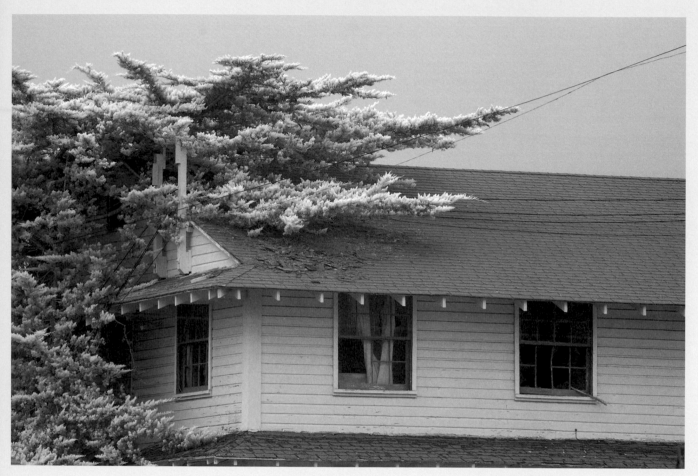

Camera: Canon EOS Digital Rebel XTD (infrared modification)

Black-and-White Prints

7

Even while all digital cameras originally capture the image in color, black-and-white printing still has its charm and followers and many of those, who loved traditional black-and-white in the traditional wet darkroom, will be looking for digital black-and-white prints as well.

The charm of black-and-white prints comes from its abstraction, from its strong graphic impression, from the reduction of the image to the essential.

It may seem very easy to print in black-and-white – even easier than in color. But that is not the case. For good black-and-white prints you will have to do a good color to black-and-white conversion – just changing the color mode won't do the trick. Then you need to use the right print modes to achieve a neutral or tinted print. There are also some considerations when selecting a printer suited for optimal black-and-white prints. We will deal with all these issues in this chapter.

7.1 Workflow for Black-and-White Prints

At first glance, printing black-and-white seems easier than color. Unfortunately, this is not the case. The main reasons are:

▸ Fine tonal gradations in B&W prints are more important
▸ Unwanted color casts
▸ Toning of the prints
▸ Metamerism (one of the major problems of black-and-white inkjet prints)
▸ Excellent black levels are difficult to achieve

The Basic Workflow Steps in our Black-and-White Workflow

The workflow for black-and-white prints does not much differ from that for color. These are the steps:

1. Prepare and tune your original image – in most cases a color photo – as described in chapter 4.

2. Convert your image to black-and-white (as described in section 7.2).

3. Fine-tune your black-and-white photography.
 Even if you have optimized your basic (usually color) image before converting it to black-and-white, in most cases you will still have to do some more tweaking after the conversion, e.g., in order to achieve better contrast, or to selectively emphasize certain areas, transitions, or gradients. Again, you can use the techniques demonstrated in chapter 4.

4. Print your image (as described in section 7.3).

Some leave the converted black-and-white image in RGB color mode, while others convert files into grayscale images. There are advantages to both solutions: Converting an RGB image to black-and-white will reduce the file size to about ⅓. Staying with RGB allows you to keep the black-and-white version as a simple layer (or layer group) on top of the original image and thus allows you to stick with the standard RGB printing workflow* if you have a suitable printer and a good gray-neutral RGB profile for your combination of printer, paper, and ink.

As described in chapter 5.

 If you intend to send your black-and-white image to a printing service for direct photo printing – from whom you will get a reasonable, but not the best result – the safer way is to convert your image to *Grayscale*. If you are using a high-end printing service, ask them for advice. (If they don't have an answer to this question, look for another service).

Tonality is everything in a good black-and-white print. Some may prefer a stark contrast, while others search for ultra-smooth gradations and open shadows.

One of the major issues in black-and-white printing is how to produce a good soft-proof. Until recently, it was quite a hassle to find a decent solution. The problem with soft-proofing black-and-white images lies in the fact that there are hardly any black-and-white profiles around (standard profiling packages create color profiles). Fortunately, Roy Harrington (creator of QuadToneRIP [86]) offers a solution (see section 6.3 and 7.5).

There are three basic methods for color mapping (here, actually, it is the tonal mapping) when producing black-and-white prints:

A. **Using a printer that provides a dedicated black-and-white printing mode**
This is true for most up-to-date fine art printers that have more than two tints of black/gray inks. Most of the printers we recommend fulfill this requirement. On their black-and-white printing mode, these printers will predominantly use their black and gray inks and use only very little yellow, light magenta, as well as some light cyan. The results are very neutral prints – if that is what you want. This mode usually also allows for some slight toning – e.g., sepia.

B. **Using a RIP suited for fine art printing**
This class of RIPs usually can produce very neutral black-and-white prints, often even if the print has only one or two tints of black inks. They also will produce the best results when your printer is stuffed with several black-/gray-only inks, and can give very good results also when using only one or two versions of black inks (standard profiles usually can't deal with this). This will cause some additional costs for the RIP.[*] Additionally, you will need an ICC profile suited for the RIP, as standard profiles that are supplied by the manufacturers of the printer or a specific paper can't be used. (Remember: A profile is specific for the combination of paper + printer + driver – in this case the RIP).

** Though there are some moderately priced RIPs around.*

C. **Using a standard, but good, gray-balanced RGB (color) profile …**
… for a printer that comes originally equipped with several tints of black inks. Profiles have became better in recent years, and up-to-date fine art printers can nowadays create quite neutral black-and-white prints even when used in the standard color print mode.[**]
For this method you simply use the printing procedure described in section 5.5, letting your application do the color mapping (e.g., use *Let Photoshop Determine Colors*).

*** We used this method, for instance, when testing some of the new Baryt papers, making use of the standard profiles provided by the paper manufacturers supplied on their web page for some Epson, Canon and HP fine art printers.*

In any case, the very first step in achieving a good black-and-white print is always to start with a good black-and-white image. Your image should have all the attributes that make a black-and-white print interesting: strong abstraction, a clear structure (meaning the omission of elements that do not contribute to the message of the picture), and a rich set of tonal values, which can also be found in low-key or high-key images.

7.2 From Color to Black-and-White

There are nearly as many ways to convert a color image to black-and-white as there are avenues leading to Rome. Some newer digital cameras even shoot in black-and-white. We do not recommend it, as a computer-based conversion will give you more control. You may also convert your color image to black-and-white either in your RAW converter, as described in our e-books[*] or in Photoshop. When you convert using Photoshop, simply converting from RGB to Grayscale (Image ▸ Mode ▸ Grayscale) in most cases does not achieve optimal results. Here are some common ways that in most cases lead to better results:

See [12] and [13].

A. Switch to Lab color mode (e.g., in Photoshop: Mode ▸ Lab Color) and delete the a and the b channel, only retaining the L channel (containing all the lightness values of the image).[**]

*** Finally, switch back to either Grayscale or RGB mode for fine-tuning and printing.*

B. Use the Photoshop Channel Mixer (as described later)

C. Use the Black & White function (available since Photoshop CS3)

D. Use one of those numerous dedicated Photoshop plug-ins for black-and-white conversion, e.g., *B/W Conversion* (which is part of Nik Color Efex [55]), *B & W Studio* by PowerRetouche [59], or some of the *Exposure 2* filters by Alien Skin [36].

The conversion methods in Adobe Camera Raw and Lightroom are very similar to that of the Photoshop function Black and White, described on page 188."

E. When shooting in RAW, you can also use the black-and-white conversion features of most current RAW converters, e.g., found in Adobe Camera Raw since version 4.0, in Adobe Photoshop Lightroom, Apple Aperture, Bibble (by Bibble Labs), Capture One (by Phase One), LightZone (by Light Crafts), Nikon Capture NX, Raw Developer (by Iridient Digital), Silkypix Developer Studio (by Ichikawa Soft Laboratory), and many more. LightZone, for instance, has more features for fine-tuning the tonality of the image – be it black-and-white or in color. Therefore, we use it quite often for this purpose.

Which of theses methods works best for you depends on your image, your budget, and on what exactly you want to achieve. B & W Studio and TIFFEN Ffx, for instance, allow you to bring back some the characteristics of analog film to your image by simulating film grain and the color sensitivities of specific black-and-white films.

With most of the methods mentioned above, your image will still be an RGB image that you may either retain in RGB or convert to Grayscale – now without any visible loss of contrast and tonality.

Another possible way is to use the Tint function of the Black & White function of Photoshop CS3.

If you want a tinted print you can either tint your RGB image – for instance using the *Split Toning* function of Lightroom – or you can leave your image in a neutral black-and-white and tint your image in your printing process, using the possibilities of the driver or the RIP. The latter method can also be used when printing Grayscale mode photos.

Black-and-White Conversion Using the Channel Mixer

While a simple RGB to Grayscale conversion is very easy and fast, a better way is to use the Channel Mixer of Photoshop:

1. Activate your Channels Palette and determine which of the RGB channels carries the most information (don't look at the channel icons; examine your image and deactivate the RGB channel first). Look for the best contrast, the best details, the most impressive single channel image. In our example of figure 7-1, it is Red and Green, which often is the case (see figure 7-2).

2. Create a new Channel Mixer adjustment layer (Layer ▸ New Adjustment Layer ▸ Channel Mixer).

Figure 7-1: Original color image

3. Enable option Monochrome (see figure 7-3) and start pushing the slider of your most important color (channel) slowly to the right. You may now mix your three channels. The sum of all three should add up to 100 %. Basic values of Red = 60 %, Green = 40 %

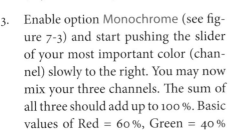

and Blue = 0 % will give you a good start. In many cases, no further adjustment is necessary (We extracted these values from Clayton Jones' paper on black-and-white conversion).

This technique involves a bit of trial and error. You may even set a channel slider to a negative value. Carefully check your image while adjusting the sliders.

Figure 7-2: Look for the channels with the most information

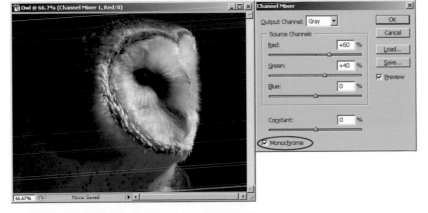

Figure 7-3:
Tune your channel sliders until the image looks OK.

4. If the image looks good, click OK. Though the image now looks black-and-white, it is still in RGB, which has some advantages for further optimizations.

5. You may still apply additional fine-tuning, e. g., using Levels and Curves. We recommend using adjustment layers for this! Fine-tuning a black-and-white image is a bit different than color, but the same tools may be used.

Using "Black & White" of Photoshop CS3

A new conversion function called Black & White was introduced with Photoshop CS3. Like Channel Mixer it can be used as an adjustment layer. While the Channel Mixer only provides three main sliders Black & White allows you to tune your black-and-white image using six sliders, thus providing finer control. Additionally, the dialog comes with a number a predefined settings that emulate different color filters already familiar from analog photography.

We started out with the color version of an eagle that can bee seen in figure 7-4. This image already is the result of some tuning and twitching of the original image. *Black & White* can be used as an adjustment layer, as create a new adjustment layer (Image ▸New Adjustment Layer ▸Black & White). Figure 7-6 shows the result of the default settings of this function. The result is reasonable, but can still be improved. One way would be to try the various predefined filters that are offered in the *Presets* drop-down-list (see figure 7-5). (You can add your own filters here by saving some settings using *Save Preset* that you will find by clicking on the 🗐 icon).

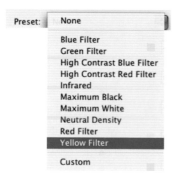

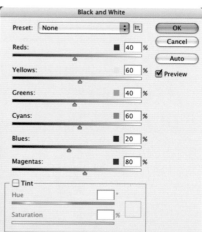

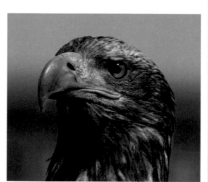

Figure 7-4: My original image of the eagle.

Figure 7-5: Predefined Photoshop Preset options for the Black & White conversion

Figure 7-6:
Image of the eagle after black-and-white conversion using the Photoshop default values.

With your *Black & White* dialog still opened, a better way is to click with your mouse in an area of the image that should be changed (brightened or dimmed). The mouse cursor will look like an eye dropper 🖋. This will activate the slider that will control the dominant color of this area (actually, the underlying colored image). For the image of this example, we brightened up the background at the top a bit (by pushing the slider for Reds to the right), pushed Yellows up a bit, reduced Cyans and finally arrived at the image and settings that are demonstrated in 7-7.

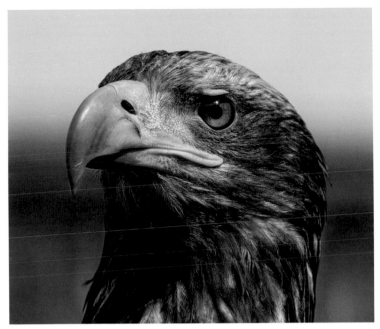

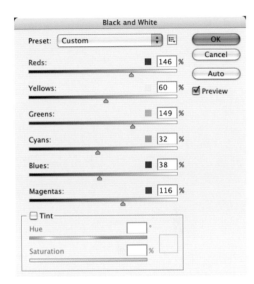

Figure 7-7: My final image of the eagle and the settings in Black and White. I could have added some tinting using Hue and Saturation.

7.3 Printers with Black-and-White-Enabled Drivers

In the past, the key issue with most inkjet printers was that they only feature one black, which left two options:

▸ This will get you very grainy-looking black-and-white prints with few good highlights.

▸ Using all colors to print black-and-white: potentially introduces various color casts and also can create strong metamerism. Prints look greenish outdoors and/or can have a magenta cast under fluorescent light.

The previous generation of Epson UltraChrome™ printers* featured at least two blacks. With these printers, you could get good black-and-white prints using the ImagePrint RIP. Using just the Epson drivers would still result in prints that show quite a bit of metamerism** and bronzing.

There were some third-party ink sets on the market that could transform your inkjet printer into a pure black-and-white machine. Well known are the Piezography inks by Jon Cone, but there have been some issues with ink clogging in the past.

In 2004, we saw the first off-the-shelf printers from HP, e.g., the Photosmart 8450, which featured color printing with an additional (or optional) three shades of black inks. In 2005, HP launched the Photosmart 8750, an improved and larger version of the 8450, and from Epson the new Ultra-Chrome™ K3 ink sets (where K3 stands for the three blacks). Now, for the

** Epson Stylus Pro 2200, 4000, 7600, 9600*
*** Meaning a slight green color cast with daylight and/or a slight magenta color cast with fluorescent lighting.*

> **Note:** In fact, the lighter blacks are very important in these printers, as they produce smoother results in building up darker tones, and adding more lighter blacks than lighter tones with sparse darker blacks.

first time, we were able to create quite amazing black-and-white and color prints on the same inkjet printer. For a long time only the Epson printers covered the range from 17" up to 44" printers, while HP was limited to 13" for printers with three blacks.

That changed in 2006, when Hewlett Packard as well as Canon introduced new printer lines that use pigmented inks and three or more variations of black inks. In 2007, both HP and Canon improved the recipes of their inks and removed most of the weak points of the first generation of pigmented inks. This improved (or eliminated) some bronzing and metamerism effects that could be encountered with their first generation of pigmented inks. With the availability of these new printers, we recommend buying only those printers for high-end black-and-white printing that use pigmented inks and have several different black inks: Photo Black and Matte Black – only one of these will be used in a single print –, Light Black (some manufacturers call this *Gray*) and Light-Light Black (also called *Light Gray*).

Here are some options for good black-and-white printing:

▸ Epson 2200, 4000, 7600, 9600 with ImagePrint or QuadToneRIP

▸ Custom third-party ink sets or even homemade diluted inks with third-party RIPs (like StudioPrint or QuadToneRIP). We know photographers that use up to seven inks. Many use the classic Epson 2000, 7500 or 9500 printers.

▸ Epson R2400, 2880, 3800, 4800/4880, 7800/7880, 7900, 9800/9980, 9900 and 11880

▸ HP Photosmart Pro B9180,[*] B8850, Z3100, Z3200

▸ Canon iPF6100, iPF8100, iPF9100

More on the handling of these printers can be found in chapter 5 and appendix A.

We do not cover in depth the use of custom and third-party inks in this book. You are better off checking out specialized forums on the net. We discuss solutions that work off the shelf and additionally allow you to print color and black-and-white using the same printer.

Again, some new printers feature three or more black inks and produce very good black-and-white prints. Most of these printers offer a dedicated black-and-white print mode in their drivers. A reliable way to achieve good black-and-white prints with these printers is by using just this dedicated mode.

[] The HP B9180 and B8850 printers use only two black/gray inks, and are therefore not the best choice for high-quality black-and-white printing. They do, however, yield good results when used with ›HP Premium Satin Photo Paper‹.*

Black-and-White Prints with Epson UltraChrome K3 Printers

We show these principles with the Epson R2400 driver dialogs. We understand the other printers are virtually the same.

Again, we use Photoshop CS2 as a printing application. (For the dialog of Photoshop CS3 see figure 7-8) We open the image and select File ▶ Print with Preview.* This means that the printer driver will do color conversion and tonal mapping. This is reasonable only when the driver offers a special black-and-white mode. When producing color prints, we use the Photoshop Color Handling setting *Let Photoshop Determine Colors* (see section 5.5, page 143); for black-and-white prints, we usually use *Let Printer Determine Colors* to do the color management:

With CS3 the Photoshop Print dialog changed a bit. For instance there is no longer Print with Preview, but only Print. (This is by no means a disadvantage.) Also, more elements are now gathered in one single dialog, which facilitates the print setup (see figure 7-9).

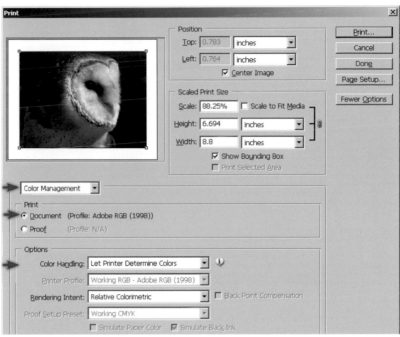

Figure 7-8: With black-and-white-enabled drivers, let the printer driver do the color management

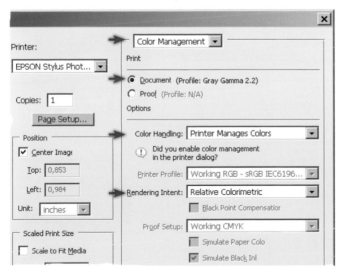

Figure 7-9:
Settings in Photoshop CS3 (only showing the relevant parts) when printing with a black-and-white enabled printer driver. We recommend to set the Rendering Intent to "Relative Colorimetric".

The rest of the workflow is the same as that with Photoshop CS1 or CS2.

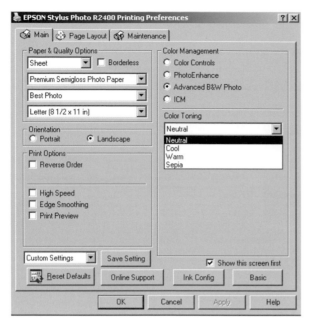

Figure 7-10: Printing in black-and-white with the Epson R2400 driver

Set *Color Management* to Advanced B&W Photo. There are four standard options available: Neutral, Cool, Warm and Sepia. It is best to start with Neutral. We liked the results very much. If you want to fine-tune toning and settings, click the *Settings* button to open the Advanced B&W Photo dialog.

Aside from the actual toning, you may first want to set a tone (e.g., "shadow brightness") you like (see figure 7-12 and 7-11).

We found the default Tone setting of *Darker* too dark, and changed our selection to *Dark* or even *Normal*.

Figure 7-11:
Tone settings

Be very careful using toning that is too strong, as you may get into a zone in which prints may show some metamerism.

If you use the Color Management selection Advanced B&W Photo for the K3 printers, you should not handle color management in Photoshop, but leave it to the printer. You have to gain your own experience in how the image on the screen is related to the print in terms of tonality, as this workflow is not really color managed. We assume that the driver treats a photo as a grayscale image, and then performs its toning. Later in this chapter, we have a note on soft-proofing black-and-white prints.

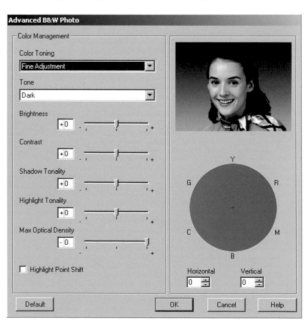

Figure 7-12:
R2400 "Advanced B&W Photo" dialog

Making Black-and-White Prints using the HP Designjet Z3100

Both the HP Z3100 and its successor, the Z3200, are excellent machines for making black-and-white prints. Like the Epson printers mentioned, both printers use three (or even four) black and gray inks. Here, Photo Black and Matte Black can be installed simultaneously, and some media make use of both inks. Additionally, both printers have an optional gloss optimizer, which allows you to reduce the difference in gloss between areas that are heavily inked and those where little or no ink is used.

For printing in the special black-and-white printing mode, we use the same Photoshop settings that we used for black-and-white prints made with the Epson printer. Assuming the image is already converted to black-and-white (but is still in RGB color mode), we select *Printer Manages Colors* in the Photoshop print dialog (see figure 7-8 or figure 7-9 for CS3). We then select the media type, size, and orientation, and all the other media and quality settings mentioned previously.

We then activate the *Color* tab to make our specific settings for black-and-white mode (see figure 7-13). Here, we activate option Ⓐ *Print in Grayscale*, then we select option Ⓑ *Printer managed colors*. In menu Ⓒ, we select the color profile of our source image (although the driver only offers a choice of Adobe RGB (1998) or sRGB). Finally, we activate *Advanced color adjustment* Ⓓ.

We now click *Settings* Ⓔ to see the color adjustments dialog (see figure 7-14 on page 194). This dialog allows you to fine-tune the tint of your black-and-white print, and even allows the use of different tints for highlights, midtones, and shadows. If you intend to use differing tints, you have to activate option Ⓐ in the dialog shown in figure 7-14. This dialog also includes a gamma slider (in this case, called *Lightness*).

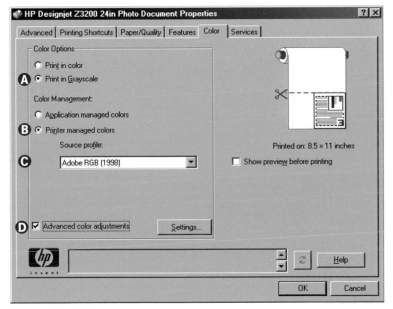

Figure 7-13: *These are the settings we recommended if you intend to use the HP z3200's printer driver in black-and-white mode.*

Finally, click on OK to return to the main dialog. If you haven't already, you should now save your black-and-white print settings as a preset.

The settings we have demonstrated for the Z3100 and Z3200 printers also work – with minor variations – for the HP B9180 and B8850 printers.[*] These models both produce excellent black-and-white prints, especially when used in conjunction with "HP Professional Satin" paper.

* *See also the description on page 249.*

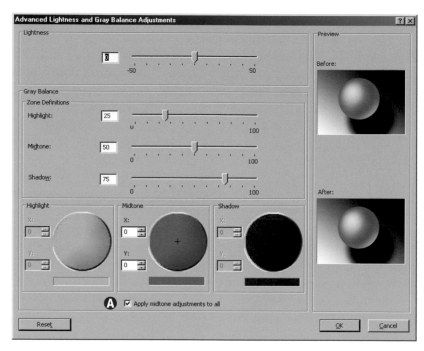

Figure 7-14:
This is the dialog for fine-tuning the tint and
gamma settings for your black-and-white prints.
Here, you can even select different tints for
the highlight and shadow areas of your print.

The results you can achieve using glossy papers with the B9180 and B8850 printers are not quite as good as those produced by the Z3100 and Z3200 because both A3 printers only use two grades of black ink.

7.4 Specialized "Raster Image Processing" (RIP) Software for Black-and-White Printing

If your printer has only one black ink, it is quite difficult to achieve a neutral image without a color cast. In this case, a RIP specialized for black-and-white printing may help. The same is true when printing with multi-black third-party inks (e.g. quadtone inks).

Colorbyte's ImagePrint

ImagePrint earned Colorbyte [82] the reputation of producing very high-quality black-and-white prints from an Epson UltraChrome™ printer generation (R2200, 4000, 7600, 9600) with only two blacks. It also uses special techniques to prevent major metamerism for black-and-white prints.

We recommend using ImagePrint for black-and-white only on printers that use at least two blacks. The black-and-white prints for the HP DesignJet look very good, but also show strong metamerism when you view the images outside in daylight. You can compensate for this by using the right tint.

We have covered ImagePrint previously (see section 6.3, page 176), therefore we concentrate here only on the features needed for black-and-white printing.

By selecting an ImagePrint grayscale profile, Image-Print is set for black-and-white printing. These grayscale profiles can only be created by ColorByte. Fortunately, ColorByte covers many different papers.

You should also find which black point you prefer for your black-and-white prints.

Photographers actually have very different preferences as to how a black-and-white print should look (even varying from image to image). Some like them cool, others warmer. This factor creates a need for print toning, and also to compensate for the original black tones of the printers.

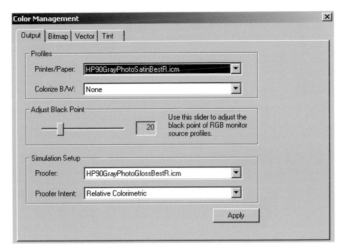

Figure 7-15: ImagePrint black-and-white color management settings

ImagePrint has very sophisticated controls for toning images:

The tint control allows more different tones than you may need for typical printing. It even allows tinting shadows differently than the rest of the image by so-called *split toning* (see figure 7-16). You should experiment with your printer to find the ideal tint, and stay with it for future prints.

If you work a lot in black-and-white, you should check out ImagePrint for your workflow. A free demo version may be downloaded from the Internet. This demo version will embed a watermark into your printed images.

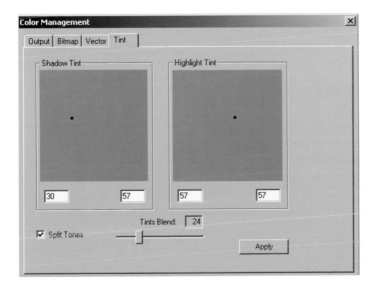

Figure 7-16:
ImagePrint tint control

QuadToneRIP

The large-format black-and-white photographer Roy Harrington looked for a simpler and less-expensive alternative to ImagePrint that he also could adapt to customize black-and-white ink sets. So he created his own RIP: QuadToneRIP.

We have seen some very good prints made by Roy with QuadToneRIP. We covered QTR in section 6.3 on page 173. We will not get into details here, but you may also want to check out this software (you can download QTR from [86] and try the software before you buy.*

* See section 6.3 "Printing Using a RIP" for more details.

Other Solutions

▸ StudioPrint RIP [85] (non-PostScript) by ErgoSoft supports third-party ink-sets, as well as quadtone inks. It provides a very good linearization process. ErgoSoft also offers a RIP (TexPrint) for printers printing on fabric instead of paper. Additionally, ColorGPS is a very sophisticated package for profiling for printing on paper as well as on fabric.

▸ Jon Cone's Piezography Neutral K7 ink-set [108]with several different black inks and profiles to support them.

▸ InkJetControl™ (see [81]) is software dedicated to black-and-white printing, and comes together with OpenPrintMaker™.

We prefer to use either black-and-white-enabled printer drivers for printers that have several black inks or use a RIP, such as QTR or ImagePrint (see section 6.3 "Printing Using a RIP").

Some photographers swear by '"Black Only" (BO) printing, using just a single black ink for their prints. The results they achieve for their kind of images are very good. The advantages of this technique are its simplicity and low cost.**

** Clayton Jones offers a nice feature-page at [47].

Figure 7-17: QTR tint control

7.5 Soft-Proofing for Black-and-White Prints

Soft-proofing your black-and-white prints will save you a lot of print iterations (meaning paper, ink, and time).

Roy Harrington came up with a solution as part of his QuadToneRIP package (QTR). The package comes with a target and a program to create black-and-white profiles. Additionally, you need the GretagMacbeth Eye One spectrophotometer and a version of ProfileMaker's Measure tool (a demo version will do).

1. First, you print the 21 gray patch target on your printer with the exact specified black-and-white settings (all black-and-white settings, paper type, toning, dpi, etc.) for your black-and-white capable printer (see beginning of this chapter). Let the print dry overnight for optimum results.

Figure 7-18:
B&W target with 21 gray patches

2. Next, launch the ProfileMaker Measure tool and select the 'QTR-21-random.txt' reference chart (see figure 7-19):

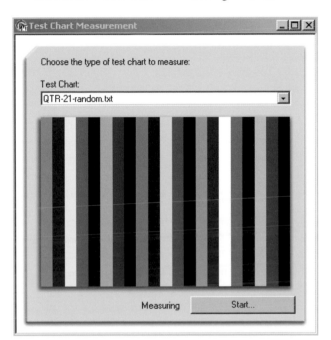

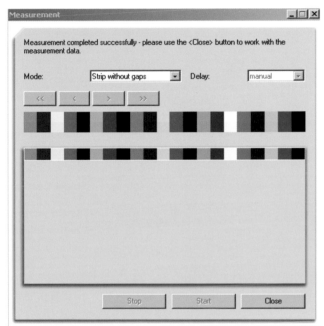

Figure 7-19: Select the chart in ProfileMaker

Figure 7-20: Read the strip

3. Start the measurement and read the line with the Eye One in *Strip mode*. As there are only a few patches, this will be quite easy and quick:

4. Finally, export the Lab values to a text file. Give it some descriptive name describing your driver settings (e.g. "*Eps_semigloss_neutral.txt*"):

5. Now just drop the text file onto the "*QTR-Create-ICC*" application and it will create the black-and-white ICC profile "*Eps_semigloss_neutral. icc*" for you: install this profile into your system profile folder.

Soft-Proofing Setup in Photoshop

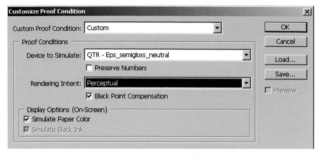

Figure 7-21: Set up your black-and-white profile for a soft-proof

* See also section 3.12 on soft-proofing.

** However, we don't use this function, as there is little control in this process, and we don't like converting an image into a device-specific gamut.

For the 'Digital Outback Open Forum' see www.outbackphoto.com/tforum/ viewboard.php?BoardID=1

Now you can use this black-and-white profile for your soft-proofing in Photoshop. Following Roy's instructions exactly, we do soft-proofing of the image using a setting like the one shown in figure 7-21 and print using Photoshop's function Print (with Photoshop CS3 or later) or Print with Preview with previous versions of Photoshop, setting Photoshop to "Let Photoshop Determine Colors" as described in section 5.3. Use the QTR profile as your ICC profile.*

Because these are real ICC profiles, you can use them as profiles in the printing dialog for Photoshop or other CMS-aware printing applications – this is one way of using method C described on page 185. You can even use them for converting a color image to a black-and-white image (Edit ▸ Convert to Profile and then select the black-and-white profile as your target).**

Thanks to Roy Harrington, this problem now also has a simple, elegant solution. If you have a licensed version of QTR, then feel free to share these profiles with other QTR users.

Some Comments from Roy Harrington Posted in Our News Group:

"As the article demonstrates, the basic procedure for these grayscale ICC profiles is very much like color profiling methods and produces a profile that is used very much like color profiles.

All standard profiles have two parts: one set of curves used for printing and to convert Lab values (i.e., colors to numbers for the print driver). The other set is used for soft-proofing that show the actual color (Lab) that is produced for numbers that are sent to the driver.

On first glance, these two sets of curves are just the inverse of each other. But in fact, they can be and usually are slightly different. In color, the obvious difference is the mapping for out-of-gamut colors. In soft-proofing the idea is to map a color to the best the printer can do and then map back to what color that actually is, so you can see it on your screen.

Grayscale profiles do nearly the same thing. There is no gamut limitation – black is mapped to Dmax and white to Dmin with *perceptual intent* mapping everything in between. This direction is pure grayscale; the result being the grayscale values that are sent to the driver (QTR, Epson ABW). The soft-proof side, however, is gray to Lab values and therefore color mapping. So, in the soft-proof, you see the actual tint of the print. In the soft-proof setup you can also Simulate Paper Color and/or Simulate Black Ink that will show those colors.

The profile-making procedure actually creates two functions in one ICC profile. Usually, one would use them both – print with the profile and soft-proof with the same profile. But the soft-proof setup has a check box

that asks whether or not you will be printing with the profile. Preserve Color Numbers *OFF* means show the output using the profile in printing. *ON* means: Show the output as if you are not using the profile in printing.

As in all soft-proofing, no screen output is identical to a print. The idea is to get a view easier for you to make a visual jump to what a print will look like.

For *Measure Tool* settings, they should be set to: Spectral OFF, Reflective ON.

7.6 Papers for Black-and-White Prints

Finding the correct paper for black-and-white prints is even more complicated and demanding than good papers for color. Why? The classic black-and-white prints are based on silver-halide, photographic paper quality levels that are not that easy to match. As with color, there are three sorts of papers that photographers prefer:

➤ *In appendix D, you will find some URLs for several resellers of fine art papers.*

- ▶ Matte fine art papers
- ▶ Satin papers with a very soft gloss finish
- ▶ High-gloss papers

Baryt papers – or those emulating the appearance of Baryt papers – can be considered to be yet another class of papers. They come with a glossy, semi-gloss, or a matte surface, all having a smooth surface. While most of the glossy types will be bright white, there are some variations in the Baryt papers that have a warm color – e.g., Harman Baryta Matt FB Mp Warmtone. While Baryt papers do produce very fine results with color prints, black-and-white prints is where they really shine.

As we discussed earlier, you cannot reach the same contrast and Dmax (maximum color density) on matte papers as is possible on glossy papers, and papers with a natural or even warm white will allow for less Dmax than those that are bright white. On the other hand, some matte papers, with their soft cotton surfaces, look just great. For a list of the papers we tested and which we recommend for black-and-white prints, see appendix B.5.

➤ *As matte papers are even more sensitive to dirt and sweat from finger prints, don't touch the paper without wearing cotton gloves and even then avoid touching the printing area.*

More Information on Black-and-White Printing

Clayton Jones [47] has a very instructive Web page on fine art black-and-white printing. Uwe Steinmueller also provides a series of papers on black-and-white photography and printing, and also provides a forum on "Digital B&W processing and printing".*

* *See www.outbackphoto.com/artof_b_w/index.html*

Camera: Nikon D1X

Image Evaluation and Presenting Fine Art Prints

8

Image Evaluation

An image for fine art printing will likely be evaluated and judged many times, starting with the first inspection after downloading from the flash card of your digital camera or after scanning. Typically, only very few of these photos will make it to fine art printing. Before you begin actually printing, you should give the image an additional close inspection, looking for minor faults like dust spots, or dead or hot pixels. Do this at least at a zoom level of 100%. Next, we recommend you make a test print on lesser-quality paper and possibly a somewhat smaller-sized print.

Repeat a close inspection, increasing scrutiny for minor deficiencies. It may even be helpful to use a magnifying glass. You may be surprised how many minor deficiencies you will find. If you proceed with an image containing defects, you'll have to patch them in Photoshop.

A test print done on a paper different from the final print is useful for the purpose described above, but not for examination of the proper colors. This inspection is next.

Presentation of Fine Art Prints

Even when you have a beautifully printed image, there is still work to be done. The image must be prepared for presentation. A nice image looks better when it is well-matted, and a framed image looks best of all. This chapter will cover presentation techniques, focusing mainly on matting.

You matting and frame choice may be strongly influenced by your personal taste – or that of a buyer or gallery. There are virtually millions of ways for matting – single matting or double matting with different colored mats or even no matting at all – and of framing or direct mounting on various kinds of boards. Here, we will mainly restrict our discussion to the technical side and will not go into any discussion on taste.

8.1 Critical Image Inspection

It may be helpful to use a magnifying glass for closer inspection. But this is more for seeing the printing dot pattern in a more technical way than to see the impression the print will have.

In the first inspection of your prints, you should look for obvious flaws in your print – tiny dust spots you didn't notice in your digital image, some dust or tiny paper fragments that came on when printing, or for stripes or banding.

The final inspection is for the correct colors of your print. Section 8.7 discusses using standardized daylight D50 for a proper inspection of colors, because that's the light today's color management systems target and rely upon. When you have a normal ICC profile, its colors are based on D50 light. Today, only a few profiling systems support other lighting, although this will be a feature any good package will have in the future.

You might argue that the print will probably not be viewed under D50 light, since most *normal* lamps have a somewhat different light spectrum. Nevertheless, your first inspection for correct colors should be done using a D50-compliant lighting. How do you achieve that? There are a number of ways – some simple and cheap and also more expensive ones:

▸ The professional way would be to use a D50 lightbox (viewing box) as seen in figure 8-1. There are boxes that serve for viewing and judging transparencies, as well as prints (incidental light).

With some boxes, you may even dim the light to a level at which you can compare the print to an on-screen image side by side, both with the same brightness level. This kind of box is the proper choice for print shops and final press work. With a price tag of about $500–$1,000, they aren't cheap and they take up valuable space on your desk top. Some of them offer different light sources, providing D50, D65 and D75.

Figure 8-1: Lightbox XL for viewing A3+ sized prints (Courtesy Quato Technology, Germany)

▸ Use of a D50-compliant luminary. This method is usually less expensive, about $100–$150. The point of these lamps is their D50-compliant light source and neutral white reflector.

There are several companies offering such daylight lamps: SoLux TrueColor Task Lamp ([77], see figure 8-2), the Ott-Lite TrueColor light ([75]]) or the Sol-Source by X-Rite ([78]).

We use the Sol-Source.

When you wish to inspect large-scale prints, you will probably want to use color viewing lamps like GRAPHICLITE 100 by GTI Graphics Technology ([71]) as they are used in printing companies. They consist of any array of fluorescent tubes with a color temperature of 5,000 K.

▸ Buy a D50-compliant bulb or tube, and use it in a lamp with a neutral white or a pure silver reflector. Your investment will be about $15–$25, including the lamp fixture.

We recommend avoiding fluorescent tubes, at least in small-scale solutions, as their light spectrum is not even and typically shows several spikes (see figure 8-24 on page 217). SoLux and Ott-Lite offer these kinds of bulbs/tubes. Some also recommend Philips TL-950 5,000 K

Figure 8-2: SoLux TrueColor Task Lamp with a light spectrum close to natural daylight (4,700 K/D50) (Courtesy Tailored Lighting Inc.)

fluorescent bulbs, or Philips Colortone F40T12/C50, as reasonably priced alternatives.

Figure 8-3:

Three types of "daylight" bulbs. While the left two are more suited for image and color inspection, the bulb on the right is filtered and halogen based (SoLux MR 16, 4 700 K), and may also be used for illuminating a print on the wall.

▸ Inspect your print in bright daylight. As the spectrum of daylight changes through the day, the best time for this will be around noon. Though the least-expensive solution, it is also the least reliable one. If you must rely on daylight, you should at minimum use the light indicator strips described on page 204 (see figure 8-4).

In most cases, your lighting does not really have to be exactly 5,000 K, but should be reasonably close to it. A light source in the color temperature range of 4,500 to 5,500 Kelvin is probably close enough. An even and balanced color power spectrum is probably more important, as color power spikes (e.g., from most fluorescent tubes) may skew some colors. This is why we prefer daylight-balanced halogen lamps.

Before you begin a color inspection, the print should be completely dry. The time required for this depends on the type of ink and paper used, but one hour should be the minimum time, as the color will change slightly during the drying process.

If you intend to coat your print (see section 8.6), we recommend doing a second inspection after coating and drying of the coating. Coating will influence the appearance of colors.

For a critical color inspection, your environment should be color neutral. Avoid colored wall papers nearby or any other colored reflection from nearby objects. Use a neutral white, gray or black background for your image. Environmental colors influence your color perception! It is well worth first using a bright light, or working close to the lamp, for inspection and using a normal-intensity light for color judgment. *Normal* here meaning about 150–400 lux, about the standard office-light intensity.

For final color inspection, you should provide a light situation similar to one the print will probably be viewed under. This, again, may influence your colors, plus some metamerism may occur. In some cases, you must go back in the entire printing process to slightly correct an image. Some newer versions of printer-profiling packages allow for this eventuality, when gen-

8.4 Matting

True Matting

Note: For your matting, mounting and framing work all materials should be archival (P.A.T.-certified).

The most common form of fine art print presentation is matting. While there are many different styles of matting, we cover some methods commonly used by fine art photographers.

▶ **Back Mat:** This may be regular mat board or archival foam board.

▶ **Mats:** The two principle styles are *single matting* and *double matting*. We mainly use single, natural-white mat boards.

The color of the mat board should harmonize with the colors of the image. Picking one of the image colors and lightening it or darkening it a bit is one way to achieve this. At the same time, the matting should show a clear contrast to the outer sides of the image to clearly separate image and mat.

More on mats:

▶ Museum boards are 8-ply thick (used often for black-and-white matting)

▶ Most boards are 4-ply (used by us)

▶ Boards need to be archival

▶ Boards are available in many colors (we prefer simple, natural white)

▶ You can use your own mat cutter, purchase precut mats, or order mats from a custom mat-cutting service. Remember that blades need to be very sharp, otherwise they make, if cutting your own mats, ragged corners. Change blades often!

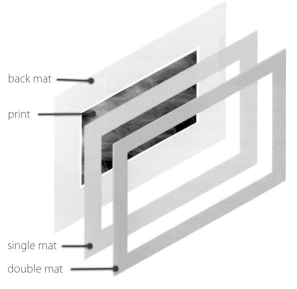

back mat

print

single mat

double mat

Figure 8-8: The matting process

Principles of the Matting Process

▶ Always print pictures with white borders at least 1" wide.

▶ Use heavy paper so that your photos do not curl. De-curl prints, if needed. We usually use paper of 250–350 gsm mats in an attempt to avoid curling.

Using precut mats or letting the mats be cut by a matting service might be a good start if you do not have the right tools and some experience in mat cutting.

▶ The first step is to mount/hinge the print onto the back-mat. We hinge the print to avoid possible side-effects of heat or glue.

Thin or large prints need to be cold- or heat-mounted (glued to the back mat). Both methods are quite delicate tasks. Testing is suggested to see how your paper behaves. We will later show a procedure to hinge a print.

▸ Cut the first mat and place it on top of the print. Here are two principle strategies for cutting the top opening in a mat.

#1: The mat opening is wide enough to show the white boarder, and a possible signature (you may prefer to tone the photo paper to match the mat).

#2: The mat hides the white border of the print.

▸ Optional: Cut a second mat if you prefer double mats.

As when handling fine art papers, wear cotton gloves when handling your mats!

Matworks! helps with your calculations

For the PC, there is a helpful, free program by Giorgio Trucco called "*Matworks!*" ([60]) which you may download from Giorgio's internet site. Matworks! aids in the calculations of mat openings:

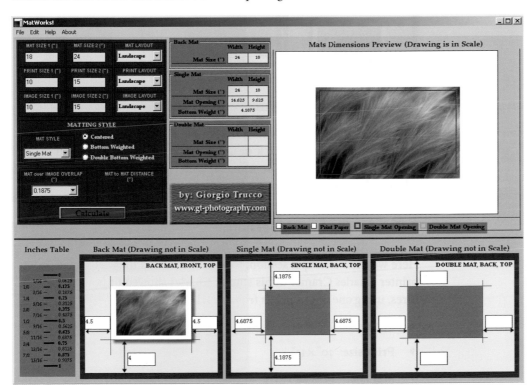

Figure 8-9: Matworks! main dialog

You enter the following values (see figure 8-9 and 8-10):

▸ **Back-mat size:** Here, 18″ × 24″

▸ **Size of the print paper:** Here, 13″ × 19″

▸ **Print size:** Size of the actual print on paper you want to display. For our example, it is 10″ × 15″.

8.6 Coating a Print

With canvas-based prints, usually no frame, glass or acrylic cover is used. In this case, it is recommended to cover the print with a protective coating. The same is true when mounting a print on foam board or other type of board to display it with no covering at all. For prints presented outdoors, coating is an absolute must. There are two specific problems with coating:

1. There are few coatings on the market that have a proven record for being truly archival (conservation quality).*

2. The coating will, to some extent, influence colors. For this reason, if color confidence is an issue, you should use an ICC profile based on a coated print. Print the image on the preferred paper, coat it, then profile this combination.

When coating, be sure the coating is suited for the kind of ink and the type of paper surface used with the print. Some coatings are only suited for dye-based inks, while only a few coatings are suited for matte or semigloss prints.

There are several ways to apply the coating, such as with a brush, a roller (we prefer a foam roller), or by spraying. Applying the coating with a brush or roller gives the surface a somewhat artistic special touch. In any case, it must be done very carefully, while avoiding dust. There is a genuine risk of spoiling a print when coating. It is advisable to test the coating method using a scrap print, before experimenting on a prized photo. Carefully clean the print prior to coating, and be certain that it is thoroughly dry. A good rule of thumb is to wait a minimum of one day after printing a photo prior to coating.

When framing a coated print, allow the coating ample time to dry before framing or storing.

When working with a spray-on coating, wear a face mask, goggles, and gloves, and work in a well-ventilated area. Maintain a stable room temperature of about 64°–77° Fahrenheit (18°–25° C).

* One product, recommended by several photographers and having a test certificate by WIR, is PremierArt Print Shield ([111]). It is offered as a spray or a liquid that may be rolled on or otherwise applied to prints.

Figure 8-23: PrintShield by PremierArt is one of the proven post-coatings and available in several packaging sizes and for matte as well as for gloss papers.

Laminating a print

Lamination effectively seals and protects an entire print from humidity, soiling, and atmospheric pollutants. With pigmented inks, laminating also provides a highly homogeneous gloss. In theory, laminating should improve lightfastness, however, studies show that this is not always the case, even in instances that followed the high-quality techniques used by some museums.

High-quality lamination requires specialized tools, therefore the services of a reputable print shop may be preferable for this process.

In our opinion, laminating may give the photo a somewhat *plasticky* appearance.

8.7 Displaying a Print in True Light

Lighting is a prominent concern when shooting a photograph. Light is also an important factor when presenting a photograph, as the impression of a printed image is very much influenced by its external lighting.

As mentioned previously, digital color management assumes that Daylight 50 (D50) will be used for image viewing (or inspection). Prints produced by our inkjet driver* are fine-tuned and color-corrected while viewing them under D50 illumination. Employing different lighting management systems may lead to incorrect coloration and/or "metamerism".

** Or any other color-managed printing technique*

Metamerism is an effect wherein two colors appear identical when viewed in one type of lighting, but look different when viewed in another type of lighting (or vice versa). The degree of metamerism may depend on the inks used, the ink mix used, the weaving pattern (dithering) employed, and a variety of other factors. But even when there is no noticeable metamerism, colors may change when viewed under different lighting.

The Characteristics of Light

When hanging your own prints or consulting with a customer about how they intend to display a print, it is important to understand the qualities of various forms of light.

Let's have a look at a few common types of lighting:

▸ Daylight (D50)
▸ Tungsten Light
▸ Sunlight
▸ Fluorescent Light

Figure 8-24 shows the various light characteristics of typical types of lighting, and suggests how the appearance of an image can change according to the lighting used.

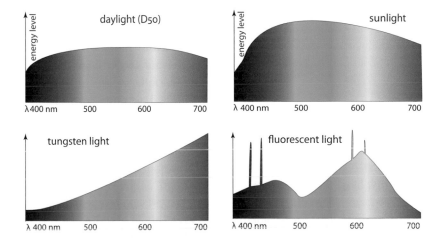

Figure 8-24:
Light spectrum characteristics of typical lighting options

Camera: Caonon 4oD

Some Fine Art Printers

A In this appendix A, we try to off-load the description and handling of different printers. We only discuss fine art printers working with pigmented inks. Using the standard inks offered by the printer manufacturers and a good fine art paper will guarantee a high lightfastness and longevity of the print. Using a good profile is another prerequisite for good prints.

As Epson, Hewlett Packard, and Canon have printer lines where features like ink types, print resolution, standard handling, and the driver dialogs are almost identical. The main difference lies in the maximum print width and perhaps the sizes of ink cartridges. We will group the printers of these manufacturers and describe their common features.

All three parties offer at least one good entry-level 13-inch fine art printer – e.g., Canon with the PIXMA Pro9500 and HP with the Photosmart B9180 and B8850. Epson has several of them: Stylus Photo R1800, R1900 and R2400, even the Letter/A-sized printer, the Stylus Photo R800.

We will update this appendix with an Internet version when new printers – suited for fine art printing – come out and we have had a change to evaluate them. Therefore, from time to time, pay a visit to Uwe's website: www.outbackprint.com.

Ink Cartridge Volume

Even if your demand for large format prints is not tremendous but you produce a lot of prints, it might be well worth considering buying a large format printer due to the larger ink cartridges available for the LFP. With the Epson lines, for instance, this is 13 ml for the R2400; 80 ml for the Pro 3800; 110 ml or 220 ml for the Pro 4880, 7880, and 9880; and 700 ml for the Pro 11880 (for each color). There are two advantages of larger cartridges: you don't have to constantly replace empty cartridges and the ink is cheaper per milliliter the larger the cartridge is. It's about $ 1.00 / ml with the 13 ml cartridge and about $ 0.40 / ml with the 700 ml cartridge for the Epson printers.

LFP = "Large Format Printer"

ml = milliliter = 1/1000 liter

However, there also is a downside to this if it takes too long to use up the ink of a cartridge: Pigmented inks should be used up in about 12 to 18 months. If it takes longer than that, the pigments in the ink will have settled down, and you will obtain an uneven distribution of pigments in the ink solution. Therefore, don't buy too much spare ink!

➜ *The specifications tell us that the ink should be consumed within six months after being opened.*

Print Plug-ins

Canon and Hewlett Packard provide a special Photoshop print plug-in for some of their printers. These plug-ins extend the printer driver interface, trying to gap the overlapping and deficiencies of the print interface of the application, operating system, and the printer driver. These plug-ins can add value at two main points:

A. Allows you to pass full 16-bit data on to the printer driver.*

B. Reduce the overlap of the interfaces mentioned above by merging all these into just one interface, and also allows you to save presets that include parameters previously set in any of these other dialogs.

** In some cases, this might help to avoid banding and result in smoother gradients.*

What we see today is the first generation of these plug-ins. We especially like the plug-in provided by Canon for the iPF5000/5100 and 6100 lines. The disadvantage of these plug-ins lies in the fact that, up-to-now, they only work with Photoshop but not with other applications like Lightroom Aperture or other image editors.

See section 5.9 at page 159 for a description of this Canon plug-in.

Printer Linearization and Calibration

Canned profiles (those internally used by a printer driver)** and generic profiles (those provided by a printer manufacturer for its own papers or those offered by a paper or ink manufacturer for its papers or inks) assume a specific color behavior of a given printer line. This only works well when all printers of a line show very similar behavior. If, however, there are significant differences between your specific printer and the one used for profiling, the profile can't provide the best result.

*** Some new versions of printer drivers now offer a color management similar to that of Photoshop, where you can select a regular ICC profile that is installed in your systems profile directory. This, for a long time, was not possible with most printer drivers.*

* You need one of the spectrophotometers supported by this tool to do the re-calibration. (The Epson Color Base tool does not work with the R800/R1800 printers, however.)

➡ With thermal print heads used by Canon and HP, this is easier, as there is a large number of nozzles per print head and ink. The HP Z3100, for example, uses 1,056 nozzles per color/ink.

Epson tries to compensate for this by explicitly linearizing each printer before it leaves the factory. The technology of the Epson print heads attains a very long head life with very little decrease over time. Additionally, Epson offers *Epson Color Base*, a tool to re-linearize your Epson printer.* You can download this free utility from:

http://esupport.epson-europe.com/FileDetails.aspx?lng=en-GB&data=zbff+0TjloFfsAjU002FDBsyGPdJYjSXVqNJ&id=318746

Another way to compensate for differences between individual printers of the same line is to do a nozzle clogging detection. Having such a detection mechanism for clogged nozzles allows the printer to initiate a nozzle-cleaning cycle or even to substitute for unrecoverable clogged nozzles by firing other nozzles of the same ink. This technique, for instance, is used with the Epson Pro 11880, the Canon iPF6100 and the HP B9180.

The most elegant solution to this problem is to have a spectrophotometer integrated into the printer. This is a feature offered by HP's Z3100 line. Supported by the calibration software that comes along with this printer, it allows you to generate custom profiles for your individual printer, ink and paper. The effort for this is a bit more than an automatic nozzle clogging detection and correction, however, it offers more opportunities. A somewhat simpler solution is a printer-integrated densitometer (measuring how much ink is laid down by a print head) and automatically compensating for variation in this. This is a feature, for instance, used by the Epson Pro 11880, Canon iPF6100, iPF 8100, and iPF 9100.

Ways to Prevent Nozzle Clogging

Nozzle clogging is one of the big hassles when working with inkjet printers and pigmented inks. But there are ways to reduce this problem. Some of them are generally applicable, while others depend on the printer you use.

A general rule is to try to prevent dust from entering your printer and thus coming close to your print heads. Therefore, when not printing for a while, close the lid of your printer (with desktop printers) or cover your printer with a tarpaulin.

As mentioned before, remove any paper dust before feeding paper to the printer. This is especially important when using cotton-based papers.

** Nevertheless, we recommend that you power on the printer once a week. This will start a nozzle-cleaning cycle.

Another point concerns whether to keep your printer powered-on or off when not printing for a while. With Epson's desktop printers (e.g., the R1900, or the R2400), it's preferable to power off the printer, as the print head will be parked in a position, where the head is covered. This prevents the ink in the nozzles from drying up and clogging the nozzles.** With the HP and Canon printers discussed here, it's better to keep the printer powered on. This way the printers will run nozzle-cleaning cycles from time to time, thus preventing the nozzles from clogging. The ink used for these cycles is minimal and preferable to nozzle clogging in any case. Another point is the electric power consumed by this power-on state. The power

consumption in sleep mode differs from manufacturer to manufacturer and from model to model – and from printer generation to printer generation and is steadily reduced by newer generations.

Printer Life Cycles

Manufacturers usually replace a printer line about every two years. Updates might be minor or major. Epson, for example, in 2002 came out with its first line of pigment-based printers: the Stylus 2000P, Stylus Pro 7500 and 9500. In 2004, the next generation followed consisting of the R2200, Pro 4000, Pro 7000, and Pro 8000. In 2006 the R2400, Pro 4800, Pro 7800 and Pro 9800 replaced these lines. With this update, the new UltraChrome K3 ink set replaced the second generation of pigmented Epson inks. The big step forward was the usage of three different dilutions of black inks, improving the color gamut as well as reducing bronzing and metamerism. This, to a large extent, rendered superfluous the need to switch a third-party ink set in order to obtain good and neutral black-and-white prints.

By the end of 2007, these Epson Pro lines were replaced by the Pro 4880, Pro 7880, Pro 9880, and the 64-inch printer Stylus Pro 1180 was added. Again, the ink set was improved by replacing Magenta with Vivid Magenta, extending the color gamut once more. Epson argues that with the 8 inks used in these lines, they can achieve very much the same gamut HP and Cannon achieve using 12 inks. We expect to see an update for the R2400 and R3800 in 2008, or early 2009 at the latest.

Both Canon and HP entered the market for fine art printers using pigment-based inks only in 2006. Canon updated their first generation of pigmented inks quite soon. In 2007, Canon followed up its iPF5000 (17-inch printer, 12 Lucia pigment inks) with the iPF5100 (17-inch printer, 12 Lucia II pigment inks), which uses its second generation of Lucia pigment inks. Canon also added a 24-inch printer (iPF6100) using the same technology, and a 44-inch (iPF8000) and 60-inch printer (iPF9000), both using 12 pigmented inks (Lucia). For Canon printers intended for fine art prints, we prefer the newer iPF5100 and iPF6100 line with the second generation of pigment-based inks (called *Lucia II pigment*).

In 2006, Hewlett Packard started out with the 13-inch B9180 using eight pigmented inks and the Z3100 (24-inch or 44-inch wide) using 12 pigment inks. HP also has the Z2100 line (24-inch or 44-inch wide) that works with eight pigmented inks. The Z2100 produces fine color prints; for black-and-white prints, however, the Z3100 line yields better results – at least when using gloss or semi-gloss papers or one of the new Baryt papers described in appendix B.3. In 2008, HP replaced the Z3100 with the Z3200, introducing a number of minor, but nevertheless important improvements.

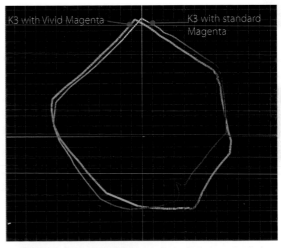

Figure A-2: Replacing Magenta with Vivid Magenta (with the new K3 ink set used by the Epson Pro 4880, 7880, 9880 and 11880) slightly shifts the gamut towards saturated Cyan and extends the gamut in the saturated Magenta areas (on Epson Traditional Paper with the Pro 4800 and Pro 4880).

There are some more inkjet printers using pigment-based inks. For example there is the Kodak EasyShare 5300 using 4 inks (C, M, Y, K), which is more of a good office printer than a fine art printer, and there is the Canon W6200 (also using 12 pigment-based inks). Additionally, there are the Canon iPF8000S (44-inch) and iPF900S (60-inch), both still using 8 inks (*Lucia pigment*) but higher print speed. With HP there is the Z2100 line using eight pigmented inks (both in a 24-inch and a 44-inch version). However, the support of all these latter printers by paper manufacturers concerning printer profiles and other information is very limited or non-existent.*

** But you can still build your own profiles, of course.*

With the printers mentioned here, the real life cycle of a printer naturally can be much longer than the 2–3 years mentioned above. With HP and Canon printers the user can even replace the print heads when quality declines. However, before replacing all six print heads, e.g., with a HP printer, you might consider replacing your printer, depending on the cost per head. Epson uses print heads with different technology and a very long durability. For Epson printers, head replacement should only be done by the Epson service.

When upgrading to a new printer, your "old" printer can still be useful, e.g., for special inks like the multi-tone black-and-white inks, for test prints, or for special media. Keep in mind, however, that you will need new profiles when using different ink sets.

You will find an open forum on Uwe's Internet site where a number of questions concerning fine art printing and appropriate printers are discussed. You will often find an answer to your problems on that site and also put your own questions there: www.outbackphoto.com/tforum/

Figure A-3:
The history of digital fine art printers is much younger than this old factory.

A.2 Epson Fine Art Printers

Epson was the first company to create a complete line of professional and semi-professional printers, using only pigmented inks to allow for better longevity. Epson still has the broadest range of pigment-based printers, starting with several entry-level printers: Stylus Photo R800, 8.5-inch (letter), Stylus Photo R1800 and R1900 (both 13-inch print width) and the Stylus Photo R2400 (also 13-inch). The Pro lines start with the Stylus Pro 3800 (a 17-inch printer) and goes up to the 64-inch Pro 11880 with intermediate steps of Pro 4880, Pro 7880, and Pro 9880.

In this chapter, we will cover the newest models, introduced mainly in 2006/2700. Epson today (2008) has four major lines of ink sets for fine art printers:

▶ **UltraChrome™ Hi-Gloss** inks (consumer printers, e.g., Stylus Photo R800, R1800). The ink set consists of eight inks: Photo Black, Matte Black, Cyan, Magenta, Yellow, Red, Blue, and a Gloss Optimizer).
The primary target of these printers is the amateur photographer. These inks are best used with Glossy and Semi-gloss RC papers. Black-and-white prints are not quite as good as with the next two ink sets mentioned.

▶ **UltraChrome™ Hi-Gloss II** inks (used with the Stylus Photo R1900). The ink set consists of 8 inks: Photo Black, Matte Black, Cyan, Magenta, Yellow, Red, Orange, and a Gloss Optimizer (thus substituting the blue ink of the Hi-Gloss I ink set with an orange ink).

▶ **UltraChrome™ K3** inks (professional and semi-professional market, e.g., R2400, R3800, R4800, R7800, R9800). The ink set consists of nine inks: Photo Black, Matte Black, Light Black, Light Light Black, Cyan, Magenta, Yellow, Light Cyan, Light Magenta. This set can be used with Glossy and Semi-Gloss or Luster papers (where Photo Black is used). With Semi-matte and Matte papers, Matte Black is used.

▶ **UltraChrome™ K3 inks with Vivid Magenta** (up-to-now, professional market only: Pro 4880, 7880, 9880, 11880). This is the newest set of Epson inks for fine art printers. Vivid Magenta slightly extends the gamut of the inks, yielding a somewhat richer total gamut. While this might not be that important with most fine art prints – these colors are rare in nature –, it helps with the reproduction of some logos and poster prints displaying computer generated graphics and colors.
We assume that by the end of 2008, all semiprofessional and professional Epson printers that use pigment-based inks will use these type of inks.

We assume, that in 2008 a new version of the R800 will also come out that will use this ink. It appears that Epson has positioned the R1900 as the replacement for the R1800, and will stop the sale of R1800.

(Courtesy Epson Europe)

Figure A-4: Complete UltraChrome K3 ink set (220 ml cartridges for the Pro 4880, 7880, or 9880)

➜ Early 2008, the R1800 was followed up by the R1900, featuring the 2ⁿᵈ generation of UltraChrome™ Hi-Gloss inks (called Hi-Gloss II).

Epson Stylus Photo R800 / R1800

Inks: These entry-level printers feature the same ink set (Epson UltraChrome™ Hi-Gloss, 8 inks) using pigmented inks:
Photo Black, Matte Black, Gloss Optimizer,
Cyan, Magenta, Yellow, Red, Blue

These printers simultaneously use only 6 inks (plus, optionally, the Gloss Optimizer). Photo Black and Matte Black are used for glossy and matte papers, respectively. The use of the Gloss Optimizer, targeted on High-gloss, Gloss, Semi-gloss and Luster papers, is optional.

Ink sets: 8 single inks/cartridges, 13 ml each.

Printing Technology: Eight-Channel MicroPiezo print heads. Head replacement has to be done by Epson service.

Print Width and Paper Specs:
R800: 8.5 inch / A4 (up to 1.2 mm), cut sheet or roll
R1800: 13 inch / A3+ (up to 1.2 mm), cut sheet or roll

Interface: USB 2 (HiSpeed) + FireWire (IEEE 1394)

Special features: Print directly on inkjet printable CD/DVDs

Drivers: Standard drivers are provided for Windows (2000, XP, Vista) as well as Mac OS X (PPC + Intel).

Figure A-5: Epson Stylus Photo R800 (Courtesy Epson Europe)

Introduced 2008

Epson Stylus Photo R1900

Inks: Epson UltraChrome™ Hi-Gloss II, 8 pigment-based inks:
Photo Black, Matte Black, Gloss Optimizer,
Cyan, Magenta, Yellow, Red, Orange

Ink sets: 8 single inks/cartridges, 13 ml each.

Printing Technology: Eight-Channel MicroPiezo print heads. Head replacement has to be done by Epson service.

Print Width and Paper Specs: 13 inch / A3+ (up to 1.2 mm), cut sheet or roll

Interface: USB 2 (HiSpeed) + FireWire (IEEE 1394)

This printer will probably completely replace the R1800 in the near future.

Figure A-6: Epson Stylus Photo R1900 (Courtesy Epson Europe)

Printing with the Epson Stylus Photo R800/R1800

The R1800 and R800 are entry-level fine art printers using only six true colors. The Photo Black and Matte Black are used for glossy and matte papers, respectively. So, for a single print, only one is used.

Gloss Optimizer is not true ink. It controls colors by improving the glossy appearance of your print. It produces less bronzing and gloss differential. Unless printing on very glossy media, you may not need the Gloss Optimizer at all. In any case, test-print your papers both with and without Gloss Optimizer.

Note: Because R1800 and R800 only use a single black ink these printers are not an ideal choice for photographers who want excellent black-and-white prints. These printers may, however, for some images produce nice, black-and-white prints, in spite of this apparent flaw. Epson's semi-professional model R2400 is a better choice for optimal black-and-white prints,

Figure A-7: Epson Stylus Photo R1800
(Courtesy of Epson America Inc.)

Driver Settings Recommendations

What is covered here is not intended to replace your printer's manual. As usual, we assume you do all your color management inside the printing application (e.g., Photoshop).

Paper selection • Most users choose single-sheet feeding with this printer (from the paper tray). When using roll stock, select it at this time.

Paper Type • Try to make a very close match here. If you use a third party paper, you will have to guess which Epson paper would be right.

Print Quality • The available quality settings will depend on the paper used. The highest-quality setting is *Photo RPM* (RPM stands for *Resolution Performance Management*), and this selection often produces the best results at a price of speed and ink. Often, a lower-quality setting may produce results close to maximum quality, but requiring less ink and resulting in faster printing time. We usually use "Best Photo".

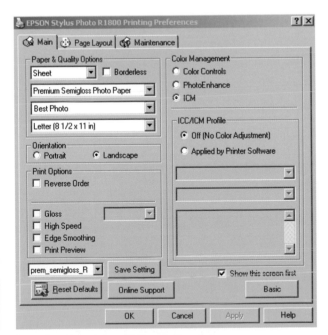

Figure A-8: Epson R1800: Main print driver dialog

Paper Size • Most often you will find your paper size listed. But, in some cases you may also need to create a custom size. Select "User Defined," and follow the instructions.

Orientation • Choose whatever is needed: Landscape or Portrait mode.

Print Options

Gloss: **Use** only for highly glossy media
High Speed: Uncheck this option for best quality
Edge Smoothing: Deactivate for fine art photos
Print Preview: We normally turn it off.
Be aware that preview colors may look incorrect, because they are not color managed.

Saved Settings

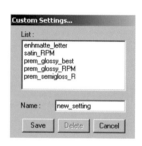

In most printing, you use only a small number of different papers, with few variations in their settings. Having found the proper settings for a certain type of print job and paper, you can save current settings and recall them much more quickly later on. This practice also helps avoid costly mistakes (ink, paper and time).

Color Management in the Printer Driver

With the R1800 and R800 we always turn printer CM off, and do the profile selection and color control inside Photoshop. The dialog of the printer driver settings shows exactly how.

Ink Monitor

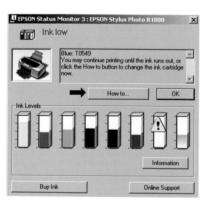

Figure A-9: Ink-low warning

With Epson printers, we print until we see an ink-low warning. When you get this message, make sure you have a replacement ink cartridge available because the printer will soon be out of ink, and some printers will stop printing.

Maintenance Tools

Most printer sets include some maintenance tools. With most Epson printers, the maintenance application may be called up from the printer driver interface. It offers some useful functions (see figure A-10 on page 231):

Status Monitor • Shows the ink level dialog (see figure A-9).

Nozzle Check and Cleaning • Select this when you have not used the printer for some days. Check for banding or missing colors. Be aware that this procedure consumes ink.

Nozzle Check (manual) / Head Cleaning (manual) • Use these only when you feel there is a major problem. Again, Head Cleaning will consume quite a bit of ink.

Print Head Alignment • Perform when you see banding.

Printer and Option Information • We rarely use these options. Check your manual when you think you may need them.

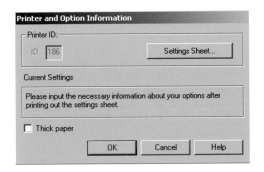

*Figure A-11:
Printer information. You may
activate "Thick paper" here.*

*Figure A-10: Maintenance tools called from the printer driver
interface by selecting tab Maintenance.*

Manufacturer-Provided Profiles for R800/R1800

Epson provides quite good generic profiles for their own papers. You can further improve color fidelity by using custom-made ones. Most profiles come specifically targeted to certain print quality settings. Check that your choice of profile (in the client application, e.g., Photoshop) matches your print quality settings (*Photo, Best Photo, Photo RPM*).

> **Note:** With the R800, some profiles showed some "smudging." Check for more details in our R800 review [42], which is written in a diary style, and which we update periodically.

SPR1800 D- S Matte Paper.icm
SPR1800 Enhanced Matte.icm
SPR1800 Matte Paper- HW.icm
SPR1800 Photo Qlty IJP.icm
SPR1800 Premium Glossy.icm
SPR1800 Premium Luster.icm
SPR1800 Premium Semigloss.icm
SPR1800 Velvet Fine Art.icm
SPR1800 WC Paper - RW.icm
SPR1800_DblSDMtte_BestPhoto.icc
SPR1800_EnhMtte_BestPhoto.icc
SPR1800_EnhMtte_Photo.icc
SPR1800_MtteHvyWt_BestPhoto.icc
SPR1800_MtteHvyWt_Photo.icc
SPR1800_MtteScrapbk_BestPhoto.icc
SPR1800_MtteScrapbk_Photo.icc
SPR1800_PrmGlsy_Photo.icc
SPR1800_PrmGlsy_PhotoRPM.icc
SPR1800_PrmLstr_Photo.icc
SPR1800_PrmLstr_PhotoRPM.icc
SPR1800_PrmSemgls_Photo.icc
SPR1800_PrmSemgls_PhotoRPM.icc
SPR1800_UltrSmth_Wtrclr_BestPhoto.icc
SPR1800_UltrSmth_Wtrclr_Photo.icc
SPR1800_VelvtFneArt_BestPhoto.icc
SPR1800_VelvtFneArt_Photo.icc
SPR1800_WtrclrRdWht_BestPhoto.icc
SPR1800_WtrclrRdWht_Photo.icm

*Figure A-12:
Profiles provided by Epson
for the R1800*

➔ *By the end of 2007 the Pro 4800, 7800, and 9800 were followed up by the new Pro 4880, 7880, 9880, and the 11880 line.*

** There is no Gloss Optimizer with these printers, as Epson argues that the new ink formulas do not require it. On high-gloss papers, however, a slight gloss difference can be seen between blank paper and printed areas. To avoid this, you may use Photoshop Curves to somewhat lower your highlights, thus ensuring that some ink is applied to all areas.*

➔ *The handling of the Epson R2400 is described in much detail in section 5.7. Printing using the Advanced Black and White mode with the R2400 is described in section 7.3.*

Epson Stylus Photo R2400 / Pro 4800 / Pro 7800 / Pro 9800

Inks: All four printers feature the same ink set (Epson UltraChrome™ K3, 9 inks) using pigmented inks:*
Photo Black, Matte Black, Light Black, Light Light Black, Cyan, Light Cyan, Magenta, Light Magenta, Yellow

These printers simultaneously use only eight inks out of the nine. Photo Black and Matte Black are used for glossy and matte papers, respectively. Unfortunately, it is required to switch the Matte Black ink for Photo Black ink when switching from matte to glossy media and vice versa. This procedure costs time and ink, and on the Pro printer line (4800/7800/9800) a substantial amount of ink (ink worth about $70 is used up for every change of black inks).

All four printers have three different blacks available at any one time (Photo or Matte Black, Light Black, and Light Light Black) allowing them to produce very good black-and-white prints with a highly neutral look and smooth gradients.

Ink sets: 9 single ink cartridges, only 8 online simultaneously
R2400: 13 ml each
Pro 4800, 7800, 9800: 110 or 220 ml each

Printing Technology: Eight-Channel MicroPiezo print heads.
Head replacement has to be done by Epson service.

Print Width and Paper Specs: The four printers each allow for different maximum print widths:

R2400: 13 inch (up to 1.2 mm)
Pro 4800: 17 inch (up to 1.5 mm)
Pro 7800: 24 inch (up to 1.5 mm)
Pro 9800: 44 inch (up to 1.5 mm)

All of them allow for borderless prints (using cut-sheet paper) up to their maximum print width and allow for cut-sheet feeding (including a cut-sheet tray). They also come with a roll-feeder and a paper cutter (the cutter is missing with the R2400).

Figure A-13: *Epson Stylus 4800 (Courtesy Epson Germany)*

Interface: R2400: USB-2 (HiSpeed) + FireWire
Pro 4800, 7800, 9800: USB-2 (HiSpeed) + LAN
 (Ethernet 10/ 100Base-TX).

Drivers: Standard drivers are provided for Windows (2000, XP, Vista) as well as Mac OS X (PPC + Intel).

Special features: All printer drivers offer an advanced black-and-white mode.

Epson Stylus Pro 3800

Introduced in autumn 2006.

Inks: This printer features the same ink type (Epson UltraChrome™ K3, 9 inks) using pigmented inks as the R2400, and the Pro 4800, Pro 7800, and Pro 9800). No Gloss Optimizer is used:
Photo Black, Matte Black, Light Black, Light Light Black, Cyan, Light Cyan, Magenta, Light Magenta, Yellow

It allows, however, for 9 inks in the printer at the same time, but uses only 8 inks with a single print, switching automatically between Photo Black and Matte Black, depending on the paper setting. Here, it deviates from the R2400, and the Pro 4800, Pro 7800, and Pro 9800. But it has to clear out the previous black ink when switching, as the print head (there is only one) can only accommodate eight inks. With this printer, however, only very little inks is needed for this switch.

Figure A-14: Epson Stylus Pro 3800 (Courtesy Epson Germany)

A new screening is used (compared to the R2400, and the Pro 4800, Pro 7800, and Pro 9800) using a maximum resolution of 2880 × 1440 dpi. It is the same screening that is used with the Epson Pro 4880, 7880, 9880, and Pro 11880 printers.

➜ *You will find a very elaborated report on printing with the Epson Pro 3800 by Giorgio Trucco in our "Printing Insights #45" at: www.outbackphoto.com/printinginsights/ pio45/essay.html*

Ink sets: 9 single ink cartridges of 80 ml each
(all 9 can be inserted simultaneously)

Printing Technology: MicroPiezo AMC (8-channel) print head, variable drop size down to 3.5 pl*.

* *pl = picoliter, or 10^{-12} liters*

Print Width and Paper Specs: 17 inch / A2 (up to 1.5 mm).

Paper feed: Sheet feed, **no** optional roll feeder available

Interface: USB-2 (HiSpeed) + LAN (Ethernet 10/100Base-TX).

Drivers: Standard drivers are provided for Windows as well as Mac OS X.

Special features: Same advanced black-and-white print mode as all of the Epson printers mentioned here

This is a very nice printer, providing perfect printing quality. The printer is excellent and a good value for the money, especially considering its maximum print width of 17 inches (A2). The large volume of its ink cartridges also offer a better price performance concerning inks (compared to the R2400). What's missing is the possibility to use a roll feeder. If you need that, you will have to use the Epson Pro 4480, which also gives you the choice between 110 ml and 220 ml ink cartridges.

Introduced 2007 **Epson Stylus Pro 4880 / 7880 / 9880**

Inks: All three printers feature the same ink type (Epson Ultra-Chrome™ K3, 9 inks), using pigmented inks. The new generation of UltraChrome K3 inks includes a "Vivid Magenta" replacing the standard Magenta of the previous line (R2400, and the Pro 3800, 4800, 7800, 9800):*

** There is no Gloss Optimizer with these printers, as Epson argues that the K3 ink formula does not require Gloss Optimizer.*

Photo Black, Matte Black, Light Black, Light Light Black, Cyan, Light Cyan, (Vivid) Magenta, Light Magenta, Yellow

These printers simultaneously use only **eight** inks. Photo Black and Matte Black are used for glossy and matte papers, respectively. It is required to switch the Matte Black ink for Photo Black ink when switching from matte to glossy media and vice versa. This switch on the Pro printer line uses a substantial amount of ink (about $70 is used up for every change).

These printers have three different blacks available at any one time, Photo or Matte Black, Light Black and Light Light Black, allowing them to produce very good black-and-white prints with a highly neutral look and smooth gradients.

Figure A-15: Epson Stylus Pro 4880 (Courtesy Epson Germany)

A new (compared to the 4800, 7800, 9800 line) screening is used with a maximum resolution of 2880 × 1440 dpi. It is the same screening that is used with the Epson Pro 3800. Additionally, the print heads have an ink repelling coating.

Ink sets: 9 single ink cartridges of either 110 ml or 220 ml, only 8 online simultaneously

Printing Technology: Eight-Channel MicroPiezo® AMC™ Print Head with Ink Repelling Coating Technology; variable drop size down to 3.5 pl.

Print Width and Paper Specs: The three printers each allow for a different maximum print width:

Pro 4880: 17 inch (up to 1.5 mm)
Pro 7880: 24 inch (up to 1.5 mm)
Pro 9880: 44 inch (up to 1.5 mm)

All of them allow for borderless prints (using cut-sheet paper) up to their maximum print width and allow for cut-sheet feeding (including a cut-sheet tray) and come with a roll-feeder and a paper cutter.

Interface: USB-2 (HiSpeed) + LAN interface (Ethernet 10/100Base-TX).

Drivers: Standard drivers for Windows as well as Mac OS X. There are 16-bit drivers available (up to now only for Mac OS X).

Special features: Advanced black-and-white mode.

Epson Stylus Pro 11880

Introduced 2007

Inks: This printer uses the same ink type (Epson UltraChrome™ K3, 9 inks) as the new Pro 4880, 7880 and 9880 lines. This new generation of UltraChrome K3 inks includes a "Vivid Magenta" replacing the standard Magenta of the previous line.
Photo Black, Matte Black, Light Black, Light Light Black,
Cyan, Light Cyan, (Vivid) Magenta, Light Magenta, Yellow

Figure A-16: Epson Stylus Pro11880 (Courtesy Epson Europe)

No Gloss Optimizer is used as Epson argues that the new ink formulas do not require it. Unlike some other printers of this line, this printer can have all nine inks placed in it, but also uses only Photo Black or Matte Black in a single print. It uses the same screening as the Pro 3800, 4880, 7880, or 9880, allowing a maximum resolution of 2880 × 1440 dpi. The print heads have an ink-repelling coating.

Ink sets: 9 single ink cartridges of 700 ml each.

Printing Technology: Eight-Channel MicroPiezo® TFP™ Print Head with Ink Repelling Coating Technology (one 8-channel print head for all colors); variable drop size down to 3.5 pl.

Print Width and Paper Specs: 64 inch (up to 1.5 mm)
The printer allows for borderless prints up to 54 inches in width. The printer allows for cut-sheet feeding and includes a cut-sheet tray. The Pro 11880 also comes with a roll-feeder and a paper cutter.

Interface: USB-2 (Hi-Speed) + LAN interface (Ethernet 10/100/1000 Base-TX).

Drivers: Standard drivers are provided for Windows (XP, Vista (32/64 bit) as well as Mac OS X. There are 16-bit drivers available (up to now only for Mac OS X).

Special features: Advanced black-and-white mode, Auto-Clogging-Detection

This is the high-end of the Epson line. The Pro 11880 not only allows for very large print formats but also uses large ink cartridges, allowing you to replace an ink cartridge while printing. This printer, complemented by a good RIP like ColorByte's ImagePrint, can be the ideal printer for a commercial print service. If provides very high printing speed (e.g., 42:10 min. for a 40" x 60" print at the highest resolution).

➜ In 2008, Epson introduced two new fine art printers:
– The 24-inch Stylus Pro 7900 and
– The 44-inch Stylus Pro 9900
Both printers use eleven K3 HDR pigment inks, and ar capable of installing Photo Black and Matte Black simultaneously. In addition to the inks used by the Stylus Pro 11880, these two printers also use Orange and Green inks to yield and even larger gamut of colors. This extended gamut helps when proofing Pantone colors or when you are making flexographic prints. The ink cartridges are available in capacities of 150ml, 350ml, or 700ml. Both new printers include a spectrometer option for calibration and profiling. All other printing techniques are similar to those we used with the Pro 11880.

A.3 Canon's Fine Art Printers

As mentioned before, Canon is one of the big three companies supplying pigment-based fine art printers. While there was an early version of a Canon printer using pigmented inks (WG620), the real market entry only came in 2006 when Canon announced a number of new printers for this market. The entry-level printer is the PIXMA Pro 9500 using 10 pigmented inks. The professional line started with the iPF5000 (a 17-inch, 12 inks) printer that in 2007 was followed up with the iPF5100 and iPF6100 models.

With these two new printers, Canon introduced a second generation of pigmented inks. The new formula for the blacks achieves less bronzing and lower metamerism.

There are also two large format variations of the fine art printer line. They are the iPF8100, a 44-inch printer, and the iPF9100, a 60-inch printer, both using 12 pigmented *Lucia II* inks. They replace the former iPF8000 and iPF 9000 versions that still use Lucia I pigment inks.

Canon also added two further fast workhorse versions of these two lines. These are the iPF8000S and the iPF9000S. Both use only eight Lucia I pigmented inks. In 2008, Canon introduced the 44-inch imagePROGRAF iPF8100 and 60-inch imagePROGRAF iPF9100 printers. Both printers use 12 separate 330ml or 700ml ink cartridges of the same Lucia II type used in the iPF6100.

Like Epson and Hewlett Packard, Canon offers a number of fine art papers for its pigment-based printers. These papers, as said in appendix B, are the easiest to use when starting with fine art printing using a Canon printer. Up to now, the support of Canon printers by third-party paper manufacturers concerning the offering of ICC profiles has not been as good as has been for the Epson and HP printers mentioned here. This, however, is going to change over time.

Figure A-17:
The Canon iPF9100. This 60-inch printer uses 12
Lucia pigment inks.
(Photo courtesy of Canon Germany)

Canon PIXMA Pro9500

Introduced in 2006

Inks: The printer uses 10 Lucia pigmented inks, but only nine with a single print. It switches automatically between Photo Black and Matte Black, depending on the paper setting, but has only one additional light black ink. There is no Gloss Optimizer:
Photo Black, Matte Black, Light Black, Cyan, Magenta, Yellow, Red, Green, Light Magenta (PM), Light Cyan (PC)

Ink sets: 10 single inks, 16 ml each.

Printing Technology: Thermal BubbleJet print heads, Up to 4800 × 1200 dpi printing resolution, 3 pl.

Figure A-18: Canon PIXMA Pro 9500 (Courtesy Canon)

Print Width and Paper Specs: 13 inch (cut-sheet up to 13" × 19"), also borderless; up to 1.2 mm paper.

Interface: USB-2 + Direct Print Port.

Drivers: Standard drivers are provided for Windows (2000, XP, Vista) as well as Mac OS X (PPC + Intel). There is a special black-and-white mode.

Special features: Photoshop plug-in for direct printing from Photoshop. Can print on suitable CDs/DVDs.

This is a nice, entry-level 13-inch printer using pigmented inks. It can do good black-and-white prints, but having only two dilutions of black ink, it can't provide quite the same quality as the 12-ink versions of Canon printers (e.g., the iPF6100). Like the Epson R2400 (using 13 ml cartridges) and the HP B9180 (using 28 ml cartridges), inks will be more expensive per print than using one of the larger printers that use more voluminous ink cartridges. Being a good, but still an entry-level printer, it is not as well supported by third-party paper suppliers as the iPF5100 or iPF6100. (Even the Epson R2400 is much better supported). One reason for this might be that there are obviously large variations from individual printers of this line coming out of the factory and there is no densitometer feature for this printer. Thus providing good generic profiles is harder for this printer.

However, if you are tight on budget and do not intend to print very much, this printer can be a good choice and we saw some really nice prints coming from our PIXMA Pro 9500.

In 2009, Canon replaced the PIXMA Pro 9500 with the PIXMA Pro 9500 Mark II. The new printer is faster than its predecessor and still uses the same type of Lucia pigment inks as the earlier version.

Introduced in 2007

Canon imagePROGRAF iPF5100 / 6100

➔ *The iPF5100 replaces the iPF5000 that was still being sold in early 2008.*

Inks: These printers use 12 pigmented inks (type *Lucia II*). The printers will automatically switch between Photo Black (here called *Regular Black*) and Matte Black when printing, depending on the paper used (set in the driver settings). No Gloss Optimizer is used:
Photo Black, Matte Black, Light Black (Gray), Light Light Black (Photo Gray), Cyan, Light Cyan, Magenta, Light Magenta, Yellow, Red, Green, Blue

Ink sets: 12 single cartridges, 130 ml each

Printing Technology: 2 thermal print heads (6 inks each)
Heads can be replaced by the user. Up to 2400 × 1200 dpi printing resolution using a droplet size of 4 pl.

Print Width and Paper Specs:
iPF5100: 17 inch (cut-sheet and roll), also borderless
iPF6100: 24 inch (cut-sheet and roll), also borderless
0.08–0.8 mm paper, top-loading; 0.5-1.5 mm, front loading roll holder

Interface: USB-2 + LAN (Ethernet 10/100Base-TX), FireWire optional

Drivers: Standard drivers are provided for Windows (2000, XP, Vista) compatibility as well as Mac OS X. There is a special black-and-white mode.

Special features: Integrated densitometer to do a re-linearization;
Photoshop plug-in for direct printing;
Automatic detection of clogged or non-firing nozzles.*

** This will initiate a nozzle-cleaning cycle. If the nozzle remains obstructed, the printer will automatically compensate by re-routing the ink to functioning nozzles.*

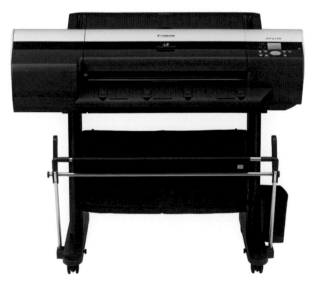

Figure A-19:
Canon imagePROGRAF iPF6100
(Courtesy Canon USA)

Printing with the Canon iPF6100

Figure A-20: Canon iPF6100 in Uwe's print studio

The iPF6100 is Canon's second-generation pigment-based professional printer. In many aspects it has inherited properties from the iPF5000 but there are some new and improved features to look at:

▸ 24 inch (that is 7 inches wider than the iPF5000/5100)
▸ It uses new formulas for its black inks in order to reduce bronzing
▸ Calibration feature

Installation • Installation takes time but is well documented. The printer comes in two basic components: The stand (see figure A-21) and the actual printer. Additionally, there is the set of print heads and ink cartridges (figure A-22) that have to be installed.

Figure A-22:
Installing two heads and 12 inks

Figure A-21: The Canon printer stand (seems very solid)

Note: The heads are quite expensive (more about the head warranty can be found at *http://canonipf5000.wikispaces.com/iPF5100+Printhead+Warranty*).

The first 12 ink cartridges are not 130 ml but hold 90 ml, instead. As much as this may be disappointing the 12 cartridges still hold a lot of ink. Also the Canon iPF printers seem to be quite frugal in their use of inks.

Software • Installing the software was very easy on our Mac Pro (Intel Quad Mac). We connected the printer via USB 2.0 to our primary workstation and used the Ethernet LAN interface to hook up our additional systems. A description of the Photoshop plug-in, available for Photoshop CS2 as well as Photoshop CS3 (these are two different versions), is given in section 5.9 at page 159.

Calibration

One complaint about the iPF5000 was that there were too many variations between individual printers. This makes canned and generic profiles close to useless. The iPF6100 now features a densitometer to linearize the printer. Canon claims that after calibration (linearization) the maximum color difference is about 2.0 Delta-E. (*E* is a measure for the distance between two colors in the Lab color space. Delta-E here is the delta between the color it should have and the color it actually has. A Delta-E of 2.0 (maximum) is very good and not obvious to the human eye.

We have right now no way to verify this, but think that a calibration feature is a must for printers using thermo heads (HP and Canon).

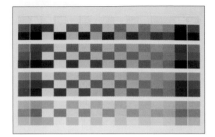

*Figure A-23: Calibration Chart generated by
the driver and used to linearize the printer*

The calibration we did was performed using the Canon Premium Heavyweight Matte paper.

There are some obvious questions concerning calibration: How often should we calibrate and when is calibration mandatory? You will find some answers to this in the printer's manual that comes along with the printer on a CD. You should re-calibrate:

▸ After initial installation

▸ After replacing a print head

▸ If colors seem different from before. However, make sure you are printing under the same conditions and in the same printing environment.

▸ When consistent color is desired from multiple printers. In this case, also use the same version of firmware and printer driver and the same settings.

Using the Driver

Here we show the central dialogs for the Macintosh. The most important settings are defined in the *Main* tab of the driver.

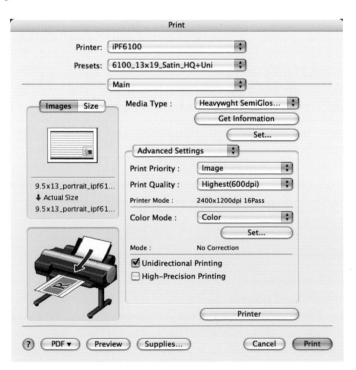

*Figure A-24:
Main settings in the printer driver*

Here are some notes on the various tabs of the printer driver:

▸ "Get Information" is a nice feature because it reads the info from the printer about the currently loaded paper, size, and feed.

▸ Behind Color ▸ Set… you will find the very important Color Settings dialog (figure A-25).

We always use *Application Managed Colors* (in Photoshop) – at least for all color prints. This implies that all printer color corrections have to be turned off in the printer driver (see figure A-25). We would prefer this control to be either in the *Main* tab of the driver or in the *Color Settings* section. The way it is now, this setting is somewhat hidden and you have to use at least two mouse clicks to see the settings in the driver. In practice though, this is not too bad because we use driver presets on the Mac and recommend doing the same on Windows.

There are also some important settings in the *Page Setup* tab (see figure A-26), where you will find the settings for:

▸ Media Source (make sure it is correct).
▸ Print Centered
▸ Sometimes "Rotate Page 90 degrees"
▸ Print Scaling

Note: We can't understand why getting custom paper sizes (especially the landscape and portrait orientations) is often so complicated. But we fight with these settings all the time.

Support Tools

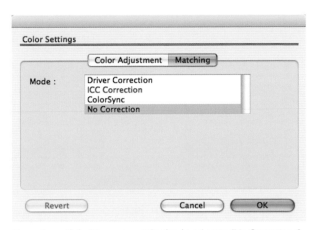

Figure A-25: Color Management (in the driver) set to "No Corrections"

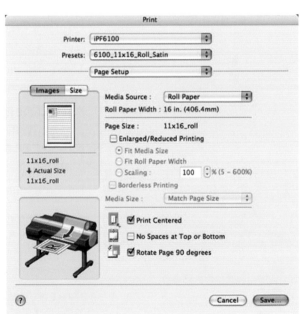

Figure A-26: Page Setup tab of the iPF6100 driver

Figure A-27:
Printer Information and Utility

The iPF6100 driver provides a lot of useful information, e.g., on the ink status and the paper (figure A-28) as well as on the calibration (figure A-29).

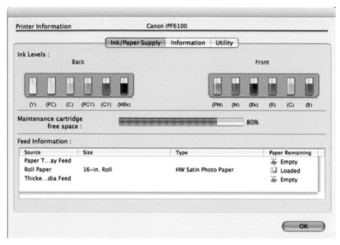

Figure A-28: Ink/Paper Supply

Figure A-29: Calibration information

Printing Experience

As mentioned before, we print often from Lightroom. The presets in Lightroom make our life easier than in Photoshop, as you can put more parameter settings into Lightroom's presets.

Single Sheet Feeding • Sheet-feeding works fine (we tested up to 308 gram papers). We don't like the facts that the single sheet falls into a basket, though we could not detect any damage.

Figure A-30: Mechanism for the roll feeding of the Canon iPF6100

Roll Feeding • The motorized roll feeding works as one would expect, and there is nothing to complain about.

Printing on glossy media • We printed on Canon Heavyweight Glossy and Heavyweight Satin paper from a roll and used Canon's generic profiles for this. Our printer evaluation image looks good on glossy media. We could not detect any disturbing bronzing.

Dmax • We measured a Dmax of 2.1 for Canon Heavyweight Satin paper. This is a fine value, and overall the images look good. Using a Harman Gloss FB AI paper, we even achieved a Dmax of about 2.35. Printing on Hahnemuehle Photo Rag we measured a Dmax of 1.58. This is a good value for this matte paper.

Note: There were some discussions about the Dmax value for Hahnemuehle Photo Rag. As we recall, Epson's papers achieved about 1.60–1.64, and that was considered good. HP papers achieved a Dmax of about 1.70, and that is excellent. We will try to explore how to enhance Dmax. However, we found our evaluation image on Photo Rag very nice for a matte paper. If we want rich, deep blacks we use the new Baryta papers with Photo Black.

Black-and-white prints • We love the black-and-white prints on glossy media. They are very neutral (using the Canon canned profiles). We encountered hardly any bronzing and no metamerism.

Note: When printing on the new Harman Gloss FB AL paper the prints look excellent. We have to play a bit with the head height, though, because otherwise we get very faint head scratches that can only be seen under a certain angle to the light.

Printing on Fine Art Papers • We think the generic profiles that come with the iPF6100 are too generic for fine art papers. We cannot imagine that papers like Hahnemuehle Photo Rag, Somerset Velvet or other rag papers should only be covered by one set of profiles. Therefore, we produced our own custom profiles using EyeOne Match and achieved very good results with them. In some ways we think that photographers using printers of this class also need to invest into a decent profiling tool, and EyeOne Photo is an excellent solution.[*]

Bronzing • In 2006 we wrote about the iPF5000: "*There is some slight bronzing visible but really needs a close inspection. We personally don't find this to be a problem even for prints that are in an open portfolio. Otherwise the black-and-white prints looked excellent and we did not find any objectionable metamerism.*"

This was written before we tested the HP Z3100 and the Epson Pro 3800. Today, we would be more critical. Actually, while the bronzing was not too bad for a first generation pigment based printer, it was clearly one of the major shortcomings of the iPF5000. As we all know, *better* is the enemy of *good*. And the Z3100 and Pro 3800 are clearly better.

This was the iPF5000, and to our great surprise (before using the iPF 6100, we were not sure what to think about Canon's marketing claims) the iPF6100 improved a lot in terms of bronzing. In some ways, we think we can forget bronzing with the iPF6100. It is so faint that it is quite academic to even talk about it. We really have to congratulate Canon for solving bronzing by just changing the black inks.

Paper Naming • It seams that there are so many papers out there that manufacturers get confused. There are actually at least four places where the paper name plays a role:

A. Printer setup (load)
B. Driver
C. Profile file names
D. Internal names of the profiles (shown in Photoshop and other applications)

We miss a consistent naming here like *Satin* or *Soft Gloss*. What does *Heavyweight* mean in grams?

* Read our review on EyeOne Photo at www.outbackprint.com/color_ management/cm_10/essay.html

Notes on Photo Black and Matte Black Installed at the Same Time

It was always annoying to switch inks on a printer. But in the past there were actually three fractions of users:

1. Those mainly using glossy media (RC papers)
2. Users that mainly use fine art papers like Photo Rag
3. Users using both kinds of papers

The third group was often only the professional printing services and they solved the dilemma by using multiple printers. However, with the new fiber-based papers (we want to mention especially the new Harman Gloss FB AL) even the photographers of group 2 may want to switch between fine art papers and the new fiber papers. This makes it essential to have both Matte Black and Photo Black installed simultaneously. It is still better when the printer provides print heads that can cover both versions of black, and do not have to rinse the print head when switching (as is the case with all Epson printers mentioned here where you have to rinse the heads after switching).

Summary

We think this printer is a big step forward from the iPF5000. The new inks really deliver excellent quality. So far, using the iPF6100 is a pleasure. We don't want to sound like "new = great", but we have to say what we find and we know the competing printers very well. We also discuss our prints with some of our editorial members who all have long printing experience. The quality level of these large format printers have improved quite a bit since the beginning of 2006.

Figure A-31:
The Canon iPF6100 is as fast as this artist
playing with fire, and it's fun printing with it.

Canon imagePROGRAF iPF8100 / 9100

Introduced in early 2008, replacing the former iPF8000 and iPF9000 that used Lucia I pigment inks.

Inks: These printers use 12 pigmented inks (type *Lucia II*). The printers will automatically switch between Photo Black (here called *Regular Black*) and Matte Black when printing, depending on the paper used (set in the driver setting). No Gloss Optimizer is used with these printers:
Photo Black, Matte Black, Light Black (Gray),
Light Light Black (Photo Gray),
Cyan, Light Cyan, Magenta, Light Magenta,
Yellow, Red, Blue, Green

Ink sets: 12 single inks, 330 ml or 700 ml per ink.

Printing Technology: 2 thermal Bubble Jet print heads (6 inks each, 2,560 nozzles per ink)
Heads can be replaced by the user.
Up to 2400 × 1200 dpi printing resolution using a droplet size of 4 pl.

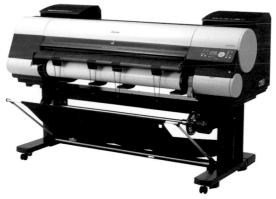

Figure A-32: Canon iPF8100
(Courtesy Canon Germany)

Print Width and Paper Specs:
iPF8100: 44 inch (cut-sheet and roll), also borderless up to 42"
iPF9100: 60 inch (cut-sheet and roll), also borderless up to 42"
0.07–0.8 mm media

Interface: USB-2 + LAN (Ethernet 10/100Base-TX), FireWire optional

Drivers: Standard drivers are provided for Windows (2000, XP, Vista 32/64 bit) compatibility as well as Mac OS X. There is a special black-and-white mode. Photoshop plug-in for direct printing.

Special features: Ink cartridges can be replaced while printing; integrated color calibration to do a re-linearization; Automatic detection of clogged or non-firing nozzles. This will initiate the nozzle-cleaning cycle. If the nozzle remains obstructed, the printer will automatically compensate by re-routing the ink to functioning nozzles. Integrated 80 GB hard drive.

These two printers are the top line of Canon's fine art printers, directly competing with the Epson Pro 11880. Canon also offers the iPF8000S (44-inch) and iPF9000S (60-inch). Both printers are high-speed printers using 8 pigmented *Lucia* inks, and allow a maximum print resolution of 2400 × 1200 dpi. For fine art prints, however, we would prefer to stay with the 12 ink versions.

A.4 HP's Fine Art Printers

In 2006 Hewlett Packard introduced three new lines of inkjet printers that used pigmented inks: the B9180 – a 17"/A3+ printer using eight pigmented inks, the *HP* Designjet *Z3100* line and then the *Z2100* line. The latter two lines were available as a 24-inch and as a 44-inch version. All these lines use the same type of pigmented inks, but while the Z3100 line uses 12 inks, the B9180 and Z2100 lines only use eight *Vivera pigment* inks. The B9180 (and since 2008 also the Photosmart Pro B8850) and the Z2100 have only two different dilutions of black inks (full Black and Light Black, here called *Photo Gray*). Thus, for printing black-and-white fine art prints, the Z3100 had a real advantage. Additionally, the Z3100 is equipped with an integrated full-fledged spectrophotometer (coming from X-Rite) that allows you to profile papers for the printer.

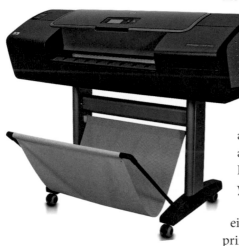

Figure A-33: HP Z2100 (Courtesy Hewlett Packard).
This printer uses 8 pigmented inks.

In 2007 Hewlett Packard added an additional fine art printer line, the *HP Designjet Z6100* line, available as a 42-inch and a 64-inch model. Like the Z2100, the Z6100 uses only eight pigmented Vivera inks. In 2008, HP replaced the Z3100 with the improved Z3200 model.

There are a number of Hahnemuehle fine art papers co-branded by Hewlett Packard (e.g., Hahnemuehle Smooth Fine Art Paper 265 and 310, Watercolor Paper, or Textured Fine Art Paper 265 and 310). The advantage of using these papers is that either Hewlett Packard or Hahnemuehle will provide good generic ICC profiles for them and that you will find these papers in your driver's media list.

All of the HP fine art printers mentioned on the following pages either have an integrated densitometer, allowing you to re-calibrate your printer (this is even true for the entry-level B9180 and the very new B8850), or they have an integrated spectrophotometer that can be used to create custom profiles. You will find such a spectrophotometer built into the HP Designjet Z3100, the Z3200 (introduced in 2008), and the Z6100.

Though this spectrophotometer can only be used to profile a paper for the specific HP printer, the set is much cheaper than buying a separate profile kit (e.g., the X-Rite EyeOne Photo kit).

With all the HP fine art printers mentioned here, the user can quite easily replace the print head if its quality declines. Though a head is not cheap, it's reasonably priced (e.g., about $60 per head for the Z3100).

As with other fine art printers using pigment-based inks, you should **not** use swellable paper (those HP recommend for its dye-based printers).

** We covered those swellable paper in the first edition of this book.*

There are also some printers in Hewlett Packard's printer lines, like the Designjet 90 and 130 and 8750, which can provide very fine prints and even a high longevity and lightfastness when used with good swellable papers,* however, since the pigment-based printer are available, we would very much recommend you to use the pigment-based versions. For pigmented inks, however, swellable papers are not a good choice.

HP Photosmart Pro B9180

Introduced in 2006

Inks: The printer uses 8 pigmented inks (*HP Vivera pigment*), but only 7 for a single print. It switches automatically between Photo Black and Matte Black, depending on the paper setting:
Photo Black, Matte Black, Light Black (Photo Gray), Cyan, Light Cyan, Magenta, Light Magenta, Yellow

There is no Gloss Optimizer used with this printer.

Figure A-34: HP Photosmart Pro B9180 (Courtesy Hewlett Packard)

Ink sets: 8 single inks (27 ml each).

Printing Technology: 4 thermal print heads (2 colors each)
Up to 4800 × 1200 dpi.
Print heads can be replaced by the user.

Print Width and Paper Specs: 13 inch (13 × 19 inch cut-sheet)
1.5 mm maximum

Paper feed: Sheet feed (2 paper trays), optional roll feeder

Interface: USB-2 (HiSpeed), optional LAN (Ethernet 10/100Base-TX).

Drivers: Standard drivers are provided for Windows XP and Vista as well as Mac OS X. There is an advanced black-and-white mode in the driver and a Photoshop plug-in to perform a direct printing from Photoshop without going via the printer driver.

Special features: The printer has a densitometer that allows you to detect clogged nozzles and to re-calibrate the printer.

This is a very nice entry-level printer for advanced amateurs and passionate hobbyists. The print results are quite good for color prints and are reasonable for black-and-white prints, however not as good as the prints using a 11 color Z3100 (which has three dilutions of black instead of only two).

For the PMA 2007, Hewlett Packard introduced the B8850, a 13-inch printer using the same ink set as the B9180. The B8850 is a slightly modified B9180 printer, having no network port, and LEDs instead of the LCD panel. The maximum paper thickness is 0.7mm with this printer.

Printing with the Hewlett Packard Photosmart Pro B9180

The installation is not complicated and takes about an hour. This sounds long but during this time the B9180 auto-aligns the heads and also calibrates the printer (this is unique in this class of printers, we think this is a color linearization).

Figure A-35: HP Photosmart Pro B9180

Printer Impressions

▸ Very solid build quality
▸ Clean form (nice design)
▸ Single sheet feeding excellent (best in its class)
▸ Printing via network included
▸ Lower price than the same kind of pigment printers from the competition
▸ Print speed good even at maximum resolution

Printing from Photoshop

Printing from Photoshop can be done in two ways:

▸ Standard driver of the operating system
▸ HP Photosmart Pro print plug-in (see below)

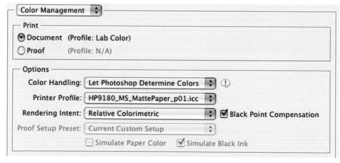

Figure A-36: Normal Photoshop print dialog that we use for color prints

When you do a color print by going through the standard Photoshop print dialog, the setup in the printer driver should roughly look as shown in figure A-36, where you let Photoshop do the color management. The printer driver settings in Mac OS X look like the one demonstrated in figure A-37. Naturally, you may have to select a different paper and accordingly a different profile in Photoshop.

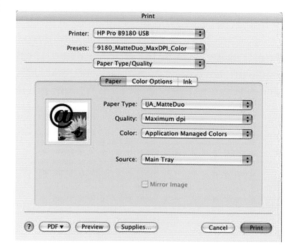

Figure A-37:
Driver setup for color prints
(color-managed by Photoshop)

Black-and-White Printing Using the Driver

The B9180 also provides a black-and-white only mode, here called *Grayscale* (see figure A-38). In this case, in Photoshop's color management settings you select *Let Printer Determine Color*, otherwise the driver won't allow you to select the Grayscale mode.

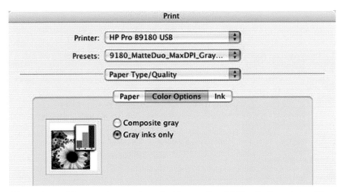

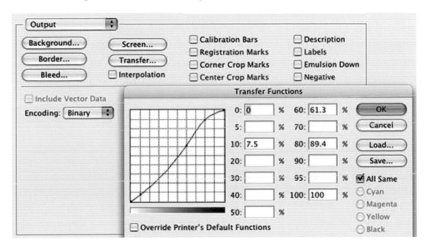

Figure A-38: Driver Grayscale mode

Figure A-39: There are two options for Grayscale with the B9180 printer driver

There are two options for grayscale images (see figure A-39): *Gray inks only* presents a more neutral rendering, while *Composite Gray* according to our experience results in prints that show some metamerism.

Note: On glossy media we experienced some banding in dark areas if using the *Gray inks only* option even on original HP papers. However, using ›HP Premium Satin Photo Paper‹, we achieved very fine results.

On real matte papers (not the slightly glossy semi-matte type of paper) we would only use *Gray inks only* mode. Because there is no *advanced* black-and-white option provided in the HP driver, allowing you to fine-tune the black-and-white print (as the Epson drivers described do), we needed to use the Photoshop Transfer Curves to get better blacks:

Figure A-40:

Sample Transfer Curve in Photoshop that we use in Photoshop to achieve better blacks.

HP Photosmart Pro print Plug-in

The B9180 software comes with a Photoshop Automation plug-in to ease printing. If you use other applications, however, you will have to use the normal driver.

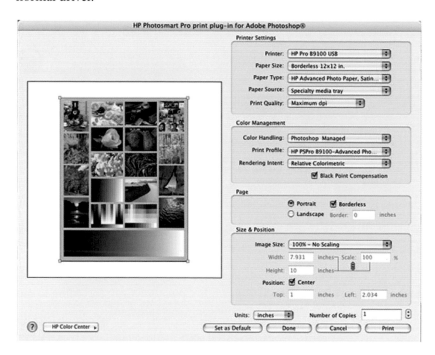

Figure A-41:
HP Photosmart Pro Print Plug-in

What is so special about this Photoshop plug-in? Printing from Photoshop is no real pleasure. You have at least three dialogs to synchronize to get a proper print:

▸ Photoshop Print dialog
▸ Print Size dialog (*Page Setup* tab)
▸ Driver dialog

If something does not match, you waste time, ink, and paper (and may even spill inks in the printer). The new HP Photoshop Automation plug-in is a one-stop printer control. In principle this plug-in is way easier to use than Photoshop using the normal driver. However, we would like to see some improvements for the plug-in:

▸ The plug-in does not allow you to control all parameters that can be set in the driver (e.g., the different black-and-white modes)

▸ We couldn't find a way to add custom paper sizes.

▸ There is no feature to save more than one preset per printer.

Setting up for Third-Party Papers

We like the way that HP allows you to add new papers to the driver and plug-in. This is done using the HP Printer Utility (see figure A-42). There, clicking on Add will bring up the dialog demonstrated in figure A-43.

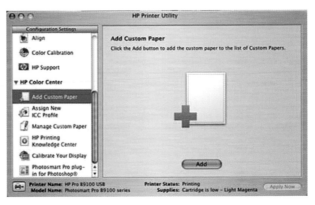

Figure A-42: Add Custom Paper in HP Printer Utility

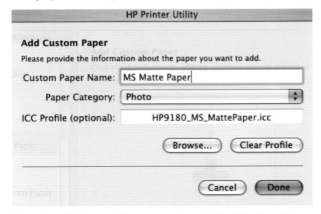

Figure A-43: Dialog to add a paper to the media list of the B9180 driver

Use the Paper Category menu of this dialog to select the proper paper type (see figure A-44) and use a descriptive name for your custom paper.

Once the paper size is loaded, you can select the paper format in the driver. So far, we have used the Paper Category *Photo* for all glossy papers, and the Category *Photo Rag* for really matte papers. In our opinion, it would be helpful if HP would provide additional paper types like these two and some more like:*

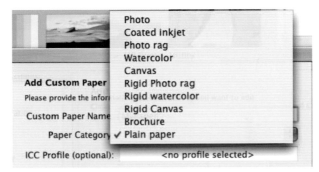

Figure A-44: Select Paper type

* *Meanwhile, HP did just that (see the description on page 263). This also works for the B9180.*

▸ Glossy (high gloss)
▸ Satin, Luster, Semigloss
▸ Matte papers (e.g., like Epson Enhanced Matte or Inkjet Art Matte Duo)

The key issue here is to optimize the printer/paper combination as much as possible.

Ink Consumption

As of now we have made about 200 prints (mainly 6" × 9" inch prints on letter sized paper but also some A3-sized paper). Light Gray is used up most, but all other colors are still on the first cartridge.

Note: The system will give you warnings concerning low ink very early (we got the last warning for light gray already at 39% of the cartridge). But don't get worried by these warnings (except for getting some replacement inks). You can often print still many more prints without any problem. We recommend waiting until the ink is really empty and the B9180 asks you to switch inks.

Some Speed Tests

From LightZone, we printed at 600 ppi a 6" × 9" on letter-sized paper. We did not measure the time the application spent rendering the file or the time the operating system held the file in the system queue.

▶ Using Quality set to *Best*: 20 seconds feeding from cassette, 2:25 minutes total print time

▶ Printing with Quality set to at *Maximum dpi*: 20 seconds feeding from cassette, 3:05 minutes total print time

Print Quality

Here are some observations:

▶ The generic profiles that come with the printer for HP's papers are very good.

▶ In most cases Quality set to *Best* is all you need. If you have larger continuous tone area, using *Maximum dpi* (this is the highest Quality setting available) printing may give you a slight edge.

▶ Color images on matte and glossy are very good.

▶ The prints show excellent detail.

▶ Black-and-white prints on matte papers look nice using the *Gray inks only* option. (To optimize your results read our note about the Photoshop Transfer Curves on page 249.)

▶ Black-and-white prints on a luster or soft gloss paper show some minor bronzing and can show either minor banding (visible only on larger uniform dark areas; we are very picky here) using *Gray inks only* or slight metamerism if we use *Composite Gray.*

Clogging

We keep the printer powered on all the time. If powered on, the B9180 performs regular head cleaning cycles. We did not experience any clogging so far.

Media Choice

▶ The HP glossy media (we very much like the HP *Advanced Soft-Gloss Photo Paper*) is an excellent match because all printer settings are optimized for these papers (there are many parameters that come into play to get an optimal paper, ink and printer match). We are not that happy with the HP logo on the back of these papers (e.g., distracting for open portfolios and binders). But for this printer, there are many more media choices.

▸ For third-party papers you have to do your own tests. The B9180 worked fine on some papers but we did not have particularly great results with the Innova Fiba Gloss paper (which prints very well on the Epson R2400 / Pro 4800 and also with our Canon iPF5000 or iPF6100). We are in contact with HP to check for this. You have to understand that it is hard for a printer manufacturer to be compatible with all papers on the market and the B9180 seems to be picky with some of them.

▸ For third party glossy and satin media we recommend you use the paper settings for HP Advanced Photo Paper Gloss paper. Third party matte papers are better adapted using the Photo Rag settings.

Conclusion

With color photos, the B9180 produces very good quality prints on both matte and glossy papers. Black-and-white printing on matte papers is best done using the *Gray inks only* mode. For black-and-white prints on glossy media we recommend you avoid using the *Gray inks only* mode because of some minor banding, visible on larger uniform dark areas.

You should only use micro porous papers for the B9180 and no swellable media. HP Premium and Premium Plus papers are swellable media (therefore, not the right choice), while HP Advanced papers are micro porous (this is the right paper). Be careful, because the paper boxes look very much alike.

All in all, the HP B9180 is a solid 13"/A3+ fine art printer at an attractive price point.

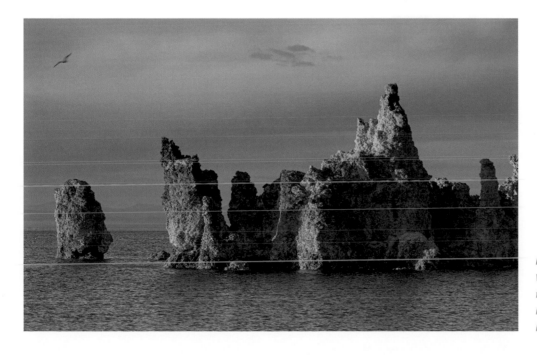

Figure A-45:
We achieved some very
fine color prints with the
HP B9180, e.g., using the
HP Premium Plus Satin.

HP Designjet Z3200 Photo

Inks: These printers use 11 pigment inks (*HP Vivera*) and optionally a gloss optimizer. It switches automatically between Photo Black and Matte Black, depending on the paper settings. With some matte media, Photo Black as will as Matte Black is used: Photo Black, Matte Black, Light Black (Gray), Light Light Black (Light Gray), Magenta, Light Magenta, Light Cyan,* Yellow, Chroma Red, Green, Blue, Gloss Enhancer

Ink sets: 11 separate inks (69 ml each), plus Gloss Enhancer (69 ml). The 44 inch printer uses 130 ml cartridges.**

Printing Technology: 6 thermal print heads (for 2 colors each). Droplet size is 4 pl (lc, lm, lg, pK, E, G) or 6 pl (M, Y, mK, CR, GN, B). The maximum print resolution is 2400×1200 dpi. Print heads can be replaced by the user.

Print Width and Paper Specs: The printer allows for different maximum print width:

Z3100 24-in: 24 inch (up to 1.5 mm)
Z3100 44-in: 44 inch (up to 1.5 mm)

Both printers support borderless prints using cut-sheet paper. A minimum 5 mm border is necessary if you are using matte media. The minimum print size is US letter.

Paper feed: Sheet feed, roll feed, automatic cutter

Interface: USB-2 (Hi-speed) + LAN interface (Ethernet 10/100Base-T).

Drivers: Standard drivers are provided for Windows 2000/XP/Vista as well as Mac OS X (PPC and Intel). The printer offers two dedicated versions of Grayscale printing and a Photoshop plug-in.

Special features: This printer contains a spectrophotometer that allows the production of ICC profiles for a specific paper. The software for this is part of the printer kit. The profile can be exported and used as a normal profile – e.g. for soft proofing in Photoshop. Optionally, PostScript + PDF 1.6 can be supported. The Z3200's ICC profiling features are a great improvement on those found in the earlier Z3100.

Figure A-46: HP Designjet Z3200 (24" version) (Courtesy Hewlett Packard Germany)

Printing With the HP Designjet Z3100

At Photokina 2006, the new HP Designjet Z2100 and Z3100 printers were big news, and HP showed them everywhere. We have had the Z3100 printer for about 1 month in our studio and can share first impressions. What is so important about this new HP printer?

➜ *A detailed review of the HP Z3100 can be found on the Luminous Landscape website: www.luminous-landscape.com/reviews/ printers/HP-Z3100-review.shtml*

▸ It is the first large format printer from HP that uses pigmented inks, and is in direct competition to equivalent printers by Epson (7800/9800) and now also Canon (iPF5000, iPF8000).

▸ It features a built-in X-Rite Eye-One spectrophotometer The printer can calibrate and profile papers using this spectrophotometer

▸ It uses 12 colors, adding Red, Green and Blue to provide a larger gamut. We will only look into the claim of "larger gamut" when we find pictures of friends and clients that need a larger gamut (compared to the gamut of the 8/9 inks used, for instance, by the Epson printers). Our own images are not very saturated, and we are printing more and more black-and-white or muted colors.

Figure A-47: The second print produced by our new Z3100 printer

▸ It has four blacks (Photo Black and Matte Black are loaded simultaneously, as with the Canon iPF5000).

▸ A Gloss Enhancer is used to avoid bronzing and gloss differential.

▸ The printer uses clog-prevention technologies.

▸ There are very high permanence ratings from Wilhelm Imaging Research (≥ 200 years). We take all these data with some grain of salt but it still proves that today's printer manufacturers pay a lot of attention to longevity.

Some Data

The Z3100 uses 12 inks (as described on page 254) and has six replaceable print heads for two colors each. The heads have 1,056 nozzles per color. Where is the Cyan? The HP engineers felt that they could create the needed color from the other colors because they also have Red, Green and Blue inks. It also has Gloss Enhancer, which can be considered to be a kind of fully transparent ink that is used to fill gaps in light areas to avoid bronzing and gloss differentials. It is used only when printing on glossy and semi-glossy photo media.

➜ *The handling of the Z3200 is very similar to that of the Z3100, and most of the information provided here is transferable between the two models.*

How many blacks are used during printing? On matte papers all four black and gray inks are used. As we understand, the Matte Black is just a coarser version of the Photo Black. On glossy and semi-glossy photo media papers, the Matte Black is not used because the coarser pigments would not hold onto the micro-fine pores of the usual microporous papers.

What about Dmax? • HP claims to have achieved a Dmax of 2.43 on HP Premium Instant Dry Gloss Paper (with Photo Black) and a Dmax of 1.77 on HP Hahnemuehle Smooth Fine Art Paper (with Photo and Matte Black inks). A friend of ours measured some test targets and got about the same values.

Note: We are very impressed with the deep black we get on HP Hahnemuehle Smooth Fine Art Paper. For some others and us, the blacks look richer than the numbers seem to tell (Dmax 1.77).

Assembly • The Z3100 44-inch is a really big printer. A single person can actually assemble the whole printer (upside down) and it needs only one or two extra people to turn the printer over. We found all steps well documented and easy to perform. The printer looks robust and comes with a very usable integrated basket.

Figure A-48: Printer Panel of the Z3100

Initializing the printer • The initialization of the printer following the clear instructions worked without a glitch. During the installation the printer guides you with the help of its excellent LCD panel (see figure A-48).

▸ Install all 12 ink cartridges (see figure A-49)

▸ Install six print heads, each for two inks

▸ Printer prepares and initializes the 12 inks and six heads. This can take 30–40 minutes; during this time you can install the software.

▸ Feed the roll of glossy test paper that comes with the printer

▸ Now the printer performs an automatic head alignment.

Figure A-49: This is 6 out of the 12 ink cartridges

Installation of the Software • While the printer was preparing the inks and heads, we installed the Software.

During software setup you will be asked how you plan to connect the printer (both options are standard): via USB 2.0 (HighSpeed) or via Network (Ethernet). We use mainly USB 2.0 for our main workstation but have also other PCs connected via Ethernet.

** See section 3.11 at page 80 for a description on this test image.*

First prints • Our first print was our usual test image.* The next print (still with the short sample roll of glossy paper) was a 30-inch wide print (see the image in figure A-61 on page 261 and the printer photo in figure A-47). This print, lying on the table in our studio at Plotter Pros, caught the eye of quite a few visitors who liked it. So far nobody has found any sort of bronzing on this print.

Paper Calibration

The HP Z3100 uses the built-in EyeOne spectrophotometer to linearize the printer. Each paper has to be calibrated (also after switching heads or maybe even inks). Calibration is a very painless process and needs only one sheet of paper (Letter size will be large enough).

Here are the steps the utility will guide you through:

1. Printing the Target (see figure A-50 and figure A-52).

2. Give the print about five minutes drying time. HP claims that a drying time of about 5 minutes is good enough for most instant dry media. We are not sure that this is sufficient, but we also don't see any problems so far.

Figure A-50: First step to calibrate your Z3100 for a new paper

Figure A-51: HP recommends to let the test print dry for five minutes.

3. In the final step the utility will install the profiles (in the printer as well as in your operating system).

Figure A-52: A sample calibration chart (fits on Letter-sized paper)

Figure A-53:
This dialog shows paper calibration status and date

The printer holds all the calibration data and even color profiles. The system to add third-party papers is very open. The user can create new paper types that will be shown on the printer and in the printer driver.

Paper Profiling

For supported HP papers we only calibrate the paper and, right now, use the generic profiles. But if you want to use third-party papers you need to calibrate and profile these papers:

1. First you create a new paper type using the "Color Center" application

2. Then you can calibrate and profile the paper (takes about 30 minutes including drying time)

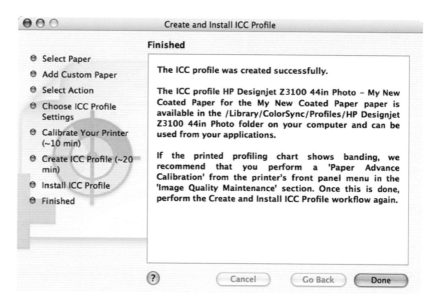

Figure A-54:
Profiling process

Figure A-55: The target used for profiling consists of about 460 patches.

Note: HP claims that they get good profiles out of these 460 patches. Time will tell whether these are enough patches or it we may need more (as we understand the Advanced Color Management package supports larger targets as well). So far, we have found the results very pleasing.

Note: For profiling you need at least A3-sized paper. If you profile paper from a roll the Z3100 will try to make use of the whole width (using landscape mode) and save you paper.

3. The final profiles are available for Windows and Mac OS X, and on the printer. They can also be downloaded from other PC or Mac systems.

We profiled a few papers and preferred this process in comparison to using other profiling packages. You should also keep in mind that profiling, which is based on reading strips using a hand-held spectrophotometer, is very error-prone compared to this fully automatic process.

The Z3100 Printer Driver

Here are the main settings for your prints:

▸ Paper size
▸ Paper source (it is better not to use *Automatic*)
▸ Paper Type has to match the paper selected by the printer. You also find here your own installed custom papers)
▸ Quality settings (extra dialog)
▸ Setting for the Gloss Enhancer (glossy and semi-glossy media only)
▸ Orientation

Color Settings

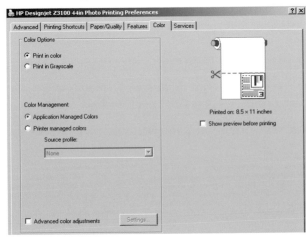

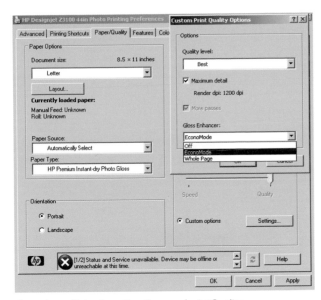

Figure A-56: Dialog for setting Paper and print Quality

Figure A-57:
Use Application Managed Colors for color management (working from Photoshop)

The printer driver also offers an *Advanced Lightness and Gray Balance Adjustments* dialog (figure A-58).

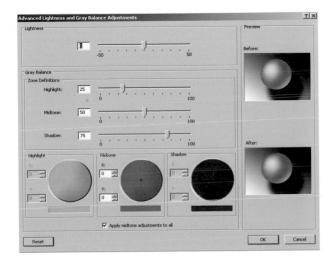

Figure A-58:
Advanced settings for black-and-white prints

So far we have printed black-and-white (actually, toned black-and-white images that are still in RGB mode) as color images and used application managed color control in Photoshop. We only mention this mode in case you want to experiment.

Note: Some users may want to use this mode to get very neutral prints. We, on the other hand, think that we want our black-and-white prints to have subtle tones and don't want to be dependent on the tone defined by the printer. Of course you can add your own toning here in the driver but this also involves a lot of testing (trial and error style).

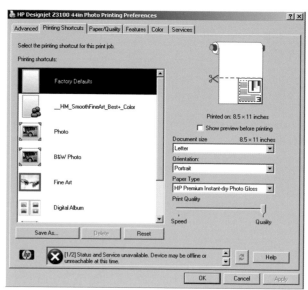

Figure A-59: Printing Shortcuts

Printing Shortcuts

As with other printers, we recommend you create your own printing shortcut (print settings) for each paper and quality setting. For this, HP provides a really big tab (see figure A-59).

Print Services Utilities

The key services are *Status of My Printer* and *Color Center* (Papers, Calibration and profiling).

Figure A-60:
Tab with the Printer Services for the Z3100.
Services are grayed out here because we
captured the screen while the printer was
offline.

Feeding Paper

You either feed from the roll or use the single sheet feed tray (one sheet at a time as we recommend with all large format printers when using fine art papers).

Most of the time we use single sheets. We don't recommend the "Easy Paper Feed" method as you may end up more often with skewed paper. The

Z3100 checks for precise paper feed and does not tolerate skewed paper. Perhaps, in the future, you will have an option for the printer to be more tolerant.

For paper feeding you have to specify to the printer what kind of feed (roll or single sheet) and which paper type you intend to use. Again, your own custom papers will also show up on the printer panel.

Actual Printing

With this printer we used quite a bit of satin papers but have recently mainly used HP Hahnemuehle Smooth Fine Art Paper and Hahnemuehle Photo Rag 310 gsm. Both papers deliver outstanding results. In the past we only used matte papers. Then, lately, with other printers, we were struggling between satin and fine art papers. Now, with the Z3100, we are clearly in to using mainly fine art papers.

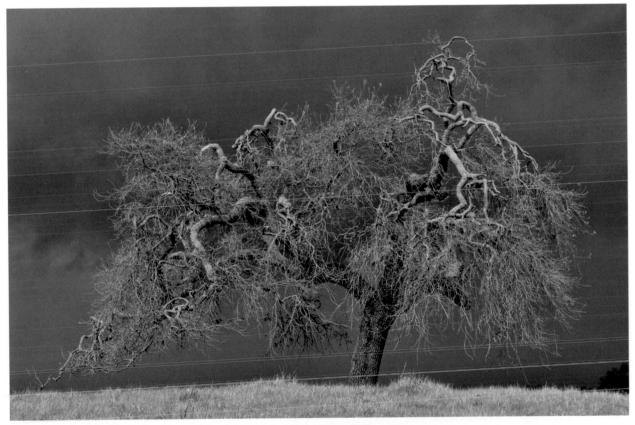

Figure A-61: This was Uwe's second print coming out of the Z3100. The print looked really excellent.

Conclusion

We really like the Z3100. Prints using matte fine art papers are excellent and also the glossy prints are impressive.

Note: We don't compare printers by sharpness (very difficult because it depends on so many factors) and also not that much by gamut charts (they probably are impressive for the Z3100). We look at prints and check whether they make us proud to present to customers. By *customers* we mean people who enjoy our photos and not people who can only look at prints with a loupe (of course we do that ourselves once in a while for some more critical inspection). We don't say this is right or wrong. This is just our personal style.

There are quite a few features that speak for the HP Z3100:

▸ There is a Gloss Enhancer if we want to print on glossy media (HP exclusive right now, Epson on consumer printers R1800/800)

▸ The printer features four dilutions of black (featured by HP, Canon and with ink switching also Epson)

▸ The Z3100 provides a built-in spectrophotometer

▸ Clogging prevention. So far we haven't had any clogs on either the Z3100 or our Photosmart Pro B9180 after about 300 prints on each printer. Both printers use the same head technology. (HP and Canon lead here and we hope Epson is catching up.)

Some More Experiences

After we had some zebra marks (ink smearing) when printing on thick papers, we turned to HP's support. A technical paper from HP helped us to solve this problem.

Note: Actually the Z3100 allows third-party paper manufacturers to even control the printer on a much finer level via so called *media profiles* (not to be confused with ICC profiles!). We don't think the creation of media profiles is something a normal user should bother with.

* You can download the HP paper dealing with the zebra stripes issue at: www.outbackphoto.com/printinginsights/ pio46/pdfs/Zebra_Stripes.pdf HP's technical paper on how to obtain saturated reds with the Z3100 can be found at: https://h41186.www4.hp.com/hpp/Data/ printingknowledge/Red_gamut_issues_ on_Z31001.pdf?pageseq=456725

If you understand the above principles then you won't have problems to understand the HP technical paper "Zebra marks (ink smearing) on thick papers" which you can download (see sidebar).*

There have been some hot debates about the Z3100 lacking in print saturated reds. In the sidebar you will find the URL of the HP paper answering this.

→ The saturated reds issue has been resolved for the Z3200 by replacing the original red ink with Chroma Red.

We switched printing for the Z3100 from the PC to our Mac. To our surprise, at first, we did not get to printing if we were feeding 13" × 19" papers in landscape mode. (We would actually recommend feeding the paper in portrait mode because that way the paper has more support when leaving the printer.) There is no really intuitive solution to the problem, but fortunately there is a quite simple trick. In the sidebar is the URL for the HP technical paper with clear instructions (created by HP based on our feedback). It works very well for us using Photoshop or Lightroom for printing.

HP's technical paper dealing with the landscape mode feeding problem can be found at:
www.outbackprint.com/printinginsights/pio46/pdfs/Z3100_13x19_landsc_OS_X.pdf

Hewlett Packard also released a new firmware update for the Z3100, which you may find at their support website:
 www.hp.com/go/knowledge_center/djz3100/.

This firmware brings along new media presets:

▶ **Fine Art Media Pearl**: This allows you to print on thick fine art paper with "pearl" coating/finishing. This new paper preset retains the carriage in the upper position but with slightly higher ink limits (not as high as *Gloss* but higher than other fine art papers) and also allows you the usage of Gloss Enhancer with the fine art papers (again, not as much quantity as in a glossy paper, but enough to get the benefit of gloss uniformity).

▶ **Glossy Paper High Ink Capacity**: This preset is recommended when more gamut is needed on glossy paper. (Be aware, however, that the paper needs to be able to absorb the amount of ink. If not, you may have paper crashes that can damage your printer or problems with ink drying and ink migration.)

With these two presets, you have more flexibility when working with third-party media.

In the technical newsletter "Working with Custom Paper", you will find a complete list of papers and their associated settings, so you know what settings you really need to select at the time when you "Create & Install ICC profile" from HP Color Center.

HP's technical paper "Working with Custom Paper" can be found at:
https://h41186.www4.hp.com/hpp/Data/printingknowledge/working_with_custom_paper_Z2100_Z31002.pdf?pageseq=716726

We have to applaud HP for creating the document "Working with Custom Paper". As far as we know, this is the first time a printer manufacturer has documented which printer settings affect certain paper selections involve. We would like to see such documents from all the other printer manufacturers too.

➡ Most of the problems we had with the Z3100 are fixed in the newer Z3200. We therefore advise you to look for Z3200 model in preference to the older Z3100 if you are shopping for a refurbished HP printer.

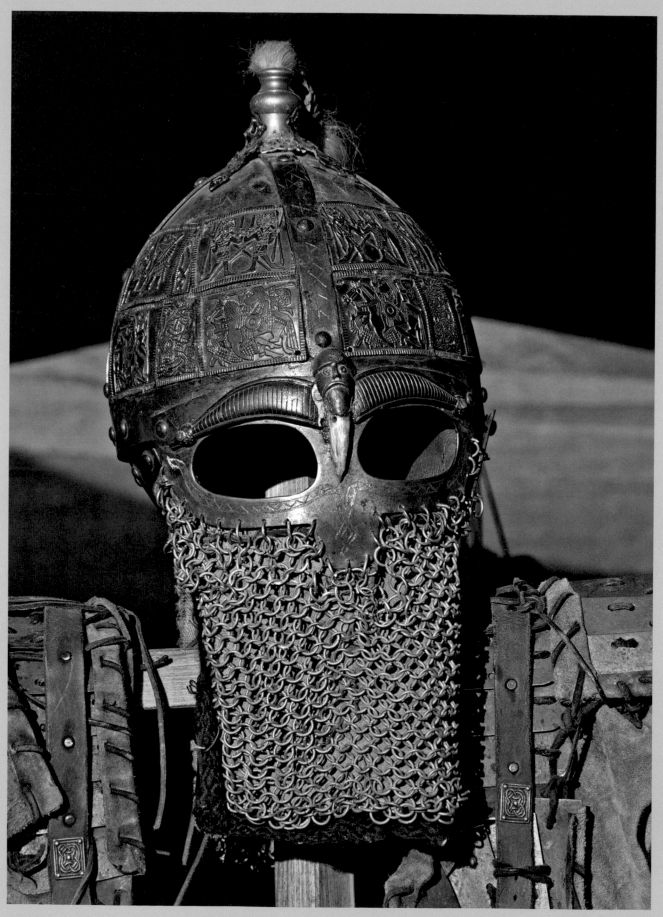

Papers for Fine Art Printing

B In this appendix we describe a number of inkjet papers for fine art prints that we have tested and liked. Naturally, this is a very subjective decision. As mentioned in chapter 2, there is no single paper that suites all printing conditions and all subjects. The "right" media for a print very much depends on:

– the image, the scene, and its specific subject,
– the intended use of the print,
– the light it will be viewed in,
– the kind of presentation and framing,
– whether the print is in color or in black-and-white,
– and, finally, your very personal taste and preferences.

So use this chapter for background information and as a suggestion, not as the absolute truth.

Which papers you prefer may well depend on the printers you use (or those your print service offers) and whether you have an adequate profile for your printer, ink, and paper.

B.1 Digital Fine Art Papers

There are many different types of fine art papers available. Here, we only list papers that we have some experience with. Papers are classified according to their surface and make:

▸ Matte papers
▸ Matte fine art papers
▸ Satin/glossy coated rag papers (a new, emerging category)
▸ Satin papers with a very soft gloss finish
▸ Luster/pearl papers
▸ High-gloss papers
▸ Specialty papers and canvas

As mentioned before, the easy way to work with papers is to use a paper offered by the printer manufacturer. Epson as well as Hewlett Packard and Canon all offer a number of really fine papers; some of these papers are co-branded with paper manufacturers like Hahnemuehle or InteliCoat (previously Crane). The advantage with these papers is that you will find the matching media type in the media list of your printer driver. A fitting paper/printer profile is in most cases either part of the printer package or may be downloaded from the website of the printer manufacturer.

But sticking to these papers will restrict you, and there are some very fine third-party papers that may better suite your taste, your subject or your budget. For most of the fine art printers mentioned in this book you will find reasonably good profiles at the website of the paper manufacturer.

This is true, for example, for third-party papers from Arches Infinity [88], InteliCoat/Museo [89], FujiFilm [90], Hahnemuehle [90], Harman [94], Ilford [95], Innova Art [99], Moab [105], Pictorico [107], Sihl [112], or Tecco [114] – just to name a few. All of these manufacturers produce really fine papers for fine art prints. But not all of them sell their papers directly to the end customers. You may have to go to your local dealer or an online shop.

Additionally, you may also find profiles at the website of some online shops selling fine art papers like Mediastreet [103], Inkjet-Mall [98], or Inkjet Art Solutions [97] (again, there are many more).

You should not only download such profiles (or create your own), but also have a look at the print recommendation these manufacturers provide for their media. They will usually name an equivalent media that should be selected from the media list of the printer driver, tell you whether Black Point Compensation should be activated or deactivated when using their profile (with some papers), and inform you which Rendering Intent should be used and whether you should use Photo Black or Matte Black (though some HP printers can use both types of black in a single print). Even when producing your own profile, these hints can help.

▸ *For the first test of a paper, the free profiles provided either by the printer or paper manufacturer are good enough when using one of the fine art printers mentioned in chapter 5 and this appendix A. They will probably achieve about 90–95% of the maximum quality that any print can deliver. Only when you want to go beyond this is it worth producing your own profile or ordering one from a profiling service.*

For most photographers it will probably be useful to use two groups of ink-jet papers:

A. A good, but reasonably cheap paper. This is used for your test prints, to see if your colors are right and the sharpness is OK, and to inspect the print for any deficiencies. This paper can also be used to pass the print on to an outside party – e.g., a customer, to see which of the pictures he or she might choose for a project, or to a printer as a color proof.[*] A Semigloss or Luster paper might be a good choice for this purpose, as these papers have a rich gamut. In order to pass on photos to an advertising or model agency, a high-gloss paper might still be better.

B. A small number of high-quality fine art papers that you will use for your high-quality fine art prints. These papers will probably be more expensive than those for normal use, and they should be handled very carefully.

** The standard (Premium) Semigloss and Glossy papers offered by the printer manufacturer (Canon, Epson, HP) are usually a good choice for this pupose.*

Some Notes on OBAs

We have been struggling for quite a while about how to talk about and judge the existence of OBAs (*Optical Brightening Agents*). It is certain that:

▶ OBAs fade over a period of time, especially under UV light.
▶ Not all papers with OBAs fade at the same rate.[**]
▶ "Bright White" papers, allowing high contrast, need OBAs.
▶ OBAs can be applied to the coating or the paper (or both).
▶ Some papers use more OBAs than others, and it can be hard to judge the amount of OBAs just by the whiteness. The amount of OBAs might also vary slightly from one batch to the next to compensate for variations in the base materials.

*** Based on our own tests and tests by other sources.*

Some time ago we received a press release by Hahnemuehle USA on this issue. What we write here is our own opinion, not influenced by this press release, but we do believe the press release is not that far off the mark. Here are some quotes from this press release that we would like to comment on.

See also the "Library of Congress Standard for Permanent Paper" at:
www.loc.gov/preserv/pub/perm/pp_1.html

"OBAs are white or colorless compounds that work by converting ultraviolet light into visible light, thereby making the paper appear brighter or whiter. They do not change the color of the paper; they only fool the eye into seeing a whiter color. After being exposed to UV rays for a long period of time, OBAs will begin to lose their fluorescent quality, leaving only the natural base color."

This seems to be an accurate description of what OBAs are and what they do. Because they all probably fade faster than the papers fade (yellow), in the long run it is better to use papers without OBAs. But there is a big *if*: If you want to accept the natural slightly yellow color of papers without any OBAs. This is a purely artistic and pragmatic decision.

"So the claim that OBAs cause paper to yellow or reduce its permanence is simply wrong. Eventually, the perceived color of the paper will revert to the same base color as papers without; but initially, OBAs allow a much brighter base. It is not yet known how long the reversion to natural might take. We do know that it is not an immediate thing; it could take as many as 50 years (even longer if the artist takes measures to protect the image from the effects of UV rays.) But the point to remember is that the paper will end up the same color as it would have had if OBAs had not been used."

This is a point that only scientists can verify. The question is whether there are side effects of OBAs besides just fading away over time.

"Consider that virtually all silver halide papers used in darkroom photography contained OBAs. Artists who wanted a bright white base simply accepted the fact that there would be a slight change over a long period of time. In fact, many photographers and collectors find this *mature* look desirable. At Hahnemuehle, we strongly feel that to provide the paper base color and print color where the artist wants it for their lifetime is better than having it wrong from the beginning."

We have always suspected that classic silver halide papers also contained quite a few OBAs. In the art world this seems to be accepted. The real question is how fast papers with OBA will yellow* and how bad photos will look once they get back to the natural base color of the papers.

There are two further problems with OBAs:

A. As a general rule, we have found non-OBA papers to exhibit far smaller (and less objectionable) changes in hue going from one light condition to another, e.g., from daylight to tungsten or to fluorescent.

B. To a certain extent, OBAs interfere with the creation of color profiles, partly fooling the spectrophotometer. Therefore, some devices are equipped with an UV filter (causing other problems). X-Rite's *Eye-One Match* and *ProfileMaker* printer profiling software tries to recognize OBAs (from some reflectance behavior) and correct the profile accordingly (as well as possible).

Conclusion

If you find that natural papers without OBAs work for your images, then this would be a safe bet. Otherwise live with the fact that your papers will yellow over time (and some seem to do so faster than others). You as the photographer have the choice of using papers with or without OBAs – there is no silver bullet.

We find the press release by Hahnemuehle very helpful because it contributes to a fairly impartial discussion on OBAs.** See also the discussion going on at the open forum at [25].

How to find out if OBAs are Used in a Paper

There are several ways to find out if a paper (generally, its top layer) contains optical brightening agents:

A. If you are lucky, the manufacturer will tell you the papers's specifications. But usually, they will only inform you when there are no OBAs in a specific paper.

B. If the paper name contains "bright white", probably quite a few OBAs are used for the production.

C. You can compare the paper color to that of a reliable white reference containing no OBAs.* If your paper is whiter than this reference, it probably contains OBAs.

D. If a lot of OBAs are used, you can detect a fluorescence effect under black light.

E. Do a reflectance measurement. For this you need a good spectrophotometer and an application like BabelColor [62].

For instance see "How to use a white Target to identify UV-enhanced paper" by BabelColor:
www.babelcolor.com/download/
AN-2 How to identify UV-enhanced paper.pdf
(Yes, there are some blanks in this URL!)

Since 2007, we have use method E on new papers we test. You will find the reflectance diagrams of those papers in Uwe's Digital Paper Directory [25] and diagrams of some papers in the rest of this chapter. But what do these diagrams show (see figure B-1 and figure B-2)?

Ideally, white paper would reflect 100% of all light falling on it, and it would reflect the full spectrum of visible light equally well. In reality, however, even white paper will absorb a certain amount of light and will not reflect all wavelengths to the same extent. The reflectance diagram is a plot of this reflectance curve of a specific paper. A reflectance of 100% for all colors (wavelengths) contained in white light would show up as a straight line close to a level of 1.0. Theoretically, reflectance cannot be higher than 100% (1.0). Thus, the reflectance curve for the spectrum of visible light of a specific paper should be close to that 1.0 line, as figure B-1 demonstrates.

Figure B-1: This paper – Ilford Galery Gold – shows a very good reflectance curve. The curve is almost flat close to a reflectance of 100% (1.0) and no spikes in the wavelength of Blue. It obviously uses no optical brightening agents.

If, however, the paper contains OBAs, light in the UV spectrum will be absorbed by the paper and the OBAs and parts of this light will be re-emitted with a different wavelength, reaching into the Blues (420 to 480 nm). This "blue" reflectance caused by the OBAs will be added to the normal blue part of the white light reflectance. A reflectance spike above 1.0 in the Blues is therefore a measurable indicator for OBAs (see figure B-2). You will find the reflectance diagrams of many fine art papers at [101] .

Figure B-2: Paper with a typical curve indicating the presence of lots of OBAs

B.2 Some Examples of Fine Art Papers

Looking around at your local dealer, on the Internet or at a photographic-oriented fair, you will find a tremendous number of inkjet papers – probably far more than photographic papers ever were. Most are simple inkjet papers targeted at the consumer market or produced for office prints. But you will also come across a very large number of inkjet papers suited for fine art prints, and new fine art papers are appearing on the market almost every week. It's really hard to keep on top of them.

But is there really a need for you to do so? Probably not. If you intend to go deeper into this subject, you should take your time to find a small number of fine art papers that suite your taste and your needs. Occasionally, it's worth having a fresh look around for some new papers, and you may discard (better, stop buying) papers you previously used and take on a new paper.

Here, we will talk about some of the numerous media out there. We will present only a small collection. First of all, we naturally didn't see all available papers, and we didn't like all the papers we did see. So, the following sections will deal with only a few papers we tested and liked. This is naturally a very subjective selection, strongly influenced by our personal taste as well as by the subjects we shoot (we do a lot of landscape and nature photography). For instance, we hardly ever use any canvas. So you will not find any information on canvas media here. Therefore, use this chapter purely for some background information, intended to help you find your way through the ocean of papers. It's neither complete nor objective.

→ *Naturally, what we present here can only be a snapshot. You will find regular updates in Uwe's "Outback Print Fine Art Paper Directory": www.outbackprint.com/papers/paper_directory/essay.html*
For some of the papers mentioned in the following sections, you will also find more information in Uwe's essay on how they work with some of the printers we tested and how certain problems can be avoided.

Matte Papers

Use Matte Black inks for these papers.

▸ **Epson Enhanced Matte** (now called **Ultra Premium Presentation Paper Matte**) • This is a nice, smooth paper that is also relatively inexpensive. Be aware, though, that the strong brighteners used in this paper may cause yellowing. This paper is also very thin, and may therefore warp more easily than thicker papers. We usually reduce Ink Values a bit to avoid this (see description on page 139) and also to prevent mottling in areas of heavy ink coverage.

Matte Fine Art Papers

You have to use Matte Black for these papers – at least to achieve the best result.

▸ **Hahnemuehle Photo Rag / Satin** • These papers are very popular, but expensive. Both papers are available in different weights (from 188 gsm to 460 gsm). Photo Rag, using some OBAs, is well suited for black-and-white prints. You have to watch for scuffing and cotton dust, and you

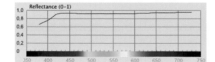

Figure B-3: Reflectance diagram of "Hahnemuehle Photo Rag 308"

should gently clean the paper with a soft brush or compressed air before printing.* This paper is also sold (or co-branded) by HP and Canon and works well with all the printers mentioned in appendix A – at least when using the 188 gsm grammage. When using the 308 grammage version, the smaller 13"/A3+ printers (e.g., the Epson R2400) may need some manual help when feeding the paper.

** This handling should be applied to **all** cotton papers – not only those from Hahnemuehle!*

▶ **Somerset Velvet Photo Enhanced** • Very nice paper. One of our favorites.

▶ **Moab Entrada Natural** • Excellent, reasonably priced paper. It's available in a natural and in a bright white version and has a two-sided coating. While the "natural white" version does not use OBAs (see figure B-4), the "bright white" version does (figure B-5).

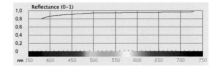

Figure B-4: Reflectance diagram for the "Moab Entrada Fine Art Natural"

▶ **Epson Ultra Smooth** • Top, natural white 100% cotton paper that is also archival. Watch for cotton dust, however.

▶ **Epson Velvet Fine Art** • A 100% cotton rag paper with high archival values.

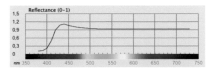

Figure B-5: Reflectance diagram for the "Moab Entrada Fine Art Bright White"

▶ **Museo II** • Very fine double-sided paper.

▶ **Innova Smooth Cotton High White** • We used this paper with Epson K3-ink printers and the HP Z3100. It had good handling for a cotton paper with no OBAs. There is also a "Natural White" version of this paper available. Both versions are also good papers for black-and-white prints.

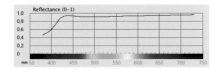

Figure B-6: Reflectance diagram for the "Innova Smooth Cotton High White"

▶ **Arches** • Expensive paper with a very good reputation. We have not yet had a chance to test it ourselves, though.

Satin/Glossy Coated Rag Papers

Use Photo Black ink for these papers.

▶ **Museo Silver Rag** • New 100% cotton fiber-based paper with a gloss finish that in its appearance is close to a Baryt paper. Museo Silver Rag was one of the first papers to appear in this category. It's a natural white paper that uses no or very few OBAs and should be highly archival. When printing on the HP Z3100, we use the Gloss Enhancer.

▶ **Hahnemuehle FineArt Pearl 285** • Like the Museo Silver Rag, this is a fine, fiber-based, bright white paper (using OBAs) with luster finish. The combination of bright white and luster results in a very rich gamut, deep blacks, the reproduction of fine details, high image sharpness and a really good Dmax value. Juergen likes this paper and used it for a lot of prints (until Hahnemuehle came out with the new FineArt Baryta 325).

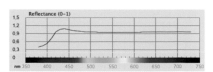

Figure B-7: Reflectance diagram for the "Hahnmuehle FineArt Pearl"

Satin or Soft Gloss Papers

Most of these papers have a slightly plastic feel. This is more of an issue in open portfolios than when displayed behind glass.

▸ **HP Premium Plus Satin** • Very nice satin surface. RC paper that is available in many popular sizes – sheets as well as rolls. The ICC profile is part of the HP B9180 and Z3100 drivers.

▸ **Epson Premium Semigloss** • We like this paper a lot for its smooth surface. It's reasonably priced. That's why we often use this RC paper for our test and proof prints when using Epson printers. Though the paper is quite white, it doesn't seam to contain OBAs (see figure B-8).

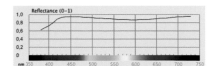

Figure B-8: Reflectance diagram for "Epson Premium Semigloss"

Luster/Pearl Papers

▸ **Epson Premium Luster** • Popular bright white RC paper with good Dmax. Some people don't like the surface texture, which is somewhat a non-issue when displayed behind glass. Beware of outgassing – let the paper dry for quite some time before framing or putting into sleeves.

▸ **Ilford Galerie Smooth Pearl** • This is a nice 290 gsm RC paper with Ilford profiles for many printers, a rich gamut, a good Dmax, no OBAs, but a slight tendency to curl.

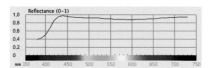

Figure B-9: Reflectance diagram for "Iford Galerie Smooth Pearl"

High-Gloss Papers

As with the Semigloss and Luster papers, use Photo Black ink for these papers.

▸ **Epson Premium Glossy** • Some bronzing may show with the older Epson printers and their inks. This bronzing may largely be reduced by using Epson's K3 inks. (We first started testing this paper using the 2000P with the Pre-K3 inks some years ago.) This RC paper has very rich gamut and reproduces fine details. It looks very white. The reflectance diagram indicates quite a bit of OBAs in this paper.

Let this paper dry (and do some outgassing) for quite a while before framing or putting it into sleeves.*

▸ **HP Premium Plus Gloss** • Very nice glossy paper surface.

▸ **Pictorico Photo Gallery Hi-Gloss White Film** • Very special paper, produced by Pictorico [107]. This paper has an ultra-smooth surface and also a lot of contrast and depth. It is rated to be highly archival.

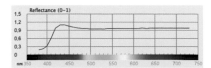

Figure B-10: Reflectance diagram for the "Epson Premium Glossy", indicating quite a lot of OBAs.

** For most RC papers you should let the paper outgas some time before framing , laminating or storing it in sleeves.*

B.3 A New Generation of Fiber-based and Baryt Papers

Since 2006 a new generation of fine, fiber-based fine art papers has been coming onto the market. Innova FibaPrint Gloss, Museo Silver Rag, Premiere Art Platinum Rag, and Hahnemuehle FineArt Pearl are early examples. The first generation of these papers was matte, semi-matte or semi-gloss and had a very fine, smooth surface. These first fiber-based papers were suitable for color as well as black-and-white prints, had a rich color gamut and a very good Dmax, typically ranging from 2.0 up to 2.5.

In 2007 a number of paper manufacturers started to offer Baryta papers. For traditional gelatin silver prints Baryta papers have been the top quality photographic papers, offering a very smooth surface, a rich color gamut, and very dark blacks and bright whites. Baryta (barium sulphate) achieves a good brightness without using too many optical brighteners.* Traditionally, (wet) prints done on Baryta papers where either supplied as air dried – resulting in a softer, semi-matte finish – or hot dried, resulting in a high-gloss surface with a gloss sheen. As these drying techniques can't be applied to digital printed paper, you will find (digital) Baryta papers offered with a gloss or semi-gloss surface (e.g., Harman Gloss FB AL), and others with a semi-matte or even matte surface (e.g., Harman Matt FB Mp). Some of the gloss papers achieve an outstanding Dmax of close to 2.6.

Some of these new papers, nevertheless, use OBAs, but so do the traditional analog Baryt papers.

While the first Baryt papers that came out were mainly semi-gloss and white or even bright white, meanwhile most manufacturers have added a second line that is matte or semi-matte and is natural or even warm white (resulting in a somewhat smaller gamut and a lower Dmax). All these papers, used with pigmented inks, should attain very high lightfastness and should be highly archival.

These new papers tend to be more expensive than the standard inkjet fine art papers (but well worth their money, according to our opinion).

Concerning the depth of the blacks, the Dmax value, the details reproduced, and the surface structure, most of the new papers surpassed the papers we had seen until then. We tested the following:

▶ **Harman Inkjet Gloss FB AL** • Harman Technology, Ltd [94] is the company that carries on the legacy of the classic Ilford B&W papers. Their aim is to match the well-known Ilford silver papers. On this Baryta fiber-based paper, images look sharper than on any other paper we have seen. This means that you need significantly less sharpening for output. This 320 gsm paper has a Dmax of 2.3 (using Epson K3 inks with an R2400 and Photo Black), a very smooth, semi-gloss surface and is quite thick for its grammage.* It contains some OBAs. Using Epson K3 inks (Photo Black) our black-and-white prints showed hardly any gloss difference between printed and plain paper areas. The alumina – that's what the AL stands for – in the substrate gives the surface a very slight metallic glow, thus adding some depth to the print.

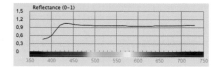

Figure B-11: Reflectance diagram of "Harman Inkjet Gloss FB AL"

You might have to adapt your printer settings for this.

Harman also offers two other fiber-based Baryt papers: **Inkjet Matt FB Mp** and **Inkjet Matt FB Mp Warmtone**. The latter has creamy whites and velvety blacks. Due to the matte paper, however, you will achieve neither the same Dmax nor the same richness of fine details as with the gloss paper. Nevertheless, for some subjects, these are both fine papers.

All three papers are available in several cut sheet as well as roll sizes. We liked the results in our early tests. In the spring of 2008 Harman plans to also launch the gloss paper in Warmtone.

▸ **Hahnemuehle FineArt Baryta 325** • This 325 gsm fiber-based paper has a satin finish (this is quite robust for its class), offers a smooth, bright white surface (strong OBAs) and a gloss that is a bit stronger than that of the Harman Gloss FB AL. A print on a Canon iPF6100 showed a Dmax of 2.55, which is extraordinary. Hahnemuehle [92] provides good profiles for some Epson, HP, and Canon printers (but for fewer printers than for most other Hahnemuehle fine art papers).

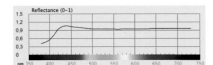

Figure B-12: Reflectance diagram of "Hahnemuehle FineArt Baryta 325"

▸ **Ilford Galerie Gold Fibre Silk** • This fiber-based Baryt paper has low (or no) OBAs (see figure B-13), and is offered in quite a few formats (8.5" × 11", 13" × 19", 17" × 22", in 10 and 50 sheet packages, as well as 17", 24" and 44" wide rolls and 40' long).

Uwe used this paper with an Epson Pro 3800 and in the driver had to use Paper Thickness 5 and Platten Gap *Wider* to avoid head streaks. Though this is a very fine paper (according to our taste), it's reasonably priced.

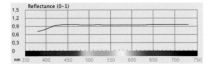

Figure B-13: Reflectance diagram of "Ilford Galerie Gold Fibre Silk"

▸ **Sihl Professional Photo Barite 290 Satin 4804** • Sihl is a European company that does the paper coating for a number of other paper manufacturers (e.g., Hahnemuehle), but also sells its own papers like this new Barite 290 Satin. Printing with an Epson R2400 using K3 inks (Photo Black), we achieved a Dmax of 2.14. The 290 gsm fiber-based paper has a semi-matte, natural white, slightly textured surface and is easy to handle.

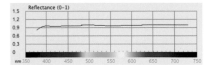

Figure B-14: Reflectance diagram of "Sihl Professional Photo Baryt 290 Satin 4804"

▸ **Tecco Digital Photo BT 270 Baryt** • In Europe, Tecco [114] is well-known for its inkjet papers for digital proofs. Since 2005, this company has, been also selling a number of fine art papers. In 2007 they came out with several Baryt papers; the first was the Digital Photo BT 279 Baryt. This 270 gsm paper has a smooth, almost untextured surface, is very reasonably priced, and is available in a number of cut sheet and roll sizes. Tecco followed up the first bright white Baryt paper by another Baryt paper with a warm tone: **Digital Photo BTI 290 Baryt Ivory**.

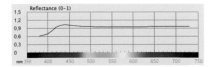

Figure B-15: Reflectance diagram of "Tecco Digital Photo BT 270 Baryt"

▸ **Epson Exhibition Fiber Paper** (called **Traditional Photo Paper** in Europe) • This 320 gsm paper is fiber-based (but uses no Baryt), has a soft gloss and some texture. This paper is available in 8.5" × 11", 13" × 19", 17" × 22", and 24" × 30" cut sheets. The paper is thick, which can help larger sheets to lie flat. Its character is quite different from that of the

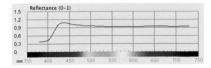

Figure B-16: Reflectance diagram of "Epson Exhibition Fiber Paper"

Harman paper. Some may love its stronger texture, while others will prefer the slightly smoother Harman paper.

▸ **Canon Polished Rag** is a new natural white (meaning no brighteners) satin-coated rag paper. Uwe likes this paper a lot for its natural look.

B.4 Specialty Papers and Canvas

This category compromises the following:

▸ All sorts of canvas

▸ Rice papers or papers made of bamboo or other exotic fibers

▸ Backlit film, clear film, and other transparencies

▸ Many more variations

Depending on your intended usage, you can find some fine media in this category, but, personally, we rarely use them.

Juergen tested the **Hahnemuehle Bamboo 290**, a paper made from 90% bamboo fibers and 10% cotton. This is an exotic paper, free of OBAs, with a natural warm tone: ◯. For some subjects, this can be a very suitable paper – e.g., for a monochrome (black-and-white) print of flowers or plants, a photo of a forest or a jungle; but it can also give a distinguished look to a portrait, the image of a mountain or a still life image.

Using the proper inks and doing proper post-processing, you can also print on fabric and even on wood and metal. But as we have no personal experience in this field, we refrain from discussing these media.

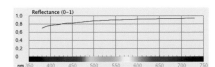

Figure B-17: Reflectance diagram for the "Hahnemuehle Bamboo 290".

B.5 Fine Art Papers Well Suited for Black-and-White Prints

Here, we only list papers we know and consider to be good:

Matte Fine Art Papers for Black-and-White Prints

▸ **Hahnemuehle Photo Rag**[*] **/ Satin** • A very popular but somewhat expensive paper; you have to watch out for scuffing and cotton dust. Photo Rag is available in a number of different grammages (188 gsm, 276 gsm dual-sided coated, 308 gsm, and 460 gsm) as well as in different sheet and roll sizes.

▸ **Somerset Velvet Photo Enhanced** • A very nice paper that is one of our favorites.

▸ **Moab Entrada Fine Art Natural** • Excellent, reasonably priced paper (see the reflectance diagram in figure B-4).

▸ **Epson Ultra Smooth** • A top paper that is also archival. Watch for cotton dust, however.

** Don't forget to brush the dust off this paper before inserting it into your printer!*

Satin or Soft Gloss Papers

Most of these papers have a slightly plastic feel. This is more of an issue in open portfolios than behind glass.

➔ *There are two ways to spell the name of this German manfacturer: "Hahnemuehle" and "Hahnemühle". The latter is the German way of spelling.*

▸ **Hahnemuehle Photo Rag Pearl** • This paper came out in 2006. Like the Museo Silver Rag, it tries to emulate the appearance of a Baryt paper. It has a very fine, smooth, pearl surface, a rich gamut, a good reproduction of fine details, and it is well suited for color as well as for black-and-white prints. It contains some OBAs.

▸ **HP Premium Plus Satin** • Very nice satin surface.

▸ **Epson Premium Semigloss** • Comes close to the Epson Premium Semi Matte paper; this paper may not be quite as nice as the Premium Semi Matte but Premium Semigloss is reasonably priced.

▸ **Mueso Silver Rag** • A very fine paper for black-and-white prints. We really like it. This fiber-based paper comes close to some good Baryt papers.

With the increasing demand for fine art inkjet papers more papers of this type have been coming to the market since 2006, e.g., Premiere Art Platinum Rag or Epson Exhibition Fiber Paper.

As mentioned before, all of the Baryta and fine fiber-based papers we enumerated on page 273 to 274 are very well suited for black-and-white prints. Actually, since we have tested these Baryt papers, we hardly use any others.

High Gloss Papers

▸ **HP Premium Plus Gloss** • Very nice glossy paper surface.

▸ **Pictorico Photo Gallery Hi-Gloss White Film** • Very special paper, which has an ultra smooth surface and also a lot of contrast and depth. It is rated to be highly archival.

We'd like to recommend Clayton Jones' article "The Great Paper Chase" [47] as another good source of knowledge about papers for black-and-white printing.

A Note on Paper Grammage and Paper Thickness

Though the grammage and the thickness of a paper seem directly connected, be aware that two papers having the same grammage (e.g., 310 gsm) may have quite a different thickness, and additionally may have a noticeable different stiffness. All these factors have to be considered when selecting a suitable paper for a specific print. If you intend to use a paper with a high grammage, which usually adds significance, make sure that your printer is able to feed the paper and doesn't smear the print.

While for a small print a lower grammage and lesser stiffness is acceptable, for a large print a high stiffness is very desirable as this ensures that the print will lie or hang flat. In the specification of a paper you will hardly find any data on its stiffness. If, however, your printer does not provide a straight through paper path, you might have problems with a stiff paper.

Figure B-18:
Try the new Baryt papers for your black-and-white print. Here, we converted the color image to black and white (using a Black & White adjustment layer of Photoshop CS3) and then slightly reduced the layer opacity to let the original color shine through a bit),

Camera: Nikon D100

Glossary and Acronyms

C

absolute colorimetric • See *rendering intent*.

ACR • see *Adobe Camera Raw* – the RAW converter of Adobe Photoshop and Bridge.

ACE • *Adobe Color Engine* is a color conversion tool created by Adobe, which is used to convert images from one color space to another.

Adobe RGB (1998) • A color space defined by Adobe. It is well-suited for digital photographs and has a reasonably wide gamut, larger than sRGB, and includes most printable colors.

artifacts (or artefacts) • An undesirable effect visible when an image is printed or displayed, such as moiré patterns, banding or compression artifacts. Compression artifacts (JPEG artifacts) may result from too severe JPEG compression. Also over-sharpening may produce artifacts.

banding • Noticeable tonal level jumps in an area, where a continuous tone level would normally be. Banding is one type of *artifact*.

black point • The density (or color) of the darkest black a device may reproduce. Black levels beyond that are clipped to the black point.

black point compensation • An option in your Photoshop color space conversion dialog (e.g., in your print dialog). When this option is activated, Photoshop will try to compensate for different black points when mapping one color gamut (color space) to another. Usually, you should activate this option. If, however, the supplier of an ICC profile recommends otherwise, follow his advice.

bronzing • Some inks (usually black inks) have a reflective property that results in a slightly bronze appearance under certain lighting conditions. This should not be confused with *metamerism*.

calibration • Adjusting the behavior of a device to a pre-defined state. Calibration, in many cases, is the first step when *profiling* a device.

caliper • refers to the thickness of a sheet of paper expressed in thousandth of an inch.

camera RAW format • See *RAW*.

candela • Unit of measurement for luminosity. Luminosity is specified in candela per square meter (cd/m^2).

cd • See *candela*.

CF • *Compact Flash* – a type of data storage used in memory cards for digital cameras.

CIE • *Commission Internationale de l'Eclairage*. This is the international scientific organization which defined the CIE Lab standard.

CIE Lab • See *Lab*.

characterization • See *profiling*.

CMM • *Color Matching Module* – the internal color engine of a color management system. It does the color translation from different (source) color spaces to the PCS (*Profile Connection Space*), and from the PCS to the output color space. Well known CMMs are Apple's *ColorSync* for the Mac and Microsoft's ICM as an integral part of Windows. Adobe provides its own CMM module with applications, such as Photoshop and InDesign. It is called ACE (*Adobe Color Engine*).

CMS • *Color Management System*.

CMYK • A color model based on the four primary printing colors *cyan*, *magenta*, *yellow* and *black* (Black is also

called the *key color, thus K*). Used in print production, they form a subtractive color model. Though many ink-jet printers use CMYK inks (and often more additional colors), they, in fact, present an RGB interface to the user.

CRT • *Cathode Ray Tube* – a component in monitors incorporating glass tubes for display.

clipping • The loss of certain tonal values usually found in the color or tonal limits of a color space. Clipping occurs, for example, when converting images from 16-bit-mode to 8-bit or when converting from RGB to CMYK. In these cases, usually some saturated colors are clipped to become less saturated colors.

color gamut • See *gamut*.

colorimeter • An instrument used to measure the color of emitted light. Often, one is used while profiling monitors.

color model • The way colors are described by numbers. RGB, for example, uses a triple, denoting the amount of red, green and blue. CMYK uses a quadruple for the percentage of cyan, magenta, yellow and black. There exist other colors models, such as Lab, HSM, Grayscale (a gray value) or Bitmap (with pixel values of 0 or 1, white or black, respectively).

color space • A range of colors available for a particular profile or color model. When an image resides in a particular color space, this limits the range of colors available to that image. It also defines *how* the color values of an image are to be interpreted. There are *device-dependent color spaces* (e.g., those of a scanner or printer) and *device-independent color spaces* (e.g., Lab, Adobe RGB (1998) or sRGB).

ColorSync • Apple's implementation of ICC-based color management (part of Mac OS 9 and Mac OS X).

color wheel • A circular diagram that displays the available color spectrum (at a particular brightness level).

color temperature • A measure on the spectrum of the wavelength of white (light). The unit used is Kelvin (K). Lower color temperatures correspond to a red

or yellowish light, higher temperatures result in a bluish tint. The term "temperature" stems from a blackbody radiator emitting (white) light when heated to a specific color temperature; for example:

candle light, fire	1 000–1 800 K
tungsten	2 600–2 700 K
halogen lamp	3 400 K
moonlight	4 100 K
D50 daylight illuminant	5 000 K
sunny and blue sky	5 800 K
D65 daylight illuminant	6 500 K
flash	6 500 K
cloudy sky	7 000–8 000 K
neon light	8 000–9 000 K
sunny mountain snow	up to 16 000 K

chroma • The technical term for *saturation*.

curves • A tool in Photoshop that allows control (change) of tonal values in an image. The curve diagram below represents the relationship between input and output. By modifying this curve, corresponding tonal values of the pixels in the image are changed.

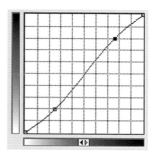

CS1, CS2, CS3 • Adobe Creative Suite 1, 2, or 3. There are several different variations of these suites (e.g, Standard, Premium, Master Collection, …). All suites include Photoshop, Bridge, and Version Cue; the inclusion of other applications like InDesign, Acrobat, Illustrator, Flash, or Dream Weaver depends on the specific suite you buy.

D50 • Daylight at 5,000 Kelvin. This is the standard light (*illuminance*) in the printing industry (prepress) for evaluating colored prints.

D65 • Daylight at 6,500 Kelvin. This is the standard (*illuminance*) that is closer to the light emitted by CRT or LCD monitors.

device profile • See *ICC profile*.

dithering • A technique used to simulate many different colors and/or halftones yet utilizing only a few primary colors by placing dots in a certain pattern. Viewed from an appropriate distance, the image is perceived as a continuous-tone image.

Dmax • specifies the maximum of a density range of a scanner, a slide or a print. Density range is the difference in density between the lightest and the darkest areas of an image. The Dmax of the paper and print technology used in this book is about 1.6. Some fine art papers can achieve a Dmax of up to 2.7. A high-end film scanner may achieve a Dmax of up to 4.2.

dot gain • Halftone dots grow slightly in size when printed (e.g., due to ink spreading). This is called *dot gain*. Coated paper has a dot gain of 8–20 %, while with uncoated paper it may grow up to 28%. Photoshop may take dot gain into account when producing output for printers by reducing a dot size appropriately to compensate for its future dot gain.

DPR • *Display Permanence Rating* – the time period a print should last before a noticeable fading of the image occurs. For comparable figures, it is important to know under what conditions this measurement was taken.

dpi, DPI • *dots per inch.* Used as a measurement of print resolution with regard to ink or toner dots per inch on paper or printing plates. Most printing techniques (e.g., inkjet printers or offset presses) simulate a halftone value or a non-primary color of a pixel, using a pattern of tiny dots. With such printing techniques, the dpi value of a printing device must be considerably higher (by a factor of four to eight) than the *ppi* (*pixel per inch*) value of the image.

ECI • *European Color Initiative.* This organization defines standardized means to exchange colors (color images) on the basis of ICC profiles. You may find some specific color profiles on their Web site (see www.eci.org).

ECI-RGB • An RGB work space for those images destined for prepress work in Europe. Its gamut is somewhat wider (slightly more green tints) than that of Adobe RGB (1998) and also covers nearly all colors intended to be printed.

EPS • *Encapsulated PostScript.* A standard file format, usually including vector graphics or a mix of vector graphics and bitmap images. Often, EPS files contain both the actual graphic information and, additionally, a preview image.

EV • *Exposure Value.*

Exif, EXIF • A standardized format for camera metadata (e.g., camera model, exposure value, focal length, etc.). These data are usually embedded in the image file and may be used for searching or by applications to act in an intelligent way on the data; for example, PTLens uses the focal-length value from EXIF data to correct lens distortions.

Extensible Metadata Platform (XMP) • defines how metadata is stored within images. Because it is "extensible", users can add to it. The most common use of XMP is to include information about the image that is added by the use of Photoshop or similar programs and stored within the image file itself. Common metadata that is added include the elements found in the Dublin Core Schema. IPTC has developed a set of custom panels that can be downloaded for XMP to store IPTC data through the use of Photoshop CS. Photoshop CS2 and CS3 has these IPTC panels built in.

Firewire • (IEEE 1394) a fast, serial interface for card-readers, digital cameras, scanners and other peripheral devices. Firewire allows for transfer rates of up to 40 MB/s (1394a) or 100 MB/s (1394b).

gamma • (1) Relationship between tonal values (or input voltage with a monitor) and perceived brightness. There are two gamma values in broad use:
(A) 1.8, the Apple standard for the Mac and preferred in prepress work.
(B) 2.2, the Windows standard. For photographs, we recommend using 2.2, (even on Apple systems) for monitor calibration and profiling.
(2) The degree to which a *color space* or device is non-linear in tonal behavior.

gamut • The total range of colors (and densities) a device can reproduce (e.g., a monitor or printer) or capture (e.g., a scanner or digital camera). *Color gamut* is the range of colors a device can reproduce (or capture) and

dynamic range refers to the brightness levels a device can produce or capture.

gamut mapping • The way colors are remapped when an image is converted from one color space to another. If the destination space is smaller than the source space, color compression or color *clipping* occurs.

gray balanced • A color space is called *gray balanced* if equal values of the *primary colors* result in a neutral gray value. This situation is preferable for work spaces.

gsm • *gram per square meter* (g/m²) – a measurement (*grammage*) for the paper weight.

halo • This is the glow around an object caused by the diffusion of light. This problem is increased when an uncoated lens is used, when a lens surface is dirty, and when the subject is backlit. Halos are created by the unsharp masking filter in Photoshop as a way to increase the contrast of edges and make the image appear to be sharper.

HDR(I) • refers to *High Dynamic Range Imaging*.

highlights • Areas of an image with no color or gray level at all.

histogram • A visual representation of tonal levels in an image. With color images, it is advantageous not only to see luminance levels but also tonal levels of each individual color channel:

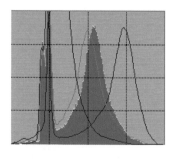

HSB, HSL • Adaptations of the RGB color model. Colors are described by a *hue, saturation* of the hue, and *lightness* (HSL) or *brightness* (HSB).

hue • Hue is normally referred to as *color tint*.

ICC • *International Color Consortium.* A consortium of companies that develop industry-wide standards for color management – e.g., ICC profiles. For more information, see www.color.org.

ICC profile • A standardized data format to describe the color behavior of a specific device. ICC profiles are the basis of color management systems. They allow CM systems to maintain consistent color impression across different devices, different platforms and throughout a complete color-managed workflow.

ICM • *Image Color Management* or *Integrated Color Management* – the Microsoft implementation of the color management module in Windows.

IEEE 1394 • See *FireWire.*

IPTC • *International Press Telecommunication Council.* In photography, IPTC is a metadata format that describes the image. It provides fields, e.g., for copyright notices, rights usage terms, a title (caption), and keywords.

intent • See *rendering intent.*

IT-8 • A family of standard targets used by profiling devices, such as scanners or digital cameras.

JPEG • *Joint Photographic Experts Group.* This ISO group defines a file-format standard for color images. The JPEG format uses lossy compression, offering various trade-offs between high quality (at lower compression) and lower quality that results in a higher compression but smaller files.

Lab, LAB, L*a*b*, CIE Lab • A perceptual- based color model defined by the *CIE*. Colors in this model are defined by L (*Luminance*) and two color components, **a** and **b**. "a" (or "A") is the axis ranging from red to green while "b" (or "B") ranges from blue to yellow.

LCD • *Liquid Crystal Display.* A display technique used for flat-panel monitors (TFT monitors).

LFP • *Large Format Printer.*

Lossless compression • is a data compression technique in which no data is lost in the compression. The original image can be exactly reproduced from the compressed version. For image compression, TIFF-LZW, TIFF-ZIP, and PNG are two formats of lossless compression.

lpi, LPI • *lines per inch.* The measure used to define printing resolution (or screen frequency) with typical halftone printing methods, such as offset printing.

luminance • Amount of light (energy) emitted by a light source, e.g. by a monitor. The unit used with monitors is *candela per square meter* (cd/m²).

lux (lx) • Unit for measuring the illumination (illuminance) of a surface. 1 lux = 1 lumen/m², 1 lux = 0.093 foot candles.

LZW • is the abbreviation for *Lempel-Ziv-Welch*, a lossless data compression technique.

metadata • Data that describe other data objects. EXIF and IPTC data are examples of metadata as part of digital photographs.

metamerism • The phenomenon that two color samples composed of a different mix of primary colors may look the same (produce the same color sensation to a viewer) with some lighting and may produce different color sensations when viewed under a different lighting.

mil • Measurement of thickness, especially in paper. 1 mil = 1/1000 inch = 0.0254 mm.

OBA • *Optical Brightening Agents* (also called *Optical Brighteners*) are additives to paper which achieve better brightness and whiteness of the paper.

P.A.T. • *Photographic Activity Test*, a testing standard (ANSI NAPM IT9.16-1993, ISO 14523-1999, DIN ISO 9706) for material in archiving and preservation. Material with a certificate to be PAT-compliant should show a good longevity and should be well suited for archival and museum usage.

PCS • *Profile Connection Space*. This is an intermediate color space used when converting colors from a source space to a destination space (say, from one profile to another). According to the ICC specification, it can be either *CIE Lab* or *CIE XYZ*.

perceptual intent • See *rendering intent*.

ppi, PPI • *pixel per inch*, used to specify the resolution of a digital image. See also *dpi*.

primary colors • Those colors of a color model used to construct the colors of the pixels. For RGB, the primary colors are red, green and blue. CMYK primaries are cyan, magenta, yellow and black.

profile • See *ICC profile*.

profiling • The act of creating a device *profile*. Usually a two-step process, whereby the first step is to linearize the device. The second step measures color behavior of the device and describes it with an ICC profile. The entire process is also called *characterization*.

PS • *Photoshop*.

PSD • stands for *Photoshop Document format*. It is the native format for Adobe Photoshop software.

RAW (camera RAW format) • Image data coming from a digital camera that mainly consists of the raw data read from the camera sensor and not yet processed and with no color interpolation (demosaicing). Today, almost all RAW image files use a proprietary format, specific to the camera manufacturer and even the camera model. This raw data has to be converted by a RAW converter to be used in an image application such as Photoshop or to be printed.

RC • *resin coated paper*, used for photographic prints in the wet darkroom, as well as for inkjet prints.

relative colorimetric • See *rendering intent*.

rendering intent • A strategy to achieve color space mapping when converting colors from a source to a destination color space. ICC has defined four different standard intents:

(1) *Perceptual* compresses colors of the source space to the gamut of the destination space (where the source space is larger than the destination space). This intent is recommended for photographs.

(2) *Relative colorimetric* does a 1:1 mapping when the colors in the source space are all present in the destination space. Out-of-gamut colors of the source are mapped (clipped) to the nearest neighbor of the destination space. This intent may be used for photographs if most of the colors in the source space are available in the destination space. In this instance, most colors of the source are mapped 1:1 into the destination. The *white point* of the source space is mapped to the *white point* of the destination space, as well.

(3) *Absolute colorimetric* does a 1:1 mapping when colors in the source space are present in the destination space. Out-of-gamut colors of the source are mapped (clipped) to the nearest neighbor of the destination space. The *white point* of the source is maintained. This intent is used (only) when *soft-proofing*.

(4) *Saturation*. This intent aims to maintain saturation of a source color, even when the actual color has shifted

during mapping. This intent may be used when mapping logos and diagrams, but is not suitable for photographs.

resolution • This term defines the depth of detail an image can reproduce. Resolution is measured in dots per inch (*dpi*) or pixels per inch (*ppi*).

RGB • *Red, Green, Blue.* These are the primary colors of the standard additive color model. Keep your photographs in RGB mode as long as possible, and use RGB for archiving your images.

RH • *Relative Humidity*, expressed as a percentage.

RIP • *Raster Image Processor.* A module, either part of a printer or a software application. The RIP converts page information into a raster image or dot pattern for printing.

saturation • (1) defines the purity of color. Saturation may vary from none (which is gray) via pastel colors (some saturation) to pure colors (full saturation) with no gray.
(2) One of the four rendering intents. See *rendering intents*.

spectrophotometer • An instrument to measure the color of emitted and reflected light. It usually is used when profiling printers and measuring the color (light spectrum) of a print or other surface.

soft-proof • Usage of the monitor as a proofing device. For soft-proofing, Photoshop simulates colors an image will have with a different output method (e.g., a print) on a monitor.

sRGB • A standard color space for monitors. It is intended for images presented on monitors or on the Web.

swellable paper • A kind of coated paper used for dye-based inks. Here, when the moist ink hits the paper, the paper swells up and lets the ink sink in (only into the top layer). When drying, the paper again closes up and encapsulates the ink particles.

tagged images • Images with an embedded color profile.

TIFF • *Tagged Image File Format.* A file format for images. TIFF acts as an envelope format for many different image formats and allows several different compression modes, most of them lossless (e.g., LZW, ZIP, Runlength encoding, uncompressed). It allows storing different color depths (from 1 to 32 bits per channel), embedded comments, profiles, and other metadata, as well as layers and alpha channels. It is well suited as an archival format for images.

USB • *Universal Serial Bus.* A computer device interface for peripherals, such as card readers, cameras, scanners and external hard disks. There are two versions of the USB bus, where USB-2 (high speed) is much faster (up to 60 MB/s) than USB-1.x (up to 1.2 MB/s).

USM • *Unsharp Masking.* A method of sharpening an image by increasing the contrast of its edge pixels. The term stems from a traditional film-composing technique.

vignetting • Vignetting is an effect where some areas of a photograph are less illuminated than others. Most camera lenses show "optical vignetting" to some degree, mostly at the outer edges, but stronger when the aperture is wide open. "Mechanical vignetting" may occur if a lens hood is too narrow or deep, or is not properly attached.

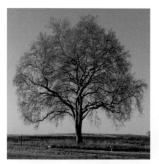 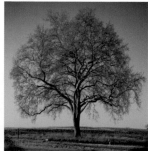

Slight vignetting *Very strong vignetting*

WB • See *white balance*.

wide-gamut RGB • A large color space that covers almost all of RGB. There is no physical device that can reproduce all color of *wide gamut*. This color space is sometimes used for archival purposes when output will be produced for photographic printers or transparent recorders.

white balance (WB) • Adjusting the color temperature and color tints in an image, so that there is no color cast, and gray areas show no color tint.

white point • (1) The color of "pure white" in an image. On a monitor, it is the brightest white the monitor can display. In photo prints, it usually is defined as the color of blank white paper.
(2) The color of a light source or lighting conditions in terms of *color temperature*.
(3) The color "white" in a color space; for example, *Adobe RGB (1998)* and *sRGB* have a white point of 6,500° K (*D65*) while *ECI-RGB, Color Match RGB* and *Wide Gamut RGB* have a white point of 5,000° K (*D50*). Most CMYK color spaces have a white point of D50.

white point adaptation • When a color mapping takes place and the source and the destination spaces have different *white points*, with some *intents* (e.g., *Relative colorimetric*) colors are adapted relative to the new *white point*.

WIR • *Wilhelm Imaging Research*. This is a well known research organization that evaluates the image permanence ratings of prints on specific papers, using specific inks and specific printers.

working space • A device-independent color space (profile). It defines the color *gamut* available to the image using this working space. For photographers, *Adobe RGB (1998)* or *ECI-RGB* (in Europe) are the recommended working spaces.

XMP • stands for Extensible Metadata Platform. See Extensible Metadata Platform

ZIP • is the process of compressing data and storing it in a zip file format file. It is also the file extension for that file format. The ZIP file can contain one or more documents or files. It is used in some cases to combine a group of images for electronic transport.

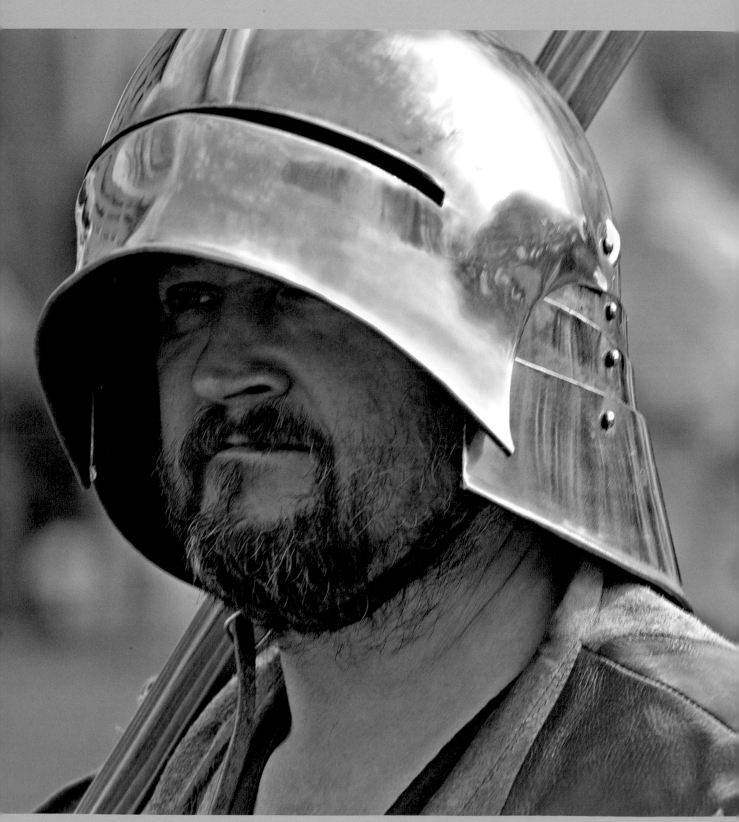

Camera: Nikon D200

Resources

D *Here you will find all the references cited (with bracketed numbers) throughout the chapters. Please keep in mind that some of the URLs given here might change or vanish over time. To help us keep this information up to date, please let us know if you find a link that no longer works at juergen@gulbins.de.*

D.1 Recommended Books

[1] Gorge Barr: *Take Your Photography to the Next Level: From Inspiration to Image.*
Rocky Nook, Santa Barbara, 2008.

[2] Katrin Eismann:
Photoshop Masking & Compositing
Peachpit, 2005.

[3] Tim Grey: *Color Confidence.*
The Digital Photographer's Guide to Color Management.
Sybex Inc, San Francisco, 2006.

[4] Juergen Gulbins, Uwe Steinmueller:
Managing Your Photographic Workflow with Photoshop Lightroom.
Rocky Nook, Santa Barbara, 2007.

[5] Bruce Fraser, Ch. Murphy, F. Bunting: *Real World Color Management.*
Peachpit Press, Berkeley CA, 2004.

[6] Brad Hinkel: *Color Management in Digital Photography.*
Rocky Nook, Santa Barbara, 2006.

[7] Torsten Andreas Hoffmann: *The Art of Black and White Photography: Techniques for Creating Superb Images in a Digital Workflow.*
Rocky Nook, Santa Barbara, 2008.

[8] Harald Johnson: *Mastering Digital Printing.*
Second Edition.
Thomson, Boston, 2005.

[9] Peter Krogh: *The DAM Book: Digital Asset Management for Photographers.*
O'Reilly, Sebastopol, 2005.

[10] Andrew Rodney: *Color Management for Photographers: Hands on Techniques for Photoshop Users.*
Focal Press, Burlington, MA, 2005.

[11] Sascha Steinhoff: *Scanning Negatives and Slides.*
Rocky Nook, Santa Barbara, 2007.

[12] Bettina & Uwe Steinmueller: DOP2000:
Digital Photography Workflow Handbook:
www.outbackphoto.com/booklets/dop2000/
DOP2000.html

[13] Uwe Steinmueller, Juergen Gulbins:
DOP3002: *The Art of RAW Conversion: Optimal image quality from Photoshop CS2 and leading RAW converters.*
E-book on RAW conversion, using Adobe Camera Raw, RawShooter Essentials, and other RAW converters:
www.outbackphoto.com/booklets/booklets.html

[14] Bettina & Uwe Steinmueller: DOP3001:
Photoshop Layers for Photographers:
www.outbackphoto.com/booklets/booklets.
html

[15] Ben Willmore: *Adobe Photoshop CS3 Studio Techniques.*
Adobe Press, 2007.

Organizations and Institutes

[16] ECI – European Color Initiative:
www.eci.org

[17] ICC – International Color Consortium:
www.color.org

[18] *IPI – Image Permanence Institute*: This institute sprang from the Rochester Institute of Permanence and does research in digital image quality, light stability tests, and on the right conditions for long-term storage of film materials and digital images (e.g., inkjet prints):
www.imagepermanenceinstitute.org

[19] *SWOP – Specifications for Web Offset Publications*
This is an industrial organization targeting the creation of standards for the Publication Printing Industry in the United States.
www.swop.org

[20] Wilhelm Imaging Research Inc (WIR).
This institute conducts research on stability and preservation of traditional and digital color photographs and motion pictures.
www.wilhelm-research.com
See also:
www.wilhelm-research.com/pdf/
HW_Book_758_Pages_HiRes_v1a.pdf

[21] Henry Wilhelm, Carol Brower:
The Permanence and Care of Color Photographs: Traditional and Digital Color Prints, Color Negatives, Slides, and Motion Pictures.
This is a 758 page e-book (PDF) that you may download for free from the WIR Web site:
www.wilhelm-research.com/book_toc.html

[22] WIR: *Sub-Zero Cold Storage for the Permanent Preservation of Photographs, Motion Picture Films, Books, Newspapers, Manuscripts, and Historical Artifacts*:
www.wilhelm-research.com/subzero.html

[23] *WIR Display Permanence Ratings for Current Products in the 4x6-inch Photo Printer Category*:
www.wilhelm-research.com/4x6/4x6.html

D.3 Useful Resources on the Internet

Remember that World Wide Web addresses may change or vanish over time.

[24] Uwe Steinmueller: *Outbackphoto.*
This is Uwe's website, full of up-to-date information on digital photography, including lots of informative papers on photography:
www.outbackphoto.com

[25] B.Digital Outback Photo Open Forum on "Fine Art Printing for Photographers":
www.outbackphoto.com/tforum/

[26] *FotoEspresso* is our free photo-letter with in-depth papers on various topics related to digital photography. As a subscriber, you will receive an e-mail when a new issue is available. You can then download the document from:
www.fotoespresso.com
There is also a German version of this photo-letter:
www.fotoespresso.de

[27] *Colors by Nature* – some of the color works of Bettina & Uwe Steinmueller:
www.colors-by-nature.com

[28] Uwe Steinmueller: *A profile for black-and-white conversion*:
www.outbackphoto.com/artofraw/raw_08/
profile_BW.zip

[29] Digital Outback Photo: *Our Tonality Tuning Toolkit* (⊞, ⌘):
www.outbackphoto.com/workflow/wf_61/
essay.html

[30] Uwe Steinmueller: *Variations Toolkit* (⊞, ⌘) :
www.outbackphoto.com/filters/
dopf004_variations/DOP_Variations.html

[31] DOP free Photoshop action "Ring around":
www.outbackphoto.com/
DigitalCameraExperiments/dce_003/
ring_around.zip

[32] EasyS Sharpening Toolkit (⊞, ⌘):
www.outbackphoto.com/workflow/wf_66/
essay.html

[33] DOP_DetailExtractor Toolkit (🪟, 🍎).
This is Uwe's cheap, easy to use Photoshop plug-in for local contrast enhancement:
www.outbackphoto.com/filters/dopf005_detail_extractor/DOP_DetailExtractor.html

[34] Digital Outback Photo: Paper on sharpening:
www.outbackphoto.com/dp_essentials/dp_essentials_05/essay.html

[35] Akvis offers a number of nice Photoshop plug-ins, e.g., *Noise Buster* for noise reduction. Personally, we only use Akvis *Enhancer* for local contrast enhancement:
www.akvis.com

[36] Alien Skin offers a number of very fine Photoshop plug-ins (🪟, 🍎). For example we often use filters form the *Exposure 2* package e.g., to achieve the look of traditional films, or *Image Doctor* for a number of image corrections and for retouching (e.g., removing unwanted objects):
www.alienskin.com

[37] *B&W-Ramp*: An image with black-and-white values to determine the black-point and white-point of your printer:
www.outbackphoto.com/booklets/resources/fap/

[38] Digital Outback Photo: Essay on Workflow Techniques *Using Actions and Filters in Layers*:
www.outbackphoto.com/workflow/wf_19/essay.html

[39] Paper on *Noise Ninja* – a noise-removal tool (🪟, 🍎):
www.outbackphoto.com/workflow/wf_25/essay.html

[40] Digital Outback Photo: Essay on printing insights:
www.outbackphoto.com/printinginsights/pi.html

[41] Uwe Steinmueller: *Printing Insights #027: The D-Roller.*
www.outbackphoto.com/printinginsights/pi027/essay.html

[42] Uwe Steinmueller: *Printing Insights #029: Epson R800 Experience Report. A review diary*:
www.outbackphoto.com/printinginsights/pi029/Epson_R800.html

[43] Digital Outback Photo. Paper on noise reduction: *Digital Photography Essentials #004: "Noise"*:
www.outbackphoto.com/dp_essentials/dp_essentials_04/essay.html

[44] Jack Flesher. Paper Upsizing in Photoshop: *Workflow Technique #060: Uprezzing Digital Images (PC & Mac)*:
www.outbackphoto.com/workflow/wf_60/essay.html

[45] Alain Briot: *The Art of Digital B/W #007: Take control of your black & white inkjet printing with Inkjet Control*:
www.outbackphoto.com/artof_b_w/bw_07/essay.html

[46] Outback Photo: *The Art of Digital B&W.*
Here, you'll find a number of papers on black-and-white photography (conversion, printing, etc.):
www.outbackphoto.com/artof_b_w/index.html

[47] Clayton Jones: *Fine Art Black and White Digital Printing: An Overview of The Current State Of The Art.*
This is a very informative page on black-and-white printing:
www.cjcom.net/digiprnarts.htm

[48] Uwe Steinmueller: *TheImagingFactory: ConvertToBW Pro 3.0*:
www.outbackphoto.com/artof_b_w/bw_08/essay.html

[49] Paul Caldwell: *Workflow Techniques #092: Sizefixer by Fixerlabs.* Paper on upsizing using Sizefixer (🪟, 🍎):
www.outbackphoto.com/workflow/wf_92/essay.html

[50] Altostorm Software: *Altostorm Rectilinear Panorama*™ (🪟) corrects geometric image distortion:
www.altostorm.com

[51] Aian Brios essay on *QuickMats* (⊞), a program for virtual matting:
www.outbackphoto.com/portfoliowork/pw_25/essay.html

[52] *Fine Art Trade Guild.* This is the UK trade association for the art and framing industry. You may find some useful hints, standards, and recommendations on framing of fine art prints here:
www.fineart.co.uk

[53] HP: *Inkjet Photo Prints: Here to Stay.*
www.hp.com/united-states/consumer/sop/pdfs/Lightfastness_white_paper_update_final.pdf

[54] Harald Johnson: *DP&I – a digital printing & imaging resource.* A very informative site on many aspects of digital printing with quite a few how-tos:
www.dpandi.com
If you want to know more on giclée printing, go to:
www.dpandi.com/giclee/

[55] Nik Software offers a nice set of Photoshop plug-ins (⊞,), e.g., Nik Color Efex Pro – a set of effect filters –, Dfine – a tool to reduce noise –, and Nik Sharpener Pro for sharpening:
www.niksoftware.com

[56] *HDRSoft* is well known for its Photomatix Pro tools (⊞,), used to build *HDR* images. But it also offers a very good tool for tone mapping and local contrast enhancement. This tool is called *Tone Mapping.*
www.hdrsoft.com

[57] TIFFEN is well known for its camera filters (⊞,), but it also offers a number of software tools that simulate filters (and some more effects):
www.tiffen.com

[58] onOne Software: *pxl SmartScale* (⊞,)
This is a Photoshop plug-in for upsizing. The company also sells *Genuine Fractals*:
www.ononesoftware.com

[59] *Power Retouche* offers several Photoshop plug-ins. One we sometimes use for color to black-and-white conversion is *Black & White Studio* (⊞,):
www.powerretouche.com

[60] Giorgio Trucco is a well-known photographer and offers *Matworks!* (⊞)as a free PC tool to calculate matte openings:
www.gt-photography.com/matworks.html

[61] ShutterFreaks "Photoshop Frames for Printing" – a set of actions that create frames and mattes in Photoshop:
www.shutterfreaks.com/Actions/ACsBigFrames.html

Color Management Tools

[62] BabelColor offers several color oriented products, e.g., *BabelColor* (⊞,), a very nice and reasonable priced tool for measuring color (e.g., using Eye-One Pro) for converting and comparing colors and color gamuts as well as measuring Dmax in a print:
www.babelcolor.com

[63] Bruce Lindbloom: Information on *Beta RGB*. You may download the ICC profile of Beta RGB here, as well:
www.brucelindbloom.com/index.html?BetaRGB.html

[64] Information on the ColorChecker at BabelColor: Here you find a lot of information on the Color-Checker of Gretag/X-Rite. This includes averaged values of the patches of the Mini ColorChecker:
www.babelcolor.com/main_level/ColorChecker.htm

[65] Color Solutions offers a number of good color management tools – e.g., *basICColor*, a package for profiling your monitors and printers:
www.basiccolor.de

[66] Cromix is a color-oriented company. One of its tools is *ColorThink Pro* (⊞,) offering many functions like profile inspection and correction, profile management, and gamut graphing:
www.chromix.com

[67] Datacolor: Color Management Tools
(e.g. Spyder3Pro, ProfilerPlus, PrintFIX Pro, etc.)
(⊞, ⬜). These tools were previously sold by
Color Vision which is now part of Datacolor:
www.colorvision.com

[68] *Dry Creek Photo*: A Web site with many useful
links on color management for photographers,
various test charts, and hints on how to prepare
an image for digital photo printing:
www.drycreekphoto.com
They also have a useful page for monitor calibra-
tion done without special hardware devices:
www.drycreekphoto.com/Learn/monitor_
calibration.htm

[69] Epson U.S.: *Profiles for Epson R2400.*
ICC profiles for the Epson R2400:
www.epson.com/cgi-bin/StoreEditorial
Announcement.jsp?cookies=no&oid=59082651

[70] GAIN store: GAIN is a service of the Printing
Industries of America/Graphic Arts Technical
Foundation (PIA/GATF).
Their store offers a lot of different photographic
materials. You may also find the "GATF RHEM
Light Indicator":
www.gain.net

[71] GTI Graphic Technology Inc:
www.gtilite.com/color-viewing-lamps.html

[72] *Hutcheson Consulting*: Good information on
color management. Go to *Free* and you will find
several useful images and test targets.
www.hutchcolor.com/Images_and_targets.html

[73] *Microsoft Color Control Panel* (⊞):
A small Windows XP utility to install and unin-
stall ICC profiles, set default profiles for devices
and for the graphic display of ICC profiles:
www.microsoft.com/windowsxp/using/
digitalphotography/prophoto/colorcontrol.mspx

[74] Monaco Systems (now part of X-Rite):
Color management tools:
www.xritephoto.com

[75] Ott-Lite Technology offers several TrueColor
daylight lamps, as well as bulbs and tubes:
www.ottlite.com

[76] *Pantone*: Pantone offers color guides and color
management software. It also sells *huey* (a kit for
monitor profiling) (⊞, ⬜):
www.pantone.com

[77] SoLux: Offers different lighting solutions for
"natural" light (close to D50):
http://ww.solux.net

[78] X-Rite: *ColorChecker* and several profile packag-
es (e.g. Eye-One Match and Eye-One Photo):
www.xrite.com

RIPs, Test Software and Test Images

[79] Our test image for your printers and monitors:
www.jirvana.com/printer_tests/
PrinterEvaluationImage_V002.zip

[80] Bill Atkinson: Bill's color profile downloads.
Here, Bill offers a number of very good ICC pro-
files for some Epson printers and for various pa-
pers for free. There are also helpful comments on
profiles:
http://homepage.mac.com/billatkinson/
FileSharing2.html

[81] *Bowhaus* is focused on black-and-white printing.
It offers InkJet Control and OpenPrintMaker
(RIP software):
www.bowhaus.com

[82] Colorbyte Software: *ImagePrint* (⊞, ⬜) is a
Software RIP for fine art printing coming with a
large library of profiles. They differentiate light-
ing under which a print will be displayed:
www.colorbytesoftware.com

[83] ddisoftware, Inc: *Qimage* – a RIP (⊞),
and *Profile Prism* (⊞) – a profiling software for
printers, digital cameras, and scanners. They sell
printer and camera profiles, as well.
www.ddisoftware.com

[84] EFI: *EFI Designer Edition* is a RIP (⊞,) supporting TIFF, JPEG, PostScript and PDF:
www.efi.com

[85] ErgoSoft: ErgoSoft is focused on Large Format Printing. The ErgoSoft RIP *StudioPrint* (⊞) is mainly for printing photos. Another useful component offered is ColorGPS for a very extensive profiling of inkjet printers:
www.ergosoft.com

[86] Roy Harrigton offers *QuadToneRIP* (⊞,), a fine RIP dedicated to black-and-white printing:
www.quadtonerip.com

[87] *Imatest*. This is an informative presentation on cameras, lenses, scanners, and printers. Imatest is also an interesting program (⊞; test version available) to evaluate image quality of a picture or a print:
www.imatest.com/docs/iqf.html
See also the photography page of Norman Koren including many technique descriptions:
www.normankoren.com

Paper, Ink, Coatings and Cutters

[88] *Arches Infinity*: This company offers fine art papers of various kinds. Here, you also find ICC profiles for papers for several Epson and HP printers (e.g., Epson R800, R1800, 1280, 2200, 2400, 4000, 4800, 7600, 9600, HP 5000):
www.archesinfinity.com

[89] *Crane & CO*, now part of InteliCoat Technologies and marketed by the name of *Museo*, produces a number of fine art products, including fine art papers of inkjet printing – e.g., the well known *Museo Silver Rag*:
www.museofineart.com

[90] FujiFilm sells a number of very nice fine art inkjet papers:
www.fujihuntdigital.com/store/
s-18-pro_media.aspx

[91] Glastonbury Design: *D-Roller*
www.d-roller.com

[92] Hahnemuehle: A maker of fine art papers of various kinds. You also find some ICC profiles there for their papers for various fine art printers (e. g., Epson):
www.hahnemuehle.com/site/us/798/home.html

[93] Hahnemuehle: *A-Z of Paper*:
A good glossary for terms about paper (PDF file):
www.hahnemuehle.com/index.
php?mid=970&lng=us

[94] *Harman Technology Ltd* is one of the companies that resulted from the decline of Ilford. They produce – in our estimate – some of the finest Baryt papers for inkjet printing:
www.harman-inkjet.com

[95] *Ilford* – now part of Oji – was well known for its traditional photo papers. But they also offer digital (inkjet) papers:
www.ilford.com/en/products/galerie/

[96] *inkAID*. A precoating to make uncoated papers suitable for inkjet printing:
www.inkaid.com

[97] *Inkjet Art Solutions* sells inkjet printers, papers and inks for these printers:
www.inkjetart.com

[98] *Inkjet-Mall*: This company offers a rich selection of fine art papers and inks:
www.inkjetmall.com

[99] *Innova Art* produces a number of fine art papers (including some sorts of canvas). They also offer albums:
www.innovaart.com

[100] *Itoya* offers art portfolios:
www.artprofolio.com

[101] *Laszalo Pusztai Photography*. The following website will show the reflectance diagrams of many fine art papers:
www.pusztaiphoto.com/articles/printing/
spectrums/webchart.shtm

[102] *Lyson*: Lyson offers third-party inks for a range of Epson and HP, as well as some Canon inkjet printers, plus inkjet papers. For their inks and papers, they provide ICC profiles and descriptions of how to use them.
www.lyson.com

[103] *Mediastreet Fineart*– an online shop with inks and media for fine art printing. They also offer the "Niagra Continuous Ink Flow System":
www.mediastreet.com

[104] *MIS Associates Inc* is an online shop for inkjet inks and media:
www.inksupply.com

[105] Moab: A maker of fine art papers of many kinds. You will also find ICC profiles there for their papers and different fine art printers (e.g., Epson):
www.moabpaper.com

[106] *Monochrom* – a German supplier of photographic material with a good Web site and an even better printed catalog (but, printed in German):
www.monochrom.com

[107] *Pictorico* Ink Jet Media: The company offers a rich selection of fine art papers (including transparency film):
www.pictorico.com

[108] Piezography: The company produces several special black-and-white inks (e.g., "Piezography Neutral K7") which achieve very fine black-and-white prints. Inks are sold online by stores like Inkjet Mall.
www.piezography.com

[109] *PixelTrust*. This is a precoating product to prepare uncoated papers for inkjet printing. Currently, this is only available in Germany, and the page is in German.
www.pixeltrust.de

[110] *Prat* is one of the manufacturers of professional-quality presentation materials. Its products are offered by many online stores:
www.prat.com

[111] *Premier Imaging Products* offers a number of quality digital fine art papers under the label *PremierArt*:
www.premierimagingproducts.com

[112] *Sihl* coats the papers of quite a number of paper manufacturers to make them usable for inkjet printing. Its also sells its own papers:
www.sihl.com

[113] *Speed-Mat Inc* offers several high quality, although expensive, mat cutters:
www.speed-mat.com/mat_cutter_standard.html

[114] *Tecco* is a European paper manufacturer which originally produced inkjet papers for proofing. Nowadays, they also offer a number of fine art papers at a very reasonable price:
www.tecco.de

[115] *Tetenal*: A maker of inkjet papers of various kinds. Also have ICC profiles for their papers for different fine art printers (e.g., Epson):
www.tetenal.co.uk

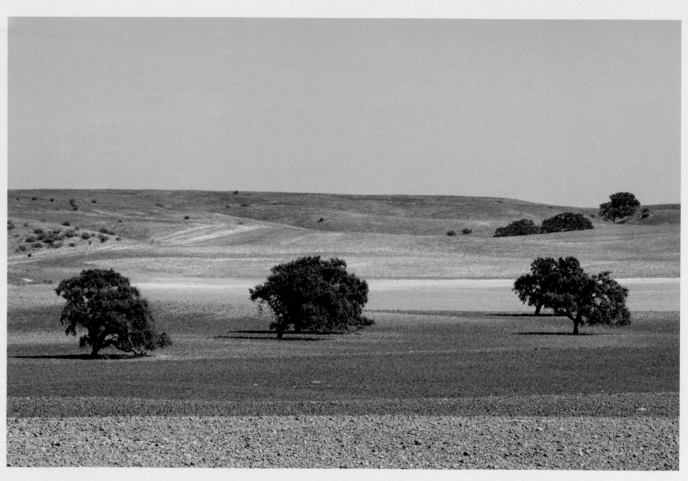

Camera: Nikon D2X

Index

rockynook

Digital
Photography
from the Ground Up

Juergen Gulbins

Juergen Gulbins
Digital Photography from the Ground Up
A Comprehensive Course

This "ground up" guide to digital photography will give the novice photographer a firm foundation in understanding the principles and techniques of modern photography. And, the more experienced photographer will be guided through the transition from analog to digital photography. In this book the reader will learn:

- How imaging occurs in digital cameras
- What to look for when buying a new camera
- An understanding of composition
- Digital shooting techniques
- Image editing, printing, and presentation
- How to archive and organize photographic images

This is not the book that explains which button to push. Rather, it is what the title promises: an in-depth course loaded with valuable information and tips. The author's goal is to share his own experience as a photographer, and to pass on the knowledge that will make photography an enjoyable and rewarding endeavor.

March 2008, 362 pages
978-1-933952-17-8
US $ 34.95, CAN $ 38.95